WHISTLER,

WOMEN,

& FASHION

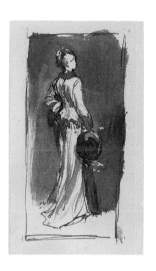

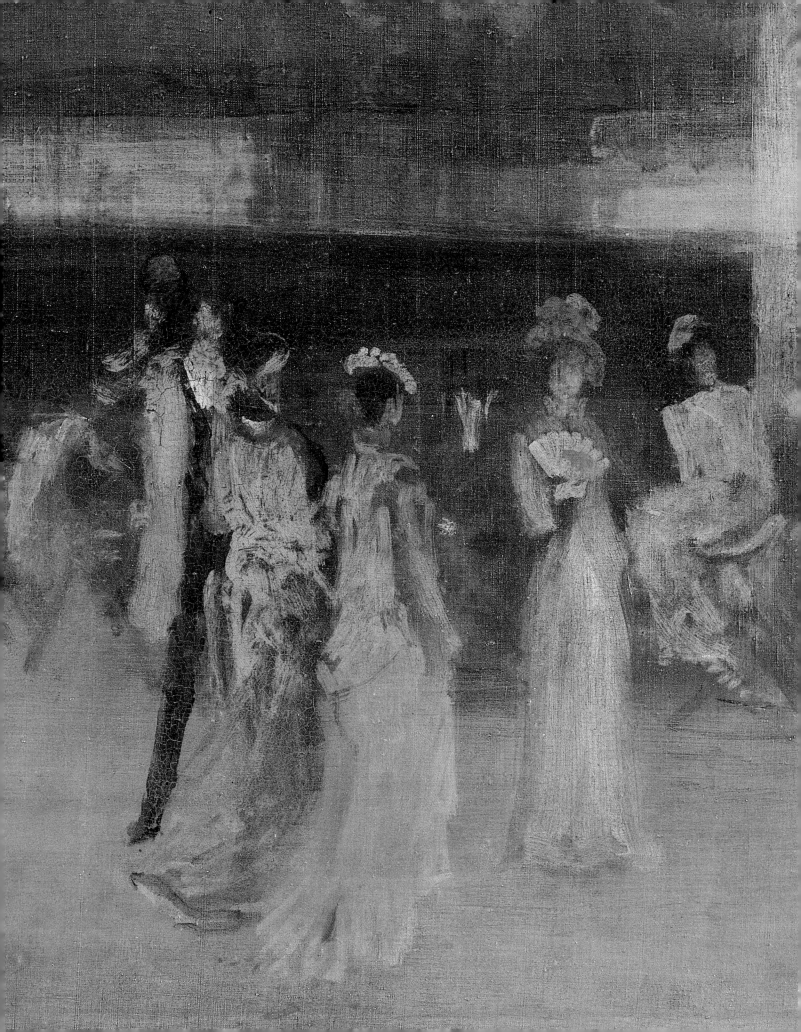

WHISTLER,
WOMEN,
& FASHION

Margaret F. MacDonald,
Susan Grace Galassi,
& Aileen Ribeiro,
with Patricia de Montfort

The Frick Collection, New York
in association with
Yale University Press, New Haven & London

Published on the occasion of the exhibition
Whistler, Women, and Fashion, organized by Susan Grace Galassi and
Margaret F. MacDonald, at The Frick Collection, New York,
April 22–July 13, 2003

Library of Congress Cataloguing Data

Galassi, Susan Grace.

 Whistler, women, and fashion / Susan Grace Galassi,
Margaret F. MacDonald, Aileen Ribeiro ; with a contribution by
Patricia de Montfort.

 p. cm.

Includes bibliographical references and index.

 ISBN Paper Edition: 0-912114-22-3

 ISBN Cloth Edition: 0-300-09906-1

1. Whistler, James McNeill, 1834–1903–Criticism and interpretation.

2. Whistler, James McNeill, 1834–1903–Relations with women.

3. Fashion and art. 4. Artists and models in art.

 I. MacDonald, Margaret F. II. Ribeiro, Aileen, 1944–

III. Frick Collection. IV. Title.

N6537.W4 G35 2003

760'.092--dc21

 2002015480

All information about titles, dates, media, and dimensions of works
by Whistler is from YMSM and M. Citations from letters retain the
original English and French spellings. Translations from the French are
the authors'. Dimensions are inches followed by centimeters in
parentheses. Height precedes width.

This publication was organized at The Frick Collection by
Elaine Koss, Editor
Christine Minas, Curatorial Assistant
Joanna Sheers, Administrative Assistant to the Curatorial Department
Helen M. Burnham, Research Assistant

For Yale University Press: Gillian Malpass and Sandy Chapman

Whistler, Women, and Fashion has been made possible through the
generosity of The Henry Luce Foundation, The Samuel H. Kress
Foundation, The Howard Phipps Foundation, The Helen Clay Frick
Foundation, Melvin R. Seiden in honor of Susan Grace Galassi,
The Ahmanson Foundation, Joseph Koerner, and Raymond and
Margaret Horowitz, with additional support from the Fellows of The
Frick Collection.

The exhibition is supported by a indemnity from
the Federal Council on the Arts and Humanities

FRONT COVER *Harmony in Pink and Grey: Portrait of Lady Meux*
(detail), 1881–82, The Frick Collection, New York, 18.1.132 (fig. 165)

BACK COVER *Symphony in Flesh Colour and Pink: Portrait of Mrs
Frances Leyland* (detail), 1871–74, The Frick Collection, New York,
16.1.133 (fig. 91)

PAGE i *Sketch of "Arrangement in Brown and Black: Portrait of Miss
Rosa Corder,"* c. 1879, The British Museum, London, 1914-4-6-1 (fig.
117)

FRONTISPIECE *Cremorne Gardens, No. 2* (detail), 1872/77, The
Metropolitan Museum of Art, New York, John Stewart Kennedy Fund,
1912, 12.32 (fig. 128)

PAGE iii *Portrait of Miss Maud Franklin*, 1883/88, The Art Institute of
Chicago, 33.298, Gift of Mr. Walter S. Brewster (M. 896) (fig. 134)

THIS PAGE *Design for Lady Archibald Campbell's parasol* (detail),
1881/82, Hunterian Art Gallery, University of Glasgow, Birnie Philip
Bequest (fig. 176)

Contents

left Detail of fig. 192

Foreword

THE YEAR 2003 MARKS THE CENTENARY of the death of James McNeill Whistler. The Frick Collection, which owns a small but significant group of oil paintings, as well as pastels and prints, by the artist is joining in tributes to the American expatriate on both sides of the Atlantic by focusing on a little-explored aspect of Whistler's art: his lifelong interest in fashion.

This book and the exhibition that inspired it are organized around three paintings much loved by our public: Whistler's portraits of Mrs. Frances Leyland (1871–74), Rosa Corder (1876–78), and Valerie, Lady Meux (1881–82). These canvases and Whistler's portrait of Comte Robert de Montesquiou-Fezensac (1891–92) and *The Ocean* (1866) are, with Gilbert Stuart's portrait of George Washington, the only works by American artists in the Collection; the Whistlers are the closest in date to our own time. It is hardly surprising that Henry Clay Frick, a collector of Old Master and nineteenth-century European painting, as well as sculpture and decorative art, acquired the paintings by Whistler as soon as they came on the market between 1914 and 1918, given that many of the masters that the painter admired and emulated—among them Holbein, Velázquez, Rembrandt, Van Dyck, and Gainsborough—already formed part of his collection. The Whistler full-length portraits are the most modern exemplars of the grand tradition of Western portraiture that is so richly represented at The Frick Collection.

A direct precedent for this event is Edgar Munhall's *Whistler and Montesquiou: The Butterfly and the Bat* of 1995, which examined the portrait of the Count in terms of the relationship of artist, subject, and the brilliant society of which they were a part. The three Frick portraits of women now take center stage, and the Count, a model of sartorial splendor himself, steps aside. Although costume figured prominently in the Montesquiou exhibition, this study is the first to explore Whistler's obsession with fashion as an integral aspect of his work and personality.

The three Frick portraits are joined in the museum's Oval Room by five other portraits of women by Whistler, spanning the years from 1864 to 1900. Together they provide abundant evidence of the artist's acute sensitivity to dress and image, as well as his involvement in dress design, at a time of tremendous change and expansion in the fashion world, when haute couture and dress reform movements coincided—or collided—and costume assumed an increasingly important role in the debate on modernism in art, literature, and criticism. The subjects portrayed here, who lived in a period of substantial change in the status of women, are now more fully understood, thanks to new

research; they represent a cross section of Whistler's fashionable world: members of the aristocracy and the demimonde, artists, actresses, and patrons, his mistresses and members of his family.

Preparatory drawings for paintings and delicate pastel costume designs offer insights into Whistler's creative process. In quick sketches, etchings, and lithographs of persons from all walks of life, Whistler made use of dress as an indicator of personality as much as rank and wealth, while he recorded as well those venerable institutions on the periphery of fashion: rag shops and laundries. Small, intimate studies in watercolor of his models and mistresses in everyday dress in interiors brilliantly evoke his bohemian life. Whistler's deep involvement with fashion as designer, observer, and a dandy himself, who carefully cultivated a flamboyant public image, is placed within the context of his aesthetics and personality and the unfolding history of dress as played out in London and Paris in the last decades of the nineteenth century.

* * *

I would like to express my sincere thanks to the authors of this book and organizers of the exhibition for their highly productive collaboration, which bridges the fields of art and dress history. Margaret F. MacDonald, Principal Research Fellow at the Centre for Whistler Studies at the University of Glasgow, is the originator of this project. She proposed it to Susan Grace Galassi, Curator at The Frick Collection, who had already researched one of the Frick portraits, and together they organized the exhibition and the book, inviting Aileen Ribeiro, Head of the History of Dress Section at the Courtauld Institute of Art, London, to join them as costume consultant and co-author. Patricia de Montfort, Research Fellow at the Centre for Whistler Studies, contributed the chapter on Joanna Hiffernan. Helen M. Burnham, a doctoral candidate at the Institute of Fine Arts, New York University, and research assistant at the Frick, wrote a section of the chapter on Lady Meux and Lady Archibald Campbell.

Many institutions have contributed generously to this project. For loans of paintings, we are deeply grateful to the Philadelphia Museum of Art, Tate Britain, London, the Honolulu Academy of Arts, the Hunterian Art Gallery, University of Glasgow, and the National Gallery of Art, Washington, D.C. We are equally indebted to the print departments of The Art Institute of Chicago, The Metropolitan Museum of Art, New York, the National Gallery of Art, Washington, and the New York Public Library for lending several examples of some of Whistler's finest engravings and lithographs. It is a pleasure to acknowledge as well the following institutions for loans of crucial prints, drawings, watercolors, and pastels: the Amon Carter Museum, Fort Worth; the Baltimore Museum of Art; the British Museum, London; the Carnegie Museum of Art, Pittsburgh; the Cincinnati Art Museum; the Davison Art Center, Wesleyan University, Middletown, Connecticut; The Fitzwilliam Museum, Cambridge; the Hunterian Art Gallery; the Department of American Art at The Metropolitan Museum of Art; The Rosenbach Museum and Library, Philadelphia; the University of Michigan Museum of Art, Ann Arbor; and the Yale Center for British Art, Paul Mellon Collection, New Haven. We acknowledge with gratitude the kindness of individuals who made available important works on paper from their collections: Janet Freeman and others who wish to remain anonymous.

Our colleagues in costume departments in New York museums were especially supportive of this endeavor by making available loans and sharing their expertise; we extend our heartfelt thanks to Harold Koda, Curator-in-Charge, The Costume Institute of The Metropolitan Museum of Art; Patricia Mears, Assistant Curator of Costumes and Textiles at the Brooklyn Museum of Art; and Phyllis Magidson, Curator of Costumes at The Museum of the City of New York.

The Henry Luce Foundation and The Samuel H. Kress Foundation provided major support for this book and the exhibition. For their generosity we also express profound thanks to The Howard Phipps Foundation, The Helen Clay Frick Foundation, Melvin R. Seiden, The Ahmanson Foundation, Joseph Koerner, and Raymond and Margaret Horowitz, as well as to the Fellows of The Frick Collection.

Samuel Sachs II
Director, The Frick Collection

Preface and Acknowledgments

James McNeill Whistler was a meticulous draftsman, a painter of subtle color harmonies, an innovative lithographer, and one of the greatest etchers of the nineteenth century. He was also a many-faceted character: charming and witty, ruthless and manipulative, a serious, hardworking craftsman, dandy, and man-about-town. In order to sell and exhibit his work, he cultivated an image that ensured that his name and work were kept in the public eye. The development of this image is the starting point of our book.

As Whistler moved from bohemian Paris to the melting pot of London, his world stretched from Wapping and the East End slums to the circles of artists, aristocrats, and the aspiring nouveaux riches of Chelsea and Kensington. His quick grasp of character and appearance and his sensitive reaction to nuances of costume made him a perceptive portrait painter, limited only by his own perfectionism and the slow pace of his work. From his earliest portraits, with their careful observation of the character and costume of the people he met—beggars in the street, fellow artists, the women he knew and lived with, and his own family—Whistler gained confidence, adapting his style and scale of work to explore new subjects.

Throughout the fifty-five years of his career—from 1858 to his death in 1903—Whistler was open to fresh visual influences, to fashion and fashion plates, to the work of Old Masters and new, to Eastern and Western art, to the aesthetics of Art for Art's Sake, and to movements such as Impressionism and Pre-Raphaelitism. These all impinged on and were absorbed in his work.

The fast-changing fashions of Whistler's time included such dramatic styles as crinolines and bustles, wasp waists and leg-o'-mutton sleeves, and the new masculine-inspired tailored suits. Whistler observed such styles—some he accepted, some he rejected—creating in his portraits an intelligent synthesis of fashion and individual taste (his own and that of his sitters). He also delighted in the details of fabrics and accessories—soft muslins, shining silks, sumptuous furs, matte woolen cloths, chic head gear, the erotic possibilities of gloves, and glittering jewelry. Aileen Ribeiro's overview provides the basis for discussions of the often-complex relationship between Whistler and fashion. The extent to which he depicted current fashion, the historical and exotic influences on costume, the significance of dress, and the manner in which it was worn are all aspects explored in the context of Whistler's relationships with particular women.

Margaret MacDonald focuses on Whistler's models and partners, including "Fumette," Maud Franklin, and

his wife, Beatrice, as well as her younger sisters. He also painted startlingly vivid studies of beautiful young girls, actresses like Kate Munro, and professional models such as Milly Finch. Their dress was not necessarily precise but reflected aspects of current fashions. His relationship with his models imparted a significant intimacy to his work, and the portraits of his wife in particular have great poignancy.

Susan Galassi focuses on a series of magnificent formal portraits: Mrs. Leyland in an aesthetic dress designed by Whistler himself, the artist Rosa Corder in walking dress, and the nouveau-riche Lady Meux in two portraits in the grand manner, in which she appears majestic in black velvet, diamonds, and furs and seductive in form-fitting pink satin and gray chiffon. Helen Burnham explores the implications of Lady Archibald Campbell's newly fashionable attire and unorthodox pose. The choices made by both artist and his models, in the face of the broad range of styles, colors, and textures available, throw new light both on the fashions of the day and on the work of Whistler and his contemporaries.

Patricia de Montfort discusses the significance of the informal poses and aesthetic dress depicted in Whistler's portraits of Joanna Hiffernan, the *White Girls*, which are among the most famous of his paintings. The pictures are harmonious arrangements that convey mood and status, in which the interpretation of dress plays a vital part.

Costume, dress, and fashion and the position and status of women changed significantly during the second half of the nineteenth century. This book explores dress through and in Whistler's paintings and sets the art of portraiture in the wider context of the world of fashion.

ACKNOWLEDGMENTS

We wish to thank the many persons at various institutions who contributed to bringing this project to fruition. At The Frick Collection, we thank the Trustees and the members of the Frick Council for their generous support. We acknowledge with gratitude the enthusiasm and participation of the Director, Samuel Sachs II, and of Deputy Director Robert Goldsmith. Colin B. Bailey, Chief Curator, deserves warm thanks for his strong commitment to this project and invaluable help at many junctures. Margaret Toubourg, Advisor to the Director, and Jason Herrick, Manager of Special Projects, were invaluable allies. Martin Duus, Manager of Development, his staff, and Heidi Rosenau, Manager of Media Relations, have been very helpful. Margaret Iacono, Curatorial Assistant, and Amy Herman, Director of Education, have contributed in many ways. Thanks are due to Diane Farynyk, Registrar, and to Barbara Roberts, Conservator, as well as to William Trachet, Conservation Technician, and Adrian Anderson, Senior Galleries Technician. We are also grateful to Stephen Saitas for his handsome exhibition design.

Many members of the Curatorial Department played essential roles in the organization of the exhibition and its accompanying book. Curatorial Assistant Christine Minas expertly handled most of the administrative matters connected with the exhibition and the photography for the book, while contributing to research. Joanna Sheers, Administrative Assistant, helped greatly in the initial phase of research, played a vital role in finalizing the manuscript in preparation for the editor, and assisted in copyediting. Helen M. Burnham, a graduate student at the Institute of Fine Arts, New York University, served as part-time research assistant to Susan Galassi; her critical acumen and fine literary skills made her an ideal collaborator and co-author of one of the chapters. Intern Karin Bejarano added to the study of Lady Meux's costume, and summer interns Kristin Roper and Julia Cottrell assisted with administrative matters. We extend warm thanks to Elaine Koss, Editor at The Frick Collection, for her fine editing and superb organization of the various parts of the book as well as her constant good will. Richard di Liberto, Photographer at the Collection, provided many of the excellent photographs in this book. It is a pleasure to acknowledge the generous assistance of Lydia Dufour, Chief, Public Services, as well as the support of the entire staff of the Frick Art Reference Library.

At the Centre for Whistler Studies at the University of Glasgow, the partner institution in this endeavor, we express our thanks to the director, Nigel Thorp, for his generous support. Margaret MacDonald extends her thanks to her colleagues for their help at all stages of research—Ailsa Boyd, Graeme Cannon, Liz Haines, Sue Macallan, Ian and Joanna Meacock, Charlene Tinney, and Georgia Toutziari —as well as to the Centre's Honorary Research Fellows, Martin Hopkinson, Linda Merrill, and Joy Newton. She also acknowledges the good support from the staff of Special Collections, Glasgow University Library, and in particular David Weston, and the expert work of the Photography Departments in the University of Glasgow and Mitchell Library.

Additionally, Margaret MacDonald wishes to thank Thomas Colville; Ayako Ono; Catherine Carter Goebel; Mrs. Mary Reid; Susan Soros; Linda Zatlin; The Fine Art Society; Joyce Townsend, Tate Britain; Mark Evans,

Prints and Drawings, Anna Jackson, Research, and Lucy Johnston, Costume Department, Victoria and Albert Museum; Martha Tedeschi and Harriet Stratis, The Art Institute of Chicago; the staff of the Museum of London; the staff of Archives, Theatre Museum, London, and Mitchell Library, Glasgow; and of the Linley Sambourne Archive, Kensington and Chelsea.

At the Hunterian Art Gallery, University of Glasgow, we enjoyed the collegiality and generous help of the Director, Mungo Campbell, the Senior Curator and Reader, Pamela Robertson, and curators Anne Dulau and Peter Black. We are grateful to the University Court of the University of Glasgow, holders of Whistler's copyright, for permission to publish excerpts from the correspondence of James McNeill Whistler.

We are indebted to many members of the costume community. Aileen Ribeiro wishes to thank the following colleagues for their help with loans and for sharing their expertise: Edwina Ehrman and Oriole Cullen, the Museum of London; Lucy Johnston and Helen Persson, the Victoria and Albert Museum; Harold Koda and Chris Paulocik, The Costume Institute, The Metropolitan Museum of Art; Patricia Mears, the Brooklyn Museum of Art; and Phyllis Magidson, the Museum of the City of New York. She would also like to record her appreciation for the help given by Valerie Cumming; Anthea Jarvis, Gallery of English Costume, Platt Hall, Manchester; Peter Funnell, National Portrait Gallery, London; Sophie Wilson, Cheltenham Art Gallery and Museum; the City of Westminster Archives Center, London; and the libraries and the photographic department of the Courtauld Institute of Art.

Susan Galassi offers sincere thanks to the many scholars, curators, librarians, and individuals who helped us with research and loans: Richard Langdon of Ashburton, New Zealand, a descendant of one of Lady Meux's brothers, shared his research into his family history through a delightful yearlong correspondence. Stéphane Houy-Towner offered gracious assistance in the Library of the Costume Institute of The Metropolitan Museum of Art. She also gratefully acknowledges the help of the late Joseph A. Allen, London; Timothy and Chloë Cockerill, Cambridge; Elizabeth Ann Coleman, Museum of Fine Arts, Boston; Philip Conisbee and Ruth Fine, National Gallery of Art, Washington, D.C.; Charlotte Gere, London; Colleen Hennessey and Linda Machado at the Archives of the Freer Gallery of Art, Washington, D.C.; Alex Kidson, Walker Art Gallery, Liverpool; Michael Marshman, County Local Studies Library, Trowbridge, Wiltshire; Felicity Marpole, Hertfordshire Archives and Local Studies, Hertford; Stephen Deuchar and Christine Riding, Tate Britain; Joseph Rishel, Philadelphia Museum of Art; Peter Rooke, Waltham Cross, Hertfordshire; Jennifer Saville, Honolulu Academy of Arts; Valerie Steele, The Fashion Institute of Technology, New York; Martha Tedeschi, The Art Institute of Chicago; Roberta Waddell, New York Public Library; and Kevin Stayton and Marc Mayer, Brooklyn Museum of Art. For their help in obtaining photographs, we thank Linda Clark at the Hunterian Art Gallery; Peter Huestis, National Gallery of Art, Washington; Ruth Jansen, Brooklyn Museum of Art; Caroline Nutley and Hsiu-Ling Huang, The Art Institute of Chicago; Niki Pollock, Glasgow University Library; Pauline Sugino, Honolulu Academy of Art; Debbie Walker, Theobalds Park, Cheshunt, Hertfordshire. We also thank private collectors who wish to remain anonymous.

We collectively thank the following scholars—whose work is frequently cited in these pages—for their kindness in responding to questions and help in other matters: Avis Berman, David Park Curry, Richard Dorment, Katharine Lochnan, Linda Merrill, Edgar Munhall, Kenneth Myers, and Virginia Surtees. We also acknowledge the invaluable assistance of Caroline Milbank, New York; Margot B. Chvatal, Kelly Troester, and Eric Wilding of Christie's, New York; and Titi Halle, New York.

The authors feel privileged to have had Yale University Press co-publish this book with The Frick Collection and thank Gillian Malpass for her superb design and for guiding it through the publishing process. We also thank her assistant, Sandy Chapman. Our families also deserve warm thanks: Helen, Kathy, and Norman MacDonald, researchers extraordinary, for their constant support, insight, and enthusiastic help; Jonathan, Isabel, and Beatrice Galassi; and Robert Ribeiro. It gives us pleasure to acknowledge our debt to one another and the great benefits of working together in what has been a most enjoyable collaboration. Aileen Ribeiro speaks for us all in saying that being involved in the world of Whistler has been an informative and joyful experience.

Margaret MacDonald, Susan Galassi,
Aileen Ribeiro, Patricia de Montfort

Chapter 1

Whistler: Painting the Man

Margaret F. MacDonald

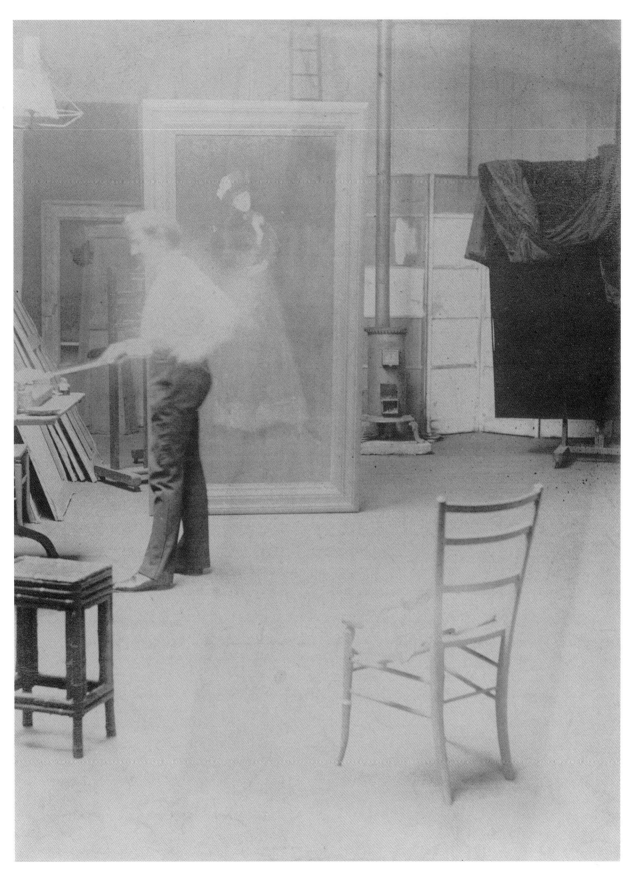

1 Unknown photographer, Whistler in his studio with *Portrait of Maud Franklin* (YMSM 353), c. 1886, by permission of Glasgow University Library, Department of Special Collections

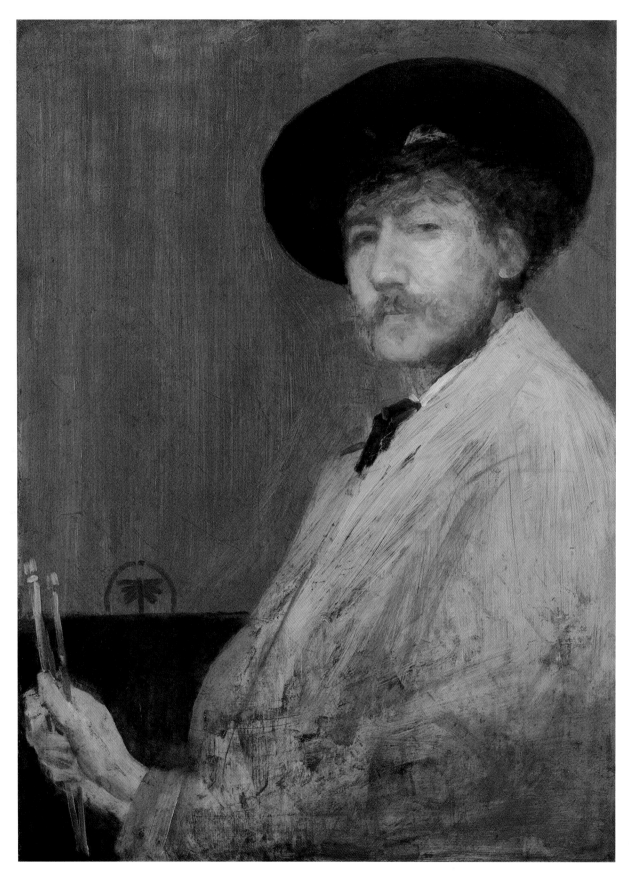

2 *Arrangement in Grey: Portrait of the Painter*, c. 1867/72, oil on canvas, 29 ¹/₂ × 21 (74.9 x 53.3), Detroit Institute of Arts, Bequest of Henry Glover Stevens in memory of Ellen P. Stevens and Mary M. Stevens, 32.47 (YMSM 122)

A YOUNG WOMAN FROM NORTH CAROLINA, Anna Matilda McNeill, visited England in 1829: "we went to the most fashionable hair dresser's. I think Maria would approve of the outside of my head at least now, it is adorned with curls, puffs, &c. as high as she used to wish me to wear it."[1] Years later, as a married woman with two sons, James and William, she joined her husband in St. Petersburg, Russia. They were affluent but unfashionable, their circle including Major Whistler's fellow railway engineers, diplomats, and merchants.

James's interest in art and costume was encouraged by his parents and inspired by new sights. Servants, peasants, and Bible characters filled his sketchbook.[2] He delighted in books of military uniforms and Hogarth engravings, and—when ill health forced him to join his half sister, Deborah Haden, in London—in her husband's print collection. London provided new subjects. "I send you a little sketch of a Young Sweep . . . we were preparing some sketches for a Scrap Book," he told his mother, adding that Haden had given him a Fuseli drawing and "two beautiful pair of pantaloon!"[3] Anna wrote wistfully, "I wish you could see a foreigner in Turkish costume I sometimes meet you would try to put him in your sketch book. . . . I promised to tell you of Willies uniform it is very plain, because the object of the Trustees of the Commercial school is to 'prevent dandyism & to bring rich and poor on an equality.'"[4] She was wont to warn him against the excesses of dress, drink, women, and other temptations common to thirteen-year-olds.

In 1849 her husband died, and the family returned to America. Two years later James entered the Military Academy at West Point. He agreed with his fellow cadets that military uniform was irresistible to women, and that the tight trousers, loud checks, and large buttons of the man-about-town appealed to both sexes (fig. 3).[5] For three years he pursued an undistinguished career, excelling in French and drawing but neglecting rules on dress and behavior.[6] His mother sent increasingly demanding letters: "it made me tremble for your future my dear son, that you thought it excusable to require your laundress to wash a garment for you, as a military custom. Trifles make

up the sum of a worldlings life!"[7] Anna and her maid sewed shirts ("4 new linen bossomed shirts . . . half dozen plain winter shirts à la militaire");[8] laundresses, seamstresses, tailors labored in vain. James was dismissed from West Point because of poor academic performance and by April 1855 was bent on an artistic career, under the patronage of the engineer Thomas Winans of Baltimore.

James Whistler filled the Winans scrapbook with character and costume sketches. *Mrs Tiffany* shows a woman obsessed with finery, financed by her husband's skill in forgery, from a play written by Anna Cora Mowatt in 1845.[9] The dress had a wide, off-the-shoulder neckline accentuated with perky bows, full sleeves, and three layers of frills on the skirt. It was typical of Whistler's style, heavily influenced by George Cruikshank's Dickens illustrations. Dress as a reflection of individual personality and the distinctions of rank, age, and wealth always fascinated Whistler.

Anna worried about his extravagance:

first send me your tailors receipt to <u>file</u>. dont be tempted to order a new vest & new trowsers till you <u>earn</u> them here. Tho Winans will be better satisfied if you come here in your old clothes, he is an observer, he wishes to help you, dont dash to destruction! . . . I depend on the Almighty Disposer of hearts to help me to prove I am not dishonest tho poverty has overtaken me.[10]

Whistler shrugged off his mother's warnings, made the most of Winans's studio, and departed as soon as possible for Paris. He received an allowance from his father's estate, cash advances from Winans, shirts from Mrs. Winans, and hand-me-down trousers from his mother.[11] Jealous of the Winans' wealth and excluded from "rich, fashionable" circles, she declared, "You must not suppose that I am hurt by the indifference of the rich in my circle. I have enough to visit who are equal."[12] Whistler, however, escaped the constraints of poverty and class by his choice of career and country, and he never returned to America.

Oh! when we go out to dress parade
We look so fine and gay;
We have to carry our guns along,
To keep the girls away.

3 *Dress Parade*, 1852/53, pencil, pen, brown ink, and wash on brown paper, 5 × 3 5/16 (12.7 × 8.4), The Metropolitan Museum of Art, New York, 1970.121.16–.19 (M. 99r)

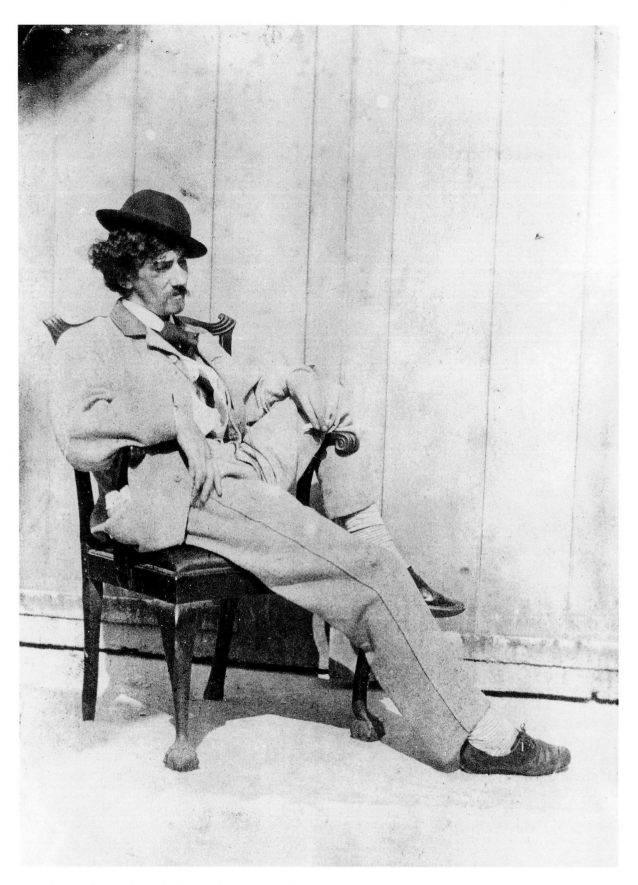

4 Unknown photographer, Whistler seated, 1860/65, modern silver print, Charles Lang Freer Papers, Freer Gallery of Art, Smithsonian Institution, Washington D.C., Gift of the Estate of Charles Lang Freer

What Whistler expected to find in Paris, judging by his drawings, was a bohemian life, owing much to Murger's *Scènes de la vie de Bohème*.[13] It involved working in garrets, smoking and drinking, informal dress, and pretty women.[14] Cross-dressing excited him, with its associated ideas of equality between the sexes and sexually available young women. Before he left America he had made several drawings of *Débardeurs*, the women dockworkers romanticized by Gavarni (fig. 5).[15]

Evidence of Whistler's studies, from 1855 on, is sparse. Some drawings of Parisian life fell victim to his mother's morality: "human imagination need not such promptings to familiarity with the snares of the pervading evil of cities, to caricature the fallen is revolting to me."[16] Others were destroyed in a temper by the "tigresse," his mistress, Héloïse. Records of the period derive mainly from memoirs written sixty years later, such as those of his fellow student Thomas Armstrong, who described Héloïse in his memoir:

> Héloïse, a girl-model well known in the Quartier. She was a remarkable person, not pretty in feature, but with good eyes and a sympathetic sort of face. As this was long before the fashion came in for women and children to wear their hair hanging loose, and not in plaits down their backs, Héloïse attracted the notice of passers-by almost as much as Whistler did when he was wearing . . . his summer suit of white duck, with the jaunty little flat-crowned Yankee hat.[17]

Whistler's earliest oil self-portrait shows him in this straw hat and a spotted neckerchief, cigarette in hand, and was painted with the thick impasto and strong lighting of Dutch masters such as Rembrandt, whom he greatly admired.[18] Another fellow student, George Du Maurier, recorded Whistler's dress style in a cartoon showing Whistler in a loose white suit with narrow trousers and slip-on mules (fig. 6). He sported a bow with flapping ends, instead of a cravat, under a small round collar, and a monocle at-tached to a long ribbon. Dark, curly hair bushed over his collar, and a trim mustache curled up wickedly. A flat straw hat with a narrow brim, tilted for-ward on his head, had black ribbon falling forward over his forehead. Even without the paintbrush, the figure read as a bohemian artist, wearing his clothes with verve, an "enchanting vagabond."[19]

Du Maurier appropriated Whistler's studio and his "dress coat and waistcoat (quite new [when he doesn't happen to want it himself])."[20] They dined with a Greek shipping family, the Ionides, and Du Maurier reported, "Jemmy was adored, I appear to be idolized. . . . Men dress tremendously here."[21] Whistler and his friends had considerable interest in their appearance. Whistler told Henri Fantin-Latour that another erstwhile fellow student had become a social lion:

> Legros is so fine you would not recognise him! his main preoccupation is the shade of his gloves.—I am going to have him photographed so that you can see him in the fine flower of his splendour! Moreover he is society's darling . . . his pictures are sold straight from the easel, and all his leisure time is spent with his tailor, one of the most famous in London![22]

Legros went on to concentrate on portraits of women and fashion and profited greatly thereby. The importance of appearance in attracting clients was not lost on Whistler, although what sort of

5 (*right*) *Vive les Débardeurs!!*, 1854, pencil, pen, and black ink on beige paper, $4^{13}/_{16} \times 2^{3}/_{16}$ (12.2 × 5.6), The Metropolitan Museum of Art, New York, Gift of Margaret C. Buell, Helen L. King, and Sybil A. Walk, 1970.121.34 (M. 133)

6 (*above*) George Du Maurier (1834–1896), "Whistler in 'Q,'" *Punch*, vol. 39 (October 27, 1860), p. 163, by permission of Glasgow University Library, Department of Special Collections

appearance and what class of clients were more of a problem.

A photograph from the early sixties shows the artist in a well-cut but crumpled white suit, with small sharp revers on the jacket, a shirt with the same round collar and loose cravat, and neat pumps on his feet (fig. 4). The mustache is rather fluffier and less structured than it appeared in Du Maurier's drawing. A bowler hat sits atilt on his curly hair. The image is informal, the young man-about-town in daywear. As he grew older he adopted a more distinctive coiffure, described indulgently by his mother:

Jemie [is] even more like his dear Father in face & the same curly head, but he is such an original he takes the greatest care to friz a white lock (such as Debo also has had always, & his a copy of it, only hers is not seen, & his was hidden by his masses of curls til he fancied Aigrettes![23]

This white lock is conspicuous in his vigorous Rembrandtesque self-portrait of 1867/72 (see fig. 2)

A formal photograph of the mature artist projects a new image, with a thoughtful pose, a sober suit, and the distinctive hairstyle (fig. 7). By this time, the artist was well known, even notorious, for which he largely had John Ruskin to thank. In *Fors Clavigera* the critic attacked Whistler's *Nocturnes* at the Grosvenor Gallery in 1877, and the subsequent libel suit projected accounts of the artist, his work, and his beliefs into newspapers across two continents. *Nocturne in Blue and Silver*,[24] which Whistler had given to Mrs. Frances Leyland, was shown in court. He defined the title "Nocturne" as indicating "an artistic interest alone, divesting the picture of any outside anecdotal interest" and "Arrangement" as "an arrangement of line and form and color."[25] Whistler, monocle in eye, bore witness before a fashionable audience (fig. 8). *Mayfair*, journal of politics, literature, and society, reported, "the form of bonnets, was rather Mediaeval, and some arrangements of velvet and ribbon in green and brown were extremely harmonious. The Court itself, during lunch, had rather the appearance of a conversazione at some Artistic Society's room."[26]

Despite his supporters' acclaim, Whistler suffered a severe setback in the aftermath of the trial. His finances were shaky, and he lived above his income. Unpaid bills reveal his uneconomic relationship with shopkeepers unfortunate enough to have his custom. One of the most influential merchants of the Aesthetic movement, A. Lasenby Liberty & Co., Japanese, Chinese, & Indian Warehouse, reminded Whistler on September 14, 1878, that three bills

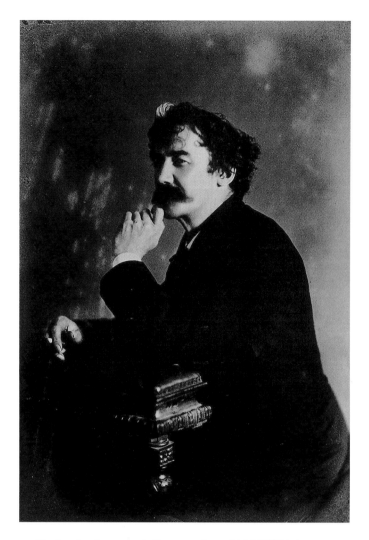

7 The London Stereoscopic Company, James McNeill Whistler, c. 1879, by permission of Glasgow University Library, Department of Special Collections

had been returned. "Can you let us have balance, part balance, or shall we draw fresh one?" asked Liberty. Unfortunately, he did not say what Whistler had been buying—clothes, materials, or furnishings. Liberty's patience went unrewarded, and he appeared on the list of creditors from Whistler's bankruptcy in 1879. By then Whistler owed £78 1s. 1d.; he apologized, "You are really more than considerate and it is not easy to thank you.—"[27]

Other firms made repeated attempts to get payment, calling in solicitors and bailiffs. For instance, on September 26, 1878, Halling, Pearce & Stone, "Silk Mercers, Linen Drapers, Lacemen, Haberdashers, Hosiers and Glovers, Costumes, Mantles and Family Mourning," begged Whistler, in vain, to settle an account for £35 17s.

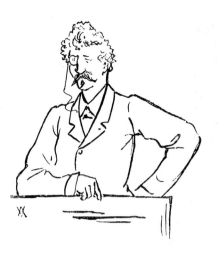

otherwise than by counsel, and Mr. Whistler had to explain to the Attorney-General his own views on his own pictures. Sir John Holker may, indeed, be more open to æsthetic influences than he seems; but the definition of a Nocturne as 'an artistic interest divesting the artistic of any outside anecdotical sort of interest,' probably left him very much where he had been. The Nocturne itself was, indeed, produced, and was rather difficult to make out, even by the light of this remarkable interpretation. Mr. Whistler appeared at once as artist and as interpreter, and everyone felt that the interpreter was the harder to be understood of the two.

In the mean time the court became inconveniently crowded, and the light was nearly as bad as the ventilation. One of the pictures was hung up behind the jury and the witness-box, while the other two were accommodated with seats on the bench. Many ladies were in court, and so Beauty and Art seemed to be the supporters of the learned judge. The Art was pronounced by subsequent critics to be 'deficient in form,' the Beauty had, however, both form and colour.

The form, especially when it took the shape of bonnets, was rather Mediæval, and some arrangements of velvet and ribbon in green and brown were extremely harmonious. The Court itself, during lunch, had rather the appearance of a conversazione at some Artistic Society's rooms, with a few pictures

8 "Whistler in court, with lady spectators," *Mayfair* (December 3, 1878), by permission of Glasgow University Library, Department of Special Collections

2d.,[28] and on October 14, 1878, William and Henry Hamper, "Shirt Makers, Hosiers and Glovers," requested payment for £15 6s. 6d. outstanding since the previous Christmas.[29] On May 7, 1879, Whistler was declared bankrupt.[30] Desperately, he borrowed and pawned what he could (portraits of Thomas Carlyle and Rosa Corder, and even of his mother, were already security for loans from H. Graves and Co.).[31] Fortunately, a commission from the Fine Art Society for a set of etchings of Venice provided an escape from this "absurd and ridiculous poverty."[32]

"THE FASHIONABLES"

Whistler returned from Venice determined to restore his fortune and reputation. A friend, Alan S. Cole (son of Sir Henry Cole of the South Kensington Museum), recorded on May 26, 1881: "met Jimmie, who is taking a new studio in Tite Street, where he is going to paint all the fashionables—views of crowds competing for sittings—carriages along the streets."[33] To this end Whistler promoted not only his work but also himself. He exaggerated his dress and mannerisms to distinguish himself from fellow artists, creating a distinctive image to present to the public.

Whistler packaged himself and his pictures to make them more marketable. The etchings and pastels were presented in frames designed to complement their color and composition (green pink or yellow gold for the pastels, white for the etchings) and hung in harmoniously decorated exhibition rooms. In 1883 the rooms were white and yellow, the men wore yellow cravats, and he designed little velvet butterflies for the women, who were advised to wear black or white, that they might not clash with the decor.[34] "All the World there—Lady Archie—the Prince...and the Butterfly rampant and all over the place!...Forty odd superb etchings round the white walls in their exquisite white frames...and finally servant in yellow livery (!)" Whistler told the American sculptor Waldo Story.[35]

A mixture of elegance and rakishness marked Whistler's own appearance. Cole met Whistler "in great form, with a new fawn coloured frock-coat, and extraordinary long cane" (fig. 9).[36] These made him seem leaner and taller. His hair was cut rather long, and the white lock waved defiantly under the curving brim of a shiny top hat. He carried a fur-lined coat over one arm, like an enormous muff. A wickedly witty tongue, a strident laugh, an American accent larded with French expressions captivated or infuriated his audience. Although sometimes targeted for his

American nationality, for his dress and behavior, as well as for his art and aesthetic views, these also served to distinguish him and freed him from the limitations of any particular stratum of society.[37]

Whistler promoted an extravagantly theatrical image. Journalists and friends collaborated in this: it made them feel part of a cultured elite. Whistler's "Sunday breakfasts" provided a carefully constructed stage controlled by the artist to entertain prospective and actual patrons. The rooms were distempered in yellow, sparingly furnished, with carefully placed fans and blue and white china. The food, French- and American-influenced, was enhanced by handwritten menus and presentation. "One must see the impeccable artist, with supreme dandyism, monocle in his eye, more correct in his dress than Lord Brummel, occupied, in the part of his studio reserved for culinary preparation, in . . . grilling a slice of salmon," wrote a French journalist.[38] The guests were writers, critics, theatrical stars, leaders of fashion, and fellow artists (at one breakfast, in 1877, Whistler painted the artist Louise Jopling; see fig. 16).[39] He continually promoted the idea that he himself and, by association, his work were the fashion. "<u>The</u> opening breakfast of the Season—'small & amazing'—as usual. . . . Of course if you choose to assert that 'our James' is the whirl and the fashion in Paris where his works [are] delighted in—Why I can't prevent you!—" he told J. E. C. Bodley, a friend in the Whistler-Wilde circle.[40]

THE "TEN O'CLOCK" LECTURE

Whistler's "Ten O'Clock" lecture, the public statement of his aesthetic ideas, was delivered at that fashionable evening hour on February 20, 1885, at the Prince's Hall, Piccadilly. It was to be an evening dress, after-dinner entertainment. "Ladies appeared 'en grande tenue.' Diamonds flashed, satins gleamed," wrote *Queen* admiringly. "Many of the ladies present were superbly dressed."[41] *Truth*, under

"Jimmy"

the editorship of Whistler's friend Henry Labouchère, a prominent journalist and Liberal politician, reported: "the Prince's Hall was crowded with literature and fashion. There were lords and ladies, beauties and their attendant 'beasts,' painters and poets, all who know about Art, and all who thought that they did."[42] Whistler was distinctive: "With his light, graceful, black figure, in an American dress suit, he appeared a remote silhouette, making graceful motions."[43]

Cole commented, "The people near me were enchanted at Oscar's long drawing face as the question of aesthete & costume was handled—."[44] In the lecture, Whistler had challenged Wilde's aesthetic dress and public pose as an arbiter of taste: "Costume is not dress. And the wearers of wardrobes may not be doctors of taste!"[45] Wilde responded immediately:

I hardly think that pretty and delightful people will continue to wear a style of dress, as ugly as it is useless, and as meaningless as it is monstrous, even on the chance of such a master as Mr. Whistler is spiritualising them into a symphony, or refining them into a mist, for the arts are made for life, and not life for the arts.

Nor do I feel quite sure that Mr. Whistler has been himself always true to the dogma he seems to lay down, that a painter should only paint the dress of his age, and of his actual surroundings. . . . For all costumes are caricatures. The basis of Art is not the Fancy Ball. Where there is loveliness of dress, there is no dressing up.[46]

Whistler accused Wilde of dressing up in extraordinary outfits, "in Polish cap and green overcoat, befrogged, and wonderfully befurred" and urged him to "Restore those things to Nathan's, and never again let me find you masquerading the streets of my Chelsea in the combined costumes of Kossuth and Mr. Mantalini!"[47] (Mantalini being the affected dandy in Dickens's *Nicholas Nickleby*).

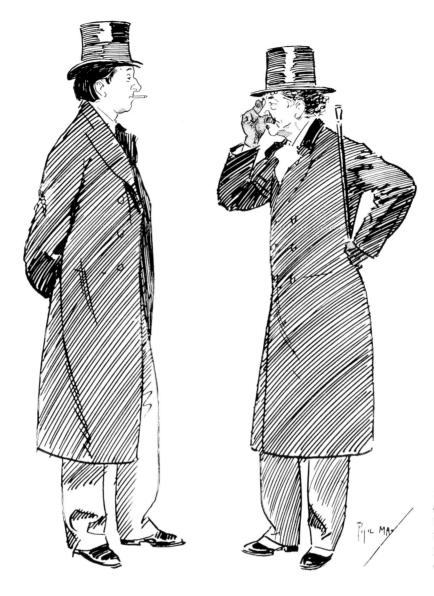

10 Phil May (1864–1903), cartoon in *Graphic* (1894), by permission of Glasgow University Library, Department of Special Collections

Whistler never passed up the chance to confront, to challenge and combat ideas on art, dress, politics, or anything at all that conflicted with his own ideas. Phil May caricatured Whistler challenging a younger aesthete somewhat like Wilde (fig. 10). With his double-breasted velvet-collared coat buttoned up, his trousers bowing slightly over immaculate spats and shiny shoes, a top hat and narrow cane, and a monocle in one neatly gloved hand, Whistler was the epitome of understated style.

A rather more effete image went alongside this substantial presence. A caricature published in *Punch* on June 19, 1886, showed Whistler holding a Japanese parasol, and another, on May 21, 1887, described "the American President M'NEILE WHISTLER, wearing such an ultra-Parisian

hat as, if he brings it back with safety, and wears it about town, will make him the observed of all the observant" (figs. 11, 12).[48] A sharply cut-away dress suit, a huge bow tie, and streamlined narrow trousers accompany the hat.

At this point Whistler was briefly president of the Society of British Artists, with an ardent group of young artists supporting him, including Harper Pennington, who drew Whistler with the parasol (a parasol cum clock face, inscribed P.R.B.A.). As president, he promoted events that would appeal to a fashionable audience and insisted that his followers dress accordingly. "Of course you will dress— mon monde is beau! that goes without saying itself! and on Saturday the Guard must be most brilliant!" he told G. P. Jacomb Hood.[49] However, the old guard objected to

12 (*right*) Harper Pennington (1854–1920), "Note of a recently 'Established President,'" *Punch*, vol. 90 (June 19, 1886), p. 300, by permission of Glasgow University Library, Department of Special Collections

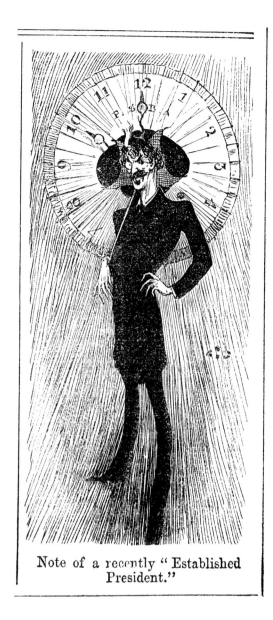

Note of a recently " Established President."

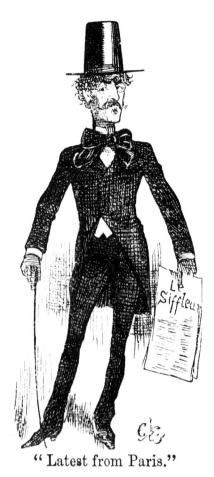

"Latest from Paris."

11 (*above*) "Latest from Paris," *Punch*, vol. 92 (May 21, 1887), p. 249, by permission of Glasgow University Library, Department of Special Collections

Whistler's exhibition hanging and selection and his autocratic style. A year later he was forced to resign, a bitter blow to him and to art in London.

MARRIAGE

Whistler spent the summer of 1888 in Paris, leaving his eighteen-year-old illegitimate son, Charles Hanson, to carry out his peremptory orders:

> Tell John that he has again made a mess of the packing and I cannot conceive what he could be thinking about when he left out my white waistcoat altogether so that I am obliged to go about in my <u>thick</u> clothes. For I cannot even wear my thin serge trousers as he has not put up the serge waistcoat with them—and what he expected me to do with the white trousers I am sure I don't know— did he think I was going to wear a black cloth waistcoat with them!![50]

Furthermore, he complained, "I was surprised and greatly vexed to find that he had put up no shirts for me—excepting the 3 white ones—so that I am without any coloured ones—and I had especially told him to pack a couple with the small dots, black & pink—."[51]

Thus the fifty-four-year-old artist, comparatively well established and prosperous, maintaining a house and studio in London, a son, a secretary, a cook and valet, and about to take on marriage, was clearly concerned about his social position and dressing with propriety. "Whistler has been seen at Tortoni's, wearing chrysanthemum coloured gloves, which harmonised perfectly with the opalescent green of the diluted absinthe which he was imbibing,"[52] reported the press. The young man in crumpled linen and straw hat had become a dandy with a reputation to preserve.

Fortunately, in August 1888 Whistler married the recently widowed Beatrice Godwin. She was an artist and designer and, with the help of her family, an efficient organizer, so that his affairs were for once well conducted. When he was away, his wife (Trixie), and young sisters-in-law, Rosalind (Major) and Ethel (Bunnie), received daily reports: "Wait till you see me in an <u>amazing hat</u>!" Whistler wrote to Trixie; "I am going to seem something quite new in London!!!"[53] After her death the artist clung to her family, who became both confidantes and models. He wrote to Rosalind after an attack of shingles,

> my hair has put on an extra touch of curl and pic-turesqueness after all these violent pains in the head! that would make one believe that one was, in a way, being, at last, born again <u>really</u>! . . . "Vous avez l'air d'avoir vingt cinq ans"!, Duret said to me yesterday!—My hair is longer! because I dare not even yet trust a Coiffeur with his comb near me! . . . the longer locks have taken to themselves an extraordinary gloss, and go waving and curling about until I begin to look like poor dear Boxall's portrait!! . . . Also I have suddenly blossomed into a new <u>arrangement of</u> tie! . . . They insisted upon my wearing a foulard round my throat when I went out . . . so Euphrasie was sent for a white silk scarf. . . . Well then I had an inspiration!—and I said to myself why, with these curls, should I not blossom forth in full Directoire . . . as a combination of Boxall cherub, and high stocked Incroyable of his period—and so Euphrasie . . . came back with a black foulard of ample dimension! The <u>result</u> Amazing!!—[54]

Whistler could laugh at himself, re-created as an *Incroy-able* of the French Revolution. He had no great need to present himself as extreme: he was established as an artist, fairly prosperous, with a considerable influence on the artists and aesthetics of the day.

In 1900 Whistler agreed to pose to Giovanni Boldini (fig. 13), wearing in his buttonhole the red rosette of the *Légion d'honneur*, an assertion of status of which he was extremely

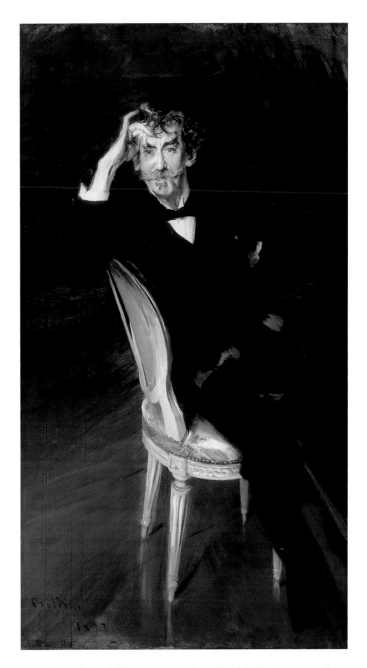

13 Giovanni Boldini (1842–1931), *Portrait of Whistler*, 1900, oil on canvas, 67 × 37⁹⁄₁₆ (170.5 × 94.4), Brooklyn Museum of Art, Gift of A. Augustus Healy, 09.849

proud. According to E. G. Kennedy, Boldini's technique was "astonishingly sure and rapid," but Whistler soon "got tired of doing what he had made other people do all his life—pose—and that he used to take little naps." Whistler commented that "They say that looks like me, but I hope I don't look like that!"[55]

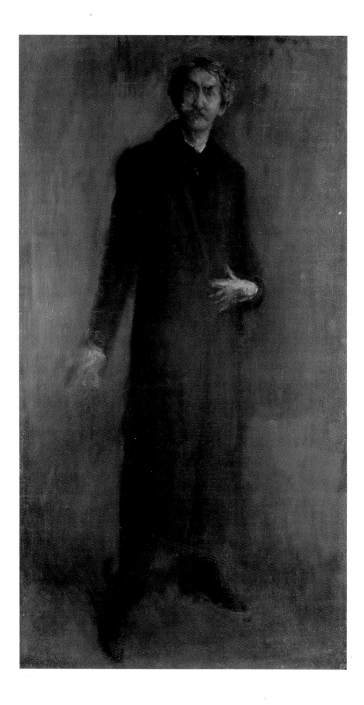

14 *Brown and Gold*, 1896–1900, oil on canvas, 37¾ × 20¼ (95.8 × 51.5), Hunterian Art Gallery, University of Glasgow, Birnie Philip Bequest (YMSM 440)

15 (*facing page*) Unknown photographer, Whistler in his studio (*The Dancer* [M. 1627] on wall), c. 1898, by permission of Glasgow University Library, Department of Special Collections

A photograph of him in the studio at this time shows him seated decorously, in a well-cut dark suit, with a narrow ribbon around a high narrow collar (fig. 15). The modest lapels of his jacket bear the ribbon of the *Légion d'honneur*. Behind him are the backs of canvases, the unsold or unfinished works that littered his studio: the beautiful portraits of Beatrice, Ethel, and Rosalind. And on the wall is one tiny pen drawing, of a young woman dancing in whirling gauzy draperies. The surroundings and the clothes and the tiny drawing are modest; the artist was not, but he had his moments of self-doubt.

The conflicts within the artist led to a constant working and reworking of these and other portraits and produced works of great subtlety and beauty. Their beauty resides not only in the sitters—and Whistler's sitters included the most popular stars of the stage and leaders of fashion—but in their dress, the color harmonies produced, the composition and technique used to explore these harmonies, and the tensions between artist and sitter. The artist, with his sensitivity to his own dress and image, united with the sitter, her motivation, and self-presentation, to produce intellectually stimulating and satisfying portraits.

Whistler aimed to paint pictures that were not specific to one age but were timeless masterpieces: "It is for the artist to do something beyond this: in portrait painting to put on canvas something more than the face the model wears for that one day; to paint the man, in short, as well as his features."[56] The picture may be moving, the character may be distinguished, the dress may be that of high fashion or working clothes. It may reflect a certain age, a social occasion, a particular light, and a moment in time. Revisiting these works a century after Whistler's death provides an opportunity to identify the sitters, context, and occasion for the pictures and explore the techniques used and the design and presentation of costume. All these combined with subtleties of harmony and composition in the making of Whistler's portraits of women and fashion, which are among the finest works of a great artist.

BROWN AND GOLD

The late photographs and self-portraits of Whistler present a rather different picture, which rounds off this image of the aging dandy. In these images from the final years of his life, the artist stares out with self-doubt. Nervous brush strokes search for the inner personality as well as the public persona of the man, in a composition taken straight from Velázquez, for his last and greatest self-portrait, *Brown and Gold* (fig. 14).

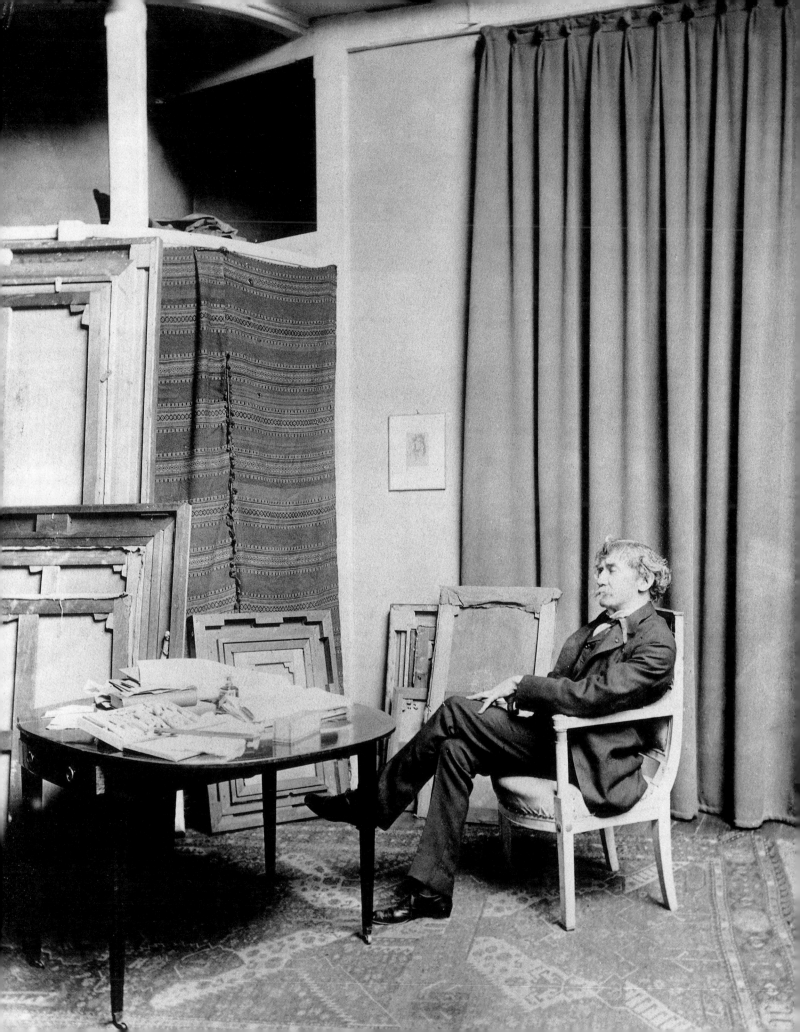

Chapter 2

Fashion and Whistler

Aileen Ribeiro

In a painter's eyes, the women, who in passing attract his attention, are moving portraits.
– Charles Blanc, 1877

No one will ever persuade me that a woman in a blue robe reading a letter,
or a lady wearing a pink robe looking at a fan,
or a girl in a white robe raising her eyes to a blue sky to see if it is raining,
constitute really interesting aspects of modern life....
– J.-K. Huysmans, 1883

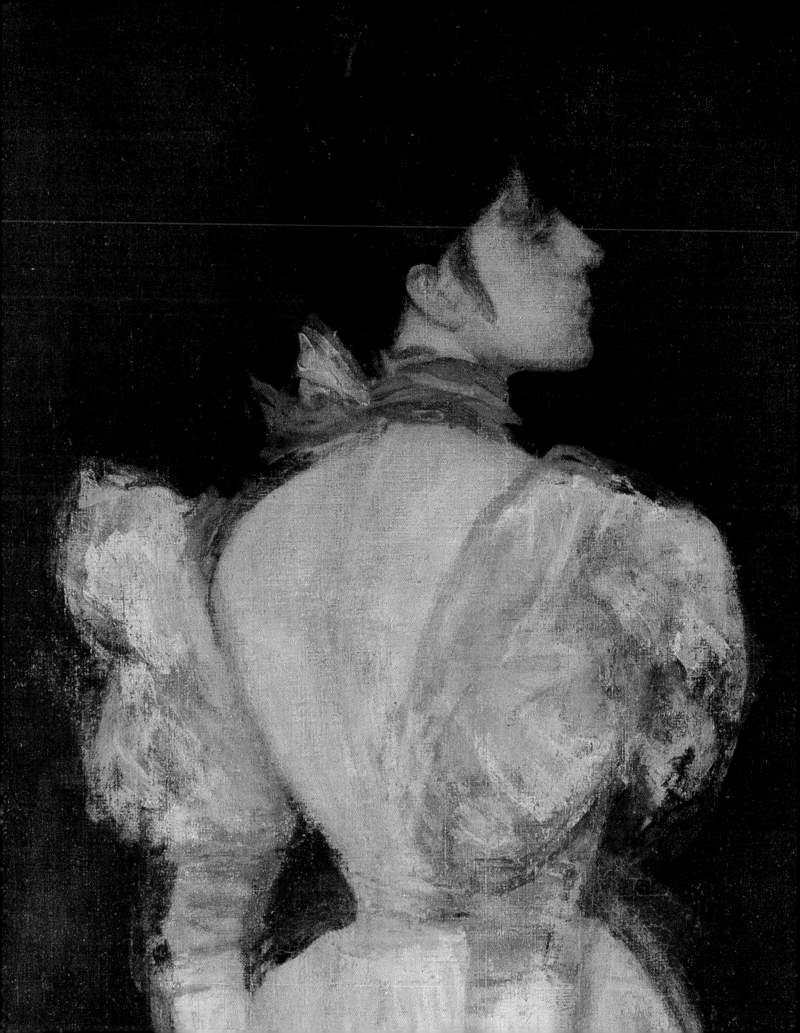

Aᴿᵀ ᴬᴺᴰ ꜰᴬˢʜᴵᴼᴺ ᴡᴇʀᴇ ɪɴᴇxᴛʀɪᴄᴀʙʟʏ ʟɪɴᴋᴇᴅ as cultures of consumption during Whistler's working life, a period when the art world in London (and the social and professional status of artists themselves) expanded hugely. This expansion corresponded with the rise of haute couture and the extension of fashion to much wider social groups of women than before. Fashion, to many women, was an all-absorbing pastime, an obsession amusingly reflected in a *Punch* cartoon of 1877, entitled "Art and Fashion" (fig. 17). Here, artist and sitter are completely at cross purposes in a conversation about the Louvre. The artist thinks of the famous art gallery's "endless stores of noble artistic wealth," whereas the fashionable sitter, posed in front of an Oriental screen, thinks of "the still more famous linen-draping and silk-mercing emporium which bears the same name."

Deborah Cherry notes that, as part of a "sustained investigation of urban modernity," an "increasingly visual culture developed in the second half of the nineteenth century," a trend she ascribes to "the rapid expansion of the art market and a dramatic increase in the number of exhibitions."[1] Not only did women increasingly sit for their portraits, but going to see them displayed (and indeed visiting art exhibitions generally) became a popular activity. As the artist Louise Jopling noted when the Grosvenor Gallery opened in 1877, the "glamour of Fashion was over it," and it became "one of the most fashionable resorts of the London season."[2] Du Maurier's *Punch* cartoon of 1887, "A Jubilee Private View," is a comment on the triangular conjunction of art (surely a sly dig here at Whistler in the portrait anathematized), gossip, and fashion (fig. 18). The artist and critic Eliza Haweis commented in *The Art of Beauty* that "much money, representing much labour, is lavished upon every garment," and therefore we "expect it to be a work of art."[3] When a gown by the great couturier Charles Frederick Worth could cost as much as a portrait, haute couture could be seen as a work of art in itself. Worth (to justify his prices) argued that "he did not design dresses, he composed them."[4]

What more natural, then, that women paying a fortune on dress would wish to see it immortalized on canvas. The novelist and historical writer Margaret Oliphant noted in her book *Dress* (1878) that "there is now a class who dress after pictures, and when they buy a gown ask 'will it paint?'"[5] Millais painted the artist Louise Jopling in 1879 in "a dress that was universally admired . . . black, with coloured flowers embroidered on it"; it was made in Paris

16 *Harmony in Flesh Colour and Black: Portrait of Mrs Louise Jopling*, 1877, oil on canvas, 75¾ × 35½ (192.5 × 90), Hunterian Art Gallery, University of Glasgow, Birnie Philip Gift (YMSM 191)

in a flattering style, with cuirass bodice and scallopped neckline (see fig. 25).[6] Whistler declared the portrait a "great work."[7] It makes an interesting comparison (*colore* versus *disegno* perhaps?) with his own restrained portrait of Jopling, *Harmony in Flesh Colour and Black* (YMSM 191), done two years earlier, where there is an equal, if different, emphasis on the lines of fashion—in Whistler's case, the convoluted back drapery so characteristic of the decade (fig. 16).

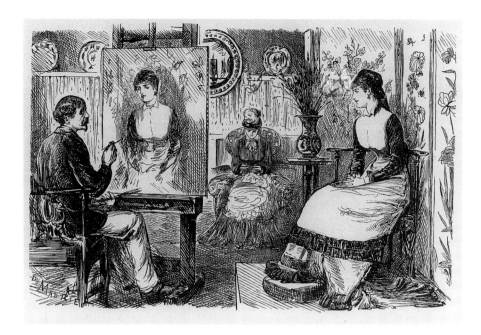

17 George Du Maurier (1834–1896), "Art and Fashion," *Punch*, vol. 73 (November 10, 1877), p. 210, Courtauld Institute, London

18 George Du Maurier (1834–1896), "A Jubilee Private View," *Punch*, vol. 92 (June 18, 1887), p. 294, Courtauld Institute, London

A JUBILEE PRIVATE VIEW.

(Turning an Honest Penny-a-Line.)

The Duchess of Dilwater (Art-Critic to the South Pentonville Gazette) writes in her Note-Book :— "THE FUNDAMENTAL THEME OR *LEIT-MOTIF* OF MR. SOAPLEY'S EXQUISITE PORTRAIT OF MRS. BLAZER, IS AN IMPASSIONED *ADAGIO* IN THE MINOR KEY OF BLUE, TENDERLY EMBROIDERED WITH A SUB-DOMINANT FUGUE IN GREEN AND GRAY AND GOLD!" &c., &c.

Lady Slangboro (Purveyor of Social Pars to the Bermondsey Figaro) :— "IT'S ALL TOMMY ROT ABOUT THE DUCHESS OF DILWATER NOT BEING ON SPEAKING TERMS WITH HER LEARY OLD BLOKE OF A SPOUSE. BOTH THEIR GRACES WERE PRESENT, DARBY-AND-JOANING IT ALL OVER THE SHOP." &c., &c.

Viscountess Crewelstown (who does the Fashions for the Barnes and Putney Express) :— "LADY SLANGBORO WAS THERE, LOOKING LOVELY IN A RICH SALMON ÉCRU POULT DE SOIE MATELOTTE RUCHÉE À LA BARIGOULE, WITH POINTES D'ESTRAGON PANACHÉ, AND BOUILLON-AISES OF THON MARINÉ EN JARDINIÈRE, FROM MADAM ALDEGONDE'S (719, PICCADILLY)." &c., &c.

Women presented particular problems when they came to have their portraits painted.[8] This was not a new challenge; Richard Brilliant notes "the extraordinary attempts made by portrait artists over the centuries to fix the image of persons by visualizing their appearance and/or character, and, at the same time, to produce an accessible and acceptable object of art."[9]

Women's dress, maintained Proust, was potentially a work of art comparable to a musical composition or a piece of sculpture;[10] it was, according to Charles Blanc, founder-editor of the *Gazette des Beaux-Arts*, for "women . . . in their dress [to be] artists, par excellence,"[11] to be embodiments of taste, harmony and elegance—in short, to be chic (a word popularized by Worth). But how could art depict fashion without troubling and distracting detail? As Huysmans implied in the quotation from *L'Art moderne* in the epigraph at the head of this chapter, how were artists to avoid becoming little more than couturiers themselves?

The dresses such artists depict, Huysmans asserted, could have been made by Worth if he had been a painter.[12] This theme was dear to Whistler's heart, in his belief that the society portrait painter was little more than a mechanic; according to A. J. Eddy, who posed for Whistler in 1894, the portrait painter's craft was "closely allied to and quite dependent upon the tailor and the dressmaker. Worth has made more portraits than any one painter in Paris."[13]

Strategies for dealing with the vexed question of fashion varied according to national temper, artists, and their clientele. Artists like Franz Xaver Winterhalter and James Tissot chose the path of photographic reality, recording the elaborate toilettes of their sitters with incredible accuracy. Henry James, reviewing the 1877 picture season, declared that "the taste for art in England is at bottom a fashion, a need of luxury, a tribute even . . . to propriety, not an outgush of productive power"; weary of seeing the specificity of dress in portraits by Tissot, he urged artists to depict more general and timeless clothes.[14] It is not clear precisely what he meant by this. He was not arguing for the kind of "timeless" draperies seen, for example, in the work of such artists as Sir Joshua Reynolds, or for "alternative" fashions such as those worn by aesthetic women, but perhaps for the kind of portraiture in which the costume did not dominate the painting, overwhelming the character depicted. In the French context, Huysmans thought that the Impressionists were "the essence of modernity, for their work involved profound analysis as well as acute observation."[15] In their work, fashion is clearly emphasized, and its essence is wonderfully captured, as in the paintings of Claude Monet, for example, but it complements the sitter, without clamoring for our attention. While Monet used fashion plates as inspiration for his art,[16] later artists such as Paul Helleu and Giovanni Boldini (see fig. 36) depicted their sitters as fashion plates themselves, idealizing and exaggerating pose and costume as is the raison d'être for such images.

While Proust used clothes to recall the past, many artists and writers, especially those in England, tried to restore the past by advocating certain historic styles. English attitudes to fashion in portraits ranged from an uncritical acceptance of the depiction of the minutiae of clothing seen in academic art, to the dislike felt by some critics and dress-reformers for such displays of materialism, which they wished to replace with aesthetic, even historicizing costume.

Increasingly in England, from the mid-nineteenth century onward, dress was subject to both moral and aesthetic judgments. Mary Merrifield, in *Dress as a Fine Art* (1854), argued that artists overemphasized fashion in their portraits to the extent that women—"the unfortunate victims of their fascination"—tried to copy the dress therein, to the disadvantage of family life and household economy.[17] Haweis, the standard-bearer of the Aesthetic movement in her writings on art and beauty (and a neighbor of Whistler's in Cheyne Walk), while admitting that dress was "the legitimate province of the artist,"[18] took artists to task for their lack of guidance on how to live the complete artistic life, which should include advice on dress as well as on household furnishings. Exceptions to her strictures included the Pre-Raphaelite artists and her contemporaries, such as Frederic Leighton, Walter Crane, and Whistler, "who occasionally devotes his great but eccentric genius to chamber decoration."[19] Haweis's thesis in *The Art of Dress*, which derived from her appreciation of the loose and simple styles worn by women in the Pre-Raphaelite circle, was that clothing should not contradict the natural lines of the body, that it should be beautiful and comfortable, that it should "follow the broad outlines of the prevailing mode" without the "vagaries of its details."[20] Moreover, colors had to be soft and "artistic" (i.e. not the brash tones of aniline dyes), for the aesthete was as prompt to pass judgment on a woman's dress as on a painting.

How far are these prescriptions recipes for Whistler's treatment of dress in his painting? As in his art (and his life), Whistler was a law unto himself, appropriating fashion (sometimes generalizing it), informal costume, and aesthetic styles to suit himself (not the sitter). Well aware of the importance of dress in portraiture—he was not unique in the naming of portraits by clothes, but the most

famous practitioner of this trend—he was not content as, say, Winterhalter or Millais were, in acting as mere intermediary between the sitter and her appearance. He was as much a dictator of image as Worth was in haute couture.

NARRATIVES OF FASHION

Modernity is a key element in any discourse on fashion from the mid-nineteenth century. With Britain the workshop of the world, fashion became part of the great consumer paradise celebrated in the international exhibitions of the period, even while—especially from the 1870s onward—such materialism began to be criticized, with a growing nostalgia for a preindustrial past that was also reflected in dress. The middle decades of the nineteenth century were good for those who benefited from the prosperity engendered by the Industrial Revolution and bad for those who suffered from its concomitant effects—urbanization, with its resulting social problems, and the increase in the use of overworked, low-paid labor, especially with regard to the clothing industries.

Modernity, with regard to fashion, embraced technical change. Mechanized clothing factories produced vast amounts of fabric (even, at the very end of the century, the first synthetics). A plethora of items of clothing with new names, and a wider range of garments, were offered for sale. A number of important inventions revolutionized women's dress, including the sewing machine, marketed by Singer in the United States in the 1840s and in wide use from the 1860s. It helped create the elaborate styles of dress so characteristic of the following decades, and it had obvious implications for home dressmaking. Paper patterns, appearing at the same time in the fashion journals,[21] enabled women of most classes to follow fashion in the home. It also contributed to what many critics saw as the headlong pace of fashion change, a breathless consumerism affecting almost everyone.

Another impact of technology on fashion lay in the use of steel wire for the huge crinoline skirts of the 1850s and 1860s, the first industrial fashion. In 1862, as Christopher Breward notes, about one-seventh of steel output from Sheffield was used for crinolines.[22] Equally dramatic in appearance were the new aniline dyes that appeared in the 1850s with the discovery of mauve in 1856, "the first artificial colour to be derived from coal."[23] Aniline dyes were relatively inexpensive and reasonably fast, and thus a boon to the expanding textile industry. By the end of the 1860s most natural colors could be produced synthetically. As Alison Matthews notes: "With his commercial recipes for new hues, the industrial chemist had superseded the painter as the colorist of the nineteenth century."[24] As so often in England, moral and class subtexts can be discerned; cheap and brightly dyed clothes were thought to encourage overexpenditure among the lower classes, and thus such colors came to be regarded by aesthetes as common and gaudy.[25]

One of the aims of the fashion magazines was to help women cope with color in their wardrobes, *The Queen*, for example, insisting that "soft subdued colours are in most cases more becoming than startling effects."[26] A heightened awareness of color and fabric became part of the vocabulary of modern living, both in the wearing of fashion and how it was represented in art. Artists needed to choose the time of day and the effects of different kinds of light (or the absence of it) on their portraits.[27]

Perhaps as a result of the rapid advance of technology, women for the first time became the dominant sex in sartorial terms. In the 1860s the size and colors of their clothes were impossible to ignore.[28] The large amounts of fabric, arranged in the complex forms that made up female dress in the later decades of the century, made women an imposing sight and increasingly emphasized their greater public roles.

Dress is formed of myriad reflections of the prevailing line, according to class, taste, and morality. The majority of middle-class women in the United States and Europe played out their own version of fashion, in between the old-fashioned dress of the elderly provincial and the lavish world of haute couture. A woman had a wide range of roles to fill, signified by her clothes. As a private individual, the "angel in the house," her dress was simple; in public, as a decorative object, more elaborate fashions were on show; her artistic and "progressive" views could equally be seen in dress. A complex language linking dress and identity evolved during the later nineteenth century. Apropos her discussion about the role of women in society, especially that of female artists (although it is equally relevant to the language created by fashion), Cherry comments: "In the jostling, crowded, perplexing world of metropolitan modernity, the visual assumed, and was ascribed, an increasing authority for telling differences and marking distinctions."[29]

Different outfits were needed for the morning, for the afternoon (either at home or visiting), for dinners, for balls, for the theater and opera, for traveling, for summer resorts, for sport, and for specific rites of passage, like christenings, weddings, and mourning. "Extremes in the forms of . . .

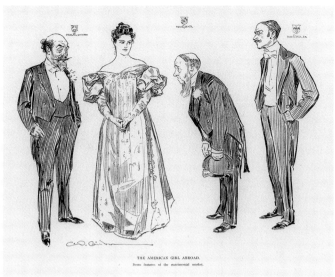

19 Charles Dana Gibson (1867–1944), "The American Girl Abroad," black and white engraving from *Drawings* (1898), Courtauld Institute, London

Looking at sources for fashion in the second half of the nineteenth century, one is overwhelmed by an embarras de richesse. Not only does clothing survive in significant amounts, but there are vast numbers of letters, diaries, and novels as well as the visual records of clothing through art, fashion plates, and photography. Fashion plates flourished from the middle years of the nineteenth century, and the removal of the paper tax in England in 1861 led to an explosion of fashion journalism, providing readers with information on the prevailing modes. Samuel Beeton (publisher of *The Englishwoman's Domestic Magazine* [fig. 20], which catered to the aspiring middle class), in 1861 founded *The Queen*, which laid emphasis on the latest French fashions. A further impetus to the success of fashion

20 "The Fashions," colored engraving, *The Englishwoman's Domestic Magazine* (June 1, 1870), Courtauld Institute, London

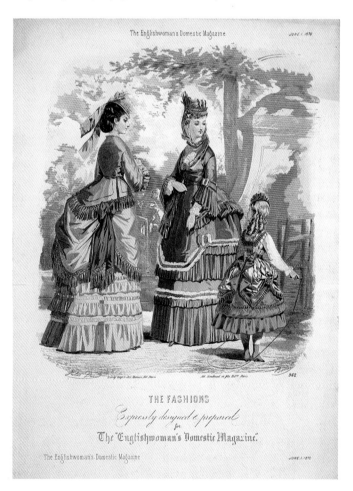

dresses worn on these occasions attract observation, but not admiration," declared Lady Colin Campbell in *The Etiquette of Good Society*,[30] a typical observation from the kind of publication that thrived on the fear of social faux pas—especially among the moneyed elites of Europe and the United States. For many women, dressing correctly for the different occasions of the day proved a comforting, if sometimes troubling ritual. Newland Archer in Edith Wharton's great novel *The Age of Innocence* (1920), set in the 1870s, considers the "religious reverence of even the most unworldly American women for the social advantages of dress: 'It's their armour', he thought, 'their defence against the unknown, and their defiance of it.'"[31]

Notions that a common heritage and language would give Americans an easy passage into English society often proved problematic—"Americans in Europe are *outsiders*; that is the great point,"[32] wrote Henry James in what is a leitmotif for many of his great novels. Charles Dana Gibson explored a similar theme in a more lighthearted way when he depicted the culture clash between the uninhibited "American Girl Abroad" and stuffy European etiquette, and in particular the search by nincompoopish and impecunious aristocrats for dollar princesses (fig. 19).[33]

✢ ✢ ✢

journalism came with the 1870 Education Act, which led to greater literacy among women.

Fashion plates depict prescribed forms of dress and thus appear static and stylized, women are "arrested in poses that would show as much of the dress as possible, even if this necessitated some rather awkward positions."[34] Their world was that of sexual segregation, with figures largely unrelated to one another and often with identical and interchangeable faces and figure-types.

Moderating the extremes of the fashion plate, photography recorded what the fashions looked like on real people. The practical uses of photography were manifold. Small carte-de-visite prints from the late 1850s were popular souvenirs among families and friends, and from the 1870s they could also be used to photograph shop models in ready-to-wear outfits. Haute couture followed suit, and from the early 1890s Worth costumes were photographed. Photography thus "enabled fashion to travel further and faster."[35] Fashion was, of course, dependent both on haute couture and the copies produced by the ready-to-wear market that began to take off in the 1840s.[36] Department stores often started out as small shops selling drapery, haberdashery, and some partly made and ready-made garments.

The middle decades of the nineteenth century saw the establishment of such department stores as Bon Marché in Paris (before 1849), Lewis's in Liverpool (1856), John Lewis in London (1864), and so on. Their growth was reliant both on the huge expansion of the textile industry and sophisticated machinery for cutting out and sewing garments; by the 1860s the majority of dresses were machine made. Department stores flourished with urbanization and the growth of public transport (the London Underground opened in 1863). Shopping became a new pleasure for women, for the department stores offered easy access, openly priced goods, and lavish displays inspired in part by those on show in the large international exhibitions in London and Paris.

These exhibitions were sites for the display of both ready-to-wear and couture, especially—in the latter case—in France. Haute couture began in Paris in the late 1850s, when Worth established his premises in the rue de la Paix with twenty seamstresses and soon gained court patronage. An empire proved conducive to luxury; by 1870 he employed 1,200 and was able to supply thousands of garments to customers all over Europe and the U.S. Before that time it was the rule for an individual to have her dress made by a dressmaker as a one-off, supplying the fabric and sometimes the trimming herself; this was known as *couture*

à façon. In haute couture, the design house created a series of models, from which the client made a choice; the grandest houses, like Worth's, had fabrics created exclusively for them. Worth revolutionized the staid business of dressmaking, emphasizing the importance to the craft of superb construction and perfect fit, introducing the concept of showing completed gowns on mannequins (live models), and offering foreign customers the same quality of service as his French clients. Even the end of the Second Empire in 1870 proved to be only a small hiatus in the fortunes of Maison Worth. With the presidency of Marshal MacMahon in 1873, Paris resumed its place as a center of fashion, a status underlined by the visit of the Prince and Princess of Wales in 1878.

There were some critics who referred disparagingly to the "man-milliner," a man conversant with the intimacies of women's bodies, hitherto the preserve of female dressmakers and milliners. Margaret Oliphant was typical of many English voices (and these included the majority of dressreformers), when she declared that "we were not born under M. Worth's sway. He is not our natural monarch, but . . . we obey him like slaves."[37] His dictatorial manner, however, only served to promote the increasingly highprofile public face of haute couture.

Through Worth, the rue de la Paix became synonymous with luxury in dress, what Henry James called "the costly authenticities of dressmakers and jewellers . . . ribbons, frills and fine fabrics."[38] Worth lived like a prince, and his dresses were the most expensive in the world.[39] For this reason—"money is the one thing needful to get into Society," said the author of *The Women of New York* in 1869[40]—the House of Worth was immensely popular in America. Improved travel in the form of steamships brought Americans to Europe in increasing numbers after the end of the Civil War, and many attended the 1867 International Exhibition in Paris, where Worth outfits were on display. American heiresses ordered their trousseaux from Worth, and a dress from Worth was magically understood to underline status (Americans were the first to build a cult of labels). Rich Americans felt some rapport with a man who "never totally mastered the French tongue, . . . a self-made man with expensive tastes."[41] Worth was—like the designers who followed him—adept at self-promotion and at the exploitation of his designs. From the 1860s Worth models were exported to the U.S., and for those unable to afford an original, dressmakers could buy his designs to copy, and even his fabrics; stores like Lord & Taylor in New York copied Worth dresses from the 1870s onward (see fig. 28). Fashion magazines like *Harper's Bazar*

(established in New York in 1867) celebrated Worth as well as the outfits of such popular designers as Émile Pingat and Jacques Doucet. Wealthy American women wore the products of French dressmakers for formal and luxury wear, but for informal costume such as tailor-made suits, riding habits, and so on, they used English designers, especially from the 1870s when, with the demise of the Second Empire, more transatlantic tourists came to London.

THE PROGRESS OF FASHION

During the 1840s dressmakers created the fashionable amplitude of skirts by making petticoats lined with horsehair (*jupons de crinoline*); eventually by synecdoche the crinoline became the dress itself. In the early 1850s hoops were inserted to form a dome-shaped crinoline, and in 1856 the metal cage crinoline of sprung steel was patented, creating a light, bell-shaped garment which swung gracefully in movement. Thus the outline of the fashionable woman in the 1850s was dominated by the crinoline, a fashion that began by liberating women from the shackles of layers of petticoats but ended by encaging them in skirts so vast and cumbersome that they were difficult to manipulate with elegance.

The crinoline suited women "who knew how to wear clothes . . . particularly the empress [Eugénie]," Worth wrote,[42] but when it was covered in tiers of fabric and flounces it assumed a size so vast that women looked like festooned lampshades, a gift to the caricaturist. As Liz Arthur comments, the crinoline "was heartily disliked by many men, reviled by the advocates of dress reform and aesthetes of the Pre-Raphaelite movement, and lampooned by caricaturists, yet it was probably the first universal fashion worn by women in all walks of life whatever their social status."[43]

There was something quintessentially "feminine" in the exaggerated curves and the voluminous folds of the crino-

21 "Kensington Gardens in 1864," engraving from E. Philpott's *Crinoline in Our Parks and Promenades* (1864), Courtauld Institute, London

line. As *The Queen* noted in a discussion of the sounds of dress (which "must not creak or crackle . . . [but] just rustle like falling leaves as it passes over the floor behind you"), a woman finds pleasure in the "immense amount of drapery about her, that she can take up and adjust, and let fall, and still be sure that it will not look meagre."[44] An illustration in Edward Philpott's book on the history of the crinoline depicts the amplitude that the fashion created (fig. 21).

From about 1862 the crinoline began to be flattened in front, a trend encouraged by Worth, whose influence can be seen in two of the dresses worn by Monet's mistress Camille Doncieux in his painting *Femmes au Jardin* (1867, fig. 23). These dresses (either hired by the artist or copied from fashion magazines) may be by Worth, as they have his signature notes of light floating white muslin with touches of black[45] and also show his new emphasis on back drapery.

The ease and freedom seen in Monet's summer toilettes is reflected generally in the appearance of informal, simple styles of dress for women, such as jackets and skirts. In 1863, at the request of the Empress Eugénie, who liked walking in the countryside and by the sea, Worth introduced looped-up crinolines with ankle-length skirts, revealing colored stockings and walking boots. Recording the Paris fashions in November 1863, *The Queen* noted that dresses "for out-door wear . . . will be looped up this winter over coloured petticoats. . . . In Paris the striped petticoats with plaid borders are the most popular at the present time. . . . With coloured petticoats, coloured stockings to correspond are indispensable. . . ."[46] These stockings became an essential element in the fashionable woman's wardrobe at this period, along with the vogue generally for bright colors created by synthetic dyes, although they later became regarded as vulgar (one reason why Manet's painting *Nana* (see fig. 166), of 1877, was banned from the Salon).

In 1866 some elegant women at the races at Longchamps (a launching pad for new fashions) appeared without crinolines; how far this was due to a *diktat* from Worth is not clear,[47] but by 1868 most fashionable women had discarded them and begun to loop the skirt up over the hips to create back fullness, aided by a padded understructure (incorporating horsehair, cork, springs, and so on), known in England as a "dress-improver" and in France as a *tournure*. In Hadol's caricature *Être et Paraître* (fig. 22), the new convoluted line—which was to dominate the 1870s—is evident, built up by artifice, from the towering false hair, the bust improver and the *tournure*, to the high-heeled boots. The so-called Grecian Bend (a term invented by *Punch*) thrust the upper body forward, and the bottom

22 Paul Hadol (1835–1875), "Être et Paraître," engraving from *Le Monde comique* (September 30, 1867), Courtauld Institute, London

seemed to be left behind, so to speak. Women, according to Blanc, seemed "always to be seen in profile . . . walking on high heels which throw them forwards, hastening their steps, cleaving the air . . . as though to swallow up space."[48]

The new style of dress emphasized a sleek line over the hips (created with the help of steam-molded corsets that drew attention to the prominent bust and hips, creating a kind of fortified nudity.)[49] The skirt was either tied back or draped over a bustle. Haweis preferred the tie-back skirt (she thought it looked Japanese), because it displayed "the clear line of the hip without the deformity of a 'bustle,' and this gives a pretty figure grace and lightness."[50]

She would therefore have approved of Whistler's portrait of Jopling in 1877, where the emphasis lies on the loosely tied-back skirt of a pinkish cream dress (see fig. 16). Jopling, as an artist, wears the simpler style of dress in vogue, disliking the panoply of pads, *tournures*, and the multiplicity of trimming, such as flounces and fringes seen in fashion magazines. The artifice of women's dress gave rise to much criticism (especially from dress-reformers and aesthetes), and from novelists too.[51]

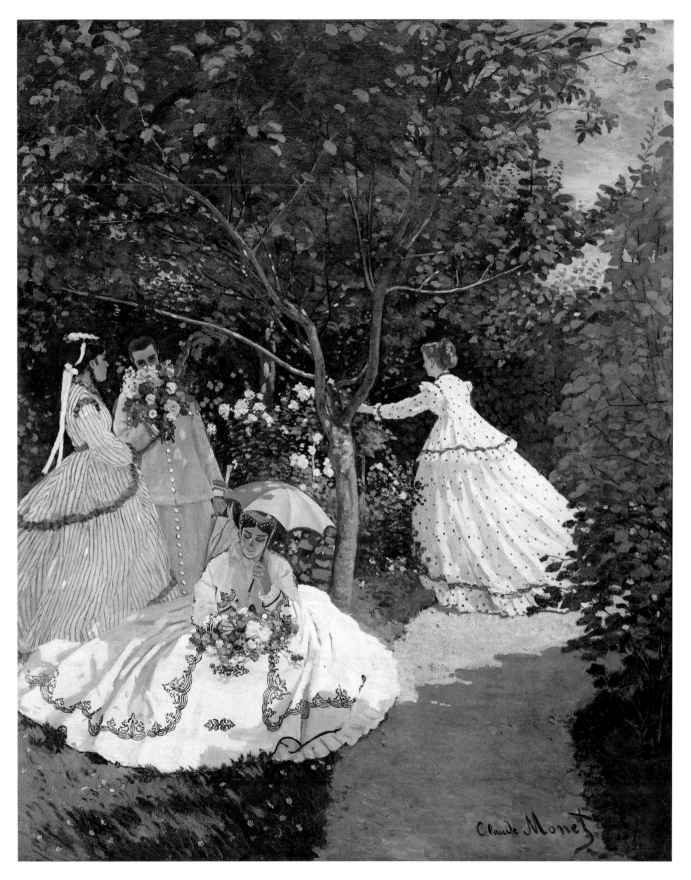

23 Claude Monet (1840–1926), *Femmes au Jardin*, 1867, oil on canvas, 100¾ × 82 (251.9 × 208.2), Musée d'Orsay, Paris

24 James Tissot (1836–1902), *Miss Lloyd (A Portrait)*, 1876, oil on canvas, 36 × 20 (91.4 × 50.8), Tate Britain, London

There was also some more considered philosophical speculation as to the way this artifice—what Blanc calls "the genius of complication"[52]—was constructed. The journalist George Ellington urged his American readers to

Reflect how many bones clasp her waist; the multitude of pins that flash and hold and defend her; the innumerable hooks and eyes that look out, catch hold and join to give strength, shape and comeliness to hosts of name-

less things; the bands of steel that flaringly course about her; the cords that give tautness, and confidence, and supposed comfort; and the myriads of laces, and flowers, and jewels that ornament and add finish to the congress of prettiness.[53]

"The seventies were glamorous and the couturier flourished," stated Worth's son and heir in his history of the house.[54] Maison Worth was responsible in the early 1870s for the fan train that appeared frequently in fashion magazines, and to such effect in the toilettes painted by Tissot. His portrait of *Miss Lloyd* of 1876 (fig. 24) is a typical example, a dress of cascading muslin flounces trimmed with pale yellow ribbon bows; the dress belonged to the artist, and it features in a number of his works from the later 1870s.

In about 1875 Worth introduced the Princess line (homage to the stylish Alexandra, Princess of Wales). This was a one-piece fitted dress with no waist-seam and darts from bust to hip, designed to draw attention to the smooth lines of the upper body; "it became the fundamental method of dress construction for the rest of the decade," states Worth's biographer.[55] An example can be seen in designs by the dressmaker Vidal, from the fashion magazine *Journal des Demoiselles* for February 1878 (fig. 26). Dress, because of the emphasis laid on the bustle and the flowing train, was designed to be as attractive from the back as from the front. Fashion plates demonstrated this, and artists followed suit, including Whistler.

Whistler's portrait of Rosa Corder (*Arrangement in Brown and Black* [see fig. 111]) shows from the back the fanned-out black skirt and fur-trimmed matching jacket of the sitter's walking costume. Similar fur-trimmed jackets in museum collections are cut to flare out slightly at the back and over the hips (fig. 27 shows a dark blue velvet jacket lined with ermine and trimmed with soft rabbit fur). A similar jacket appears in Whistler's portrait of Maud Franklin, *Arrangement in Black and Brown: The Fur Jacket* (see fig. 121).

To the fashion historian James Laver, writing in 1930, Whistler's "most typical women wear the dress of the seventies, a costume which suited well with Whistler's notions of elegance, for the bustle, unlike the crinoline, did not dwarf the feminine figure, and did not conceal but emphasized its curves. It was a dress to walk in. . . ."[56] Apropos the portrait of Corder, Laver wondered why "women did not flock to the painter of such a picture as they might have turned to the creator of some new gown—to be made more elegant," for "Whistler was as much obsessed by elegance

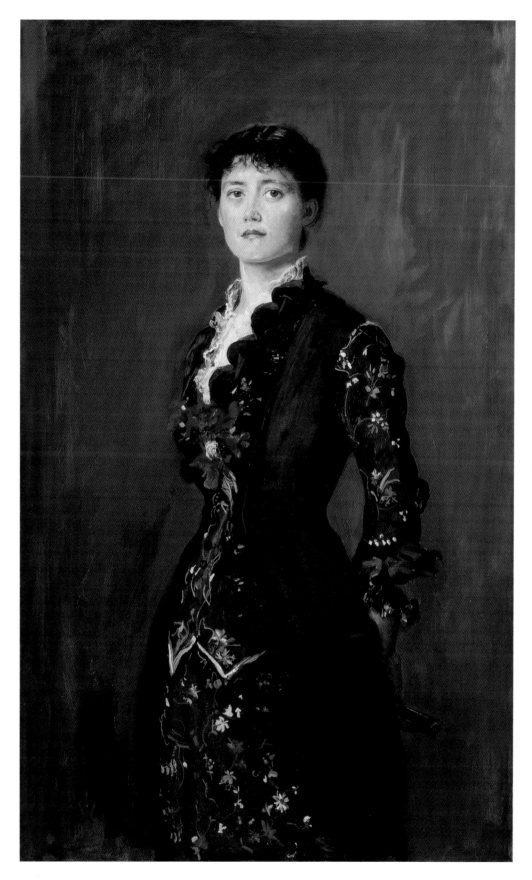

25 Sir John Everett Millais (1829–1896), *Louise Jopling*, 1879, oil on canvas, 49¼ × 30 (125.1 × 76.2), National Portrait Gallery, London

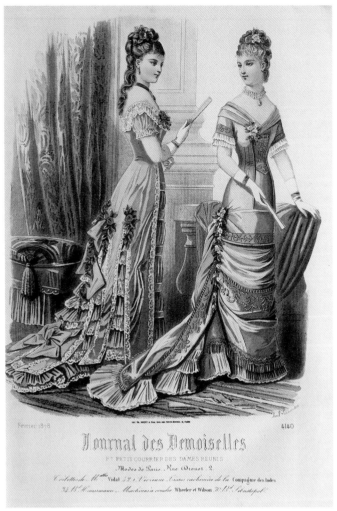

26 "Toilettes de bal de Mesdemoiselles Vidal," colored engraving from the *Journal des Demoiselles* (February 1878), Courtauld Institute, London

27 Jacket, 1870s/1880s, from Mrs. Cassell's Mourning Warehouse, English, blue velvet lined with ermine and trimmed with rabbit fur, Victoria and Albert Museum, London, T. 622–1999

as a man-milliner."[57] As a dress-historian, Laver had an acute sense of Whistler's affinity with fashion, not the glaringly obvious relish in its details (as Tissot, for example, had), but a nuanced appreciation of how it could enhance his portraits. Unlike the Pennells, writing in 1908, who talk of "the ugly fashion of the late seventies,"[58] Laver knew that there are no such things as innately ugly fashions, though some styles may appear so briefly when they are no longer the height of fashion; an artist like Whistler, in any case, has the ability to transmute costume, even that perceived as banal, into greatness.

The Pennells were referring here to Whistler's most stylish and fashion-centered portrait, *Harmony in Pink and Grey: Portrait of Lady Meux* (see fig. 165), which has the feel of the 1870s, although painted early in the following decade. Lady Meux wears a wonderful pink and creamy gray ensemble, a combination of colors appealing both to the fashion conscious and the aesthete. Blanc loved "contrasting and striking colours, such as pearl-grey and China rose," and Haweis wrote that pink is "becoming to all complexions," and gray, "the most beautiful colour for old and young . . . throws up the bloom of the skin."[59] Lady Meux's face is shaded by a stylish wide-brimmed hat, rather historical in feeling, possibly inspired by the "mushroom" hats seen in Gainsborough's drawings of women of the 1760s (perhaps on advice from Haweis, who recommended hats copied from "the pictures of the finest masters").

The early 1880s saw no radical change in the female silhouette, with the smooth, uncluttered line over the bust and hips (Lady Meux's pink waistcoat/vest mimics the

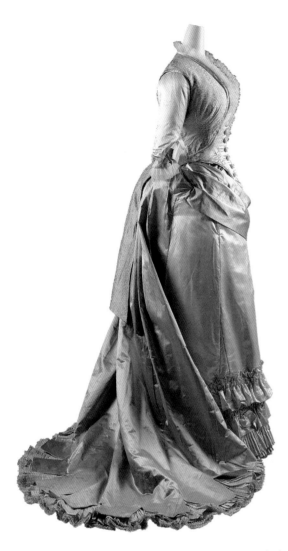

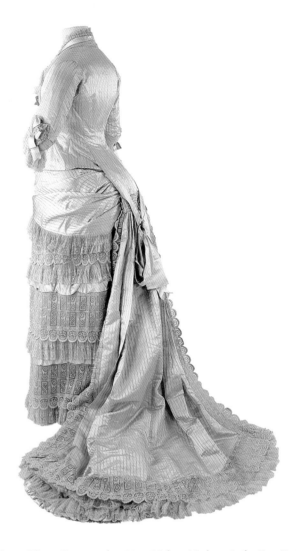

28 Dinner Dress, two piece, c. 1877–83, American or French, brocade and satin, The Metropolitan Museum of Art, New York, Gift of Elizabeth Kellogg Ammidon, 1979, 1979.34.2a–d

29 Ivory Dinner Dress, early 1880s, Maker: Madame Laferrière, Paris, silk and lace, side back view, Museum of London, 40.41

cuirass corset beneath her dress) and the elaborate decoration of the skirt and back drapery. Although the bustle disappeared briefly at the end of the 1870s, the train of the dress remained a focal point, as Lady Meux indicates, her hand holding the fabric to underline its splendor. An ivory dinner dress of about the same time, by Laferrière (who had made the Empress Eugénie's day dresses), shows a similar bodice and train, the skirt swathed with lace (fig. 29). Lord & Taylor's contemporary pale blue and cream dress (fig. 28) displays similar opulence in the swathed and pleated silk and lace in the skirt and train, and the bodice incorporates a sleeveless bolero/waistcoat effect, as in the portrait of Lady Meux.

In the summer of 1881 Worth reintroduced the bustle, in the form of the *crinolette*, which was often built into the skirt itself. *Punch* complained in "The Chant of the Crinolette" (July 2, 1881)—"Why revive the old wire-fencing, though you call it Crinolette?"—but to no avail. The bustle grew in importance (it lasted to the end of the decade), assuming by 1884 a hard-edged square shape, reputedly at an angle on which a tea tray could be balanced! Clothing was even more heavily trimmed than in the previous decade, upholstered with ruching, ribbons, and pleats. The equation with overstuffed and decorated furniture is deliberate; in Henry James's novel *The Wings of the Dove* (1902), the young journalist Merton Densher describes the "heavy horrors" of a Victorian drawing room, "so fringed and scalloped, so buttoned and corded, drawn everywhere so tight . . . so much satin and plush, . . ."[60] and this is the sense of formal fashions in the 1880s, too, as one can

30 Gourlay Steell (1819–1894), *Form versus Fashion*, 1885, pencil and watercolor on white paper, 14 × 10 (35.6 × 25.4), Scottish National Portrait Gallery, Edinburgh

discern from contemporary fashion plates and extant costumes. The distortion of the fashionable female shape, created by tight corsetry and bustles, is the theme of Steell's satirical drawing of 1885, *Form versus Fashion* (fig. 30). Here "form" in the guise of Pygmalion's statue of Galatea looks askance at "fashion," symbolized by two modish women in their fur-trimmed costumes, a far cry from the harmony and natural body shape perceived to be the ancient Greek ideal, as admired by artists and dress-reformers.

The lavish, complicated toilettes of haute couture can be seen in society portraiture, where it was a sine qua non that every detail of expensive cut and fabrics had to be recorded. James Sant's portrait of Adelina Patti of the mid-1880s (fig. 31) is a case in point, an accomplished depiction of an elaborate costume of figured silk and chiffon (possibly by

Worth, for the great coloratura soprano was one of his constant clients, both on and off the stage).

By this time there was no longer a court in France to set fashions and to wear them with flair, and actresses increasingly filled this role. Patti's costume, in terms of its fabrics and delicate colors, reflects the growing importance of the fashionable tea gown, an informal dress (possibly deriving from the peignoir and the dressing gown) that had appeared in the late 1870s as a reaction to the rigor of formal costume. It was worn for the newly popular five o'clock tea, when a fashionable woman changed out of her elaborate afternoon visiting dress into something more comfortable before returning to formality for evening wear. *The Woman's World* for 1888 (a progressive woman's journal edited by Oscar Wilde) stated that "dressmakers are directing more attention to tea-gowns, than to almost any other style of dress, the demand is so great." The same journal stated that tea gowns were originally worn without stays (reflecting their bedroom origins), but by the 1880s the gown "can be made dressy enough for home dinners," and therefore a light corset was appropriate. Alternatively, the gown itself could be boned under the loose front drapery that was one of the characteristics of the style. *The Woman's World* declared that the "back should flow easily, and the front is generally loose. . . ."[61]

Many tea gowns incorporated the eighteenth-century "Watteau" pleat, or the loose folds of the kimono (the very word "tea gown" conjured up the Japanese tea ceremony). Because of the elegance and comfort of the tea gown and the ways in which women could experiment with the historical or the exotic, it became a garment of romance, an essential luxury. According to Mrs. Pritchard's popular book *The Cult of Chiffon*, tea gowns—"flowing garments of beauty"—had the extra cachet of being made by the dressmaker to the woman's individual taste and not bought ready-made. "There is much affinity," the author wrote, "between a beautiful tea-gown, daintily perfumed lingerie, and a love of art and beauty."[62] No doubt this was why these garments appealed both to such professional beauties as Lily Langtry and to aesthetes and artists, Whistler included.

So popular was the concept of the tea gown that it entered the wardrobe of the middle-class woman, transmuted into the informal house gown, some of which incorporated modest elements of the aesthetic, such as shirring and smocking. An example in the Museum of London (fig. 32) is of striped, brushed cotton, buttoning all the way down the front, and pleated and gathered at the back waist. These comfortable yet stylish gowns feature in a number of

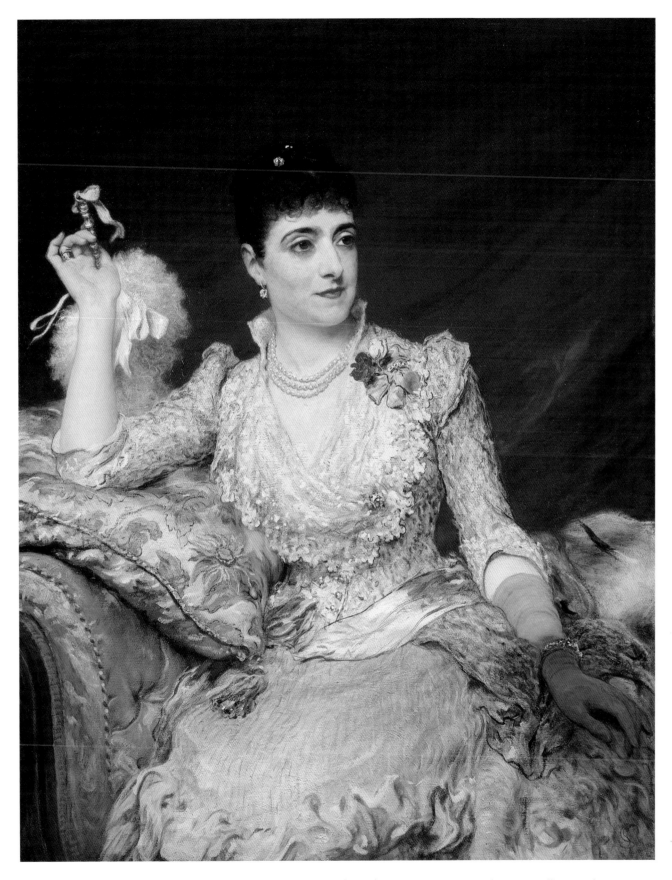

31 James Sant (1820–1916), *Adelina Patti*, c. 1885, oil on canvas, 43¼ × 33½ (109.9 × 85.1), National Portrait Gallery, London

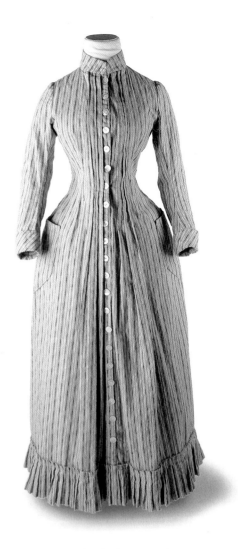

32 Striped Dress, 1880s, brushed cotton, front view, Museum of London, 80.231/2

33 *Maud Franklin*, c. 1878, chalk and wash on beige laid paper, 6¹⁵/₁₆ × 3⁷/₈ (17.7 × 9.8), Munson-Williams-Proctor Arts Institute, Utica, New York, 69.94 (M. 689)

Whistler's drawings of Maud Franklin in the late 1870s, early 1880s (fig. 33).

Increasingly, the woman of the 1880s spent time outside the house, involved in a more active life of sport, travel, and even paid employment. English designers, like John Redfern, found a profitable market in providing masculine-inspired tailored suits for a clientele that included royalty. He supplied "tailor-mades" for the trousseau of Princess Beatrice, daughter of Queen Victoria, in 1885, as well as for women of the demimonde (in 1879 he introduced the jersey wool suit in honor of Lily Langtry, who was known as the Jersey Lily because she was born on the island of Jersey).[63] According to Mrs. John Sherwood's *Manners and Social Usages*, both the Princess of Wales and the Empress of Austria—arbiters of fashion and style—preferred to wear "dark, neat suits [of cloth] . . . and also broadcloth dresses."[64] The tailored suit, worn over a blouse or a riding-habit shirt, became an essential out-of-doors costume for professional women, as illustrated in *The Woman's World* for 1888 (fig. 34). Made of wool (tweed was especially popular), such a suit was hard-wearing, versatile, and especially appropriate for the "New Woman," *Punch*'s gently mocking term for young women who went out to work, liked vigorous exercise, and agitated for university education and for female suffrage.

Lady Archibald Campbell in Whistler's *Arrangement in Black: La Dame au brodequin jaune* (1882–84, see fig. 175) wears a tailored woolen costume, the skirt wrapping

over at the sides to give the taut, tubular look of the decade. Over her shoulders is a cape, possibly of sable (*The Graphic* for September 13, 1884, notes "sable capes which fit the shoulders"), or beaver. Such shoulder capes in "figured"

34 "Tailor-made Costumes," engraving, "September Fashions," *The Woman's World* (September 1888), p. 524, Courtauld Institute, London

and glossy furs were very much a fad of the late nineteenth century. They were warm and practical for out-of-doors; *Punch* chided that they had been borrowed from the attire of coachmen.

It was not just the challenging (or flirtatious?) look over the shoulder that created criticism of Whistler's portrait but possibly the attention paid to the newly fashionable accessories, such as shoes and gloves. The gesture of inserting the hand into the glove—if that is what she is doing—had a clear element of sexuality. Shorter walking skirts revealed the shoes—here, prominently displayed against the somber dress, is a high-heeled brown shoe, eighteenth century in style (possibly this is why the archaic word *brodequin* [translated, not very aptly, as "buskin"] is used). Accord-

ing to Blanc, shoes had to be in keeping with the rest of the ensemble, to avoid "discordance"; and gloves should be pale brown or "cinnamon."[65] In 1893 Lady Archie's sister-in-law, Lady Colin Campbell, decreed that if the gloves were made of suede, they should only be worn for evening.[66]

Apropos this portrait, Whistler had considerable trouble in choosing the costume. He had originally decided to paint her in court dress of black velvet with a train appliquéd with the Argyll arms. Black would have fit in with the vogue from the mid-nineteenth century for this flattering and stylish "color." When novelists as diverse as Trollope and James wish to underline the taste of their heroines, black is the color chosen. Trollope's seductive American heroine with a rather shady past, Winifred Hurtle in *The Way We Live Now* (1875), chose always to wear black— "not a sad weeping widow's garment, but silk or woollen or cotton as the case might be, always new, always nice, always well-fitting, and most especially always simple." When Paul Montague took her to the theater, "Nothing could be more simple than her dress, and nothing prettier. . . . The lady wore a light, gauzy black dress—there is a fabric which the milliners I think call grenadine—coming up close round her throat. It was very pretty, and she was prettier even than her dress."[67]

One imagines here a stylish, semitransparent black dinner dress like that worn by Dickens's daughter Kate Perugini in Millais's perceptive portrait of 1880 (fig. 35), rather than the somewhat risqué sleeveless evening gown worn by Whistler's Lady Meux (*Arrangement in Black: Lady Meux*, see fig. 152) of 1881. Whistler's portrait is a tour de force of modernity and ambiguity. Strikingly fashionable, the dress of black silk has a French chic and flair; it is not unlike a sumptuous black dress from the rue de la Paix, trimmed with bugle (glass) beads, which fans out with black net into a train at the back (see fig. 157). The diamond jewelry is also in the latest style, and as she stands holding the voluptuous stole or cloak (a possibly deliberate ambiguity), she has the air of a modish French *chanteuse* about to entertain her audience.

Black was above all the color of the femme fatale, the female type so characteristic of fin-de-siècle life and art; Boldini's *Lady Colin Campbell* (fig. 36), a society woman involved in a scandalous divorce case, is archetypically seductive in her black satin evening dress with its plunging neckline and wafting chiffon. Black velvet, in particular, had a sensual quality and appealed also to artists and critics. Blanc and Haweis—usually with opposite views on dress—were united in their love of black. Blanc was espe-

35 Sir John Everett Millais (1829–1896), *Kate Perugini*, 1880, oil on canvas, 49¹/₂ × 31¹/₂ (125.7 × 80), private collection

36 Giovanni Boldini (1842–1931), *Gertrude Elizabeth, Lady Colin Campbell*, c. 1897, oil on canvas, 71¾ × 46¼ (182.2 × 117.5), National Portrait Gallery, London

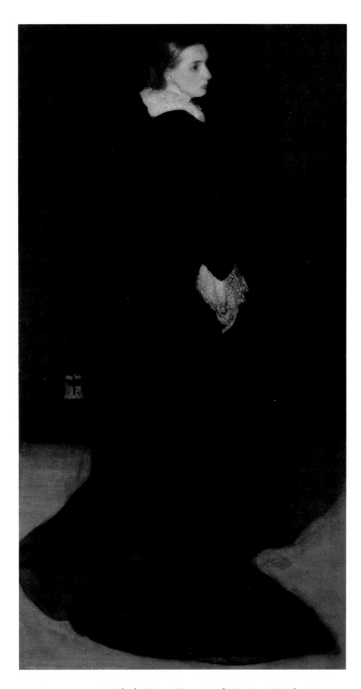

37 *Arrangement in Black, No. 2: Portrait of Mrs Louis Huth*, 1872–73,
oil on canvas, 75 × 39 (190.5 × 99), Lord Cowdray, United Kingdom
(YMSM 125)

cially fond of a "soft and deep black . . . the black of velvet,"[68] and Haweis loved black with a touch of lace at the neck, "to soften the harsh line between the skin and the dress."[69] In Whistler's *Arrangement in Black, No. 2: Portrait of Mrs Louis Huth* (fig. 37) of the early 1870s, the artist depicts a black velvet dress, the train fanning out at

the back, the sobriety of the ensemble broken with a white muslin collarette at the neck and lace ruffles at the wrist. The sitter's husband, like Whistler, was an admirer of Velázquez, and in the composition and black and white of the costume, there is clearly a sense of Spanish inspiration. From the middle of the nineteenth century, more Spanish art was exhibited in Europe, and Spain itself—a country made popular by the Spanish-born Eugénie, empress of France—gradually opened up to travelers and artists; by the late 1870s Spanish dress became popular for fancy dress balls.[70]

Spanish influence in the dress of a portrait could be the obvious result of a visit to Spain, or contain a more subtle inspiration of Spanishness. An example of the former is Carolus Duran's *Dame au gant: Portrait of Mme. X**** of 1869 (Musée d'Orsay, Paris), with her black dress, lace mantilla, and flowers in her hair. For the latter, one might look at Whistler's portrait of Ethel Philip in the early 1890s, *Mother of Pearl and Silver: The Andalusian* (see fig. 206), where the silvery gray dress with its black net cape or bolero (creating the effect of the wide sleeves of the period) shows the Spanish influence in high fashion, which the artist has captured with his intuitive skill.

Also partly indebted to Spain was the vogue for red and black costumes that were particularly fashionable in the 1880s and 1890s. The Victoria and Albert Museum possesses a stunning black and red ensemble from the mid-1890s (fig. 38), consisting of a tiny hat (red velvet and ribbons, trimmed with jet and French jet), a black satin bodice, a skirt of black satin lined in red, and a cape of red velvet and black lace with a ruched neck-ruff ("a very becoming ornament," according to Haweis). Black and red is the theme of another portrait by Whistler of Ethel Philip (*Red and Black: The Fan* [see fig. 192]) of the late 1880s. Again one notes the ambiguity regarding what she actually wears. Is it a fur-trimmed coat-dress in the sheathlike tubular style of the mid-to-late 1880s?[71] In Wharton's novel *The Age of Innocence*, the "outsider," Ellen Olenska, causes a stir at a New York dinner table when, "heedless of tradition . . . [she] was attired in a long robe of red velvet bordered about the chin and down the front with glossy black fur," an effect that Newland Archer, already falling in love with her, finds "perverse and provocative . . . undeniably pleasing."[72] Does Ethel Philip, on the other hand, wear a red dress with a long black feather boa looped round her neck and down to the ground? Whatever the actual detail of the outfit, there is certainly a Spanish touch (intimations of Goya's great portraits of the Duchess of Alba, perhaps) in the color scheme, the red ribbon in the

styles of dress, as women revealed in their clothing the concerns of social and political emancipation in general and the growing influence of sport and leisure in particular. Dress, explains Stella Mary Newton, "has always responded more quickly than any of the other applied arts not only to changes in the social pattern but even to the first idealistic theories that have preceded them."[73]

"Luxury" could still be expressed in fine fabrics, muted "sweet pea" colors, and a growing taste for high-quality underwear, which was largely made by hand: "The cult of Chiffon has this in common with the Christian religion —it insists that the invisible is more important than the visible."[74] Skirts too were often lined with silk, which made the

38 Ensemble outfit, 1893–96, Maker: "Mrs. Ball," cape: red velvet with red ribbon and black lace trim; hat: red velvet with red ribbon trim; bodice: black satin with black chiffon and sequin trim; skirt: black satin with red lining, Victoria and Albert Museum, London, T.11-1932

hair, and the large gauze fan. Large see-through fans were especially popular in the 1880s (fig. 39 is an example, with a design of bats, and signed by "F. de Valeriola"), prompting *Punch* to comment that women could no longer hide their boredom in conversation behind a fan, as their faces were clearly visible to their interlocutors.

During the 1890s the wealthy were still reliant on luxury and artifice but also looked forward to simpler everyday

39 Black Gauze Fan, late 1880s, signed F. de Valeriola, black gauze with design of bats, Museum of London, NN 8138

40 (*above*) Fashion plate, *La Mode Pratique* (1894), hand-colored engraving, from Whistler's collection, by permission of Glasgow University Library, Department of Special Collections

41 (*right*) Day Dress, c. 1895, Maker: J. Bourely et Cie, Paris, black and green spotted silk, front view, Museum of London, 38.272/2

soft rustling *frou-frou* sound regarded as so seductive in the period. "Artifice" was to be seen in the dramatic narrative of the sleeve, which was the dominant characteristic of dress in the decade, growing appreciably in size in the early 1890s, as the skirt lost some of its fullness.[75]

By 1893 the hourglass figure began to evolve, as it was felt that the large sleeves needed the counterbalance of widening skirts to maintain a sense of proportion. By the mid-1890s the sleeves were huge, in imitation of the *gigot* sleeves of the 1830s (just one of the revivalist features in dress so typical of the end of the nineteenth century), and they retained their size until about 1896/97. The round, wide sleeves and the use of luxury lace also hinted at the dress of the time of van Dyck, a popular period to imitate;

this trend can be seen in the fashion plate from *La Mode Pratique*, 1894, once owned by Whistler (fig. 40). A Parisian day dress of green and black spotted silk of about 1895 (fig. 41) creates the ideal body shape of the period, as the ballooning sleeves and flared skirt draw attention to the tiny waist. For evening wear, a similar hourglass figure was created by the puffed sleeves, tight bodice, and wide skirt of a Worth dress of the same period, made of ice-blue satin with a design of woven ribbons and butterflies studded with tiny brilliants (fig. 42).

Whistler seems to have had a particular feel for fashion in the late 1880s and 1890s; perhaps this affinity was triggered by marriage (his wife and her sisters became his models). His work shows a new authority with which he

40

captured the essence of dress. It can be seen in his portrait of Ethel Philip, *Rose et or: La Tulipe* (see fig. 205) of the mid-1890s. The sleeves of the evening dress are puffballs of pink chiffon, and the skirt opens out like a lily tulip. It can also be seen in his grasp of the new, taut simplicities of women's everyday costume, such as in another portrait of Ethel, *Harmony in Brown: The Felt Hat* (YMSM 395). The somber, rather masculine dress and hat strike an important chord regarding women's dress of the 1890s—the increased fashion for simplicity. Lady Grenville, author of *The Gentlewoman in Society* (1892), attributed the popularity of tailor-mades to "the rage for simplicity," which affected much everyday wear, even at the highest level: "A fashionable woman must have her ordinary country gowns of cloth

or serge prettily made; her short walking dresses without foundations [i.e. bones], and bodices made to serve as outdoor jackets, trimmed with braid, velvet, or fur as the season demands"; and tight-lacing, she proclaimed, was out of fashion owing to the vogue for exercise.[76]

By this time, "artistic" elements had entered mainstream fashion, appearing especially in evening wear. Lady Grenville stated that although aesthetes were "hideous and foolish," they "taught women to think for themselves, and not to bow the knee slavishly to the autocratic dictates of a bevy of French dressmakers."[77] Charles Dana Gibson's healthy, athletic all-American girls of the 1890s, created for *Life* magazine—they made the simple blouse and skirt into high fashion—also appear in dress with the flowing lines adapted from aesthetic dress of the 1870s and 1880s.

Alongside the Aesthetic movement, as promoted by "artistic" dress-reformers, went the efforts of other dress-reformers (they were sometimes linked) to promote practical clothing for women, suited to their increasingly high profile in work, in play, in agitation for female suffrage, and in education. From the 1860s women's colleges in England and in the U. S. were established[78] against a background of attacks on "strong-minded women."[79]

The Rational Dress Society was founded in 1881 with the aim of urging women away from tight-lacing and layers of fussy and cumbersome costume toward more functional clothing such as divided skirts. This suggestion raised the specter of the American dress-reformer Amelia Bloomer, whose embryonic "feminist" movement of the early 1850s linked bifurcated costume to female emancipation, battles not won until the following century. When the Rational Dress Society held an exhibition in Piccadilly in 1883, the disapproval of *Punch* was predictable.[80] A further attempt at reform, linking all aspects of "progressive" dress, was made in 1894 with the foundation of the Healthy and Artistic Dress Union. Its aim was "the propagation of sound ideas on the subject of dress," and members of the board included Louise Jopling and the artist G. F. Watts.

In July 1893 the first issue of the Rational Dress Society's journal, *Aglaia* (named after one of the three Graces, representing adornment), was published. In the third (and last) issue, autumn 1894, an illustration of "Recent Fashionable Vagaries" (fig. 43) accompanied an article by Walter Crane,

11.
RECENT FASHIONABLE
VAGARIES

43 "Recent Fashionable Vagaries," illustration from *Aglaia III* (1894), Courtauld Institute, London

attacking the giddy, aimless masquerade of fashion and the kind of body distortion—large sleeves and a tiny, tight-laced waist—that fashion generally decreed during this period. Yet this illustration is as stylized and exaggerated as a contemporary fashion plate; *Aglaia*'s readers would be unlikely to wear such extremes of fashion, preferring in fact the simple blouse and skirt and even the "bicycle suit." Following on from roller skating and tennis—popular sports of the 1870s and 1880s—cycling was the rage of the 1890s (Dunlop invented the pneumatic tire in 1888). While some women managed to cycle in skirts, the more emancipated chose to wear various forms of trousered costume, either a divided skirt or knickerbockers, to the glee of cartoonists and the rebukes of those fearing the empowering implications of such dress for the future.

* * *

To a large extent, Whistler's views on fashion were a reflection of his own personality and appearance—complex, eccentric, controversial, stylish, utterly calculated, and self-centered. Whistler's high public profile and appearance—the slight, natty, dandyish figure with long coat and cane in hand—is familiar through the descriptions of his friends and enemies, as was his skill in self-aggrandizement, his wit, and his combativeness. Together they formed a template of how an artist should look and behave (it is interesting how often cartoonists in the period base their image of the artist on Whistler, as indeed W. S. Gilbert did in part in his comic opera *Patience*).[81] Mortimer Menpes recalled that Whistler was particular as to the cut of his clothes. Visits to his tailors in Bond Street were occasions of high drama, and while his coat was being fitted, all other business stopped. Everyone "no matter how pressing their business, became highly interested in Whistler and his coat."[82] While the cut of his clothes might be slightly unconventional (he liked to wear his coat long), he never resembled an accepted member of the Establishment, as did, say, Millais or Tissot.[83] Nor did he transgress the accepted black and white sartorial codes of the time (perhaps fearing the accusation of effeminacy sometimes attached to men in "artistic" dress, like Wilde). On Whistler, as his friends asserted, the conventional formality of dress became a harmony in black and white. He was precise not just about the cut of his clothes but how they were worn.[84] Accused of being vain, Whistler may have used an element of self-parody (as well as self-advertisement) in some of his comments on his appearance. Laver records a meeting between Val Prinsep and Whistler, the latter on his way to a dinner party, coat thrown back and a coral-colored silk handkerchief in his waistcoat. Prinsep, worried that he would lose it, thrust it out of sight, causing Whistler to exclaim in anguish, "'What are you doing? You've destroyed my precious note of colour!' Hastily he rearranged the delicately tinted folds, and passed on his way, flourishing the long, white wand."[85]

Henry James might have had Whistler in mind when he gave the following words to the subtle Madame Merle in his *Portrait of a Lady* (1881): "I know a large part of myself is in the clothes I choose to wear. I've a great respect for *things*! One's self—for other people—is one's expression of one's self; and one's house, one's furniture, one's garments, the books one reads, the company one keeps—these things are all expressive."[86]

Whistler, too, loved to express himself in his clothes and his surroundings. Even his meals were choreographed; the artist Jacques-Émile Blanche attended a lunch at Whistler's studio on Tite Street in June 1882 when the theme was blue and yellow, and "all the ladies wore a little yellow or a little blue to match the colours of the dining room."[87] His mission to upgrade the applied arts led him to the belief that they should be in harmony with one another, that furniture and interior design should be simple and should blend with the art on the walls—"every room was an arrangement and every sitter had to fit in."[88]

Whistler's views on the harmony of art, fashion, and design were initially inspired by the Japanese concept of the unity of the arts, both fine and decorative. He had what Henry James calls "a lust of the eyes" for beautiful objets d'art; the cynical dilettante Gilbert Osmond in James's *Portrait of a Lady* may partly be based on Whistler, with his "taste for old lacquer" and his wish to go to Japan ("it is one of the countries I want most to see").[89] Whistler never went there either, but, as Klaus Berger notes, Whistler's paintings of the 1860s "surprise by their use of Japanese objects and the resulting perfumed and cultivated atmosphere; they are bewildering in their spatial construction and often astonishing in their choice of colour."[90]

Certain artists, according to Richard Brilliant, adopt "a confessional mode of self-presentation, tinged however with pride, confident that their personal reflections would reach beyond themselves to an audience."[91] Whistler, one could add here, would suggest that such a style was particularly relevant in portraiture, when, over time, the identity of the sitter loses importance, and the decorative elements in the image assume even greater prominence.

The emphasis of style over substance was a criticism leveled at Whistler apropos his portraits, enhanced by the nomenclature of his works, in which color and music were given equal importance to the name of the sitter. Tom Taylor, the art critic of *The* [London] *Times*, attacked Whistler for his "vaporous full-lengths... [which] it pleases him to call 'arrangements' in blue and green, and white and black, as if the colour of the dress imported more than the face; and as if young ladies had no right to feel aggrieved at being converted into 'arrangements.'"[92] Notions about the unity of art and music were generally held at this time. Blanc, for example, praised "the admirable relationship which exists between all the arts— how the painter colouring his picture, the musician writing his score, obey the same laws as the artist who decorates the human form."[93] But Whistler, as he himself said, wanted to produce a painting as much as a portrait, an image with universal qualities. Too much detail of costume in both literature and art could be pedantic and deadening. Henry James, writing about the "leaden pedantry" of the costume and scenery of Henry Irving's productions at the Lyceum Theatre, noted "the more it is painted and dressed... the less it corresponds with our imaginative habits,"[94] a statement aligned with Whistler's views on fashion. Thus, it is not always possible to establish the dates of Whistler's paintings by dress because there is sometimes a deliberate vagueness with regard to the details of fashion.

James, an enthusiast for Sargent, later "developed an appreciation of the elliptical style of his compatriot J. M. Whistler."[95] Like James, we need to "read" Whistler (especially the works of his mature years) between the lines to record what the novelist calls "the process and the effect of representation." According to James, Whistler's "manner of painting is to breathe upon the canvas."[96] His work is subtle and atmospheric like the misty harmonies of Debussy, a composer who argued that music, by its very nature, could not be treated in a traditional, fixed way but was made up of rhythms, light, and color—a kind of *sensibilité*, akin to aesthetic principles.

Whistler's aesthetic sense was particularly demonstrated by his susceptibility to color ("the musician of the rainbow," according to A. J. Eddy).[97] In a letter to Henri Fantin-Latour of 1868, Whistler explained that colors in a painting should be, so to speak, "embroidered... the same colour reappearing continually here and there... the whole forming in this way an harmonious pattern."[98]

Like his friend Mallarmé, Whistler's aim in his work was to pursue beauty in modernity. The poet declared that beauty on its own "can just become some sort of forsaken ornament," whereas usefulness was "inelegant"; he concluded: "To shape in true fashion demands a certain oblivion from the artisan as to what the use of the object will be; that is what counts—the application of the idea as a totally modern expression of truth."[99] How, then, did Whistler deal with beauty and modernity in his rendition of fashion on the canvas?

WHISTLER'S WAY WITH WOMEN

The women in Whistler's portraits have been considered, in the words of James Laver, "scarcely creatures of flesh and blood at all, yet in their sophisticated fashion, infinitely seductive...."[100] Whistler liked to paint in the half-light of dusk, so that sometimes the figure on the canvas could scarcely be seen. When asked why by a sitter, he replied:

As the light fades and the shadows deepen, all petty and exacting details vanish, everything trivial disappears, and I see things as they are in great strong masses; the buttons are lost, but the garment remains; the garment is lost but the sitter remains; the sitter is lost but the shadow remains. And that night cannot efface from the painter's imagination.[101]

It is, perhaps, the decorative element that leaves the strongest impression, and in particular the artist's own interpretation of fashion, which often involved some element of blurring, generalization, or simplification—removing excessive frills from a skirt, or reducing the elaboration of a carefully built-up coiffure. Whistler's women are "distant, aestheticized, and thus essentially asexual" (a description of Mallarmé's fashionable women in *La Dernière Mode*).[102] When Whistler painted Mallarmé's daughter Geneviève in 1897, the poet, watching the progress of the portrait, indicated "the puff of a sleeve," to which the artist replied, "I was forgetting! Mallarmé loves chic!"[103] The point here is complex; was Whistler intending to reduce the size of the sleeve as a too-fashionable detail, or—and great artists often have the uncanny ability to sense a change in fashion—was he aware that the huge sleeve was no longer as stylish?

Although Whistler might appear to be the antithesis of the Pre-Raphaelites, with their fidelity to every detail of dress, he needed to have the garments in front of him. Only after apprehending the essence of the clothing from its reality could he use his imagination and paint, a process that sometimes involved the skills of a dress designer. In the context of the couturier's work (though the words would apply to Whistler as well), Blanc says

it is only a true artist that can render the clothing of the human body a decoration, either by guiding a woman in her choice, or by dressing her according to her height and carriage, the colour of her hair and skin . . . the particular bent of her mind—I was about to say, her heart.[104]

Undoubtedly, Whistler, through his experience in painting female portraits, "guided the woman in her choice" of costume, or decided himself what she was to wear; after which the dress would undergo the artist's unique system of selectivity and generalization. Sometimes the costumes changed completely—he often exhausted his sitters by the number of sittings he demanded and the alterations he made. In the famous lawsuit, *Eden v. Whistler* of 1895 (when the artist refused to hand over a portrait of Sir William Eden's wife, Sibyl, in protest at the amount and

manner of payment), much of the argument in court revolved around whether the portrait was recognizable by dress after Whistler had altered and rubbed it down.[105] In his defense, Whistler used the not very convincing argument that if a customer ordered a pair of slippers and the shoemaker decided to make "elaborately dandy boots" instead, this would be all right, for the cobbler (artist) had a right to decide what happens to his own work.[106]

For some portraits Whistler had the costume made up, sometimes by theatrical costumiers—the Pennells instance his *Scherzo in Blue: The Blue Girl* (YMSM 226) of the early 1880s, when the model's sister noted that the "dress was made by Mme Alias, the theatrical costumier, to Whistler's design, and I believe cost a good deal. . . ."[107] Whistler certainly had a hand in the white dresses of the 1860s, especially the portraits of Jo Hiffernan as *Symphony in White, No. 1: The White Girl* (1862, see fig. 76) and *Symphony in White, No. 2: The Little White Girl* (1864, see fig. 82). Both dresses have the loose, natural lines of the Pre-Raphaelite dresses seen in Rossetti's images of Elizabeth Siddal and Jane Morris. The absence of harsh dyes made white a popular choice for aesthetes and dress-reformers. In the first picture Jo's dress of white cambric reminded the French critic Théophile Thoré of the opaque, matte whites of Reynolds; to Léonce Bénédite the influence of Millais, whom Whistler much admired at this time, was strongly evident.[108]

These dresses also incorporate quasi-Renaissance features, such as the softly pleated bodice and puffed, ruched sleeves. When the art critic of the *Athenaeum* described the painting as a "woman in a quaint morning dress," the "quaintness" lay in the historicized sleeves and in the lack of fullness in the skirt, a curiosity to eyes used to the familiar amplitude of the crinoline.[109] The soft fullness of the dress and the ruched sleeves in the 1864 portrait recall the lines of mid-sixteenth century dress, and the fixed fan (as distinct from the folding fan), although Japanese, was similar in shape to those carried by women in the Renaissance.

Looking at extant examples of similar white dresses in museums (see fig. 85), one can see how ably Whistler managed to characterize the essence of such frail, insubstantial fabrics, "like rising, fanciful mist made up of all whiteness," in Mallarmé's words.[110] It is possible that it was this portrait (and not the 1862 one) that was inspired by Théophile Gautier's *Symphonie en blanc majeur* (1849), for the images conjured up in the poem—the downiness of female swans, the snow, and the white sea foam—have more resonance with the *Little White Girl*.

White was a favorite color for women (formally for court—in England young brides wore their adapted wedding dresses for such presentations—and informally for summer and leisure wear). It was, of course, especially suited to the innocence of *jeunes filles* and children. "Nothing is so becoming to a young face as attendant clouds of white muslin; there is poetry and modesty in its very appearance," wrote *The Englishwoman's Domestic Magazine*.[111]

Whistler's rather mutinous-looking Cicely Alexander (the painting was said to have taken seventy sittings), or *Harmony in Grey and Green* (1873, see fig. 73), wears a dress of white starched muslin with a sash at the waist and gray gauze draped over the top of the skirt, white stockings, and black pumps trimmed with gold and pale green gauze bows. She holds a gray hat trimmed with black velvet and a wispy pale-green gauze "feather." In the background lies a gray burnous (an outdoors mantle, usually hooded, inspired by the French conquest of Algeria), decorated with a gold tassel (fig. 44).

Cicely's dress itself is very up-to-date, and the gauze looped up at the waist echoes the fashionable *tablier* style of adult dress. But, as critics noted, there is something of Velázquez here as well, a popular inspiration in the dress of the girl of the period. Henry James's young Pansy Ormond (in his *Portrait of a Lady*, written in 1881 but set in the 1870s) is described as having "the style of a little princess; . . . the small, serious damsel, in her stiff little dress . . . looked like an Infanta of Velasquez."[112] Millais's painting *Leisure Hours* of 1864 (fig. 45) showed the two daughters of Sir John Pender in red velvet and lace Velázquez costumes, behind them a screen of embossed Spanish leather. From the 1880s fashion magazines contained designs for children's dress; according to Lady Grenville, they "have their own costumiers and milliners" and increasingly had their portraits painted, looking—especially, she says, in the work of Millais—"arch, wilful, coy, beseeching or coquettish."[113]

Historical themes were all the rage for girls; this was due, as Constance Wilde wrote in July 1888, "to artists having turned their attention to matters of dress, that we see so many picturesquely dressed children around us."[114] The vogue for historical elements in dress was partly due to the popularity of fancy-dress parties; the fifth edition, in 1887, of Ardern Holt's *Fancy Dresses Described; or What to Wear at Fancy Balls* ascribed the popularity of fancy dress

44 Detail of fig. 73

to the vogue for "artistic dressing" and illustrated the character of "Art" itself as wearing a "flowing classic dress of light cashmere."[115] Popular home entertainments such as tableaux vivants were often inspired by famous historical paintings and by fashionable exhibitions of such paintings at, for example, the New Gallery and the Grafton Gallery in London in the late 1880s and 1890s. Lavish theatrical productions such as those by Henry Irving at the Lyceum also served to fuel an interest in the "glamour" of the historic past.

Perhaps the most important factor in popularizing historical dress was the Aesthetic movement. This was, according to the literary historian Leonée Ormond, "char-acterised by a belief that anything old was bound to be better" and was informed by a "passion for the old masters, then uncleaned and suitably mysterious."[116] In an ideal world, according to Wilde, women's dress should be "delightful in colour, and in construction simple and sincere,"[117] but could these qualities encompass modern fashion?

Haweis had singled out for particular scorn the "vulgar" thesis propounded in Blanc's book *Art in Ornament and Dress*, published in 1877 in English, that "whatever is fashionable is never ridiculous."[118] She believed that whatever was worn, the upper arms should be covered, for she felt that this part of the female body was not attractive; "if we

45 Sir John Everett Millais (1829–1896), *Leisure Hours*, 1864, oil on canvas, 34¹/₂ × 46³/₄ (87.6 × 118.7), Detroit Institute of Arts, Founders' Society Purchase, Robert H. Tannahill Foundation Fund

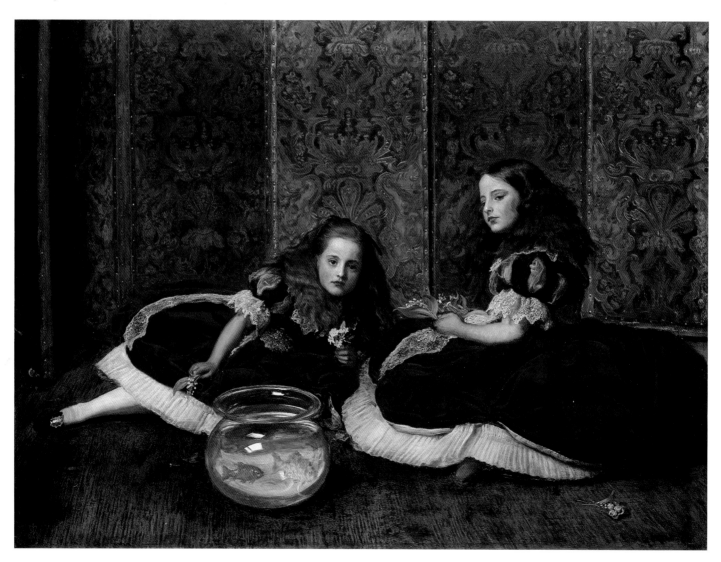

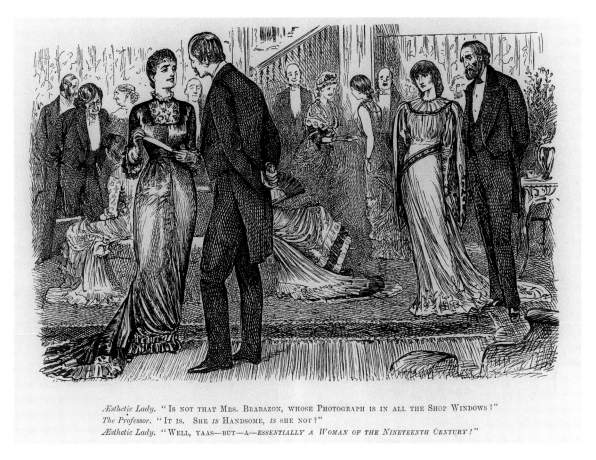

46 George Du Maurier (1834–1896), "Faint Praise," *Punch*, vol. 80 (April 30, 1881), p. 198, Courtauld Institute, London

judge English arms from Mr. Whistler's unflattering portraits, we may see they are as a rule of the skinniest."[119] The most artistic dress, she stated, was that of the classical world, which was "loose and graceful," and the early medieval period because it followed the natural shape of the body.[120] It is the medieval period that inspires the sleeves, in particular, of the dress worn by the "Aesthetic Lady," with her limp hair and intense stare in Du Maurier's cartoon "Faint Praise" (fig. 46).

Historical dress became a fashion itself during the 1880s. In 1882 the Costume Society was founded with the aim of promoting the knowledge of the history of dress from contemporary sources; the members included Wilde, Whistler, Leighton, and Alma-Tadema, and the honorary secretary was E. W. Godwin. In 1884 the International Health Exhibition in Kensington included a "complete collection of British historical costumes . . . from the time of William the Conqueror to the present day"[121] (in fact they were reconstructions of dress mounted on wax models supplied by Tussauds). In the context of a lecture on this exhibition,

Godwin suggested that "Greek and Roman dress was beautiful, but only practicable in England when worn over woollen combinations"[122]—hardly an aesthetic image!

Godwin was also involved as director of the Costume Department established by Liberty's in 1884; the dresses offered included modern interpretations of classical, medieval, Renaissance, late eighteenth century, and Japanese costume.[123] The dresses were designed and made in Liberty fabrics, including the soft Oriental silks and cashmeres imported (and later imitated) by the firm and in the subtle colors so admired by those who subscribed to the Aesthetic movement and by artists. In an interview late in life with the *Daily Chronicle*, Liberty noted: "The soft, delicate coloured fabrics of the East particularly attracted these artists because they could get nothing of European make that would drape properly and which was of sufficiently well-balanced colouring to satisfy the eye."[124]

Japanese fabrics and kimonos became widely popular from the 1860s onward through the agency of international exhibitions and the 1867 International Exhibition in Paris,

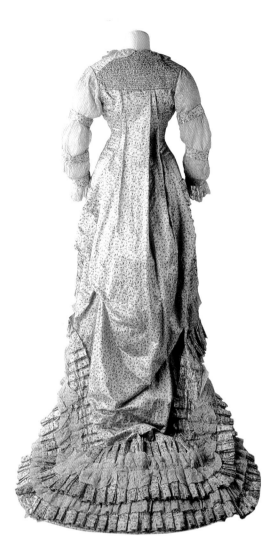

47 Dress, 1880s, Maker: Chipperfield and Butler of Brighton, floral printed satin with Watteau pleat, Museum of London, 55.85

48 Detail of fig. 49

where the Japanese pavilion attracted even more attention.[125] By the 1870s the South Kensington Museum (now the Victoria and Albert Museum) had large Oriental arts and crafts collections, and even department stores opened Oriental departments.[126] By that time, also, artists increasingly followed Whistler's path in buying Oriental artifacts of all kinds to incorporate into their work. Such artists include the famous, such as Monet (who painted his wife as *La Japonaise* in 1876),[127] and the less well known, such as Jopling, who bought in Paris "pretty dresses . . . [from] the Japanese warehouse," which she used for her paintings and for a self-portrait "in Japanese attire."[128] Above all, in fabric and flowing lines, it was a potent influence on the design of the popular tea gown, as can be seen in Whistler's portrait of Frances Leyland (see fig. 91).

In the context of fashion, kimonos and Japanese fabrics were made into dresses, and from the 1880s Worth included Japanese-style embroideries in his designs. The kimono was an exotic form of loose dressing gown for European women, a favorite garment, for example, of Proust's Odette de Crécy, later Madame Swann. An article in *Aglaia* (1894) by Lasenby Liberty aimed to challenge the "supremacy of the French modistes" by promoting more individual styles of dress, including the "soft and clinging, daintily-coloured, deftly-designed, classic draperies of old Japan."[129] Tea gowns used the exotic and a sense of the historic past to make a statement about the "artistic." According to *The Women's World*, Liberty's was "the chosen resort" of such an "artistic shopper." This kind of customer, perhaps wearing "a tea-gown of silver-grey pongee cashmere, with

49 William Powell Frith (1819–1909), *Private View at the Royal Academy*, 1881, oil on canvas, 40¹/₂ × 77 (102.9 × 195.6), A. Pope Family Trust, St. Helier, Jersey

full-front of yellow Surah . . ." would have "her drawing-room arranged in the very last scheme of colour—cool silver-grey, possibly, in conjunction with yellow terra-cotta and ivory. . . ."[130] It all sounds very Whistlerian.

An American student at Newnham in the early 1880s recorded the "vogue among the initiates . . . for the beautiful silks and velvets to be had from Liberty. . . . Instead of the prevailing fashions, we copied the long, graceful lines of costumes in old paintings."[131] The prevailing "long, graceful lines" among these cultivated intellectual women were derived from the eighteenth century, and in particular the style of dress known as a "Watteau pleat," with its flowing back drapery falling from the shoulder to the hem. Such a fashion feature was not exclusive to Watteau, but the delicacy of his colors and the mysterious elegance of his poses particularly caught the nineteenth-century imagination.

This style of dress (properly known as a *robe à la française* and popular throughout the eighteenth century) seemed to evoke all the charm of a vanished, preindustrial period. As such it features widely in both extant costume and in painting, often happily allied to other historical fea-tures and to contemporary dress as well. An 1880s dress of printed satin (fig. 47) has a Watteau pleat with a huge train and Renaissance-revival sleeves. Frith's painting *Private View at the Royal Academy* of 1881 (fig. 49) was a work he intended to record "for posterity the aesthetic craze as regards dress."[132] The group surrounding Wilde (a lily in his buttonhole) includes a number of women in aesthetic costume, one in a pink Watteau pleat dress with a looped-up train and sleeves with a ruched or smocked feature (fig. 48), another element of aesthetic/artistic dress. Frith's canvas includes famous politicians, writers, and artists, the actors Ellen Terry and Henry Irving, and George Du Maurier, who was currently having fun with his cartoons in *Punch* at the expense of the Aesthetic movement. His "Cimabue Brown" family[133] may have been based on the unconventional household of Ellen Terry and E. W. Godwin in the 1870s (although another candidate for the ultra-aesthetic Mrs. Cimabue Brown may have been Alice Comyns Carr—a friend of Whistler's), who designed stage costume for Terry.[134]

Ellen Terry was at the center of an important artistic and theatrical circle from the time that Holman Hunt designed

the dress for her ill-fated wedding to Watts in 1864. Godwin designed costumes for her, and Whistler was a frequent visitor to their house and sent her daughter Edith a Japanese kimono of white georgette printed in peach color.[135] This is in the collections at Smallhythe, Terry's house in Kent, along with an aesthetic dress of white linen that has a Watteau-pleated back and panels of tambour-work floral embroidery in blue and pink. One wonders if this is the dress that *The Brooklyn Times* (1884) reports the actress as wearing—"an artistic gown, with a Wateau [*sic*] plait."[136]

By the late 1880s aesthetic dress entered the fashion mainstream, and fashionable women, in a fin-de-siècle mood of experimentation, bought such garments. Worth, for example, began to make tea gowns, often inspired by aesthetic dress with its flowing lines, in which historical touches feature. A Liberty tea gown made for Mrs. Andrew Carnegie in 1891 (see fig. 95), of peach-colored silk has the fashionable Watteau back and sleeves ruched up as in fashionable portraits by Gainsborough of the 1770s and 1780s. More than any other period, the eighteenth century was the *beau idéal* to be copied, if not in life, then in art. In France in the 1860s Worth made the costume for the themed fancy dress balls held at St. Cloud, which were based on the eighteenth-century *fête champêtre*. The Empress Eugénie made a cult of Marie-Antoinette, a way perhaps of reinforcing the Second Empire. In the postimperial period, Maison Worth went on to pursue a lucrative business in designing historical theater costume. In 1885 Lily Langtry wore dresses by Worth when she played Lady Teazle in Sheridan's *School for Scandal*.

The pages of the fashion magazines and fancy dress guides are littered with names like Watteau, Gainsborough, Marie-Antoinette, and Pompadour. Even Haweis found that "the pointed Watteau shoe, with its slender heel is very pretty; it raises the instep and makes the foot look small."[137] The billowing draperies of the Watteau pleat made a seductive and comfortable dressing gown in which to receive intimates. Jopling remembered in Paris in 1881 "reclining on a sofa in my pale blue and pink dressing gown, 'pompadouring it,' as Whistler calls it."[138] The artist sent her a bunch of forget-me-nots to go with this costume, which clearly appealed to him as a genre, as it did to many Impressionist artists as well.

In 1894 the Grafton Galleries held a hugely popular exhibition of historical female portraits, concentrating on the late eighteenth century (Romney was a special favorite), in contrast to modern portraiture. Here, as Margaret Maynard points out, "notions of beauty and the feminine

50 John Singer Sargent (1856–1925), *Lady Agnew*, c. 1893, oil on canvas, 50 × 39³/₄ (127 × 101), National Gallery of Scotland, Edinburgh

were elided with revivalism";[139] there was also a slap on the wrist here against the masculine-inspired costume of the New Woman.

Portraits by Romney and his European contemporaries of the late eighteenth century inspired the very simple loosely gathered gowns that were popular during the 1890s and the last years of Whistler's life. In Henry James's *The Ambassadors* (1903), the seductive Marie de Vionnet (who symbolizes ancien régime glamour to Lambert Strether, the American hero of the novel) appears in a dress of the "simplest, coolest white," recalling to his mind that "Madame Roland must on the scaffold have worn something like it,"[140] thus indicating a date of the 1790s.

There is no sacrificial element, however, in Sargent's portrait of Lady Agnew of about 1893 (fig. 50), but a celebration of fashion and texture in the artist's depiction of a stylish tea gown of white satin and chiffon, with lilac ribbon bows on the sleeves and a wide sash round the waist. The ensemble was inspired perhaps by the informal

neoclassical dresses seen, for example, in the portraits of Angelica Kauffmann or Élisabeth Vigée-Lebrun of the 1780s and 1790s.

Whistler's pupil Mortimer Menpes stated that "the English school of Romneys, Gainsboroughs and Reynolds he would not tolerate at all. For them he could find no place."[141] This was not true; whether consciously or unconsciously, in the stance of a sitter, in the shape of a sleeve or a hat, in the light on a gauzy fabric, and so on, the influence of these great English portraitists is perceptible. Whistler also depicts himself, perhaps in ironic homage to Reynolds, in a self-portrait (see fig. 2),[142] dressed in his painting jacket, paint brushes in hand, and wearing his hat in a way that echoes the "Rembrandtesque" cap worn by Reynolds in *his* self-portrait wearing his academic costume of Doctor of Civil Law.[143]

"Costume," Whistler remarked in his famous "Ten O'Clock" lecture of 1885, "is not dress. . . . And the wearers of wardrobes may not be doctors of taste!" He attacked Wilde's theatrical appearance and his views on dress reform. He also discussed "artistic" dress, how far it existed as a concept in the past (not at all, Whistler said) and its impact at the present day—"the disastrous effect of Art upon the Middle Classes." This is all good fun in a rather Shavian way, but Whistler was also making a serious point about the incongruity of incorporating too much of the past in the present, either in costume or in art. His views on achieving a happy medium in dress on the canvas are typified in his most enchanting portrait, that of Frances Leyland; this is a seminal study in Whistler's work prac-

tices with regard to clothing in a portrait. As with so many Whistler commissions, the sitter's wishes about dress were brushed aside in favor of the artist's own choice. Mrs. Leyland, the stylish wife of a Liverpool shipowner, had wanted to be painted in black velvet, but Whistler decided on a loose gown in artistic taste, designed by himself. It combined Oriental delicacy with the elegant lines of a pink and white *robe de chambre* inspired by Watteau (perhaps his *L'Enseigne de Gersaint*).[144]

There were innumerable sittings and many designs for the costume. Some of the costume studies relate to fashions of the early 1870s; others are more overtly historical or generalized. Was Whistler solely engaged in an artistic struggle to find the golden mean in terms of dress, or might he have been in love with the sitter, endlessly unraveling his art like Penelope undoing her weaving each night to foil her suitors while waiting for Odysseus to return? The dress itself as revealed in the portrait is deliberately enigmatic, and a number of questions arise: Did Whistler design a complete gown, or was it loosely cobbled together as a studio prop? What exactly is the style of the costume? Is it a loose pink chiffon overgown on top of a white silk sleeveless "slip"? What happens at the front of the dress? What does she wear underneath? Can we see the line of her chemise beneath the white fichu over her shoulders? What happens to the mulberry-colored ribbons that snake down her arms, some going over the transparent silk sleeves and some under? Finally, how much (if at all) did Whistler depart from the script of his own design to let his imagination take flight like the butterfly he took as his signature?

East and West: Sources and Influences

Margaret F. MacDonald

the story of the beautiful is already complete—hewn in the marbles of the Parthenon—
and broidered, with the birds, upon the fan of Hokusai.
– Whistler, "Ten O'Clock" Lecture, 1885

facing page Detail of fig. 61

THE PERIOD FROM 1858 TO 1872, when Whistler was trying to establish himself in Paris and London, was one of experimentation, during which his imagination was nourished by Western and Eastern, ancient and modern culture. Velázquez and Gainsborough, Rembrandt and Kiyonaga, Murger and de Musset, *robes de chambre* and kimonos, Tanagra statuettes and Nankin porcelain were among diverse influences on his choice of composition, design, technique, costume, and even of the women themselves.

FUMETTE AND FINETTE

Whistler's first partner was Héloïse (nicknamed Fumette), a milliner and *grisette* of the Latin Quarter. The *grisette*, as described in Henri Murger's *Scènes de la vie de Bohème* and Alfred de Musset's poem *Mimi Pinson*, was a hard-working young seamstress or milliner, a fun-loving, faithful lover.[1] Héloïse knew de Musset's poems by heart, and she and Whistler enjoyed a bohemian life together for two years. Whistler's biographers, Elizabeth and Joseph Pennell, say dismissively that they "lived together in misery.... Later she was the mistress of a musician. Then she went to America, thinking to find an opening as a 'modiste,' but she was too old, and died there."[2]

Héloïse posed for several drawings and etchings in 1859, including a nude *Venus* (K. 59) reminiscent of Rembrandt,[3] and *Fumette* (fig. 51), where she sits on a low stool or step, her curly hair and crouching pose suggesting a wild, gypsylike street girl. However, this impression is modified by Whistler's careful realism. With her embroidered collar and neat dress, with full sleeves gathered into narrow tucks, she appears a respectable working girl.

Years later Whistler went on a nostalgic visit "to the students ball—the 'Closerie de Lilacs' ":

> The Gavarni kind of wonderful people in great hats and amazing trousers were gone—and the Grisettes with or without caps were no longer there.... Still there were one or two "types"—I did see an amazingly tall hat or so with marvellous broad brim—and there were some costumes—it being about Carnaval time—but poor—and rather shamefaced & shabby—[4]

The young Whistler had no such reservations. He was in Paris in 1859 to etch a series of portraits, and *Finette* (fig. 52), his largest full-length to date, showed a woman shrouded in a domino (a voluminous wide-sleeved gown, as worn at carnival balls and revels)[5] with, behind her, a

feathery fan and a black carnival mask. Finette was a dancer at the *bal Bullier*, a popular dancehall at 33 avenue de l'Observatoire.[6] Wedmore, in cataloguing Whistler's etchings, described her as "a dancer...in a famous quadrille then in vogue."[7] He added that it showed her fifth-floor apartment in the Boulevard Montmartre. In Whistler's ledger the etching was entitled "Finette—The Creole—Dancer."[8] Duret's description of her—"a creole of light character"—reflects his own bourgeois prejudices against women without money.[9] The Pennells called her "a cocotte, very elegant, who sometimes danced the cancan in the dancing places."[10] It has been said that she was

51 *Fumette*, 1858, etching, 6⅜ × 4¼ (16.2 × 10.8), S. P. Avery Collection, Miriam and Ira D. Wallach Division of Art, Prints and Photographs, The New York Public Library, Astor, Lenox and Tilden Foundations (K. 13, IV)

52 *Finette*, 1859, drypoint, 11⅜ × 7⅞ (28.9 × 20), S. P. Avery Collection, Miriam and Ira D. Wallach Division of Art, Prints and Photographs, The New York Public Library, Astor, Lenox and Tilden Foundations (K. 58, IX)

Whistler's mistress, but there is no proof of that.[11] She was in fact the leader of a troupe of dancers, famous for bringing the cancan to English and American stages. As a professional dancer she had the stamina and ability to adopt and project character that mark an effective model.

Finette was one of the most elaborately worked of Whistler's early etchings. The composition evolved through at least a dozen states, altered and printed at each stage. In the first state, Finette is smiling, but in later states, she looks sad and wistful. The composition was more or less established by the fourth state, when Whistler added the mask

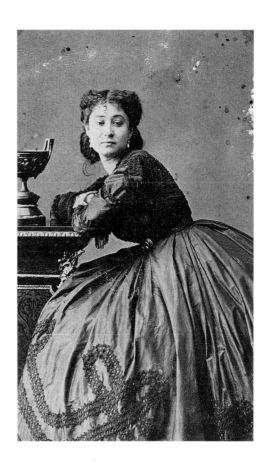

53 Wenceslas Hollar (1607–1677), *The large study of muffs and other finery*, 1647, etching, 4³⁄₁₆ × 8 (10.7 × 20.3), The Metropolitan Museum of Art, New York, Gift of Dr. Van Horne Norrie, 1917, 17.34.9

and fan. These alterations turn what was potentially a portrait of a fashionable woman into a "study of human life" with emotional undertones. In early proofs, the drypoint lines with their slight burr suggest the silky texture of the domino. Most were printed in black (although a few are in brown), but the mask and the cigarette in her hand make it clear that she is not in mourning,[12] while her weary expression reflects a bohemian lifestyle. The piling up of detail (box, papers, feather fan, and mask) suggests parallels with Wenceslas Hollar's superb etching *The large study of muffs and other finery* of 1647 (fig. 53).[13] Whistler

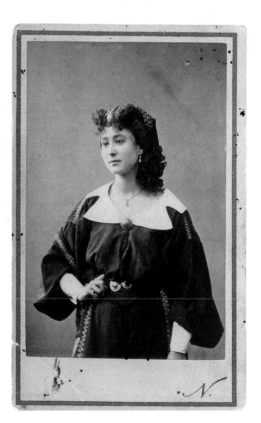

54 (*above right*) Unknown photographer, *Finette*, 1863/68, carte-de-visite, by permission of Glasgow University Library, Department of Special Collections

55 (*right*) Nadar (Gaspard Félix Tournachon) (1820–1910), *Finette*, 1863/68, carte-de-visite, by permission of Glasgow University Library, Department of Special Collections

absorbed ideas on composition and technique from such masters as Hollar, Rembrandt, and Van Dyck, who etched grand portraits on a small scale.

When Finette first brought her troupe to London in 1866, the cancan caused a sensation. At the Lyceum pantomime, their dresses, with short skirts, short boots, and a lot of leg in between, caused a furor. Photographs of Finette were sold in the print shops of London and Paris. One owned by Whistler shows her seated in a full-skirted dress in dark silk with broad bands of braid studded with sequins sewn in an interlacing pattern, and the bodice or bolero is ornamented with braid and beads (fig. 54). A heavy buckle on a narrow belt clasps a tiny waist. Pearl earrings, hair centrally parted and folded over her ears, with a couple of curls escaping artfully, complete the picture. She looks down thoughtfully, her expression a little withdrawn. Other photographs show her in the rich folds of a paisley shawl, or a dark shawl and heart-shaped bonnet, or, in a carte-de-visite from the studio of the fashionable Paris photographer Nadar, in a loose tunic and with the same pearl drops in her ears (fig. 55). There are also photographs of Finette in working dress in, for instance, a short skirt with boldly printed and sequinned patterns.[14] Such exotic outfits, common among circus and vaudeville entertainers, were assumed to indicate women of a class that was promiscuous and available. Photographs of Finette in provocative poses nurtured this image. One shows her reclining on the floor, wearing a scarf embroidered FINETTE (fig. 56), in a mocking subversion of a famous cultural icon, Ingres's painting *La Grande Odalisque* in the Louvre, Paris.

56 Disderi & Co., Finette in a volupté pose, 1860s, The Kinsey Institute, Bloomington, Indiana

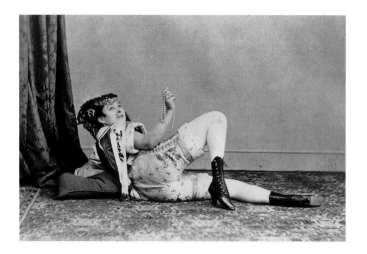

Finette's fame may also have helped to sell Whistler's etching. A significant proportion of Whistler's portraits show actresses, dancers, and singers, and this choice may have been dictated by the potential market as well as their availability to pose by day, by their ability, and by their beauty. The selection of woman and dress was crucial to the economic success of his work, and these early etchings demonstrate his movement toward a more complex interpretation of costume and meaning.

THE EXOTIC EAST

Whistler's work was given new impetus and direction as Japanese goods flooded into the West following the American Commodore Perry's arrival in Japan in 1853. By 1863 Whistler was avidly combing the junk shops of Amsterdam, Rotterdam, and Paris for Oriental artifacts, and by December he had started his first Oriental subject painting, *Purple and Rose: The Lange Leizen of the Six Marks* (fig. 57). The following February, he told Henri Fantin-Latour: "it is full of superb porcelain from my collection, and as arrangement and colour is fine—It represents a seller of porcelain, a Chinese woman painting a vase."[15] Anna Whistler added, "he has for the last fortnight had a fair damsel sitting as a Japanese study.... A girl seated as if intent upon painting a beautiful jar which she rests on her lap, ... she sits beside a shelf ... upon which several pieces of China & a pretty fan are arranged as if for purchasers."[16]

A conventional Victorian genre subject, it shows his Irish model (Joanna Hiffernan) surrounded by miscellaneous Far Eastern finds, including a K'ang Hs'i "lange lijzen" jar.[17] There was no attempt at an Oriental pose or composition, despite the Chinese chair, robes and porcelain, and a circular Japanese fan and lacquer tray. This combination of Eastern and Western artifacts with Western models dressed up in exotic clothes recurs frequently in Whistler's work.

The embroidered patterns on her robe are traditional Chinese motifs (fig. 58).[18] The elaborate arabesques of butterflies in rich colors alternate with bright leaves and pale flowers (peonies, chrysanthemums, and buds) embroidered on cream silk. The black kimono underneath is embroidered with delicate sprays of flowers among narrow leaves. The sultry pink of the robe's broad sleeve-band with its black and white border is painted with broad brushes; patches of short strokes, scumbled over the grain of the canvas, convey the texture of material catching the light,

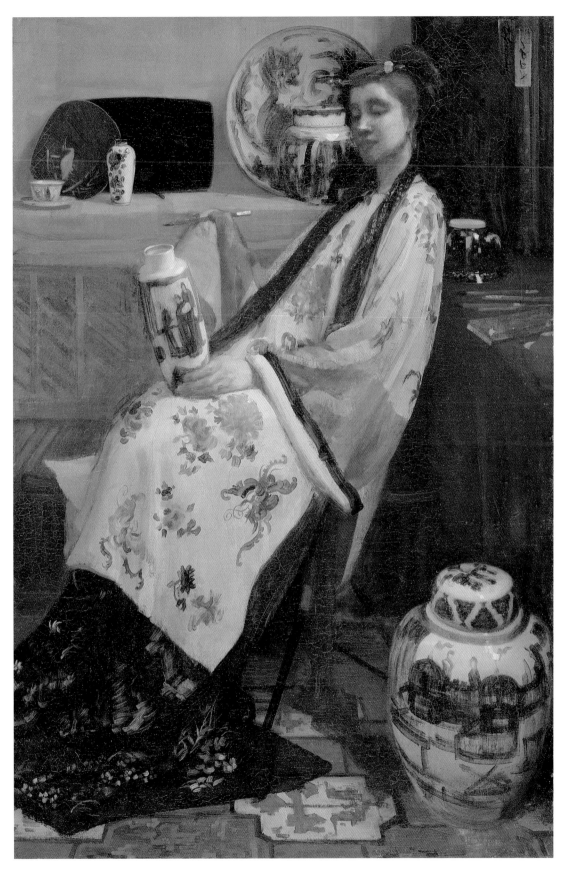

57 *Purple and Rose: The Lange Leizen of the Six Marks*, 1864, oil on canvas, 36 × 24¼ (91.5 × 61.5), Philadelphia Museum of Art, John G. Johnson Collection (YMSM 47)

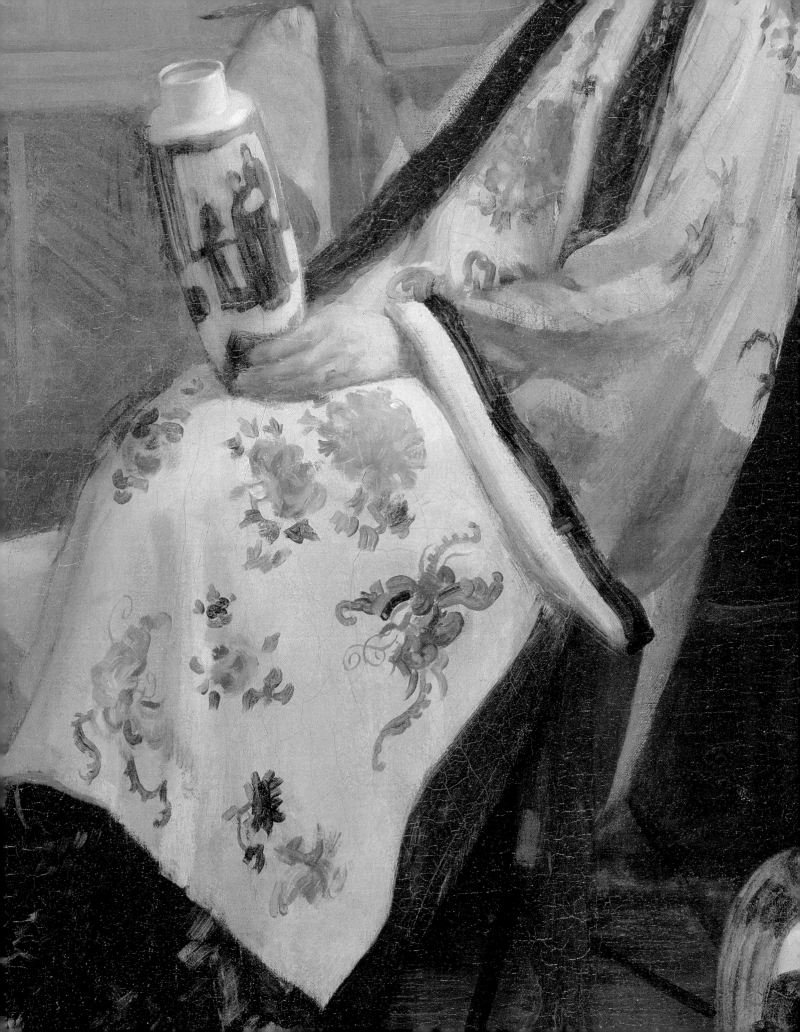

facing page Detail of fig. 57

58 (*right*) Silk embroidered Chinese sleeve-band, late nineteenth century, textile, Victoria and Albert Museum, London

while longer strokes indicate the fabric folds. Single strokes with narrower round bristle and fine pointed sable brushes define the individual shape of leaves and buds. The vigorous technique, thick paint, and vibrant color were entirely in the Western tradition. The robes inspired a range of brush strokes and attention to color and detail new in Whistler's work.

The painting was exhibited at the Royal Academy in 1864, impressing critics by its novelty and color:

> [Whistler] appears with great force of characterisation and superb colouring in a quaint subject, styled *Die Lang[e] Lizen* (i.e. the long ladies)—*of the "six-marks." Die Lange Lizen* is the title by which the decoration on certain Chinese specimens of pottery is known. Our readers will recognise the decoration in question upon the "old blue" jar which the not very fair Celestial female artist holds, and upon the surface of which she is supposed to be painting "the long ladies" so endeared to Dutch collectors of old china. "Of the six marks" refers to the signature and appropriate date always found on rare china. . . . Here, then, is the Chinese lady amusing herself by working, . . . This picture is among the finest pieces of colour in the Exhibition—see the beautiful harmonies of the woman's robes . . .[19]

Nearly twenty years later Whistler saw the *Lange Leizen* again, after a long interval, and although he admitted it was "<u>young</u>," the freshness of the color struck him with immense force: "wonderful—Such pots & plates & fans!— Such purples & Reds & blues!!"[20]

The kimono from the *Lange Leizen* reappears in *Caprice in Purple and Gold: The Golden Screen*[21] teamed with a dark pink and gold scarf. This scarf was wrapped like an *obi* (waistband) around a different black and silver kimono in *La Princesse du pays de la porcelaine* (fig. 61); the kimono reappeared hung on the wall in *Arrangement in Grey and Black: Portrait of the Painter's Mother*.[22] Small silver five-petaled flowers, gold foliage, and a few spots of crimson and deep blue cover the *Princesse*'s kimono, which is very long, trailing the ground in front and to the right. Over it she wears a flesh pink robe, plain at the top but embroidered below with gray scrolls and pink, purple, and magenta flowers. The *Princesse* was a Greek beauty, Christine Spartali, herself an artist (fig. 59). She posed in the winter of 1863–64, and Whistler continued with a different model a year later. He called it "japonaise" in contrast to the "chinoise" of the *Lange Leizen*. The question of whether it was Japanese or Chinese concerned many over the years.[23] A sympathetic review in *L'Indépendance belge*

59 Julia Margaret Cameron (1815–1879), *Portrait of Marie Spartali*, 1864, National Portrait Gallery, London

Rossetti's, is European, as is the setting. None of Tissot's "Japanese" subjects was exhibited until 1869. The first, *Jeunes femmes regardant des objets japonais*, showed two pretty *Parisiennes* admiring his collection.[27] Such works showed Oriental art as worthy of the admiration of the fashionable classes and helped to spread its popularity.

Fantin-Latour, a close friend of Legros's and Whistler's, helped the latter to acquire kimonos (he asked the "Japonaise" in the rue de Rivoli to set aside "tous les costumes" for Whistler).[28] At least six kimonos from

60 James Tissot (1836–1902), *La Japonaise au bain*, 1864, oil on canvas, 81.9 × 48.8 (208 × 124), Musée de Beaux-Arts de Dijon

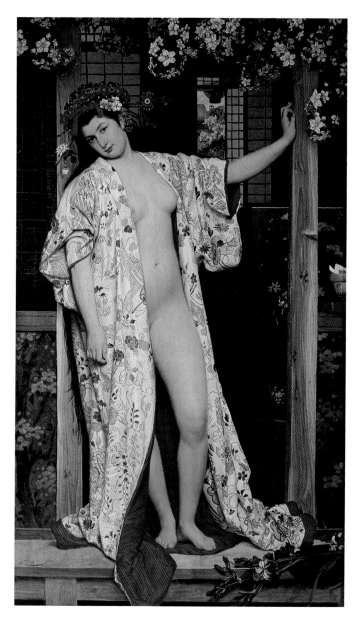

in 1865 opted for Chinese: "princess of the land of chimeras, as well as the land of the Chinese, a vague apparition, impalpable, like butterfly wings; a real life 'chinoiserie,' as fantastic and fine as the little figures on porcelain; . . . I hope that the style of her costume will become fashionable. . . ."[24] Thus the critic saw Whistler as a trend setter.

By 1864 Whistler, Rossetti, and Tissot were competing with one another in collecting Oriental robes. On November 12 Rossetti wrote from Paris,

> I went to [William's] Japanese shop, but found that all the costumes were being snapped up by a French artist, Tissot, who it seems is doing three Japanese pictures, which the mistress of the shop described to me as the three wonders of the world, evidently in her opinion throwing Whistler into the shade.[25]

Rossetti bought some costumes, and by March 1865 he had painted the central figure in *The Beloved* in "a Japanese lady's dress" or rather in a dark green material, possibly Japanese, embroidered with tiny flowers and reconstructed as a Victorian dress with full sleeves.[26]

One of the first flowery kimonos Tissot collected and painted with fine attention to detail appears in *La Japonaise au bain* (fig. 60). The model, like Whistler's and

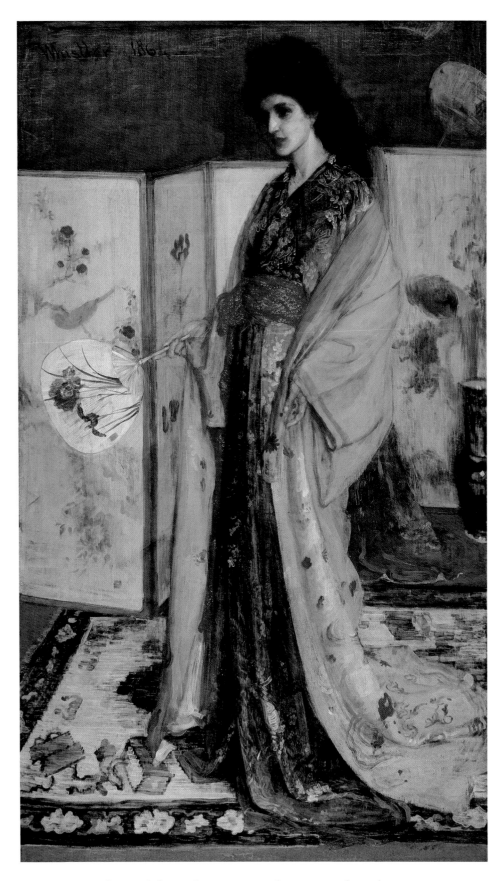

61 *La Princesse du pays de la porcelaine*, 1863–64, oil on canvas, 78¾ × 45¾ (199.9 × 116.1), Freer Gallery of Art, Smithsonian Institution, Washington, D.C., Gift of Charles Lang Freer (YMSM 50)

62 Torii Kiyonaga (1752–1815), *Autumn Moon on the Sumida*, from the series Twelve Months in the South, woodcut, 14¹/₂ × 9⁵/₈ (36.9 × 24.6), The British Museum, London

Whistler's collection, including the *Princesse*'s flesh pink robe, were incorporated in *Variations in Flesh Colour and Green: The Balcony* (fig. 63), started in February 1864.[29] Flowers in bright clear colors were painted with impressionistic freedom, with brush strokes following the pattern and silky folds of the material.[30] Dolls clothed in Japanese costume may have been used in the design,[31] and details of the composition possibly derive from Kiyonaga's series Twelve Months in the South of 1784 (fig. 62). However, the prints that Whistler owned (including this one) apparently did not teach him how kimonos and accessories were worn.[32] In none of his Oriental paintings did the pose or the arrangement of the kimono bear more than a superficial relationship to Japanese art. In fact, Whistler had few

illusions about his accuracy and later commented, when *La Princesse du pays de la porcelaine* was exhibited in Scotland:

> It is rather a bore in a way that those Glasgow papers should be so over wise and minute in all their knowledge ... much more tiresome in its diletante connoisseurship of appreciation—Such nonsense about joyousness & period—The picture takes its place simply with all the others and differs in no way from the portrait of Carlyle, excepting in as much as Carlyle himself dear old Gentleman differs from a young lady in a Japanese dressing gown, in which it was not likely the Chelsea Sage should ever be seen!—[33]

The model Milly Jones, whom Whistler called "la Japonaise," posed in the pale pink flesh-colored "Japanese dressing gown" for the continuation of *La Princesse du pays de la porcelaine* and with Hiffernan for *Whistler in His Studio*.[34] This was among several ambitious paintings in the studio by 1868, with *The Balcony* and a new series of studies, the Six Projects for F. R. Leyland. An old American friend of the Whistlers, Mary Perine, described her visit to his Lindsey Row (later Cheyne Walk) studio:

> The artist's paintings were Chinese; on the easel stood a half-finished picture in which were Chinese figures; ... very pretty and delicate, some Chinese girls were standing around a jar and were very prettily grouped. From a basket in the room, he took dress after dress of the Chinese costumes, men and women's; these were his models in drapery, his living model was the wife of one of the Ethiopian minstrels; Mrs. Whistler said it was a long time before she could reconcile herself to this; but it seems to be one of the necessities of art. The artist himself wore a shirt of Chinese silk, and did not look overly clean. ...[35]

What became of Whistler's costumes at the time of his bankruptcy is not known, but most of his collection was sold. Thus he lost the "models in drapery" for several unfinished works. One casualty was a commission received in 1872 from Sir Henry Cole of the South Kensington Museum for mosaic panels showing "a Japanese art worker" and "Neath [*sic*]," the Egyptian goddess with her spindle.[36] However, two pastels dating from some twenty years later, one known as *Design for a Mosaic*[37] and *The Japanese Dress* (fig. 64) may be reworkings of the original designs. They show sumptuous kimonos from Whistler's postbankruptcy collection. Some of the kimonos that Whistler acquired were undoubtedly antiques, rejected by

63 *Variations in Flesh Colour and Green: The Balcony*, 1864–70, oil on canvas, 24¼ × 19¼ (61.4 × 48.8), Freer Gallery of Art, Smithsonian Institution, Washington, D.C., Gift of Charles Lang Freer (YMSM 56)

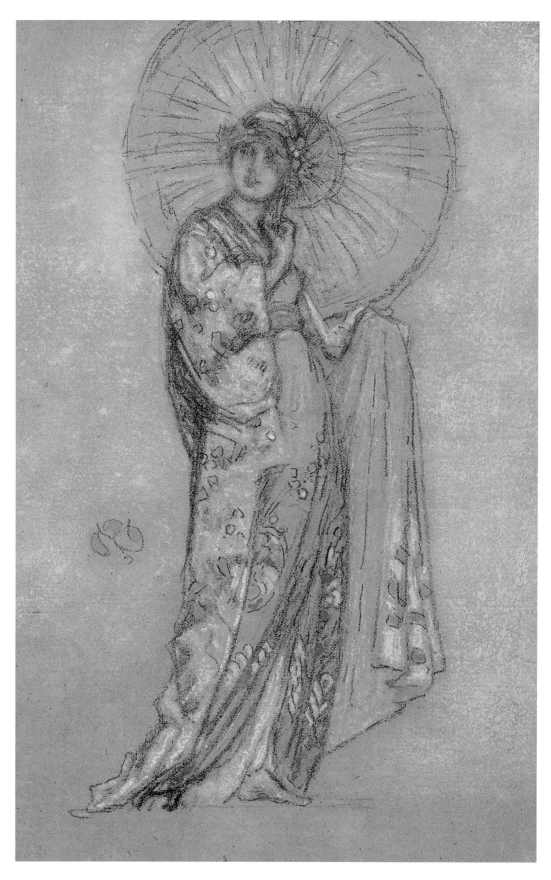

64 *The Japanese Dress*, 1870/78, pencil, chalk and pastel on brown paper, 10½ × 7¹/₁₆ (26.6 × 17.9), Davison Art Center, Wesleyan University, Middletown, Connecticut, DAC 1952.D1.10 (M. 1227)

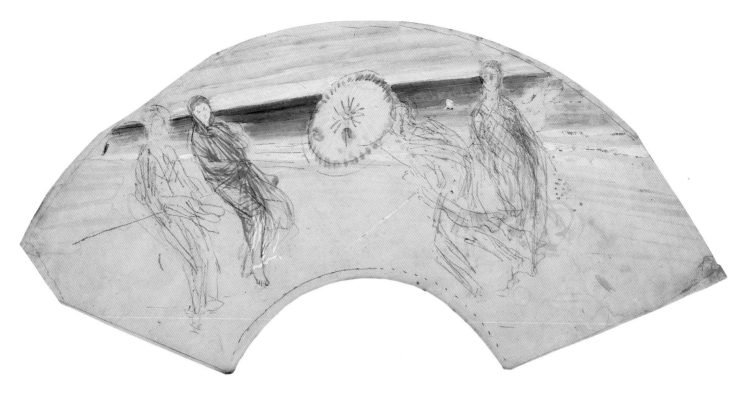

65 *Design for a fan*, c. 1870, pencil and watercolor on japan paper, 6½–6¹³⁄₁₆ × 7⁹⁄₁₆–19⅜ (16.6–17.3 × 19.3–49.2), private collection (M. 392)

Japanese women in favor of newer fashions, but others reflect contemporary styles.[38] The prices for kimonos varied considerably; the South Kensington Museum had started to collect them not long after Whistler, and they bought a green silk kimono in 1871 for 10 guineas and an elegant kimono with bamboo pattern from Liberty's in 1891 for £1 15s.[39]

The Japanese Dress shows an ivory-colored kimono with figured patterns all over in blue and ocher and a gold lining. The kimono is suited to the age and gender of the wearer, an adult woman, as is signaled by the bulky sleeves folded and rounded rather like those on an 1860s Victorian sleeve.[40] It was worn over a narrow violet robe bearing roundels with a swirling design in pale blue, pink, and purple, with scattered dots of gold and flashes of pale blue. Under this again there is a pale blue underskirt. The drawing is a synthesis of Eastern and Western traditions. The gentle curve of the figure echoes women in Japanese prints. The Oriental parasol had been part of Whistler's vocabulary since the time of the Six Projects and was recognizably Whistlerian (see fig. 90). However, Whistler made no attempt at the elaborate hairstyles and combs of the geisha. The roundness of his model's small pink face is accentuated with a curly fringe. Her head-hugging cap is

bound with a classical filletlike ribbon, set off by a flower, or bunch of ribbons (rather like the dainty headdresses of contemporary fashion).[41] The kimono itself is worn open, with one side held up in her left hand, like the train of a skirt, in a manner reminiscent of classical drapery. The gown underneath is held by a narrow ribbon rather than the broad *obi* of contemporary Japan; and it is high waisted in the style of the First Empire, which itself reflected classical style.

THE CLASSICAL TRADITION

The neoclassical element that emerges even in Whistler's Oriental subjects reflects one of the main influences on his work. He attempted to re-create the essence of Greek art—"repeated line . . . the measured rhyme of lovely limb and draperies flowing in unison"[42]—within the context of modern modes and accessories. For instance, in a fan with a design related to the Six Projects (fig. 65), robed figures emerge like leaves blown in the wind from the curving lines of pencil and brush.

A *Venus*, in the tradition of the *Venus de Milo* (which he greatly admired) shows the possible influence of the Medici

foundation for portraits and figure subjects. A design for the portrait of Mrs. Leyland, for example, is found on the verso of a splendid nude study.[46] However, when these drawings were exhibited with the portrait of Mrs. Leyland in 1874, or in the Society of French Artists in 1875, one critic dismissed them as "scrawls of the human form, hung about with old clothes."[47]

The "human form" was a controversial subject, and the danger to models of a life associated with prostitution raised questions about the morality of drawing from the nude.[48] Nudity in art (even disguised with classical titles) was condemned, and artists, galleries, and the public were attacked for countenancing it. The model in Whistler's *Parasol; red note* (fig. 66), exhibited in 1884, was criticized; "I don't admire the young lady who considers a parasol full dress costume," wrote a critic.[49] Whistler asserted that there was no question of morality involved in drawing nudes,[50] but perhaps to prove this point, he completely reworked the pastel (fig. 67). The woman was dressed in gauzy robes, fastened at her shoulders like a classical Greek *chiton*, and tied around her breasts and at her waist with ribbon. The glittering ribbons of color and glimpses of flesh rendered the

66 (*above left*) *Parasol; red note*, 1884, pastel on brown paper, 11⁷⁄₁₆ × 4¾ (29 × 12), whereabouts unknown. From *La Revue Indépendante de Littérature et d'Art* (1886), vol. 1, n.p., by permission of Glasgow University Library, Department of Special Collections (M. 957)

67 (*above right*) *Parasol; red note*, 1889, pastel on brown paper, 11⁷⁄₁₆ × 4¾ (29 × 12), whereabouts unknown, photograph, Centre for Whistler Studies, University of Glasgow (M. 957 reworked)

Venus in the British Museum as well as Greco-Roman and Asian art. She is surrounded with Oriental fans and was to be clad in "thin transparent drapery."[43] In style and concept the drawing is extremely close to the work of Albert Moore, who was by this time (1869) a close friend. It was never completed, perhaps because in tackling a classical subject Whistler became acutely aware of his deficiencies in draftsmanship. He told Fantin-Latour that he should have been the pupil of Ingres, not because of the Frenchman's classicism (he thought Ingres's paintings "French" rather than "Greek"), but because of his skill as a draftsman: "How wisely he would have taught us—drawing! my God! color—is the real vice!"[44] Ingres's recent death may have inspired the outburst, but Whistler was serious and spent months drawing from models—sometimes the same model nude and clothed in the classical *chiton* appeared on the same sheet.[45] Right through the 1870s, drawing formed the

68 *Sketch after a Greek terracotta figure*, 1894, pencil on cream card in photograph album, page size: 6⅛ × 5 (15.5 × 12.7), panel size: 3¾ × 2¾ (9.5 × 7), Hunterian Art Gallery, University of Glasgow, Birnie Philip Bequest (M. 1419)

clothed figure more sensual than the nude. She still had the turban and parasol and held a terra-cotta jug, but it was by no means a correct representation of classical dress, and the suggestion of a distant place and period led to various interpretations. One critic called her "an Egyptian princess but for her Japanese parasol" and noted the "very transparent" draperies.[51] The *Daily Telegraph* commented on "the graceful, delicate girl draped in rose, with a red 'note' in the shape of falling drapery around her head, a little thing that might have been produced thousands of years ago in Etruria had but the Etruscans gone in for fantastic pastel instead of pottery."[52]

It is perhaps no coincidence that Whistler was asked in 1894 to help Alexander Ionides sell his collection of Tanagra figurines, which included some collected by Constantine Ionides in Greece in the 1860s and others of doubtful authenticity. Whistler went so far as to sketch one of the photographs of these statuettes in an album (fig. 68):[53] a woman in a simply draped toga similar to figures he had drawn at the time of the Six Projects around 1870. Indeed, a pastel *Venus* of the late nineties is a reprise of his Six Projects *Venus* of thirty years earlier.[54] His work in the 1890s shows a reawakened interest both in the nude and in semi- or neoclassical costume, neither wholly Greek, Roman, Tanagra, or even European.

"WHY DRAG IN VELASQUEZ?"

Whistler's arrival in Europe in 1855 had coincided with a resurgence of interest in Velázquez and the publication of William Stirling Maxwell's influential book, *Velasquez and His Works*. Courbet admired Velázquez's depiction of society, and both Whistler and Manet copied *La Réunion des cavaliers*, which entered the Louvre in 1851 as a Velázquez.[55] However, the definitive moment came in 1857, when Whistler saw twenty-six paintings by, or attributed to, Velázquez at the international art exhibition in Manchester.[56]

A year later, he painted *At the Piano* (fig. 70), a portrait of Deborah Haden and her daughter Annie. At the Royal Academy in 1860, *The Times* commented, "In colour and handling this picture reminds me irresistibly of Velasquez. There is the same powerful effect obtained by the simplest and sombrest colours. . . . The execution is as broad and sketchy as the elements of effect are simple."[57] This marked an important moment for Whistler: the first time his name was coupled with Velázquez's.

At the Piano was sold for £30 to John "Spanish" Philip, whose copy of Velázquez's most famous work, *Las Meninas* in the Prado, hung in the Diploma rooms at the Royal Academy—a copy, as Whistler said later, "full of atmosphere really, and dim understanding."[58] At some time Whistler also acquired some photographs of Velázquez's paintings.[59] One was a detail of *Las Meninas*, showing the central figures, Velázquez and the princess with her maidservants (fig. 69). The gentle seriousness of the figures, and the relationship between the maid in profile and the child, suggest parallels with *At the Piano*. Whistler's assimilation of the image was distanced from the original painting by photography, which emphasized light and composition at the expense of scale, color, and texture. But despite these distortions of truth, the sepia-toned miniaturized image of the composition, with its complex interrelationships, apparently had a profound effect.

69 Photograph owned by Whistler showing a detail of the painting *Las Meninas* by Diego Velázquez. By permission of Glasgow University Library, Department of Special Collections

70 *At the Piano*, 1859, oil on canvas, 26¾ × 36¹/₁₆ (67 × 90.5), The Taft Museum, Cincinnati, Ohio, Bequest of Mrs. Louise Taft Semple (YMSM 24)

In 1860 critics sought to establish a frame of reference for this unknown young artist by comparing him with established masters. The association with Velázquez helped to validate Whistler's work, setting him in the context of a particular portraiture tradition. The Spanish master had painted his sitters in contemporary dress and settings that emphasized their rank and status. However, he went beyond formulaic likeness to convey a deeper level of psychological insight through subtle lighting, color, and brushwork. The comparison flattered Whistler and was worth following up.

In 1862 Whistler set off for Madrid and wrote the following to Fantin-Latour:

I am sure you are impatiently awaiting my journey to Spain. . . . I shall be the first capable of looking at the Velasquez for you. . . . Also if photographs can be bought, I shall bring some back. As for sketches, I hardly dare attempt any. . . . You know it must be that glorious kind of painting that does not allow itself to be copied. . . . Oh mon cher how he must have worked.[60]

Unfortunately, Whistler never reached Madrid and made do with studying the *Infanta Margherita* in the Louvre; it was, said Fantin, the most sympathetic of all portraits.[61] Thus, Whistler remained unclear about what exactly constituted a Velázquez, as he admitted when asked to comment on the authenticity of a portrait:[62]

If a Velasquez at all . . . it is not one containing the beauties either in color or execution of that great Master. The Drawing is very weak & the lovely grey tones

are supplanted by curious brown-reds. . . . Now if I were learned in the mass of his works, I might be more able to fix this, but knowing only the few that I do, I have formed by myself an ideal this one does not come up to—[63]

However, Whistler's knowledge of the great masters of portraiture—Titian, Rembrandt, Gainsborough, and Reynolds as well as Velázquez—was extended by the loan exhibitions of the day.[64] These fueled new directions in his work, resulting in the portraits of the Leylands, of Whistler's mother, of Thomas Carlyle and Cicely Alexander.

Cicely was the eight-year-old daughter of the banker W. C. Alexander, who was filling the rambling paneled rooms of Aubrey House with a fine collection of art. The second eldest in a family of seven, she was still in short dresses, with long blond hair. Whistler asked his mother to give Mrs. Alexander explicit instructions on the choice of material and design of the dress (fig. 71). Although numerous dress designs by Whistler exist, this is the most detailed surviving description:

the Artist is very sorry to put you to any additional trouble, but his fancy is for a rather clearer muslin than the pattern enclosed in your note. I think Swiss Book muslin will be right, that the arms may be seen thro it, as in the "Little White Girl" you may remember. it should be without blue, as purely white as it can be. he likes the narrow frilling such as is upon the upper skirt of the dress Sicily [*sic*] has worn, & I suppose the new one can be made in the same fashion exactly.

If possible it would be better to get fine Indian muslin—which is beautiful in color—. . . perhaps Farmer & Roger may have it they often keep it. . . .

The dress might have frills on the skirts and about it—and a fine little ruffle for the neck—or else lace . . .

Also it might be looped up from time to time with bows of pale yellow ribbon—

In case the Indian muslin is not to be had—Then the usual fine muslin of which Ladies evening dresses are made will do—the blue well taken out—and the little dress afterwards done up by the laundress with a little starch to make the frills and skirts &c stand out, & of course not an atom of blue!—[65]

For her portrait Cicely wore contemporary dress, which Whistler preferred, for, as he said later, this was the practice of Velázquez, "whose Infantas, clad in inaesthetic hoops, are, as works of Art, of the same quality as the Elgin marbles."[66] The elements he accentuated—the muslin and decorative ribbons—emphasized her age, class, and status

(fig. 73). The layers of muslin were stiff and uncomfortable, but the light shone through them, creating shifting moiré effects.

The wide-brimmed hat was called a "picture hat" because it was seen in the pictures of Gainsborough and the Old Masters. Curiously enough, Cicely's pose, with foot forward and the flourish of the large hat, was associated more with men than women. The pose, the dress, and the hat with its Old Master connotations suggest a gentle archaizing on Whistler's part. Costume and pose emphasized Cicely's youth and her slim, sexless body, but her glowing skin and the textures of the dress left no doubt as to her femininity and indeed gave her a compelling, sensual appeal. Twenty years later, when the costume was decidedly out of fashion, a reviewer commented: "It is a little girl in short petticoats and white stockings, which look somewhat strange in these days of sable hose; but see how wonderfully all her garments are painted, how well are the textures of the frock, the slightly wrinkled stocking, the flash of the furtive frill, conveyed."[67] To achieve this deliberate ambivalence required many long sessions in the studio. The painting is said to have taken seventy sittings, which may account for Cicely's pouting lips, a pout perhaps accentuated by the artist to give her the long lip and chin of the Spanish Hapsburgs. She is a princess by association of wealth and looks, in a regal portraiture tradition.

The Pennells tell a story about Thomas Carlyle, whose long and repeated sittings for his portrait overlapped with those of Cicely Alexander. Meeting her at the door, " 'Who is that?' he asked the maid. Miss Alexander, who was sitting to Mr Whistler, she said. Carlyle shook his head. 'Puir lassie! Puir lassie!', and without another word, he went out."[68]

Cicely's parents, Whistler's mother, and the artist conspired to pressure her into posing. Indeed, she had no more choice, and less reward, than a paid model:

I'm afraid I rather considered that I was a victim all through the sittings, or rather standings, for he never let me change my position, and I believe I used to get very tired and cross and often finished the day in tears. This was especially when he had promised to release me at a given time to go to a dancing class, but when the time came I was still standing, and the minutes slipped away, and he was quite absorbed and had forgotten all about his promise, and never noticed the tears; he used to stand a good way from his canvas, and then dart at it, and then dart back, and he often turned round to look in a looking-glass that hung over the mantelpiece at his back—I suppose to see the reflection of his painting. . . .

71 *Design for a dress for Miss Cicely H. Alexander*, 1873, pen and brown ink on off-white laid paper, letter in album, 7⅜ × 9 (18.8 × 22.9), The British Museum, London (M. 503)

I was painted at the little house in Chelsea.... Mrs. Whistler ... used to preside at delightful American luncheons ... a servant used to be sent to tell him lunch was ready, and then we went on again as before. He painted, and despair filled my soul, and I believe it was generally tea-time before we went to those lunches.... I didn't appreciate ... being painted by Mr. Whistler, and I'm afraid all my memories only show that I was a very grumbling, disagreeable little girl.... I was too young to appreciate Mr. Whistler himself, though afterwards we were very good friends when I grew older, and when he used to come to my father's house and make at once for the portrait with his eye-glass up.[69]

The painting itself provides the evidence of these long sessions. It was scraped down and reworked repeatedly. The composition was resolved in a series of pen and pastel sketches (fig. 72). There were minor variations in the muslin sash, the rosettes, and the ribbon trim on her bodice, plus adjustments in the dado and panels behind her.

Whistler described Velázquez as "a good craftsman" who "knew his tools and his trade."[70] Velázquez, he said, "dipped ... [his] brush in light and air, and made his people live within their frames, and stand upon their legs, that all nobility and sweetness, and tenderness, and magnificence should be theirs by right."[71] However, in his photograph, only a section of *Las Meninas* appears. The figures are therefore larger and more constrained within the geomet-

72 *Study for the portrait of Miss Cicely Alexander*, c. 1873, pastel on brown paper, 5⅛ × 3⅞ (13 × 9.8), private collection, London (M. 505)

ric bounds of the architectural features of the room than when the whole painting is considered. The space in which Cicely stands is much simpler, but she also stands well back in the frame, with regal poise. The somber studio setting— the same that appeared in the portraits of Mrs. Whistler and Carlyle—provides an austere geometric framework.

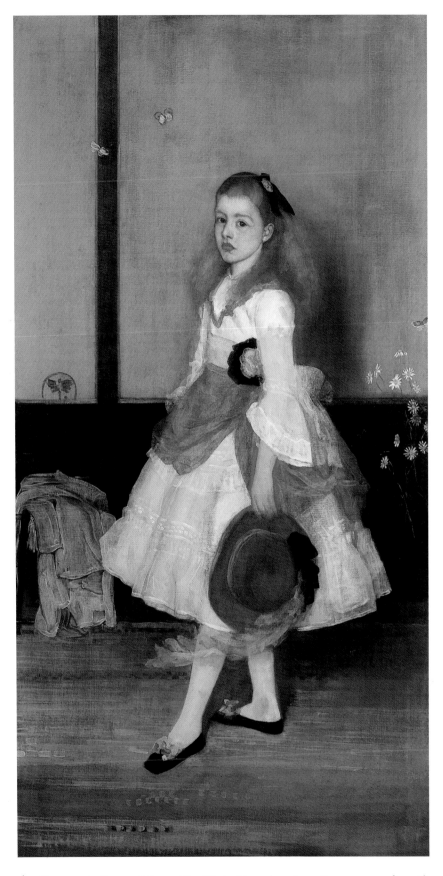

73 *Harmony in Grey and Green: Miss Cicely Alexander*, 1873, oil on canvas, 74¾ × 38½ (190 × 98), Tate Britain, London (YMSM 129)

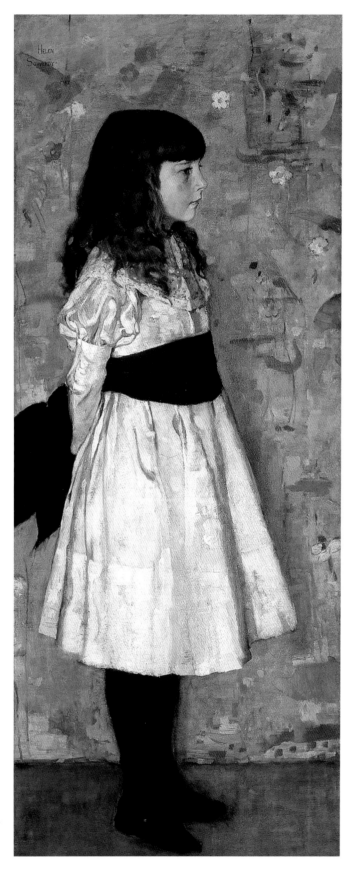

The brushwork deliberately echoed the master's work. Creamy luminous ribbons of paint were applied with comparatively small flat brushes a half inch and a quarter inch wide. The color scheme of white and gray and black, setting off the rosy flesh and the gold of Cicely's hair, as well as the touches of gold in the background, reminded viewers of Velázquez.

Such is the emotional force of the painting that the comparison was almost universally seen as complimentary to Whistler. His work gained by the association, and memories of it were reinforced and subsumed in those of Velázquez's portraits of the *Infanta*. By 1908 the Pennells were describing the portrait of Cicely as a masterpiece: "The little girl, in her white and green frock . . . is as familiar as Velasquez' Infantas in wide-spreading hoops."[72]

The painting was immensely influential, although it would be hard to differentiate the direct influence of Whistler's portrait from that of its illustrious inspiration.[73] For instance, in 1881 the portrait of Cicely was exhibited at the Grosvenor Gallery, and shortly after James Guthrie painted his portrait of Helen Sowerby (fig. 74), a child in white wearing a black sash set against golden yellow figured Oriental material. This is a striking restatement of Whistler's portrait, by an artist who admired Velázquez, Oriental art, and Whistler. There are even echoes of it in Whistler's own work, as in his *Chelsea Girl* (private collection, YMSM 129), which subverts Cicely's pouting discontent in a powerful portrait of a child of a much lower class—a street girl.

" 'I only know of two painters in the world,' said a newly introduced acquaintance to Whistler, 'yourself and Velasquez.' 'Why,' replied Whistler in dulcet tones, 'why drag in Velasquez?' " When asked if he was serious, Whistler replied, "No, of course not. You don't suppose I couple myself with Velasquez, do you? I simply wanted to take her down."[74] With the help of the artist, the story spread across the country, from the *Suffolk Chronicle* to *Household Words*, and entered into Whistler folklore, but it reflects a basic truth: the profound influence of Velázquez on his work.[75]

Works by such artists as Rembrandt, Titian, and Velázquez formed an essential and formative part of Whistler's vocabulary.[76] In aiming for the skies—for the art of Velázquez and Rembrandt—Whistler achieved unique masterpieces, which included a little girl in a white dress: a Victorian *Infanta* in the person of Cicely Alexander.

74 James Guthrie (1859–1930), *Portrait of Helen Sowerby*, 1883, oil on canvas, 63¼ × 24 (161 × 61.2), National Gallery of Scotland, Edinburgh

facing page Detail of fig. 73

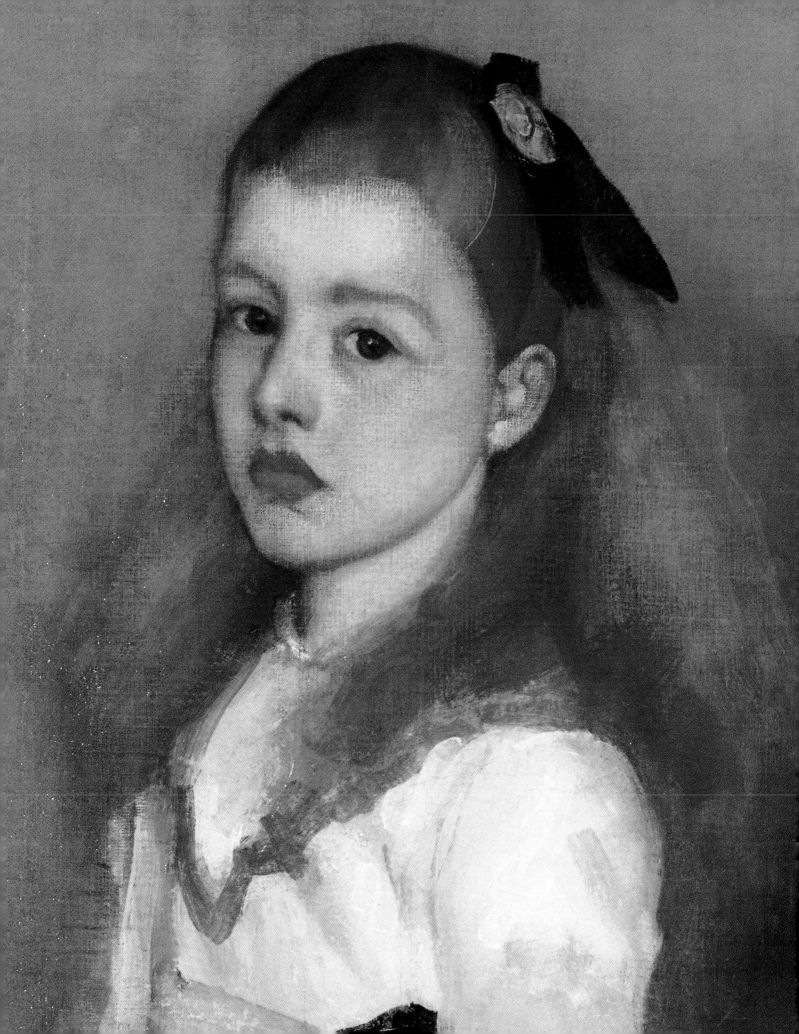

White Muslin: Joanna Hiffernan and the 1860s

Patricia de Montfort

Do you remember Trouville and Jo who played the clown to amuse us.
In the evening she sang Irish songs so well[,] she had the spirit and the distinction of art.

– Gustave Courbet to Whistler, 1877

facing page Detail of fig. 82

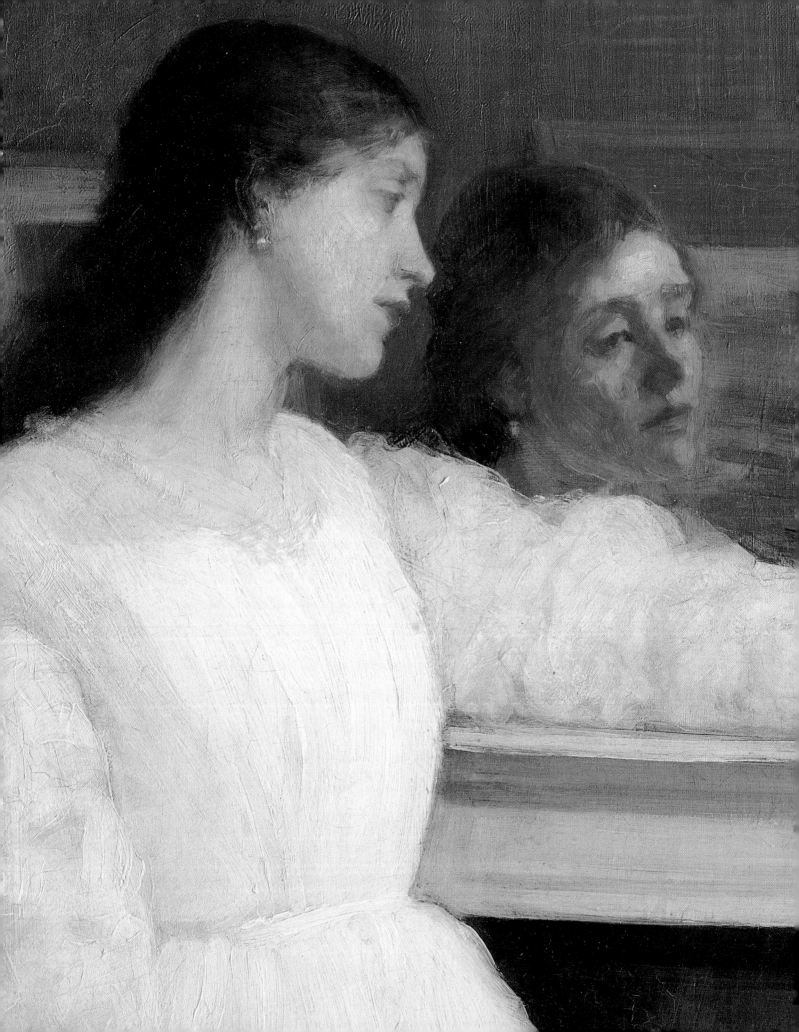

JOANNA HIFFERNAN, BORN IN IRELAND in about 1843,[1] was Whistler's most important artistic model during the 1860s, when he was closely associated with Pre-Raphaelite circles in Chelsea. She was a highly visible presence in Whistler's series of portraits of women in white—notably *Symphony in White, No. 1: The White Girl* (fig. 76), *Symphony in White, No. 2: The Little White Girl*, and *Symphony in White, No. 3*. The *succès de scandale* of the *White Girl* when it was first exhibited in London in 1862 and Paris a year later made the red-haired Irish model in a white dress a sensational artistic image. Unfortunately, we know only sketchy details of her life. The social ambiguity of Hiffernan's role as Whistler's mistress (his loyalty to her caused a major family split) ensured that she has remained a shadowy figure. However, the evidence leaves two distinct impressions, firstly, of a spirited personality of musical and artistic talent. Secondly, she loved fashion. On a practical level, Hiffernan acted as agent as well as model for Whistler. These indications of her character—a fondness for display and a collaborative, pragmatic streak—connect with the study of dress in Whistler's art during the 1860s.

75 Gustave Courbet (1819–1877), *La Belle Irlandaise*, 1866, oil on canvas, 22 × 26 (55.9 × 66), The Metropolitan Museum of Art, New York, H. O. Havemeyer Collection, Bequest of Mrs. H. O. Havemeyer, 1929, 29.100.63

MEETING WHISTLER

The scant evidence of her life suggests that Hiffernan was obliged to become independent at a young age. She was living with her family in London at 69 Newman Street when she first met Whistler in about 1860. He was then sharing a studio next door with the caricaturist George Du Maurier. Her father, Patrick Hiffernan, was "a sort of Captain Costigan, 'a teacher of polite chirography'"; Whistler implied that he became close to the family, to the extent that Patrick Hiffernan spoke of him as "me son-in-law."[2] In March 1862 Patrick's wife, Katherine, died. George Du Maurier described the event to the artist Thomas Armstrong:

> Jimmy came to town just for a day.... The reason for his hurried visit was the death of his *Mother-in-Law*; about which he was quite sentimental, and very much afraid that the bereaved widower, Joe's Papa, who is an impulsive and passionate Irishman, will do something to *disgrace* Joe's sisters.[3]

This apparent sense of obligation toward the family necessitated a hasty journey from Paris, where he was painting Hiffernan in *The White Girl*. For Hiffernan at that time, the relative security of life as Whistler's muse and live-in mistress might have seemed an attractive prospect.

Du Maurier's letters provide the most vivid picture of Hiffernan's life with Whistler, even if they hint at his growing jealousy of Whistler and disapproval of his attachment to her. In about June 1862 domesticity beckoned, and Whistler and Hiffernan moved to 7a Queen's Road West, Chelsea, and later, a pretty eighteenth-century house at 7 Lindsey Row (later named Cheyne Walk). In December Du Maurier reported, "Jimmy and Joe are as thick as ever— Jim going to retire from the world altogether and work hard."[4] Whistler seems to have been loyal to her in his fashion; the Pennells claimed that she became the mother of a son, Harry.[5] They summarized her role thus: "She was not only beautiful. She was intelligent, she was sympathetic. She gave Whistler the constant companionship he could not do without."[6] While it is difficult to separate the Pennells' confident judgment from Whistler's own slightly romanticized view of the past, it is clear that she performed the stereotypical female role for the creative spouse, providing essential domestic support. Whatever the exact nature of the emotional attachment between them, her presence enabled him to focus on his work.

On painting expeditions, from the docklands of East London, where he painted her in the riverside scene *Wapping* (see fig. 80) to the seaside resorts of northern France, Hiffernan was Whistler's artistic muse and travel

companion. She was in Paris during the winter of 1861–62, at the Boulevard des Batignolles, posing for *The White Girl* in a studio all hung in white.[7] Whistler was proud of Hiffernan's beauty. When he brought her to meet Courbet, he let down her hair "and drew it over her shoulders" to show him.[8] In the summer of 1862 they traveled to Guéthary in southwest France, where he made plans to paint her in a large-scale seascape, now lost: "among the women, there will be Jo all bright and rosy, next to her an old woman all in black."[9] In Trouville with Whistler in late 1865, she posed for Courbet in *La Belle Irlandaise*, a portrait to which Courbet remained long attached (fig. 75).[10]

Hiffernan's role went beyond that of the passive Victorian wife at home warming the domestic hearth. Whistler's trust in her judgment is suggested by a legal document Hiffernan signed before he departed for Valparaiso, Chile, in January 1866. It gave her authority over his business affairs during his seven-month trip. It was agreed that she should sell any pictures in Whistler's studio or any that he might send from Chile, "for the best prices she can obtain for the same."[11] But Whistler's works were not selling in his absence,[12] and such pressures, or perhaps boredom in Whistler's absence, may have led her to Paris to pose for Courbet in *Le Sommeil*, a highly erotic work painted for Khalil Bey, a wealthy collector.[13] This episode may have contributed to her evident separation from Whistler after his return from Valparaiso in October 1866. Nonetheless, it seems the relationship survived in some form beyond this date.[14] Certainly, Hiffernan remained involved in Whistler's irregular domestic life throughout the 1870s and 1880s, caring for his illegitimate son, Charles James Whistler Hanson. On January 11, 1877, Alan Cole recorded a visit with Whistler to "the original of his White Girl now a buxom short woman of say 40."[15] Whistler's letter to Hanson from Venice in May 1880 suggests his lingering affection for her:

> My dear little Charley . . .
> Very anxious am I to get back to you all and hear all the good accounts of you from Auntie Jo. . . . I am so glad my dear boy to know that you are doing so well with your studies and are so obedient and attentive to your kind Auntie Jo—Tell her with my love that she must expect a letter from me at once—as I shall write tomorrow—indeed often would I have written to you all had I not each day been such a slave to my work.[16]

Hiffernan may also have continued to act on his behalf in business matters. Walter Dowdeswell, Whistler's dealer during the 1880s, told Elizabeth Pennell how "'Joe' often

came to them—came even down to the time Whistler was giving his shows in their gallery—with bundles of prints or drawings she would sell for anything she could get."[17]

COSTUME AND DOMESTICITY

Whistler's portraits of Hiffernan during the 1860s belong under several generic headings. Firstly, they are about private moments in their domestic life. Secondly, they are about collaboration in literary projects such as his illustrations for the popular periodicals *Good Words* and *Once a Week* in 1862. Lastly, they are about public display at the Royal Academy and the Salon.

Etchings such as *Jo* (K. 77) and *Weary* (fig. 77) document moments of quiet domesticity at Lindsey Row. In *Weary*, Hiffernan reclines exhausted in a lightly sketched armchair, her full skirt spread out in front of her. Her long tresses stream out behind her as she rests her head against the chair. Whistler highlights the detail of her crinkly red hair and, below it, the puckered sleeve of her dress. It is a relaxed, intimate portrait. In *The Sleeper* (fig. 78), a related chalk drawing, Whistler chose a viewpoint that allowed him to build up a rich, coarsely textured surface on the skirt that recedes into darker built-up areas of the bodice, creating a ghostly intensity around Hiffernan's face. The same technique enlivens his illustrations for the serial novel *The Trial Sermon* in *Good Words* in 1862. Whistler was in the company of the finest artists (including Holman Hunt and Millais) and engravers (chiefly the Dalziel brothers), and the publication provided a broad exposure for his work. Whistler's free-flowing drawing technique distinguishes his work from that of the other artists, notably in his treatment of the costume.[18] Strongly etched vertical lines describe the contours of the skirt, a technique that is echoed in his treatment of Hiffernan's dress in *The Little White Girl*. In *Joanna Douglas* (fig. 79), he uses energetic, downward strokes and zigzag lines to describe the seated pose of the figure in her voluminous dress.

However, in the end, illustration did not pay sufficiently (between £6 and £9 a drawing), and Whistler's ambitions were focused more on the Royal Academy and the Paris Salon. His oil *Wapping* (fig. 80) was a "sensation" picture—intended to make a public impact—although it was not actually exhibited at the Academy until 1864. Whistler created a seedy atmosphere in which Hiffernan appears as a docklands woman, perhaps a prostitute, playing two customers off each other. It shows him striving for maximum artistic impact with Hiffernan as the

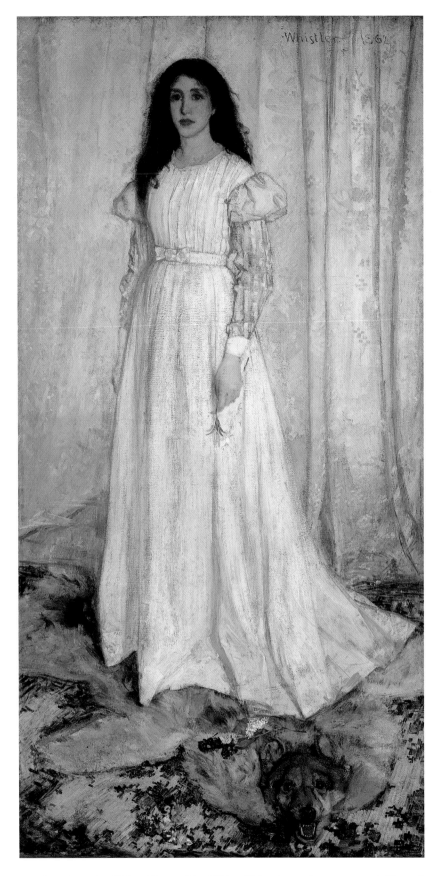

76 *Symphony in White, No. 1: The White Girl*, 1862, oil on canvas, 83⁷⁄₈× 42¹⁄₂ (213 × 108), National Gallery of Art, Washington, D.C., Harris Whittemore Collection (YMSM 38)

77　*Weary*, 1863, drypoint on Japanese paper, 10¾ × 6⅝ (27.3 × 17), National Gallery of Art, Washington, D.C., Gift of Myron A. Hofer, Rosenwald Collection, 1947.10.5 (K. 92, II)

78 *The Sleeper*, c. 1863, chalk on white wove paper, 9¹³/₁₆ × 6¹⁵/₁₆ (24.9 × 17.6), Sterling and Francine Clark Art Institute, Williamstown, Massachusetts, 55.1751 (M. 309)

79 *Joanna Douglas in "The Trial Sermon,"* 1862, wood engraving, engraved by Dalziel Brothers, published in *Good Words*, 6 × 4½ (15.2 × 11.5), General Research Division, The New York Public Library, Astor, Lenox and Tilden Foundations (M. 301)

psychological lynchpin of the picture. Whistler described an early version:

> There are three people—an old man in a white shirt, the one in the middle who is looking out of the window—then on the right in the corner, a sailor in a cap and a blue shirt with a big collar turned back in a lighter blue, who is chatting to a girl who is jolly difficult to paint! . . . She has the most beautiful hair that you have ever seen! a red not golden but copper—like the Venetian of a dream!—a white skin golden or yellow if you will—and with the wonderful expression I described to you—an air of saying to her sailor "That is all very well, my friend! I have seen others!" you know she is winking and laughing at him! . . . Her breast is exposed—her blouse can be seen almost entirely and how well it is painted my

dear—and then a jacket you should see it! in a white material with big arabesques and flowers of all colours![19]

Whistler's enthusiasm for the painting of the costume is notable. His first thought seems to have been that it should be highly visible. Early versions suggest an open neckline and looser hair (more daring than in the final result).[20] In the sketch Whistler sent to Fantin, Hiffernan wears the jacket, her left arm boldly outstretched, to show off the exaggerated cuff of the sleeve.

Whistler's painting of the costume is a reminder of the ambiguity of Hiffernan's position in his life. Whistler, who as a student combined a carefree if penurious life in Paris with luxurious respectability at the London home of his half sister Deborah and her husband, Francis Seymour Haden, was an observer of life on the margins in working

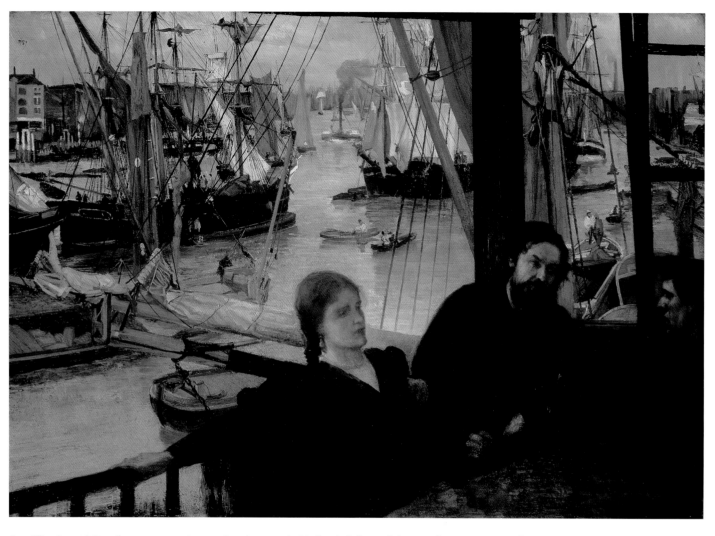

80 *Wapping*, 1861, oil on canvas, 28 × 40 (71.1 × 101.6), National Gallery of Art, Washington, D.C., John Hay Whitney Collection, 1982.76.8 (YMSM 35)

London. His fascination with moral and social ambiguity, exemplified by *The White Girl*, persisted in *The Little White Girl*; Hiffernan poses in a sentient moment of self-reflection. Despite her status in polite society as a "fallen woman," she participated in social events, attending séances with Whistler at Rossetti's house at Lindsey Row. On August 8, 1862, the artist-diarist George Boyce recorded her presence: "a handsome girl with red hair and altogether fine colour" at Whistler's studio in the company of Rossetti, Swinburne (whose verses would adorn the frame of *The Little White Girl*), and Edward Poynter.[21] She would also have been acquainted with the female half of this set—the models, the mistresses, perhaps one or two of the wives. When Boyce visited Whistler on November 17, 1866, those present included "Joe," Gabriel Rossetti, and

Fanny.[22] Fanny was Fanny Cornforth, Rossetti's then model and mistress. Hiffernan's presence was also tolerated by members of Whistler's family. The American diplomat Benjamin Moran described how he was brought by Hiffernan to the studio (with Whistler's half brother George) to see works, including *Wapping*:

> met James Whistler, a brother of Geo. W., who is an artist of rising reputation in Europe. He was on his way to the continent and his *mistress* was there to bid him goodbye. George and I went home with her to her house in Cheyne Walk, Chelsea, where I saw several remarkable pictures by him.[23]

During the winter of 1863–64 the domesticity of Lindsey Row was interrupted by a row between Whistler and his

brother-in-law Seymour Haden. The Hadens had long been Whistler's chief means of support and refuge in London. But Haden, a surgeon and etcher of repute, could be pompous and overbearing and was wont to give unsolicited artistic advice. His relationship with Whistler deteriorated. The sudden arrival of Whistler's mother from America brought matters to a crisis point. Du Maurier reported:

> Jimmy and Haden a couteaux tires; quarrel about Joe, in which Haden seems to have behaved with even unusual inconsistency and violence; for he turned Jimmy out of doors *vi et armis*, literally, without his hat. . . . It appears he had told Haden that he (Haden) was not better than him (Jim)! . . . The best of it is that Haden has dined there, painted there, treating Joe like an equal; travelled with them and so forth, and now that Joe is turned into lodgings to make place for Jim's mother, and Jim is living in respectability, Haden turns round on him and won't let Mrs H. go to see her mother at a house which had once been polluted by Joe's presence. Droll eh?[24]

There are also suggestions in Whistler's circle that such was Hiffernan's fondness for display (and perhaps misplaced belief in the security of her position) that she began to make demands regarded as excessive. In February 1862 Du Maurier reported disapprovingly that "Joe came with him to me on the Monday afternoon, got up like a duchess, without crinoline—the mere making up of her bonnet by Madame somebody or other in Paris had cost 50 fr. And Jimmy describes all the Parisians on the boulevard as aghast at 'la belle Anglaise!'"[25] By May Whistler was "in his furnitures somewhere with Joe, qui devient de plus en plus insupportable et grande dame I am told."[26]

What did Du Maurier mean by "got up like a duchess, without crinoline"? What kind of social values was he applying to her apparent love of finery and the faux pas she had committed by not wearing a crinoline? Were Parisians (according to Du Maurier) "aghast" at Hiffernan's appearance in the sense of being overcome with horror or were they overcome with amazement—bedazzled by Hiffernan "la belle Anglaise" and her beauty? Du Maurier was offended, firstly, by the apparent fact that Hiffernan was attempting to dress above her station. Her second unforgivable sin (and what emphasized her "fallen" status) was that she dressed extravagantly. It was immodest of her to parade her finery on the Parisian boulevards. The morality of the situation in the 1860s according to Victorian notions of respectability can be summarized as follows: "The words refinement and gentility were used approvingly of the perfect lady; the worst possible term of abuse was vulgarity. This was equated with showing off in public in unsuitably expensive and luxurious dress."[27] Whatever the doubtful social status of her life with Whistler, Hiffernan was in proximity of a fashionable and moneyed world of patrons and artistic celebrity. Whistler's own fastidious dress sense was known, as was his indifference to financial constraints. Du Maurier's comment about the cost of making up Hiffernan's bonnet indicates her fondness for extravagant display that seems consistent with Whistler's own values and is perhaps unsurprising.

Hiffernan's best sources of fashion ideas would have been magazines, fashion plates, and observation in centers of fashion like Paris. In the *Painter of Modern Life*, Baudelaire evoked an image of Parisian woman and "the muslins, the gauzes, the vast iridescent clouds of stuff in which she envelops herself."[28] Paris, as Du Maurier's jaundiced comments intimate, may well have stirred Hiffernan's aspirations to patronize the leading fashion names of the day. The Parisian boulevards—the Tuileries and the Bois de Boulogne—were the places to be seen and admired. In London, a commentator noted (with both amusement and revulsion) the crowds of "pretty women" who thronged the streets "to see what is being worn."[29] Eliza Lynn Linton complained in 1870, "the fatal habit of fine-ladyism is gradually descending to the tradesman's and mechanic's classes."[30] For the "Girl of the Period," Linton wrote, the "sole idea of life is plenty of fun and luxury. . . . Her main endeavour in this is to outvie her neighbours in the extravagance of fashion."[31]

Hiffernan's liaison with Whistler gained her entry to a cosmopolitan world. For the artistically minded wives of Whistler's well-connected friends, there was a certain license to experiment with dress. Lady Frederick Cavendish wrote of Rosalind Howard, wife of the artist and collector George Howard, later ninth earl of Carlisle, "she dresses madly in odd-coloured gowns with long trains, which cling about her *unbecrinolined*."[32] In this context, one might say that by going without a crinoline in 1862 (as Du Maurier had noticed), while fashionably dressed, Hiffernan was advanced in her ideas.[33] We know that Hiffernan was acquainted with Fanny Cornforth and possibly Jane Morris, both of whom were Rossetti's favored sitters during the 1860s. We also know from photographs of Jane Morris's taste (under Rossetti's influence) for "aesthetic" gowns.[34] The poet Mary Howitt described a studio party given by Rossetti in 1861:

> The uncrinolined women, with their wild hair, which was very beautiful, their picturesque dress and rich colour-

ing, looked like figures out of the pre-Raphaelite pictures. . . . I think of it now like some hot struggling dream, in which the gorgeous and fantastic forms moved slowly about. They seemed all so young and kindred to each other, that I felt as if I were out of my place, though I admired them all.[35]

Whistler painted Hiffernan during the 1860s before his reputation as a painter of fashionable society women like Frances Leyland had really taken off. She was portrayed in the ethereal White Girl series, but even earlier, in 1861, Hiffernan posed, dressed in a white robe gazing out a window, for the little-known *A White Note*,[36] a stark, thickly painted portrait of raw intensity. No doubt these pictorial projects encouraged her sense of display. One of Hiffernan's most distinctive features was her vibrant red hair. While the Pre-Raphaelites' fondness for the color did much to banish established prejudice (Mrs. Haweis wrote in 1878 how the Pre-Raphaelites had made it "all the rage"),[37] in 1864 red hair still had connotations of vulgarity and female deviancy. In Wilkie Collins's *Armadale* (1864–66), Lydia Gwilt, the archetypal female villainess, has blue eyes and abundant red hair: "the lustre of her terrible red hair showed itself unshrinkingly in a plaited coronet above her forehead."[38] Hiffernan may have known Rossetti's portrait *Helen of Troy*,[39] in which Annie Miller, another of his favored models, appears with burning, red gold intensity. She may well have hoped that her appearance would cause a similar stir when *The White Girl* was exhibited the same year. Her eager anticipation of events in a letter to George Lucas in April 1862 could only have come from a feeling of involvement in the picture:

I note the W[h]ite Girl has made a great sensation for and against. Some stupid painters dont understand it at all while Millais for instance thinks it splendid, [*sic*] more like Titian and those old swells than anything he [h]as seen—but Jim says that for all that, p[e]r[h]aps the old duffers may refuse it altogether.[40]

With the rejection of the picture by the Royal Academy and its exhibition at the private Berners Street Gallery in June 1862 came notoriety. Whistler told their friend George Lucas, "She looks grandly in her frame and creates an excitement in the Artistic World here which the Academy did not prevent, or forsee after turning it out I mean."[41] The influential literary review the *Athenaeum* associated it with Wilkie Collins's "sensation" novel *The Woman in White* (1860), a link Whistler publicly disputed.[42] While he was anxious to stress the abstract values of the picture, he delighted in the controversy that *The White Girl* was causing. He described to Lucas in a sketch how the picture was being advertised on a sandwich board as "Whistler's Extraordinary picture the WOMAN IN WHITE" (fig. 81). The same advertisement also jostled for space in the *Athenaeum*[43] alongside "Frith's celebrated Picture of THE RAILWAY STATION . . . NOW ON VIEW."[44] The exhibition of *The White Girl* took place at a time when the "sensation" novel, personified by Collins's *Woman in White*, was the talk of the town amid a popular obsession with theater melodrama. These novels were generally about (and often written by) women caught up in a violent masculine world struggling to survive. Themes around murder, madness, and incarceration predominated. They spawned merchandise of all kinds, from popular waltzes to Woman in White perfume.[45]

DRESS IN *THE LITTLE WHITE GIRL*

A highly charged atmosphere hung over Whistler while he was painting Hiffernan in *The Little White Girl* during the winter of 1864. He was painting it under social pressure from his family, only a few months after his drastic quarrel with Haden. He was also eager to succeed at the Royal Academy.[46] Hiffernan's image in *The White Girl* has been interpreted as that of a deflowered young bride (although she wears no wedding ring); in *The Little White Girl*, she wears a glistening wedding ring that is almost impossible to miss (fig. 82). Whether Whistler intended the ring as some sort of statement is unclear, as are Hiffernan's own thoughts about the controversies surrounding his portraits of her. However, what is important is that the atmosphere

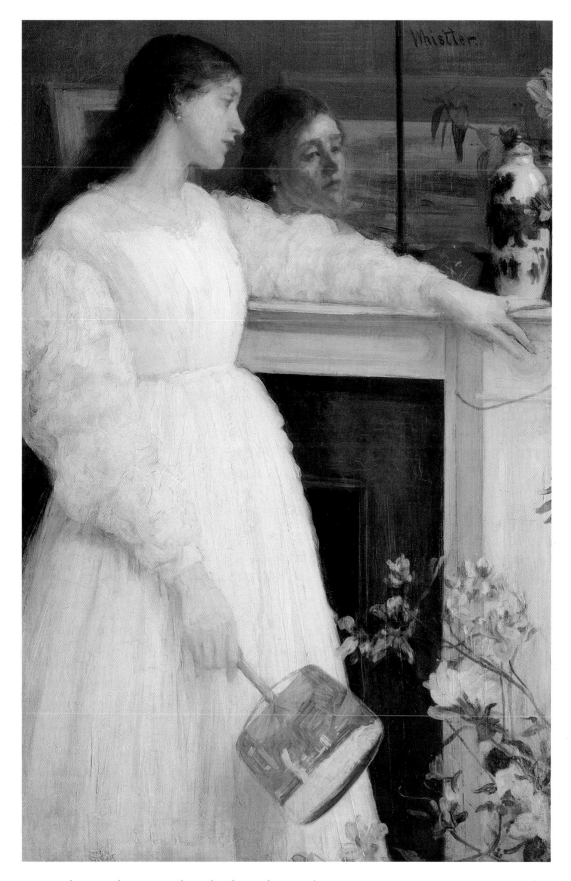

82 *Symphony in White, No. 2: The Little White Girl*, 1864, oil on canvas, 30 × 20 (76 × 51), Tate Britain, London, Bequeathed by Arthur Studd, 1919, NO3418 (YMSM 52)

83 Photographer unknown, Jane Morris, 1865, Victoria and Albert Museum, London

84 Dante Gabriel Rossetti (1828–1882), *Lady Lilith*, 1864–68, oil on canvas, 38½ × 33½ (97.8 × 85.1), Delaware Art Museum, Wilmington, Samuel and Mary R. Bancroft Memorial, 1935

in which she wore her dazzling white dresses was richly experimental.

Whistler painted *The Little White Girl* during the years of his closest acquaintance with Pre-Raphaelite circles. If the rich palette and chiaroscuro used by Rossetti in *Monna Vanna*[47] seems at odds with the tonal restraint of Whistler's White Girls, closer examination indicates that they shared common ideas about costume.[48] Both men were specific in their requirements of fabric to serve their artistic purpose.[49] A fascination with historic dress was well established in Pre-Raphaelite circles through such sources as Camille Bonnard's *Costume Historique* (1829–30), from which Madox Brown, Holman Hunt, and Millais are known to have made tracings.[50] By the 1860s Rossetti focused on portraits of women in opulent, rather oppressive surroundings. On these occasions, Fanny Cornforth not only acted as assistant seamstress for the dresses and draperies but was also dispatched to purchase lengths of unusual fabric.[51] It is possible that Hiffernan may have sewn the white muslin or cambric dresses for Whistler's White Girls. A notebook

attached to Whistler's passport dating from 1862/64 contains notes about the purchase of fabric for a dress, including a note (in handwriting resembling Hiffernan's own) that the sleeves were to be made of muslin.[52]

Rossetti developed an antipathy toward the rigid silhouette created by the modern crinoline. In his *Study for Lucrezia Borgia* (the finished work is often compared with Whistler's *Little White Girl*), the folds of the fabric flow so freely from the shoulder of the model as to begin to obscure the figure altogether.[53] Photographs of Jane Morris (fig. 83) and Fanny Cornforth during the 1860s show them dressed in a loose, unadorned style without crinoline.[54] In Rossetti's portraits *Monna Vanna* and *Lady Lilith* (fig. 84) from this period, the stiff pose of the figure (who dominates the foreground composition) contrasts with the rich, loosely flowing drapery and hair.

Whistler's association with Rossetti during the 1860s and his correspondence about works like *The White Girl*, *Wapping*, and the *Cicely Alexander* suggest that he took great pains over the costume and props for *The Little White*

Girl. This was noted by the critic of the *Saturday Review* when he castigated Whistler for choosing not "to put heads and hands at least on a level with screens and dresses" when the picture was first exhibited at the Royal Academy in May 1865.[55] Its charge, that he took more care and thought over costume and props than human features, was a calculated jibe, since it also attacked his abstract aesthetic values, that a painting was an arrangement in line, form, and color. It is a pertinent point, though, since Whistler had also depicted an unspecific fashion in the costume that created a vague sense of time and place in the painting. It lacked, according to the convention of Victorian fashion plates, a readable narrative of fashion. The nearest label that the critics could find to describe Hiffernan's costume was "morning dress," of the loose type worn at home by middle-class Victorian women early in the day.

Cambric, the finely woven linen Whistler used in *The White Girl,*[56] and muslin, a sheer, plain-weave cotton of soft texture used for Hiffernan's dress in *The Little White Girl,* are fabrics associated with modesty and home life rather than showy public display. In 1864 white was the antithesis of the new chemically produced aniline dyes in colors such as electric blue and magenta, popular for modish outdoor and day wear. In *The Little White Girl,* Whistler sought out the appropriate fabric to create the luminescent effect he desired. This was noticed by the *Saturday Review*:

> It is . . . when the artist chooses his subject from English life that he can not only astonish, but arrest us. Such is Mr Whistler's "Little White Girl," a young lady in transparent muslin, standing with one hand—upon a common mantelpiece. There is nothing in the rooms, not even by Mr Millais which can stand its ground against the soft purity, the full undertone of exquisite tint, in this sketchy picture. The tenderness, for instance, with which the girl's arm, as it were, warms the sleeve, is something that, as Mr Ruskin once said of Turner, can rather be felt than pointed out.[57]

The touch of the fabric on her arm could be "felt" by the viewer. There would have been several choices of fabric with this kind of floating, ethereal quality. The dress that Hiffernan wears is comparable to the type of white linen or muslin summer dress that could be made up at home or by a dressmaker quickly and cheaply. Typical surviving examples include a day dress with fitted bodice, ruched sleeves, and a full skirt (fig. 85).[58]

In *The Little White Girl,* Whistler uses touches of pink and red at the base of the folds in the gathered skirt of

85 Dress, c. 1864, American, bleached linen tarlatan dress with a matching sash, The Museum of the City of New York, Gift of the Misses Braman, 47.83.1ab

Hiffernan's uncrinolined dress to create a gauzy effect. He creates a similar effect on the shoulders and ruffle around the neckline. On the sleeves, he uses swirling brush strokes to build up a lively paint surface. By contrast, he uses vig-

orous downward brush strokes on the skirt (which are quite distinct under raking light) that create a compositional tension between figure and pink azaleas, mantelpiece and mirror (fig. 86). Dress and mantelpiece are treated as elements of the same whole. The brushwork of the mantelpiece is also vigorous under raking light, and although the brushwork on the skirt comprises wider bands of color, it is quite similar in both areas. Likewise, he uses a thin band of red just below the mantelpiece to convey mass and form that is consistent with his treatment of the folds of the skirt. Closer observation of the picture suggests that the dress and the mantelpiece were painted first, before each hand was worked in over the top. Flecks of pink, applied at a later stage, suggest pink flesh beneath the gauzy

87 Albert Moore (1841–1893), *The Marble Seat*, 1865, oil on canvas, 29 × 18½ (73.6 × 47), whereabouts unknown, from Alfred Lys Baldry, *Albert Moore, His Life and Works*, London, 1894, facing p. 28

86 *Symphony in White, No. 2: The Little White Girl*, under raking light, Conservation Department, Tate Britain, London

material.[59] Thick bands of paint make up the surface of the Japanese fan held by Hiffernan, and her red hair is set off by pearl earrings. The earrings may well be those Whistler mentioned in July 1863 when he requested Fantin to collect "two imitation pearl earrings" that he had left at a Paris repair shop as they were needed for a picture.[60] The soft glint of the earrings connects with the hard shininess of the wedding ring, blue and white pot, and mirror and completes Whistler's incandescent effect in *The Little White Girl*.

The Little White Girl is closely linked to *Symphony in White, No. 3* (fig. 88), Whistler's final portrait of Hiffernan, first exhibited in 1867, in which costume and fabric play an integral role in the picture composition. This time, Hiffernan appears with another model, Milly Jones, also dressed in white. The unstructured style of the dresses helps define the pose of the models. Hiffernan lounges on an off-white sofa on the left, resting her head on one bent arm, while Jones kneels at her feet, resting one arm on the sofa. In 1865, describing the progress of his work to Fantin-Latour, Whistler confirmed that Hiffernan's dress was that used in *The Little White Girl*—"of very white material, the same dress that the white girl had before." The paint was built up to follow the natural curves of the body to transparent effect, as Whistler noted: "This figure is all that I have made most pure—charming head. The body, the legs, etc., are seen perfectly through the dress."[61] The painting has a close relationship with Albert Moore's *Marble Seat* (fig. 87) and *Musician* (1867).[62] The latter was exhibited at the Royal Academy in 1867, the same year as *Symphony*

88 *Symphony in White, No. 3*, 1865–67, oil on canvas, 20½ × 30⅛ (52 × 76.5), The Barber Institute of Fine Arts, University of Birmingham, England (YMSM 61)

in White No 3. They share a friezelike composition, languidly posed models, and a fascination with gauzy fabrics. However, Whistler's models are in modern dress; he is interested in costume as an abstract arrangement of color rather than the linear detail of each limpid fold. While acknowledging the depth of their shared interest in Hellenism at this time, Whistler reminds us in *Symphony in White No 3* of his preoccupation with and growing understanding of the principles of Japanese art—flattened perspective, bold placement of the figure, and the importance of broad effect over detail.

Chapter 5

Whistler and Aesthetic Dress: Mrs. Frances Leyland

Susan Grace Galassi

What poet, in sitting down to paint the pleasure caused by the sight of a beautiful woman, would venture to separate her from her costume?

– Baudelaire, 1863

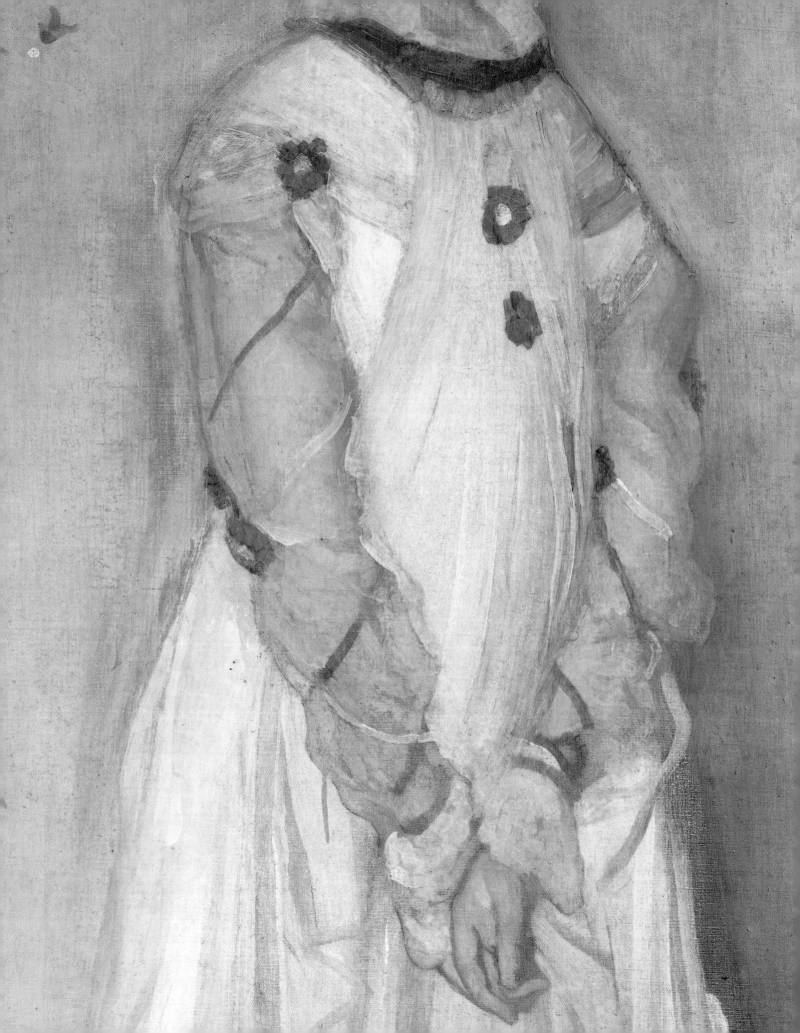

In *Symphony in Flesh Colour and Pink: Portrait of Mrs Frances Leyland*, the subject and her dress compete for the viewer's attention (fig. 91). Mrs. Leyland is depicted from the back, shoulders at a slight angle to the picture plane, and hands clasped behind her, wearing a soft pink gown over a white underdress. A panel falls to the floor from a mulberry-colored collar between her shoulders, culminating in a train that curves around her feet. Mulberry and white appliquéd rosettes, strewn down the side of the dress, gather in the folds of the train. Her arms, glimpsed through transparent gray white sleeves bound in dark pink ribbons, set off her beautiful head. Mrs. Leyland's face is shown in profile facing left; her downcast eyes and a slightly down-turned mouth convey a sense of gravity. Her auburn hair—the key color tone in the painting—is arranged simply in two coils on top of her head. Enveloped in diaphanous fabric which conceals most of her body, and turned away from the viewer, she appears majestic and remote.

In his portrait, Whistler created a complete aesthetic environment for Frances Leyland; he designed her dress and the interior of the room as an ensemble. She stands on a rush rug with checkerboard stripes in front of a low white-paneled dado and a pink wall in a space that suggests a sparely furnished room, which was, in fact, the drawing room of Whistler's Chelsea house at 2 Lindsey Row. Her pink gown harmonizes not only with her reddish brown hair, but with her surroundings. Blossoming almond branches, cut off at the left by the edge of the painting in the manner of a Japanese print, set off the delicacy of the floral appliqués of her dress, while at right a spray of green foliage points to the artist's prominent butterfly signature. Frances Leyland stood for her portrait between 1871 and 1874. Though Whistler was unable to complete it to his satisfaction, the resulting work is one of his most beautiful portraits and a testament to his mastery as a complete artist—painter and designer—as well as an homage to his subject.

In later life, Mrs. Leyland told Elizabeth Pennell that "she had pretended to be indignant with Whistler because she had wanted to be painted in a black velvet dress but that he had insisted on her wearing the one that he had designed for her."[1] The style of the costume in the painting, for which a number of studies exist, differs from the dominant fashions of the time in Victorian England. In paintings of the 1860s, such as *Purple and Rose: The Lange Leizen of the Six Marks*, *La Princesse du pays de la porcelaine*, and *Symphony in White, No. 2: The Little White Girl* (see figs. 82, 57, 61), Whistler had already created images of artistically appareled, introspective single female figures in harmony with their surroundings.[2] Throughout his career, he almost always selected what his clients or models wore in his paintings—effectively styling them—but his portrait of Frances Leyland is the first instance of his designing a dress for his sitter.

The portrait raises a number of intriguing questions. Why, when the sitter herself expressed her wish to be depicted in a distinctly different mode, perhaps in a gown of her own, did Whistler insist on creating a dress for her and devote so much attention to it? And why did he choose a style that would have been perceived as unconventional? Was it Frances herself who inspired such a garment—or does the gown reflect Whistler's idealized image of her, or a persona he constructed for her? Was he in fact painting a portrait of Frances Leyland or showcasing his talents as a designer—or an amalgam of the two—and why did he choose to portray her as majestic and remote when she was, by all accounts, lively and accessible?[3]

In the early 1870s Whistler was in the vanguard of the design-conscious Aesthetic movement, with its cult of beauty and focus on the harmonious relationship of furniture, decorative objects, and even clothing with the décor of a room. Whistler took on the challenge of designing a dress for an important client at a time of transition in both art and fashion, and of greater fluidity between them. The Pre-Raphaelite painters had led the way in creating "artistic dresses" worn by their models and wives, and Whistler's gown belongs in this category. Aestheticism quickly spread from its origins in literature and the fine arts to the applied arts as well: the elevation of design to high art led to the creation of artistic objects, including dresses, and dress design became recognized, in the words of a contemporary writer, "as a legitimate area of concern for the artist."[4]

Mrs. Leyland's dress may be loosely classified as a tea gown, which has a distinct form and significance in the language of clothing. The tea gown blossomed in England and America in the late 1870s and 1880s as an alternative to the tightly corseted, highly structured clothing of mainstream fashion.[5] Loose, flowing lines, simplicity of design, and references to historic and exotic styles were the hallmarks of the new fashion.[6] Mrs. Leyland's gown is situated somewhere between the earlier Pre-Raphaelite artistic dresses and the later modes of aesthetic attire, which it anticipates in some respects, yet it remains a unique creation made expressly for her to wear in her portrait. Like all of Whistler's work of the period, the costume draws from an eclectic mix of historic traditions and current trends, freely adapted to articulate his ideas of the beautiful and to assert his modernity, for which fashion was an

important signifier. The portrait of Mrs. Leyland presented an opportunity for Whistler to express his artistic aims and complex relationship with his sitter by creating an ideal modern world—a symphony of the arts.

THE PATRON: FREDERICK RICHARDS LEYLAND

Like his American contemporary Henry Clay Frick, who purchased the portrait of Frances Leyland in 1916, Frederick R. Leyland (1831–1892) was a self-made magnate who quickly worked his way up the ladder of the major industry of his native area. Born in Liverpool, the eldest of three sons who were raised by their mother in difficult financial circumstances, Leyland entered the firm of John Bibby & Sons, the oldest independent shipping company in Liverpool, as an apprentice at age fourteen.[7] Frances Dawson (1836–1910), one of three daughters of Thomas and Jane Dawson, came from Toxteth Park, a working-class neighborhood of Liverpool. Her father was a master mariner and an iron molder.[8] She was twenty when she married Frederick Leyland, by then an ambitious young bookkeeper at Bibby & Sons. As a contemporary writer noted: "When he married, he did so purely from love, and without reference to fortune or social rank, finding his reward, as many others also have, in a family of noble children."[9] The Leylands' four children, Frederick Dawson, Fanny, Florence, and Elinor (Babs), were born between 1856 and 1861.

After a swift rise to partnership in the firm, Leyland bought out his colleagues at Bibby & Sons and launched his own shipping firm in 1873 (Leyland & Co.), extending the business to the North Atlantic. Throughout his life, Leyland remained committed to advanced ideas, serving in later years as president of the National Telephone Company and deputy chairman of the Edison Electric Light Co.[10] He was similarly adventurous as an art patron, commissioning works by the most advanced contemporary artists as well as acquiring works by Old Masters.[11] As his son-in-law the painter Val Prinsep noted, Leyland followed popular taste at first, but as his taste developed, he required "stronger stimulants" and began to acquire works by members of the Pre-Raphaelite school.[12]

In April 1866 Leyland commissioned a painting from Dante Gabriel Rossetti, launching a long relationship.[13] Through Rossetti, Leyland met Whistler, Rossetti's Chelsea neighbor and close friend. Leyland and Whistler's relationship as patron and artist began in 1867.[14] They developed a close bond. Both were outsiders to mainstream Victorian society, and both had "created" themselves. They shared

a passionate antipathy for philistines and for bourgeois values, allying themselves with the aristocracy of taste. In 1867 Leyland was a new-made partner at Bibby & Sons and in the process of adopting the style of life of a wealthy gentleman. By all accounts he had carefully educated himself as a man of taste and refinement. A major stimulus to Leyland's collecting and social ambitions was his taking over the lease that year of Speke Hall, a historic sixteenth-century Tudor mansion outside Liverpool, which he would restore to magnificence.[15] Two years later the Leylands established a home in London at Queen's Gate, and soon after moved to Prince's Gate. With the help of his artists and architects, Frederick transformed their residences into showcases for his rapidly growing collections of fine and decorative art.

The Leylands were Whistler's major patrons from 1867 to 1877.[16] Frederick Leyland commissioned the portrait of his wife in 1871 as a pendant to one of himself that the artist was then in the process of painting (fig. 89). In addition to these two portraits and others of the Leyland family, Whistler was also commissioned to execute decorative paintings for their residences; Leyland's generous patronage provided him with essential financial support, though only a few of the works were completed.[17] While at work on these paintings, Whistler developed a close relationship with the entire Leyland family, often staying with them at their Liverpool estate for months at a time. For a brief period he was engaged to Frances's youngest sister, Elizabeth Dawson, an alliance that ended amicably. His relationship with his longtime patron, however, came to an abrupt and bitter end in 1876 over payment for work that Whistler had carried out without Leyland's prior approval in the famous Peacock Room, the dining room of his London house at Prince's Gate. The rift was undoubtedly exacerbated by Whistler's close friendship with Mrs. Leyland.

While 1867 marked a time of expanding horizons for Leyland, it was one of artistic crisis for Whistler. Back from a bungled business speculation in Chile, in dire financial straits, and mired in remorseless self-criticism, Whistler entered a reclusive, anxiety-filled period during which he sought to reeducate himself. The new direction in Whistler's art had begun earlier in the 1860s, when he turned away from realism and embraced the French avant-garde theory of *l'art pour l'art* championed by Baudelaire, Gautier, and Swinburne, emphasizing the preeminence of the formal, abstract properties of art over any moral, didactic, or narrative function. Whistler's concern with the formal aspects of art led him to explore the exotic artistic traditions of Japan and China, while the reinstallation of the Parthenon

(Elgin) Marbles at the British Museum in 1865 prompted his renewed interest in Classical art.

Whistler's *Symphony in White, No. 3* (see fig. 88) brought together some of his new ideas. It was on view at the Royal Academy in 1867, where Leyland most likely saw it.[18] Leyland stepped in at this critical moment, with a commission for two paintings in the same vein as *Symphony in White, No. 3*. One of the paintings has not been identified, but the other is the famous work known as *The Three Girls*, which would have been the next in the series of paintings of women in white.[19]

The Three Girls was to have been Whistler's masterpiece: the summation of the redirection of his art and the expression of his aesthetic ideals over the past several years. The work is known today through oil studies, verbal descriptions of the work at various stages, and a fragment of the nearly completed work.[20] One study, *The White Symphony: Three Girls* (fig. 90), which depicts three women in filmy "classical" dress on a balcony tending a potted flowering plant, represents most closely Whistler's intentions for his magnum opus.[21] It is part of a group with five other related works from the period, similar in style, subject, and dimension, that have become known collectively with *The White Symphony* as the Six Projects, thought to be Whistler's first attempt at a decorative series.[22] The subject matter of the paintings—women in loosely draped fabric, some in poses reminiscent of the Parthenon Marbles and Hellenistic Tanagra figurines, some carrying Japanese parasols and fans—alluded to art as a form of pure beauty that exists for its own sake. The Projects brought together in a creative synthesis the artistic traditions from which Whistler drew inspiration. The use of the word "Symphony" in the title of his oil study *The White Symphony: Three Girls* and in several other panels that make up the Six Projects, perhaps initially prompted by Leyland himself, links painting with music in the manner of Baudelaire's *correspondances*.[23]

Whistler continued to work on *The Three Girls* periodically up through the completion of the décor of Leyland's Peacock Room in 1876, in which a prominent place had been set aside for the work. He scraped it down again and again; despite having secured the approval of his patron at various points, he could not meet his own high standards. As Mrs. Whistler commented astutely in a letter of 1869 to Leyland, "He has only tried too hard to make it the perfection of Art."[24] Whistler's ongoing endeavor to realize this aim in *The Three Girls* forms the backdrop to his portrait of Frances Leyland.

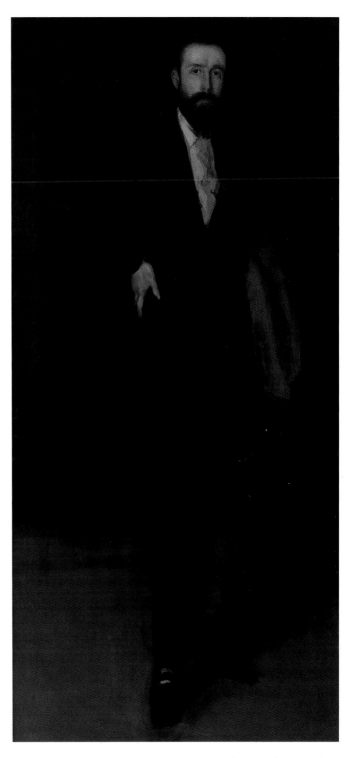

89 *Arrangement in Black: Portrait of F. R. Leyland*, 1870/73, oil on canvas, 75⅞ × 36⅛ (192.8 × 91.9), Freer Gallery of Art, Smithsonian Institution, Washington, D.C., Gift of Charles Lang Freer (YMSM 97)

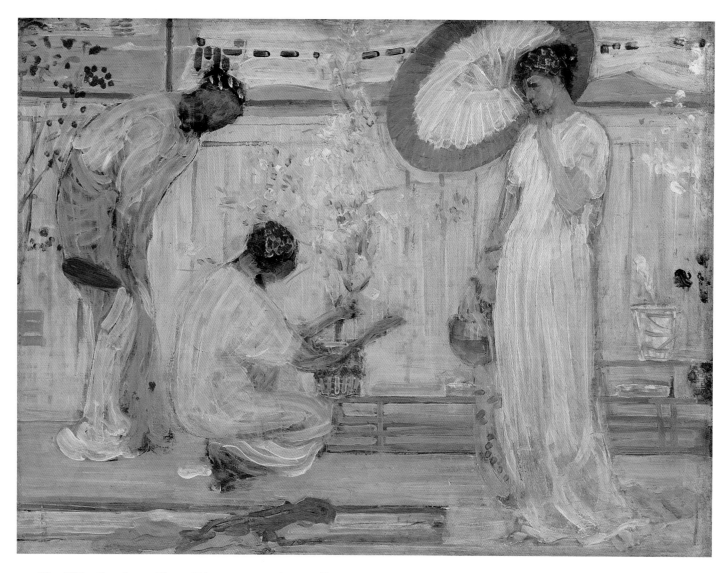

90 *The White Symphony: Three Girls*, c. 1867, oil on millboard mounted on panel, 18¼ × 24¼ (46.4 × 61.6), Freer Gallery of Art, Smithsonian Institution, Washington, D.C., Gift of Charles Lang Freer, 02.138 (YMSM 87)

WHISTLER AND FRANCES LEYLAND

Mrs. Leyland was the liaison between Whistler and his patron, as well as the painter's confidante and muse. Whistler, in turn, provided her with companionship, amusement, and relief from her hard-driving, difficult husband. The artist's letters to her during the years he was connected with the family reveal his affection for her. "What shall I tell you of this dreary waste they call London—You seem to have carried away with you not only the life and the joy of the place but even the sun too—..." Whistler wrote to Mrs. Leyland in August 1871.[25] There is no evidence that they were lovers, but their

close relationship prompted gossip. Elizabeth Pennell noted: "People talked about her and Whistler, went so far as to say she was going to elope with him, which was absurd, as if she would! Though she didn't say that if she had been a widow then she mightn't have married him."[26] Strains in the Leylands' marriage, which ended in divorce in 1879, were already apparent in the early 1870s, when Whistler was their "never ending guest."[27]

It was on Whistler's first extended trip to Speke Hall in the fall of 1869, in the company of his mother, that Leyland commissioned him to paint portraits of himself and his family, perhaps to distract the painter from his anxiety over completing *The Three Girls*.[28] (He completed three of them,

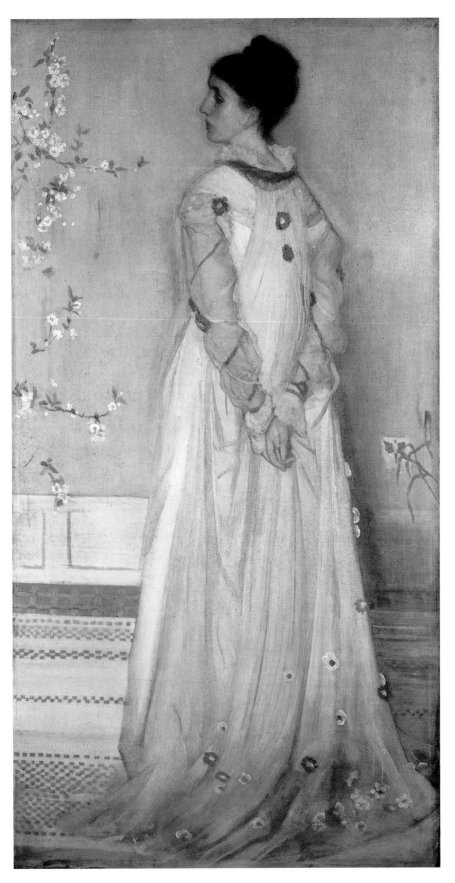

91 *Symphony in Flesh Colour and Pink: Portrait of Mrs Frances Leyland*, 1871–74, oil on canvas, 77⅛ × 40¼ (195.9 × 102.2), The Frick Collection, New York, 16.1.133 (YMSM 106)

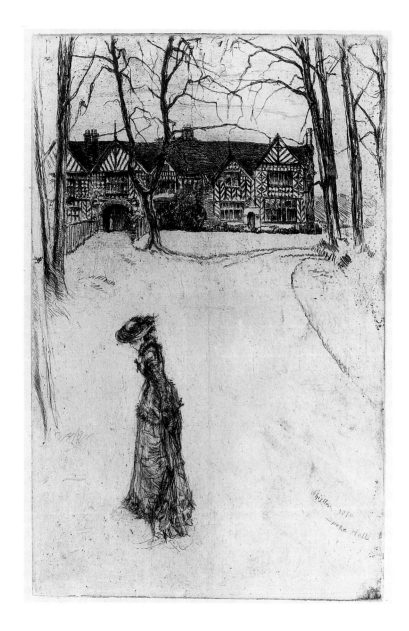

92 *Speke Hall, No. 1*,
1870–75, etching, plate:
8⅞ × 5⅞ (22.5 × 14.9), sheet:
13¼ × 8⅛ (33.7 × 20.7),
The Metropolitan Museum of
Art, New York, Harris
Brisbane Dick Fund, 1917,
17.3.66 (K. 96, VII)

of Mr. Leyland, of Mrs. Leyland, and of their eldest daughter, Florence.) In *Arrangement in Black: Portrait of F. R. Leyland* of 1870/73 (fig. 89), Whistler depicted his patron as an aesthete in elegant black evening clothes in a dark atmospheric space, drawing inspiration from Velázquez—an artist both men admired.[29] The challenge of capturing the likeness of a figure standing directly before him, and the example of Velázquez, helped to free Whistler from his creative paralysis of the late 1860s. In the early 1870s he completed several major portraits—the black portraits of Leyland and Helen Ogilvy Huth (the wife of an early London patron, see fig. 37) and the emotion-laden portrait of his own mother in black and gray.[30]

In 1870 Whistler began one of his most beautiful and haunting etchings, entitled *Speke Hall*, carrying it through ten states.[31] A figure, generally considered to be Frances Leyland, appears in the foreground of the print, fashionably attired in a formal day dress with a train and a broad-rimmed hat (fig. 92). She is depicted from behind, small and alone, looking back at the imposing façade of Speke Hall in a winter landscape.[32] The etching sounds notes that are developed in his oil portrait of Mrs. Leyland. The canvas, however, appears to have drawn Whistler back into the issues that had absorbed and enmeshed him in *The Three Girls*. It may well be that he was now attempting to resolve these issues in the portrait of one specific woman,

while continuing to work on the decorative painting. He would thus clear his debt to Leyland and elevate Leyland's wife to the role of muse—both as an embodiment of beauty and as a recognizable person—while also presenting her, like her husband, as a fashionable figure in contemporary society. No element of this complex undertaking could be left to chance, especially the all-important matter of the dress.

THE PORTRAIT OF FRANCES LEYLAND

In a letter of November 3, 1871, Whistler's mother noted to her sister Kate Palmer, "Mrs. Leyland writes me that she thinks that the full-length Portrait he has begun of herself will be as lifelike as she is sure mine is!"[33] Beyond this point, however, there is little firm evidence on which to establish a chronology of the development of the painting, which was first exhibited publicly in June 1874.

Whistler remained at Speke Hall into March 1872, and he continued his work on the two portraits at Lindsey Row; the Leylands were then in London for the "season." Frances came to the studio nearly every day. While posing was for Leyland, as he put it, "my own martyrdom," for his wife it was clearly a pleasure: she told Elizabeth Pennell that "she herself didn't mind, she didn't get tired, and she knew that Whistler liked to have her stand because he always talked to her freely, told her all his troubles and looked to her for sympathy."[34]

Whistler had hoped to meet the April deadline for submitting the two portraits to the Royal Academy exhibition. However, "the beautiful life-sized portrait of Mrs. L.," as Anna Whistler noted in a letter of March 12 to her sister, was nowhere near finished when the deadline arrived.[35] (Whistler was represented instead by the portrait of his mother.) Given that Whistler was far enough along with Frances's portrait to consider exhibiting it at the Academy of 1872, it seems reasonable to conclude that there had to have been a dress, perhaps made in Liverpool, for Frances Leyland to pose in at this point. The Pennells state clearly: "[Whistler] designed the dress in her portrait, white and rose chiffon with rosettes scattered here and there...."[36] They also note that Mrs. Whistler was in the studio to receive Frances and help her with her toilette, indicating that she was posing in the dress in the Chelsea studio.[37] Some thirteen undated elaborate pastel studies by Whistler —several of which were exhibited during his lifetime— document the design process, which will be explored later in this essay.

Other factors, however, suggest that the design of the dress was still in process when Whistler returned to London in March 1872. It could only have been after she began to pose in Chelsea that Mrs. Leyland would have seen Helen Ogilvy Huth standing for her portrait in a black velvet gown, and teasingly told Whistler that she wanted to be painted in similar dress.[38] (Both women posed between 1872 and 1874.) Perhaps to appease her, Whistler did, in fact, carry out an etching showing her in a velvet dress. In a beautiful, spare drypoint entitled *The Velvet Dress* (1870–73), she stands in profile in a full, heavy gown, whose prominent, ruffled collar gently cradles her face (fig. 93).[39] However seriously the artist may, or may not, have entertained the idea of painting Mrs. Leyland in such a dress, his interest in creating a visual harmony of sitter, gown, and setting took priority. The background of some

93 *The Velvet Dress*, 1870–73, etching, plate: 9³⁄₁₆ × 6³⁄₁₆ (23.3 × 15.7), sheet: 12¹⁄₈ × 8³⁄₁₆ (30.8 × 20.8), The Metropolitan Museum of Art, New York, Gift of Miss G. Louise Robinson, 1940, 40.3.1 (K. 105, IV)

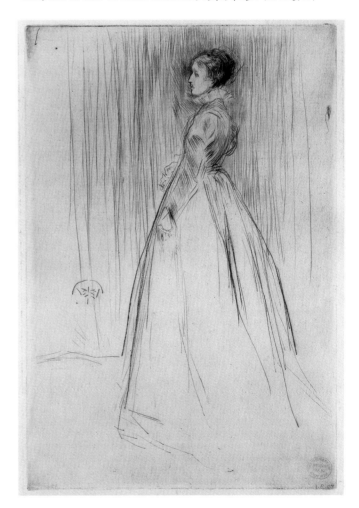

of the drawings for Frances's portrait contain hints of the pink wall in Whistler's drawing room at Lindsey Row, the setting that appears in the portrait.[40] Since the drawings are part of the design process for the dress, the references to the room suggest that the costume was still in flux when Whistler returned to Chelsea with the portrait in the spring of 1872. This possibility is supported to some extent by another statement made by the Pennells: "Mrs. Leyland stood in the flesh-colour and yellow drawing room and he designed her gown to harmonize with it. . . . Every room was an arrangement and every sitter had to fit in."[41]

Frances became ill during the summer of 1872, and progress on the portrait was interrupted. Whistler resumed work in 1873, intending to show it at the Academy that year. It may have been during this period that, as the Pennells reported, his model Maud Franklin occasionally posed in the dress when Frances could not come "so he could paint the draperies."[42] In a process all too familiar from his work on *The Three Girls*—which was still under way—Whistler exhibited the same obsessive behavior, constantly reworking and scraping down the canvas, just at a point when, in the sitter's view, one more session would have completed it.[43] The painting was still unfinished at the turn of the year. Whistler wrote to her on New Year's Day:

> The thought of your portrait is upon me! Well do I remember the persevering kindness with which you so patiently bore the fatigue of those many tiring days!—How can I ever thank you!—And I am now so unhappy to know that the work itself is not worthy of the weariness it caused you—It should have been so beautiful! Do you know that I sometimes dare to hope that still it may be saved—The strange little something, that stands between a master-piece in its perfection, and failure, might at any moment yield—and a mornings work bring with it the bright life that is now smoldering with in—So lovely is the conception, too! Ah well! Believe me though my dear Mrs. Leyland it is not only selfish glorification or ambition that still frets me in my disappointment—It would have been my pride to in some measure through my work thank the kind hostess who has I fear been often vexed by the waywardness & tiresome eccentricities of a never ending guest![44]

* * *

THE DRESS: THE FASHION CONTEXT

The new form-fitting dresses with bustles and abundant trimmings that emerged in the 1870s, as Ribeiro described in Chapter 2, would have been against the grain of the aesthetic ideals of naturalness, simplicity, and truth that Whistler had embraced. The influence of Pre-Raphaelite artistic dress on Whistler was already apparent in his series of paintings of women in white in the 1860s.

Women associated with Pre-Raphaelite artists as wives and models, many of them painters, actresses, and literary women, including patrons of the arts, occasionally wore the new mode of artistic dress.[45] As the wife of Whistler's and Rossetti's patron and Whistler's frequent companion, Frances was connected with this elite group.[46] Whistler signaled this through the dress he designed for her, adapting

94 Dante Gabriel Rossetti (1828–1882), *Monna Rosa (Portrait of Frances Leyland)*, 1867, oil on canvas, $68^{5}/_{8} \times 53^{5}/_{16}$ (174.2 × 136), private collection

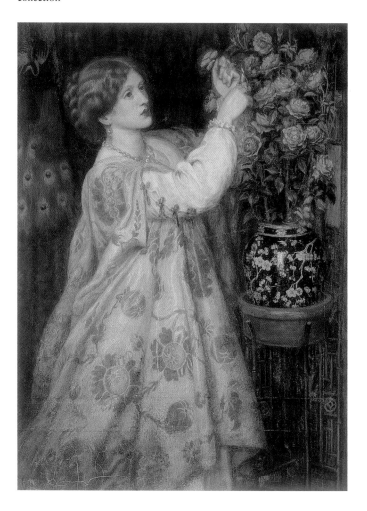

Pre-Raphaelite ideals of dress to his own aesthetic interests. One work that Whistler would have known well, and undoubtedly sought to surpass in his portrait, is a painting by Rossetti entitled *Monna Rosa* (fig. 94) depicting a richly garbed woman with flowers. Leyland commissioned this painting in 1867, and the model was Frances Leyland.[47] In the painting, Rossetti appears to have transformed her features to resemble more closely the Pre-Raphaelite type, with full lips, a long curved neck, and thick, heavy hair— a look epitomized by Jane Morris (see fig. 83). Frances Leyland's auburn hair is elaborately coiffed in waves and a braided chignon. She wears a heavy gold necklace, earrings of an antique design, and an improvised, flowing robe made of rich brocade over a white shift. Exotic decorative objects in the background set off her beauty in a painting that is more of an allegory than a portrait.[48]

Nevertheless, Rossetti's gemlike work would have served as a challenge for Whistler: he could do no less than paint her in a costume and setting of his own creation. The gown that Whistler would design for Frances, in fact, has affinities with the robe she wears in *Monna Rosa* in its unstructured form. In other respects, however, Whistler's portrait differs distinctly from the earlier representation of the sitter. The Pre-Raphaelite's highly finished realism, strong color contrasts, and material opulence are countered by Whistler's broad manner of painting, subtle, monochromatic tonalities, and simplicity. The gown and décor in the Whistler portrait are subordinate to the harmony of the painting as a whole and to the unadorned beauty of the sitter with her introspective expression. Frances wears no jewelry, and her hair is arranged in a contemporary, everyday style. Furthermore, the type of garment he designed for Frances—a tea gown—was up-to-date.

At the time Whistler painted the Leyland portrait, the tea gown was new to the Victorian woman's wardrobe, gaining popularity in the late 1870s and having its heyday in the last two decades of the nineteenth century. A magnificent example in peach-colored silk made by Liberty & Co. in 1891 is in The Metropolitan Museum of Art (fig. 95). The origin of the tea gown is not entirely certain, but it is generally believed to be derived from the French *peignoir* or

95 Tea Gown, 1891, Maker: Liberty of London, pale pink and white China silk, embroidered in pink silk floss, The Metropolitan Museum of Art, New York, Gift of Mrs. James G. Flockhart, 1968 (CI 68.53.9)

robe d'intérieur with which it shared a loose shape, soft lines, and often a train.[49] In as early as 1873 Watteau pleats and a loose center front panel appeared in gowns labeled *robe d'intérieur* and became standard features of the tea gown, often mixed with other revival styles.[50] In England in the 1870s, the tea gown developed from a house robe, or negligee, into a sophisticated form of hostess gown worn over a light corset for receiving intimate friends.[51] The relative looseness of the garment, and the ease of disrobing it afforded, associated the tea gown in the 1870s with loose morals;[52] it was typically worn in the late afternoon, during the famous five to seven when lovers met.

A painting of the period which featured a young woman in a *robe d'intérieur* is Manet's *Young Lady in 1866 (Woman with a Parrot)* (fig. 96). It was shown privately to Manet's friends in his studio and exhibited the following year in his solo exhibition at the Pont de L'Alma. Whistler was in Paris in 1867 for the International Exhibition and would have seen his friend's show. In *Woman with a Parrot*, the auburn-haired Victorine Meurent, accompanied by her parrot (the symbol of a confidante), wears a pink satin gown, which, in its loose shape, glossy fabric, and color evokes the style of dress seen in Watteau's paintings. Émile Zola noted that the garment "succinctly characterizes the innate stylishness of Edouard Manet."[53]

Manet, along with the critics Théophile Gautier and the Goncourt brothers, was at the forefront of the revival of Watteau that began in the Romantic period and grew throughout the century. By the 1860s Watteau had earned a place in the pantheon of French masters; fourteen of his paintings entered the Louvre through a bequest from La Caze in 1869. As part of the general revival of rococo art and new appreciation of Watteau, a vogue for Watteau-inspired dresses had begun to appear in the fashion periodicals of the later 1860s in France. Thus Victorine in her Watteau gown is indeed stylish and up-to-date—a "Young Lady in 1866"—as the painting was originally titled.

Like Manet, Whistler also interacted creatively with rococo art and the work of Watteau in figure paintings and decorative pieces in the 1860s.[54] The Watteau style in fashion, however, was not fully established in England at the time that Whistler was painting his portrait of Frances Leyland.[55] Whether Whistler drew directly from Watteau's art or from the emerging fashion for Watteau-style dresses in France is a matter of debate.[56] Most likely he took from both. The affinities between the two auburn-haired beauties wearing voluminous pink gowns suggest that Manet's depiction of Victorine Meurent may figure among

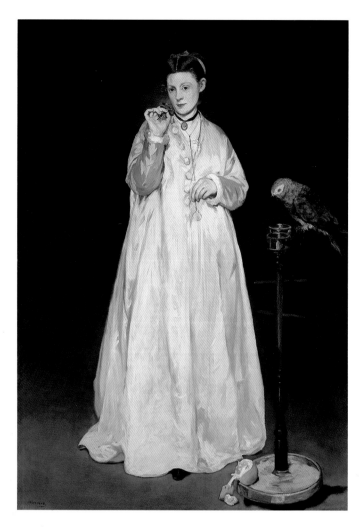

96 Édouard Manet (1832–1883), *Young Lady in 1866 (Woman with a Parrot)*, 1866, oil on canvas, 72⅞ × 50⅝ (185.1 × 128.6), The Metropolitan Museum of Art, New York, Gift of Erwin Davis, 1889, 89.21.3

Whistler's sources for his portrait of Mrs. Leyland. Or, both artists may have been responding to the same artistic currents, blending the *grand luxe* of the ancien régime with modernity in a style that was both contemporary in its unstructured form and reminiscent of a bygone era of elegance and refinement.

The tea gown slipped ambiguously between the areas of formal and informal wear and was open to invention and fantasy in its design. Whistler's gown for Frances Leyland, with its loose shape, pliable material, pastel color, and fusion of historical references fits in with the early tea gowns of the 1870s. Both ultrafeminine and refined, it also carried with it suggestions of intimacy. To clothe an important client, the wife of his patron no less, in attire for private use in a full-length formal portrait was a daring,

unexpected gesture.[57] In contrast to the tightly laced fashion extravaganzas of the Victorian period that compartmentalized and exaggerated the parts of the female body, Whistler's flowing gown, and the pose from behind, render Frances Leyland essentially bodiless.

THE EVOLUTION OF THE DRESS: THE DRAWINGS

Whistler's working drawings for the dress show his assimilation of different styles that served as raw material for his design.[58] A number of the studies are distinctly designs for the dress on a mannequin or model showing the garment from different points of view. Other drawings depict the sitter herself in different poses and variations of dress. As the drawings are undated, the order in which they were executed cannot be determined with certainty.[59]

Group 1

Two drawings, *Study of Mrs Leyland* (fig. 97) and *Study for "Symphony in Flesh-colour and Pink: Mrs F. R. Leyland"* (fig. 98) are drawn on coarse brown paper in pink and white pastel with accents of orange on the rosettes, fan, and hair. The featureless figure is outlined in delicate black

97 *Study of Mrs Leyland*, 1871/74, chalk and pastel on brown paper, 10⁷/₁₆ × 6⁷/₈ (26.5 × 17.4), Freer Gallery of Art, Smithsonian Institution, Washington, D.C., Gift of Charles Lang Freer, 05.157 (M. 430)

98 *Study for "Symphony in Flesh-colour and Pink: Mrs F. R. Leyland,"* 1871/74, chalk and pastel on brown paper, 10⁷/₁₆ × 6¹⁵/₁₆ (26.7 × 17.6), Freer Gallery of Art, Smithsonian Institution, Washington, D.C., Gift of Charles Lang Freer, 05.156 (M. 431)

lines, and the pastel is applied thickly. In the elongation of the figure and its linear, stylized form, these drawings resemble sketches for theatrical costume. They are similar in size and style and show the dress from the front and in profile, facing right, respectively, and were most likely carried out at the same time.

This design is the most "classical" in concept in these working drawings, recalling the garb seen in the Six Projects. The skirt falls in regular, vertical folds. The material appears heavier than in the oil painting. In the front view, the drapery of the bodice is arranged in loose imitation of a Greek tunic. (A sketch of a Greek tunic, probably from a source in antique art, appears to the right of the figure in profile view.)[60] Whistler also tries out a wrapped form of the sleeve, as seen in the detail in the first sketch.

Adjustments are made to the dress shown in the profile view. Here the sleeves are gathered into horizontally banded puffs in a modern style that looks back to sixteenth-century examples. Whistler has added to the dress a long flowing Watteau pleat that falls from just below a standing, ruffed Medici-type collar to the ground. A French fashion commentator of the period noted that by 1879 *le style Watteau* vied with *le style grec* as the dominant influence of the 1870s; Whistler's gown, which draws freely from both traditions, is thus up-to-date, possibly ahead of its time.[61] Whistler also borrowed not only from the classical style and eighteenth-century dress but also from other traditions. The delicately wrapped transparent sleeves of the dress, bound with ribbon, recall the type of sleeve seen in Botticelli's paintings, such as the famous *Primavera* in the Uffizi, Florence; the Italian master was greatly admired by the Pre-Raphaelite circle and by Frederick Leyland.[62]

Group 2

Five drawings—*Mrs Leyland, Standing, Holding a Book; Study for "Symphony in Flesh-colour and Pink: Mrs F. R. Leyland"; Mrs Leyland, Standing, Head Turned to the Front; Mrs Leyland Seated,* and *Mrs Leyland, Standing Holding a Fan*—are among the most realistic and detailed of the sketches, depicting a more elaborate gown than the dress in the painting. *Mrs Leyland, Standing, Holding a Book* (fig. 99) is rendered in flowing lines in chalk, with strokes of pastel in off-white, orange, and brick-red.[63] Whistler's use and handling of pastel in this and other drawings for the dress provide further links between the costume at its inception and Watteau, a master of the medium.[64] The costume can now be read as consisting of a

99 *Mrs Leyland, Standing, Holding a Book*, 1871/74, chalk and pastel on brown paper, 11⅛ × 7¹/₁₆ (28.2 × 18), Freer Gallery of Art, Smithsonian Institution, Washington, D.C., Gift of Charles Lang Freer, 08.196 (M. 437)

princess-line overdress with a high-standing ruffed collar and banded puffed sleeves, a looped-up skirt in an eighteenth-century style known as a *polonaise*, and a detachable Watteau pleat. The lightness and transparency of chiffon are suggested in Whistler's delicate strokes. The greater clarity of the parts of the dress and the figure's expression of absorption in her reading imply that this drawing was made from a model posing, perhaps Mrs. Leyland herself. The artist appears to have been in the process of arranging component parts of the costume to his satisfaction while working out the pose.

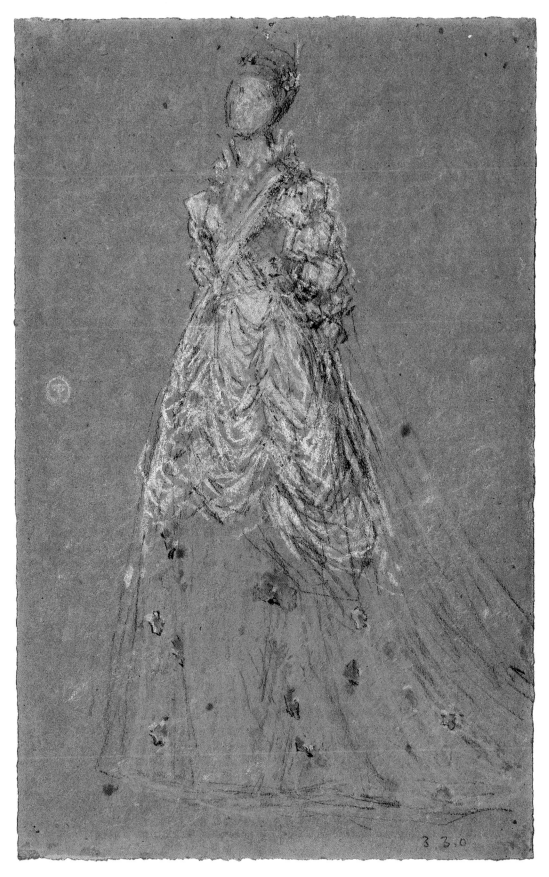

100 *Study for "Symphony in Flesh-colour and Pink: Mrs F. R. Leyland,"* 1871/74, chalk and pastel on brown paper, $11^5/_{16} \times 7^3/_{16}$ (28.8 × 18.2), Amon Carter Museum, Fort Worth, Purchase with funds provided by the Council of the Amon Carter Museum, 1990.9 (M. 433)

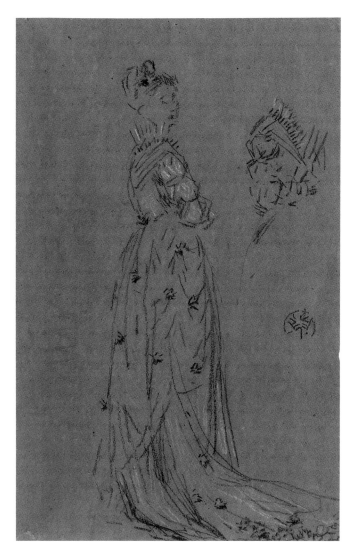

101 *Mrs Leyland, Standing, Head Turned to the Front*, 1871/74, chalk and pastel on brown paper, 11³/₁₆ × 7⅛ (28.3 × 18.1), Freer Gallery of Art, Smithsonian Institution, Washington, D.C., Gift of Charles Lang Freer, 08.197 (M. 438)

102 *Rosettes*, 1871/74, chalk and pastel on brown paper, 11¼ × 7¼ (28.5 × 18.5), Fitzwilliam Museum, Cambridge, PD 72-1959 (M. 435)

An elaborate drawing, *Study for "Symphony in Flesh-colour and Pink: Mrs F. R. Leyland"* (fig. 100) develops the design further in a dress in delicate shades of lemon, orange, pink, and light red. This drawing is thought to represent the front view of the garment depicted in *Mrs Leyland, Standing, Holding a Book*. In it, Whistler was exploring ways of draping the skirt, harking back to the eighteenth century. Here the skirt is pulled up in regular folds.

Alternatively, an overskirt could be caught up in an asymmetrical fashion by ribbons or flowers, as seen in *Mrs Leyland, Standing, Head Turned to the Front*, where the Watteau pleat has been removed, and rosettes mark the

places the fabric is secured (fig. 101). To the right of the figure in this drawing, Whistler sketched a detail of the bodice of the dress with a banded sleeve in a sixteenth-century style. Here the pose is close to the position of the figure in the painting, but in reverse. Whistler also devoted two drawings to the design of the rosettes for fabrication in three dimensions (fig. 102); they appear as a decorative motif throughout the studies, varying in position on the dress from one sheet to another, and they figure prominently in the oil portrait.[65]

In a magnificent pastel and chalk drawing, *Mrs Leyland Seated* (fig. 103), Whistler continues to experiment with the placement of the rosettes, here touched in tones of orange

103 *Mrs Leyland Seated*, c. 1871, chalk and pastel on brown paper laid down on card, 11⅜ × 7⁵⁄₁₆ (28.9 × 18.6), Carnegie Museum of Art, Pittsburgh, Andrew Carnegie Fund, 06.12.6 (M. 429)

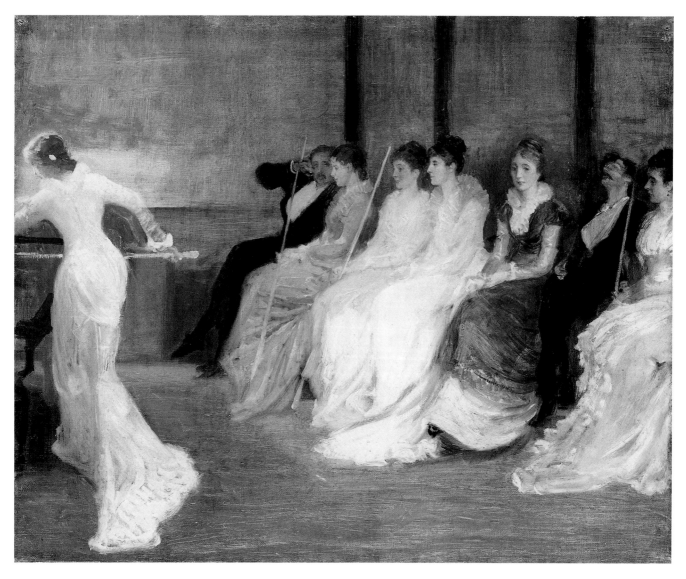

104 British School, *J. McN. Whistler and the Family of F. R. Leyland at Speke Hall*, c. 1873, oil on canvas, 42^{13}/$_{16}$ × 63$\frac{1}{2}$ (108.7 × 161.3), Board of Trustees of the National Museums and Galleries on Merseyside, Walker Art Gallery, Liverpool, WAG 9524

and light red, and attached in diagonal lines across the skirt. This and one other sheet are the only drawings that show the figure seated, a pose perhaps momentarily considered for the comfort of the sitter.[66] The naturalness of the pose and the fall of the drapery in this drawing suggest the presence of a body underneath the dress, while others have the more abstract quality of a fashion plate.[67]

In addition to drawing on the emerging eighteenth-century style, Whistler also incorporates aspects of contemporary fashion. His designs for Mrs. Leyland's dress are similar in mood to the historically inspired dresses of contemporary fashion, with their draped overskirts and

standing ruffed collars, as seen in a charming genre scene by an anonymous artist, *J. McN. Whistler and the Family of F. R. Leyland at Speke Hall*, of about 1873 (fig. 104).

In *Mrs Leyland, Standing Holding a Fan* (fig. 105), the figure is depicted strictly from the back, a stance occasionally used in fashion photographs and fashion plates to highlight the elaborate treatment of the back of the dresses of the period. The focus in this drawing is again on the Watteauesque train, which falls from shoulders to the floor and curves left. The rosettes are scattered randomly in the hem of the dress, as they are in the painting. At the left, we see indications of the blossoming almond branches that cut

105 *Mrs Leyland, Standing Holding a Fan*, c. 1871/74, chalk and pastel on brown paper, 11⅝ × 7 (28.7 × 17.8), Freer Gallery of Art, Smithsonian Institution, Washington, D.C., Gift of Charles Lang Freer, 08.195 (M. 432)

into the painting, indicating that at this point Whistler was considering the pose, dress design, and setting as a whole.

None of the drawings discussed so far shows the actual pose, with hands clasped behind her, that Frances assumed in the portrait, a pose that she later told Elizabeth Pennell was natural to her.[68] However, on the verso of an elaborate pastel drawing for the portrait of Mrs. Huth is a lightly sketched headless figure seen from behind in a flowing gown decorated with rosettes with hands clasped behind.[69] This sketch appears to be a study for Mrs. Leyland's gown, which may have been drawn after the dress was fabricated

and while Whistler was perfecting the pose.[70] In the oil portrait, Mrs. Leyland's pose injects something of her personality and graceful bearing.

A superb half-length drawing, *Mrs Leyland Seated*, though not related to the oil, is the one actual portrait drawing that Whistler made of his patron and friend (fig. 106).[71] Mrs. Leyland is depicted in profile, facing left, wearing a small hat trimmed with flowers and ribbons that fall down her back. Whistler picked out the ruffed collar of her bodice and the ruff at her cuffs with white chalk; the rest of her costume dissolves into energetic, summary lines. The focus is her fine profile and gentle, wistful expression, which is not only in her facial features but in her posture. Far from a formal arrangement, this sketch goes directly to the inner being, capturing her mood in a combination of carefully drawn and exceptionally free strokes of chalk.

In two other related pastel drawings, Whistler depicts a standing figure holding a fan and wearing a dress close in style to the designs for Mrs. Leyland's gown, although the banded sleeves are here puffed at the shoulder. In *Study for a Dress* (fig. 108) a pink gown accented with blue is adorned with rosettes—a large one at the waist and smaller ones trailing down the skirt. In *Two Standing Figures* (fig. 107), Whistler depicts the figures side by side in different positions, experimenting with color—warm orange and cream in one and cooler tones of pink and blue in the other—and with the treatment of the overskirt. Whether these drawings belong to the group of costume studies for the portrait of Mrs. Leyland, with which they have obvious affinities, or are studies for another portrait of the period, is not known.

Another magnificent sheet (*Girl with a Fan*, fig. 109) that forms part of a group of contemporaneous chalk drawings depicting young women shown from the back with long hair and holding a fan—possibly one of the Leyland daughters—is also closely connected with the drawings for Mrs. Leyland's portrait. The dress in this drawing, though simpler, shares with the designs for Frances's gown flowing lines, a train, loosely banded sleeves, and a historicizing quality. The artist's attention to the details of costume, the texture of fabric, and the figure's graceful bearing, as well as his mastery of execution, belie the intensity of his focus at this time on the expressive aspects of dress and pose.

* * *

106 *Mrs Leyland Seated*, 1873/75, chalk and pastel on brown paper laid down on card, 11 × 7¹/₁₆ (27.9 × 18), Hunterian Art Gallery, University of Glasgow, Birnie Philip Gift (M. 549)

107 *Two Standing Figures*, c. 1872, chalk and pastel on brown paper, 11⅛ × 7¼ (28.3 × 18.5), private collection, New York
(M. 464)

108 *Study for a Dress*, 1872/76, pastel on brown paper, 9³/₄ × 3³/₄ (24.8 × 9.5), private collection, London (M. 465)

THE DRESS IN THE PORTRAIT

The details of the costume and historical sources, seen clearly in the drawings, are synthesized in the oil into a simpler style in keeping with Whistler's aesthetic taste. Certain salient details, however, such as the rosettes, the beribboned sleeves, the standing collar, and the Watteau train are carried over directly. The dress we see in the painting may consist of three parts: a white chemise or shift worn next to the skin; a white sleeveless underdress with a ruffed collar and a fichu or scarf over the shoulders; and the gown with its loose back in pink chiffon with trans-

parent sleeves, although as Aileen Ribeiro has noted in Chapter 2, the parts of the garment cannot be read clearly from the painting.

With no extant photograph of the actual dress, it is impossible to know how much Whistler continued to modify the design in the long process of painting, scraping down, and repainting. Once made, the dress became a pictorial element in the design of the painting as a whole. In the oil painting, the Japanese element assumes greater importance than in the drawings. The Watteau pleat, suspended from a mulberry-colored collar, is pulled down, and the back of Mrs. Leyland's neck is exposed. In Japanese dress, the back of the neck—considered an erogenous zone—is often revealed.[72] Whistler had frequently depicted Western women in kimonos in the 1860s, exotic garments quickly adopted in Europe as *robes de chambre* or tea gowns. In the final form of Mrs. Leyland's dress, a Japanese element appears more as an inflection, perhaps added to inject an erotic note to the painting and to bring the figure into greater harmony with the décor of the room.

The portrait was set in Whistler's drawing room with its pink walls and the rush rug he designed.[73] The artist's taste for Japanese-inspired interior design manifested itself subtly and gracefully in his second home (into which he moved in 1867) and is revealed in the portraits he painted there. The minimal décor of the room in *Symphony in Flesh Colour and Pink*, for example, reveals Whistler's sophisticated application of *japonisme*. The uptilted floor of the room and the decorative almond branches cutting into the frame at the left of the portrait are further testaments to Whistler's assimilation of Japanese design principles absorbed from *ukiyo-e* prints.[74] The dress in its final version reflects a similar spirit of simplicity.

While Frances's dress synthesizes elements of Classical, French eighteenth-century, Renaissance, and Japanese dress, in the final form, the Watteau mode, associated with the tea gown, prevails. The *style Watteau* bestows a sense of grandeur and aristocratic grace on the subject, lifting her above bourgeois taste and placing her in a distinctly modern, although timeless, context. In stylish "artistic dress," Frances Leyland is the female counterpart to her aesthete husband, as luminous in her image as he is dark.

The softly nuanced color and diaphanous material of the dress must have been conceived by Whistler in its final form as the fabric equivalent of the painter's art; the garment seems to transcend its artistic and fashion sources and to rise, in part, from the process of painting itself. The dress translates with ease into Whistler's broadly applied layers of malleable oil paint and delicate brush strokes, as if he

109 *Girl with a Fan*, 1873/75, crayon and chalk on brown paper, 8³/₁₆ × 5⅛ (20.8 × 13.1), University of Michigan Museum of Art, Ann Arbor, Bequest of Margaret Watson Parker, 1954/1.226 (M. 533)

were, in the end, painting it on her, wrapping his subject in the sensuousness of his art, which appears as an extension of her—his unattainable feminine ideal. The seemingly unlabored, smooth application of layers of translucent

oil paint—attained at tremendous effort after continuous scraping down—works hand in hand with the simplicity, refinement, and flow of the dress's gossamer layers of chiffon. Evidence of industry in painting appeared to him "a blemish, not a quality; a proof, not of achievement but of absolute insufficient work, for work alone will efface the footsteps of work."[75] It was as much in his seemingly rapid technique of painting as in the style of the dress and décor that Whistler expressed his aesthetic ideals. With the effect of lightness and simplicity Whistler achieved in the design of a gown that glides over the body, and its fusion of historic references, he demonstrates as well an affinity with Baudelaire's notion of modernity. In his influential essay *The Painter of Modern Life*, the poet exhorted artists to extract "the mysterious element of beauty" contained in modern life: "By 'modernity' I mean the ephemeral, the fugitive, the contingent, the half of art whose other half is the eternal and the immutable."[76]

Embedded in the portrait of Frances Leyland by way of setting, pose, and costume is Whistler's intense, ambivalent relationship with his sitter. Her artistic garb may have been difficult to categorize by contemporary viewers; all, however, would have recognized it as a type of informal attire, worn only in the privacy of one's home. The dress signifies the privileged access of the painter to his subject's private world, yet the world represented in the painting is Whistler's own drawing room—not her own, nor the more neutral space of his studio. Like Jo Hiffernan in *The Little White Girl*, Frances Leyland is presented as integral to Whistler's world of art. Yet Mrs. Leyland is represented as unreachable, her back turned to the artist, gaze to the side, and absorbed in thought, a woman whom Whistler could only possess by means of his art. The painter's complex relationship with his subject, who inspired a fusion of art, fashion, and design, allowed him to attain in *Symphony in Flesh Colour and Pink* what he set out to realize in *The Three Girls*—"the perfection of Art."

The Artist as Model: Rosa Corder

Susan Grace Galassi

ROSA CORDER WAS ONE OF the most enigmatic women in Whistler's circle. An accomplished painter in her own right, she is remembered largely as the subject of one of his most beautiful portraits. In *Arrangement in Brown and Black: Portrait of Miss Rosa Corder*, the subject stands with her back to the viewer in a dark atmospheric space, wearing a black suit and holding a brown hat encircled by a brown ribbon and a long feather (fig. 111). Soft light focuses attention on her pale face turned in pure profile to reveal her straight nose, full lips, and strong chin. She looks to the right with an air of gravity. Her long brown hair is wound into two coils high on the back of her head in the fashion of the time—unwound, it was said to have touched the ground.[1] It is difficult at first to detach her from the shadowy surroundings.[2] Except for the white collar of her blouse and a shot of white along the edge of her open jacket, her figure is set off from the background by only subtle differences in tone and the curved shapes and texture of her fur-trimmed jacket and sweeping skirt. But the allure of a beautiful and stylish young woman "almost drowning in darkness," in the words of one observer,[3] draws the viewer in. Rosa's vigorous contrapposto stance, the angle of her uptilted head, and the dynamic lines of her attire convey vitality and self-possession, while the gesture of her left arm, bent at the elbow with her hand resting on her hip, contributes a note of assertiveness.

The portrait forms part of Whistler's ongoing series of some twenty black paintings executed between 1870 and the early 1890s, inspired in part by both Velázquez's dark portraits of the Spanish royal family as well as monochromatic Chinese painting. In his black portraits, Whistler pushed forward his search for greater purity of design and deeper connection with the inner spirit of his sitter.

The portrait of Rosa Corder has long been regarded as one of the artist's finest achievements. For the painter Sir William Rothenstein, it was "a triumph of unaffected ease."[4] Other commentators remarked on the serenity of the sitter: "It is one of the most noble feminine figures that one could encounter . . . the model, serious, almost grave, displays a quiet authority, a mild serenity."[5] The theater designer Graham Robertson, who owned the portrait for a period and came to know the sitter as well, described her as a person of "beautiful stillness."[6] But beneath the muted tones of the painting and the apparent serenity of the sitter was a vital, strong-willed person, while the circumstances surrounding the creation of the painting were anything but tranquil. One observer, who was unfamiliar with the subject, remarked to Robertson: "That woman's a horse-breaker."[7] He was not far wrong. Corder was in fact a

horsewoman and specialized in paintings of dogs and race horses, as well as portraits and copies of other artists' works.

Rosa Frances Corder was born on May 18, 1853, at 3 The Grove, Hackney, Middlesex, the fifth and youngest child of Micah Corder and Charlotte Hill of Peckham.[8] In the mid-eighteenth century, another Micah Corder had taken the tenancy of Feering Bury Manor House with several hundred acres in Feering, near Colchester, and the Corder family, most of whom were Quakers, remained there until 1928. Rosa's grandfather, however, left the Quaker faith for the Church of England. Her father entered the firm of Scott, Garnett and Palscar, London Bridge, in 1820 as a lighterman and eventually owned a wharf of his own, which bore his name. He was an amateur musician, and his interest in music most likely encouraged the artistic interests of his children. According to a family historian, Francis Corder Clayton, at the age of ten, Rosa and a sister and brother formed a Literary Society and wrote and illustrated their own novels. One sister, Charlotte, became a painter and an actress. An older brother, Frederick, was a noted musician and composer, serving later in life as vice director and curator of the Royal Academy of Music.

Rosa studied briefly in Boulogne but received most of her rather eccentric education at home. Clayton notes that Frederick taught her "mathematics, book binding, and organ building." By late adolescence, Rosa—seen here in a photograph (fig. 110)—had decided that she "must be a painter": she had two years of instruction from Felix Moscheles and took evening classes at the University of London.[9]

Opportunities for women in the field of art were expanding in the 1870s, as they were in many other professions. In the first book published on English women artists, which appeared in 1876, the author noted that it became necessary for many women "to adopt the profession as the means of acquiring an income."[10] The Slade School, founded in 1870, accepted both male and female students, and women could attend all but the life classes at the Royal Academy and show in the juried exhibitions, though they were barred from membership until the 1890s. Rosa, however, followed an earlier model of training for women: a patchwork of classes and an apprenticeship. Her lack of professional training may have been due to a change in her family's circumstances: in 1869 her father met with financial difficulties and was forced to retire.[11] Rosa, it seems, had to fend for herself.

Far more significant for Rosa's career than her education was the entry into her life in the early 1870s of the charis-

110 Photographer unknown, *Rosa Corder, c. 1870*. Photograph courtesy of Mr. and Mrs. Timothy J. Cockerill, Cambridge

matic con man Charles Augustus Howell, an Anglo-Portuguese of supposed aristocratic descent, and one of the great characters of the Victorian art world.[12] Howell ("the Owl") had been Ruskin's secretary, was agent for Burne-Jones and Rossetti, and would be Whistler's unofficial agent between 1876 and 1879. He was exceptionally well connected: "He introduced everybody to everybody else."[13] Most of these relationships ended disastrously, owing to some unscrupulous business dealings on Howell's part, but his roguish ways nevertheless inspired admiration. By 1873 Rosa was his mistress and maintained a relationship with Howell for the rest of his life, as well as with his wife (who apparently tolerated her husband's unconventional ménage) and children. Rosa stood by him through his many

upheavals and bore him a daughter. It was through Howell that she gained entrée into the magical circle of Chelsea artists. Indeed, it was Howell who commissioned her portrait from Whistler. For better and worse, Rosa's fate was inextricably linked with his. It has been suggested that she aided Howell in his nefarious activity as a facsimilist, or forger, an implication that may have colored her reputation—and undoubtedly added to its interest.[14] As one contemporary noted, "His influence upon her was terrible and far-reaching."[15]

Corder is first recorded as an assistant to Rossetti, Whistler's neighbor and friend on Lindsey Row (Cheyne Walk). In a letter of 1874 Rossetti commented to his brother-in-law, Ford Madox Brown:

> You were speaking of needing an assistant. I have lately met through Howell a young lady . . . a Miss Corder . . . of extraordinary talent . . . so remarkable that I mean to buy a portrait she has done of herself if she will sell it. She mainly maintains her family by such art as she can get . . . her father having gone down in the world. Her powers are very great, and I should think adaptable: but if you employed her, I should have to reserve the privilege of doing so also if I needed her, as I not improbably may.[16]

Howell reports her progress on a painting for Rossetti in a letter to him:

> [The painter Frederick] Sandys . . . met Rosie here and for a wonder of his own accord thought her the most remarkable girl he ever met and a very fine nature. He has given her two lessons in drawing . . . he has only tackled her on drawing and outline . . . no colour or modes or anything else of the kind. He says that if she is backed and helped for two years, she will be able to do anything.[17]

After Rossetti broke with Howell, Corder took up her lover's defense in a letter to Rossetti of March 23, 1876, from her studio in Russell Square, which also gives insight into her own situation and strong personality:

> I who have known wealth and poverty and the turning of old friends who lived entirely on my father for years, can tell, pe'rhaps better than outsiders, how far the man is one of the right sort. You are wrong about him, and everyone who does not see him clearly as I do is wrong. [He is] . . . Striving to aid me in name, work and reputation, and personal comfort, no matter how much he has been hampered and worried, as I know he has been.[18]

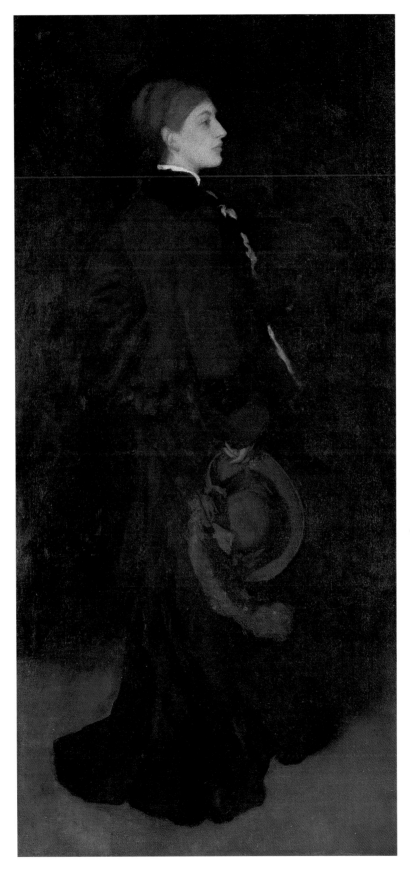

111 *Arrangement in Brown and Black: Portrait of Miss Rosa Corder*, 1876–78, oil on canvas, 75¾ × 36⅜ (192.4 × 92.4), The Frick Collection, New York, 14.1.134 (YMSM 203)

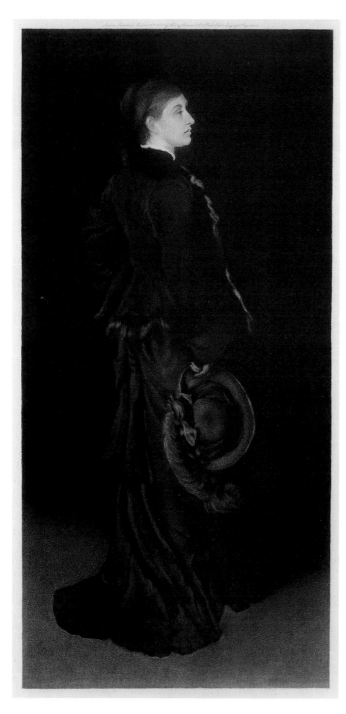

112 Richard Josey (1840–1906), after Whistler, *Arrangement in Brown and Black: Miss Rosa Corder*, 1880, mezzotint, image: 20¹⁵/₁₆ × 11³/₁₆ (53.2 × 28.4) The Metropolitan Museum of Art, New York, The Elisha Whittelsey Collection, The Elisha Whittelsey Fund, 1964, 64.614.10

According to Robertson, Whistler, who was fully aware of Howell's questionable business dealings, took on his commission to paint Howell's mistress "with little or no hope of payment." Undoubtedly, the appeal of the sitter's beauty was incentive enough. Rosa was twenty-three when she began to pose for her portrait at Lindsey Row in 1876; Whistler, at forty-two, was a highly public figure at the height of his powers. She later recounted to Robertson that she had "posed for it . . . some forty times, standing in a doorway with the darkness of a shuttered room beyond her; long sittings, lasting on two occasions until she fainted, and at last she had refused to go on with them." An artist herself, commented Robertson, she could see the painting was finished "and struck for freedom."[19]

On September 1, 1878, Whistler wrote to Rosa asking her for a sitting the next day: "I want to thank you for your kind endurance . . . the work is complete and an hour or two longer or less will entirely end the matter—I am charmed myself, and one of these days you will forgive me."[20] Whistler wrote to Howell on September 5 asking him to make arrangements as he hoped to finish the painting "right out of hand," and on the ninth Howell recorded in his diary that he paid Whistler 100 guineas for it.[21] (Whistler later recounted to Robertson that it was only after several months that he realized that Howell had paid him out of money he had lent him the week before.)[22] The canvas went to the firm of Henry Graves & Sons to be engraved by Richard Josey; Whistler hoped to make a profit from the sale of the mezzotint but was disappointed by the artistic and economic results (fig. 112).

According to the Pennells, Whistler is said to have arrived at the color scheme for the portrait of Rosa Corder when he saw her pass by one of the black doors of his studio in a brown suit.[23] (In the painting, however, the suit is black, while the hat provides the note of brown.) In choosing to depict Rosa in contemporary street wear, Whistler selected an identity for her as a modern urban woman, one of a new breed—artists included—who were making their own way in the working world.

It has been said that Rosa posed in riding habit, which her suit closely resembles and would seem appropriate for her, given her involvement with horses.[24] Whistler, in fact, portrayed women in equestrian garb in a number of works. In an early painting, *Harmony in Green and Rose: The Music Room* (1860), an "amazone" in black riding dress and hat, holding a crop, is boldly silhouetted against the colorful patterns of the curtains and dominates the other figures—a young girl in white (his niece, Annie Haden), seated, and her mother reflected in the mirror (fig. 113). In

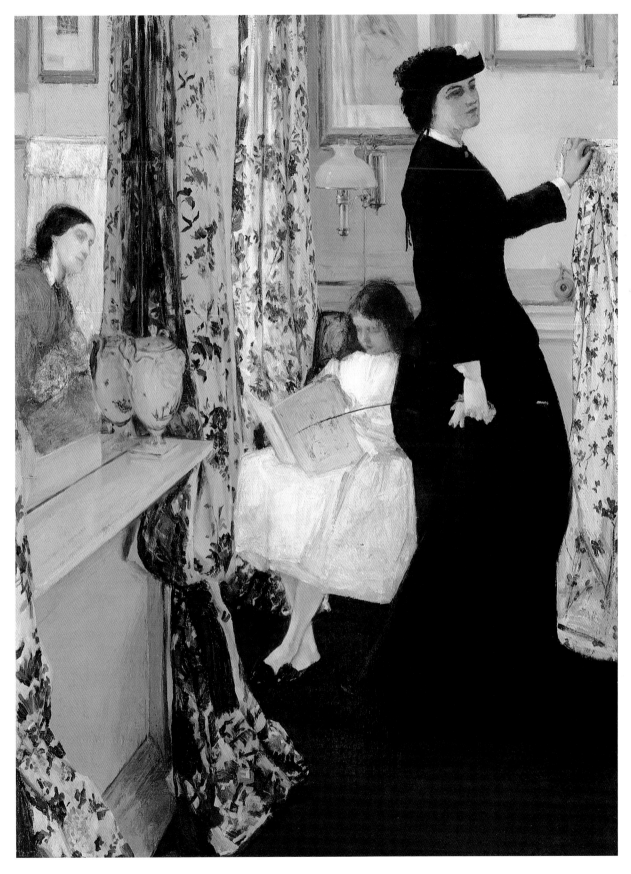

113 *Harmony in Green and Rose: The Music Room*, 1860, oil on canvas, 37⅜ × 27⅞ (95.5 × 70.8), Freer Gallery of Art, Washington, D.C., Gift of Charles Lang Freer (YMSM 34)

the early 1870s Whistler depicted May Alexander in riding habit at the request of her father.[25] In one of the drawings for the oil portrait (fig. 114), we see details of the habit, such as the buttons running along the front of the jacket, the pleats of the long flowing skirt, and her large brimmed hat. Details that identify the dress as riding habit, along with the riding crop she holds, however, disappear in the painting, where the dress becomes more generalized, as the figure, costume, and décor are harmoniously integrated.

In *Arrangement in Black, No. 8: Portrait of Mrs Cassatt* (1883–85), the artist insisted on riding clothes for an important American client (a sister-in-law of the painter Mary Cassatt), although she claimed she would have preferred to have been painted in evening dress.[26] Isolated against a plain black ground in black top hat and wearing

the new slender style of riding dress of the 1880s (the hunting enthusiast Empress Elizabeth of Austria had to be sewn into hers), the figure is imposing and austere.

It is hardly surprising that riding habit would have appealed to Whistler: the purity of black offset with white, its flowing lines, and its unadorned style were in keeping with his aesthetic principles. The habit was further enhanced by the provocative combination of aspects of male and female dress. Masculine tailoring, durable fabrics, and accessories adapted from menswear, such as the top hat, are set off in the short form-fitting jacket and long skirt of female riding attire, which reveal the natural lines of the body. The close connection with masculine dress, from which riding habit derived, had long provoked comment: "There is another kind of occasional dress in use among

114 *Study for "Portrait of Miss May Alexander,"* c. 1873, pencil and gray wash on cream paper, laid down on paper, 5 × 2⁹⁄₁₆ (12.7 × 6.8), The British Museum, London, 1958-2-8-3 (M. 499)

115 Riding Habit, 1876, detail from an unidentified fashion plate

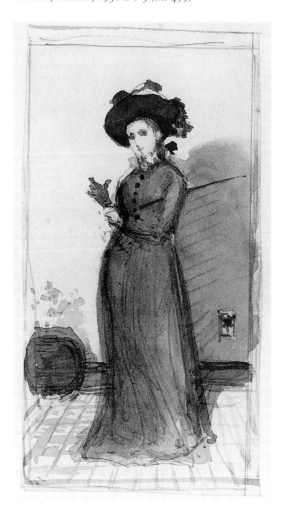

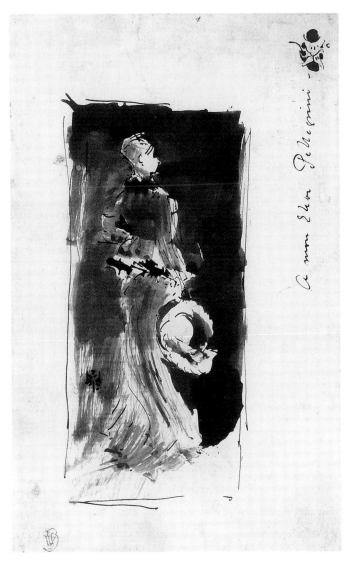

116 *Sketch after the portrait of Rosa Corder*, c. 1879, pen, brown ink, and wash on off-white laid paper, 7 × 4½ (17.9 × 11.3), The Art Institute of Chicago, Gift of Walter S. Brewster, 33.295 (M. 715)

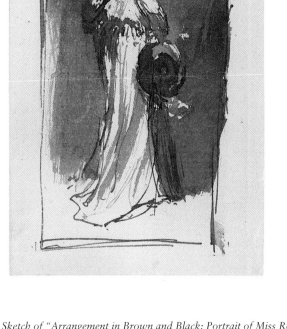

117 *Sketch of "Arrangement in Brown and Black: Portrait of Miss Rosa Corder,"* c. 1879, pen, brown ink, and wash on cream laid paper, laid down on paper, 5¾ × 3⁷⁄₁₆ (14.6 × 8.7), The British Museum, London, 1914-4-6-1 (M. 714)

the Ladies, I mean the riding habit, which some have not injudiciously stiled [*sic*] the Hermaphroditical, by reason of its Masculine and Feminine composition,"[27] commented a writer in the *Guardian* in 1713.

A woman in riding habit exuded vitality and boldness—she appeared stylish, yet remained outside the realm of fashion per se. Indeed, riding habit was traditionally made by male tailors, not dressmakers, as it continues to be today.[28] Baudelaire, in his essay *The Painter of Modern Life*, and Hippolyte Taine in his *Notes sur l'Angleterre* praised the elegance of women *en tenue amazone*.[29]

Whistler emphasized the affinity of riding garb with fashion, depicting his female equestrians in domestic interiors or neutral spaces.

Rosa's attire in her portrait echoes to some extent the riding dress of the period, as seen in a fashion plate of 1876 (fig. 115). The sleek black habit consists of a short form-fitting jacket, pulled in at the waist and molded over hips, and a skirt that is flat in front and gathered in simple pleats at the back of the waist, falling freely to the ground. A large, round hat trimmed with a feather completes the attire. The cut of Rosa's close-fitting short jacket and long

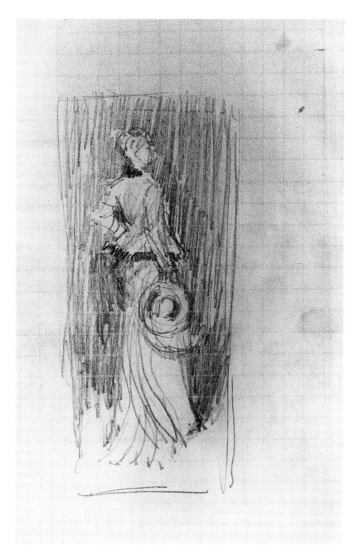

118 *Study of "Arrangement in Brown and Black: Miss Rosa Corder,"* c. 1879, pencil on pale blue, squared, wove paper, image: 6⅜ × 2⅞ (16.3 × 7.5), sheet: 8⁵⁄₁₆ × 5½ (21.2 × 13.9), The Baltimore Museum of Art, The George A. Lucas Collection, BMA 1996.48.18113 (M. 713)

119 Walking Suit, *Peterson's Magazine* (October 1877)

skirt follows the habit somewhat, but the fabric of her suit appears to be one of the new lighter, supple wools used for women's tailor-made suits, and it is trimmed with fur.[30] Two vivid drawings in pen, ink, and wash, which Whistler executed after the painting, show the dynamic lines of the suit and the fur trim more clearly (figs. 116, 117). A third drawing, in pencil, distills the image into a pattern of vigorous swirling lines (fig. 118).

Rosa's costume also has elements in common with fashionable outdoor wear of the period, as seen, for instance, in the walking suit depicted in a fashion plate of October 1877 (fig. 119). The suit jacket, also pulled in at the waist,

is longer than Rosa's and is made of a bulkier fabric. It is trimmed with plush and may be lined with this material or with fur. An example of this type of jacket may be seen in the blue velvet fur-lined jacket of the 1880s (see fig. 27). The streak of white at the edge of Rosa's open jacket suggests that it too may be lined with white fur, though it could also be the frill of a white blouse worn underneath. The walking suit's skirt is trimmed with fur as well, and the fabric is tied back and caught up in a bustle below the hem of the jacket, terminating in a ruffled train of a darker color. Rosa's skirt, although simpler, also appears to be tied back in a low bustle beneath the edge of her jacket and

ends in a train. (The details of Rosa's costume, especially the skirt, are seen more clearly in the mezzotint than in the painting.)

Rosa's ensemble is difficult to classify: it appears to be a cross between the new functional tailor-made suits criticized at the time as "apt to follow riding habit too closely"[31] and the fashionable walking wear made by a dressmaker, perhaps after a Parisian model. Unlike the more structured, constricted high fashion ensembles, Rosa's attire allowed for comfort and freedom of movement, yet it retained elements of the purely fashionable, such as the train, once associated with aristocratic women who did not have to walk in the streets.[32] The ubiquity of the train provoked Ruskin to exclaim: "I have lost much of the faith I once had in the commonsense and even the personal delicacy of the present race of average Englishwomen by seeing how they will allow their dresses to sweep the streets."[33]

Another prominent feature of the portrait is its round hat, which Rosa holds in her gloved hand and is similar to the one worn by May Alexander and held by her sister Cicely in their portraits. In a letter to the girls' mother, Whistler makes reference to a shop in South Audley Street that sold these "feather picture hats . . . such as you cannot get elsewhere."[34] Rosa's similarly large, round feathered hat provides another focal point in the composition, second to the figure's head. The warm brown of the hat echoes the color of her hair, while it repeats in a tighter curvilinear form the swirl of fabric around her feet. Whether the hat belonged to Rosa, was bought from the shop on South Audley Street for her portrait, or was appropriated by Whistler from another work of art is not known; what is clear is that it contributes to the artistic mood of the painting. Similar broad-rimmed hats appear in portraits by Gainsborough, as, for instance, in *A Morning Walk* (1785, National Gallery, London). An almost exact prototype for the hat may be seen in Sir Francis Grant's portrait of 1857, *Georgina Naylor*, a work exhibited in the town hall of Leighton in 1867 (fig. 120). (Like the Leylands, Thomas Naylor and his wife were important Liverpool collectors.)[35] The similarities between the Naylor and Corder portraits are striking, suggesting that Whistler may have known Grant's painting: both women are dressed from head to toe in simple black walking dress (though Mrs. Naylor's dress is offset with a white shawl); both are simply coiffed and hold identical brown plumed hats in the right hand in the same position.

As an artist herself, Rosa would have been highly conscious of her image and worked with Whistler to create an aesthetic arrangement of shape and tone in which she

120 Sir Francis Grant (1803–1878), *Georgina Naylor*, 1857, oil on canvas, 88 × 52¼ (223.7 × 132.7), Board of Trustees of the National Museums and Galleries on Merseyside, Walker Art Gallery, Liverpool, WAG 6853

appears both fashionable and modern, in attire that reflects the avant-garde milieu in which she lived and worked. *Arrangement in Brown and Black* belongs to a group of works that Whistler referred to as his "artists pictures," as distinguished from fashionable portraits.[36] While Rosa's portrait was in progress, he also painted his mistress Maud Franklin in a similar costume and pose. In *Arrangement in Black and Brown: The Fur Jacket* (1877, fig. 121), Maud, her back to the viewer and facing the opposite direction to

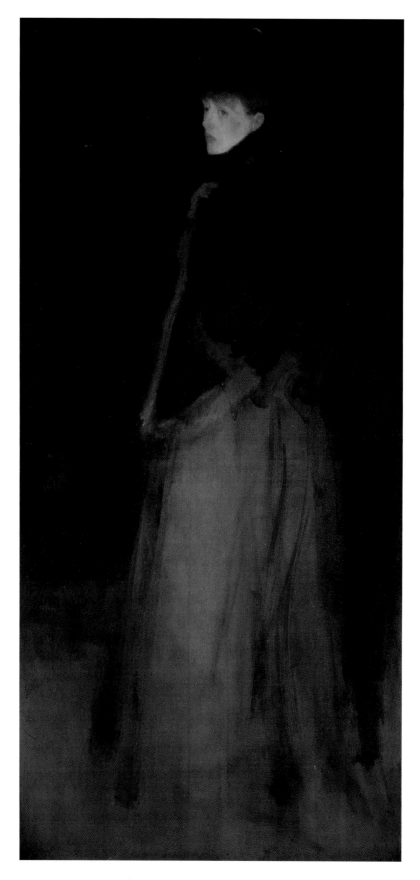

121 *Arrangement in Black and Brown: The Fur Jacket*, 1877, oil on canvas, 76⅜ × 36½ (194 × 92.7), Worcester Art Museum, Massachusetts (YMSM 181)

Rosa, stands in a shadowy space, wearing a simple, flowing woolen skirt and a fur jacket with fur trim.[37] The same year, Whistler asked another artist friend, Louise Jopling, to pose for him at one of his famous breakfasts at Lindsey Row. Mrs. Jopling recalled, "I stood for two hours without rest, in which time he had painted a life-sized full-length of me."[38] The unfinished painting, *Harmony in Flesh Colour and Black: Portrait of Mrs Louise Jopling* (see fig. 16), shows the subject from the back in a pink beige, sheathlike tunic dress tied back over a black skirt, which terminates in a long narrow train, and a hat completed with "a broad wet stroke of red."[39] Together the portraits of Rosa Corder, Maud Franklin, and Louise Jopling provide an image of the simple but glamorous clothing, with a touch of luxury, worn by fashionable female artists in the mid-1870s. In its elegance and somewhat romantic mood, Rosa's portrait is something of a later reflection in contemporary attire of the beautiful black-on-black full-length oil of 1872–73 of Mrs. Huth in a long velvet gown, in which the figure is also depicted from the back (see fig. 37).

Under the impact of the Rational Dress movement of the early 1880s, the long trains that had provoked Ruskin's ire were abandoned for day wear in favor of more practical, shorter skirts in a tubular style, which became the norm for the professional woman. Rosa's transitional attire reflects the changes of the time, just as the subject herself slipped between classes, between amateurism and professionalism, and between respectability and a more shadowy existence.

"WORRIES & IRRITATIONS"

The two years during which Rosa posed on and off for her portrait were the most turbulent of Whistler's career. In 1877 the artist sued Ruskin for libel for his attack on Whistler's painting *Nocturne in Black and Gold: The Falling Rocket*.[40] The expenses of the trial contributed to his bankruptcy in May 1879. In a letter of December 11, 1878, to an older friend, the collector Francis Mewburn, Rosa expressed her acerbic view of the trial, which she considered "a complete fiasco on both sides . . . unworthy of either as men of genius with any pretensions to common sense." "Whistler won't appeal," she continued,

he affects to consider the trial a glorious victory! No one else does, I fancy. . . . I can't help thinking such a procedure a fit ending to such an unworthy squabble . . . that the greatest living literary genius should descend to

personal abuse & call it criticism is a sad fact only to be equalled by the imbecility of our greatest painter submitting his artistic reputation to the judgment of petty tradesmen ignorant even of their own language.[41]

Yet Rosa herself, through her connection with Howell, may also have been under fire around the time of the completion of the portrait. In a letter to *The Times* of August 1878, Rosa's first mentor, Rossetti, denounced as spurious certain drawings attributed to him that surfaced at a pawnbroker.[42] Some years later, William Rossetti noted in a memoir of his brother,

I will not lay any blame on Mr. Howell . . . but it is a fact that he was an ingenious facsimilist, and that there was a lady of his acquaintance, known to my brother likewise, who was a capable artist and many persons have, within my knowledge, formed and expressed the opinion that the imitation Rossettis had their origin in that quarter.[43]

Rosa Corder did make and sell copies of Old Master and modern paintings quite legitimately, but allegations of her involvement in forgery of works by Rossetti, Whistler, Fuseli, and others arose during her lifetime and beyond.[44] It is perhaps to this side of Rosa's reputation that another of Whistler's sitters, the Comte de Montesquiou (see fig. 161), referred in a poem: "Miss Corder, her hat encircled by a feather,/Her dissident's profile with the airs of a good-natured plotter."[45]

Arrangement in Brown and Black: Portrait of Miss Rosa Corder was exhibited for the first time at the Grosvenor Gallery in the spring of 1879. The timing could not have been better for Whistler and Corder. The trial had driven many of Whistler's clients away, and Rosa was attempting to launch her own career. The portrait's favorable notices—"broad passages of sombre colour are most artistically arranged, and the general effect is remarkable and harmonious,"[46] and "broad, grand passages of execution worthy of Velázquez"[47]—gave Whistler's damaged reputation a boost, while placing Rosa in the limelight.

While her portrait was being admired at the Grosvenor, Rosa made her first and only appearance at the Royal Academy in the May exhibition of 1879 with a portrait of her mother, and her prospects were high.[48] She was considering establishing her own studio—a *Design for a cottage/studio for Rosa Corder* by Whistler's friend E. W. Godwin appeared in *The British Architect* in August 1879. (The studio was to be on Tite Street near Whistler's White House, but was never built, undoubtedly for lack of funds.)

A letter from Rosa to Francis Mewburn dated January 11, 1879, reveals her dedication to her work:

I have begun a picture I think you will like, & being hard at work the outer world is a matter of complete indifference to me. I really don't wonder at the selfishness of artists: their work is so absolutely engrossing & must seem to them (if they are artists) of such paramount importance that the one longing of their own existence is to be left alone to live in the world of their creativity which is quite away from the outer world. I do not pretend to be anything of the genius which can excuse such preoccupation, but directly I feel with the faintest glimmer of pleasure in any picture I am about to become indifferent to all worries & irritations, which at other times would take such a hold on me....[49]

Another letter from the painter Matthew Robinson Elden to Whistler, then in Venice, attests to her growing success: "Miss Corder has lately painted a picture of a deceased lady which so pleased the widower that he gave her £120 twice her price—Howell & she in high delight—Miss Corder has got 9 commissions various & full of prospects."[50] Among her sitters in the early 1880s were Frederick Leyland (whose portrait was exhibited at the Grosvenor Gallery in 1882); Algernon Graves, the son of the engraver Henry Graves; and the young etcher and follower of Whistler, Mortimer Menpes. It may have been while Menpes was sitting for his portrait that he etched one of Rosa, showing her, as it were, from the other side of *Arrangement in Brown and Black*—facing front and in working attire—an image as natural as Whistler's is arranged (fig. 122). Around 1883 Rosa retreated from London to pursue her practice in Newmarket of painting racehorses and dogs, returning only occasionally to her apartment in Bloomsbury. Her only child, Beatrice Ellen Howell, was born in 1887.[51]

Details of Rosa's life after the mid-1880s are scarce. One intriguing glimpse of her appears in a review in *The World* in April 1887 about the Society of British Artists exhibition. Rosa, in later years, apparently maintained her stylish artistic mode of dress:

The crowd at Suffolk Street on Saturday had some curious characteristics: there were no really handsome dresses, and scarcely even effective ones; while there were a number of fresh bright faces which needed neither crème nor rouge. Many of the owners of these countenances had evidently come to look at the pictures, and were sombrely dressed in long coats of dark blue or

122 Mortimer Menpes (1855–1938), *Rosa Corder*, 1880–82, etching, image: 3⅜ × 2⅜ (8.7 × 6.2), sheet: 8½ × 6⅞ (21.7 × 17.5), Department of Prints and Drawings, The British Museum, London

brown, as if for wet weather; so I suppose they belong to the artistic world. Miss Rosa Corder, a bright representative of this particular world, was dressed all in black, and wore a high black hat of the style that only suits a few faces, but which suited hers extremely well; black tulle strings were tied in a smart full bow under her left ear.

Howell's death in 1890 was followed three years later by Rosa's untimely demise. The *Newmarket Journal* of December 1893 noted the events surrounding her death: "We have to record the death of Miss Rosa Frances Corder, the well-known artist which sad event took place at her residence Vale Lodge, Fordham on 28 November. The deceased had been out riding on a very wet Saturday some 3 weeks since which resulted in a very severe cold. Peri-

123 Max Beerbohm (1872–1956), *Mr. __ and Miss __ Nervously Perpetuating the Touch of the Vanished Hand*, 1922, pencil and watercolor, 12½ × 15 3/16 (31.8 × 38.7), Tate Britain, London

tonitis set in. . . . The deceased was forty years old."[52] Rosa's daughter, who was six years of age at the time of her mother's death, was raised by her sister. Most of her paintings have disappeared, although the small number that remain give a sense of her considerable talent, which Rossetti had been the first to recognize and encourage.

Rosa Corder reappears posthumously in a watercolor by Max Beerbohm published in his book *Rossetti and His*

Circle of 1918 (fig. 123). It refers to an incident, reported by Williamson, in which she and her paramour were supposedly at work on spurious Rossettis in a room on Bond Street, when an unexpected knock at the door put an end to their labors.[53] Tall and demure, Rosa stands at the easel wearing an artist's smock over the suit she wore in the famous portrait by Whistler, with its long trailing skirt that once swept the streets of Chelsea.

Chapter 7

Maud Franklin and the "Charming Little Swaggerers"

Margaret F. MacDonald

*I need not tell you that she is very charming
and that you will be delighted with her.*

– Whistler, 1879

facing page Detail of fig. 148 (larger than actual size)

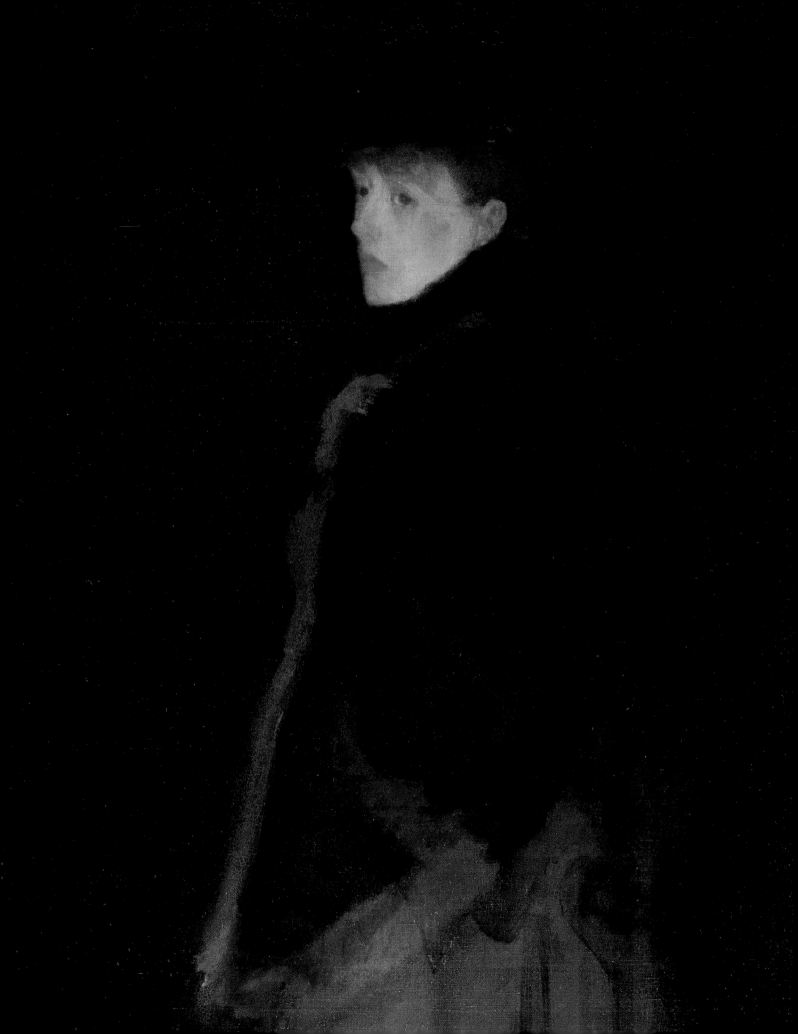

MAUD FRANKLIN WAS BORN IN 1857 in the country town of Bicester near Oxford, where her father, Charles Franklin, was a cabinetmaker and upholsterer. She was christened Mary after her mother, Mary Clifton. It is not known when exactly she came to London or started to model for Whistler. She apparently stood in for Mrs. Leyland, before that portrait was exhibited in 1874 (when she was seventeen, and the artist, forty).

From understudy she progressed to mistress and principal model, posing for more than sixty works (see fig. 1). The impression produced by her portraits is that of a refined, fashionable woman, with regular features, a pink and white complexion, and dark red hair. She thought a woman should aim to improve herself in manners and appearance, and be "distinguished looking"; she despised snobbery, criticizing one woman as "a terror & a snob who talks about nothing but her fine pedigree."[1] She herself was not generally accepted in society, except among Whistler's fellow artists. A. S. Cole, for instance, happily dined in Whistler's house, where Maud was hostess, but when Whistler said he was bringing her to visit, Cole replied that it "would not do."[2]

When she "dressed up" in a full skirt and shawl for *Arrangement in Yellow and Grey: Effie Deans* (YMSM 183), this was both historically acceptable and practical (she was probably pregnant).[3] Whistler rarely used literary titles, but here it was appropriate, "Effie" being the unmarried mother and heroine of Sir Walter Scott's novel *The Heart of Midlothian*. Maud's two daughters, Ione, born in 1876 or 1877, and Maud McNeill Whistler Franklin, born in 1879, were left with foster parents in Southsea. To everyone's sorrow, little Maud died young: "I went of course to see the 'grave' and put some flowers," her mother told Ione; "It looked very nice."[4] Ione married and Maud duly welcomed news of her pregnancy: "You are in my thoughts night & day: if only I could see you. . . . I know how good & kind Warwick must be & how he must worry so do all you can to take care of yourself for his sake."[5] This belief that a woman's primary duty was to support her partner may explain why she put up with Whistler's treatment of her.

Her portraits vary so much in pose and costume, mood and color, that she is not always clearly recognizable. Several have disappeared or were destroyed or painted over, and others were probably never finished. *Effie Deans* was painted with a free, splashy technique, with paint so thin that it ran down the canvas. Other portraits, like *Arrange-*

ment in Black and Brown: The Fur Jacket and *Arrangement in White and Black* were worked up to a higher degree of finish for exhibition (fig. 126). Several, including *The Fur Jacket*, were shown at the Grosvenor Gallery in 1877. The title, designed to stress the abstract quality of color, also aroused curiosity about the mysterious figure lost in reverie. Wilde, however, described the pictures as "life size portraits of two young ladies evidently caught in a black London fog; they look like sisters, . . ."[6] prefiguring years of jokes in which Whistler's women were said to be lost in coal cellars, tunnels, and so on.

As Whistler said in evidence at the *Whistler v. Ruskin* trial, "These were impressions of my own. I make them my study. I suppose them to appeal to none but those who may understand the technical matter."[7] He also said that, after the show, he painted over *The Fur Jacket* "with a view to alter it and change its character as a picture."[8] Since it was painted over several years, it does not reflect Maud's appearance at any one moment. Though thinly painted, with soft brush strokes that merge and blur the outlines of the figure, it is warm and dark in color. Furs set off Maud's fine profile, but the swinging fur-trimmed jacket is absorbed into shadows so that although it corresponds to the prevailing styles of 1876–77, fashion is not the dominating factor.

This portrait contrasted dramatically with the portrait exhibited at the Grosvenor in the following year. In *Arrangement in White and Black*, Maud fairly sizzled with youth and vigor. The close-fitting dress was the height of fashion. Contemporary cartoons mocked the fashionable woman's inability to bend, climb stairs, and so on (fig. 124). The *Graphic* for May 4, 1878, described a hat with delicate plumes curling over the brim, just like Maud's, and recommended similar costumes: "white sateen will be much worn, more or less trimmed with coloured ribbons . . . those whose features are irregular . . . can disguise their high foreheads with light curls, fringes etc. . . . Bonnets and hats are very graceful. . . . White or black, whether in silk, satin or tulle, form dress-bonnets and hats." The figure-hugging satin dress was downright sexy, and she strode out in a way that signaled sexual freedom. Her confrontational pose, hands on hips, offended the critics: the *Magazine of Art* considered it "vulgar in action."[9] The various elements that contributed to the image, including beauty and self-confidence, color and costume, were analyzed by an audience that was highly attuned to nuances of caste and class.

THE NEW HUSSAR HESSIANS AND PANTS.

"See, I've dropped my Handkerchief, Captain de Vere!"
"I know you have, Miss Constance. I'm very sorry. I can't Stoop, either!"

124 George Du Maurier (1834–1896), "The New Hussar Hessians and Pants," *Punch*, vol. 74 (May 25, 1878), p. 239, Glasgow University Library, Department of Special Collections

Years later Whistler compared a portrait of the aristocratic Lady Archibald Campbell with Maud in *The Fur Jacket*, which he described as "an artists picture . . . the portrait of . . . an obscure nobody."[10] This sounds amazingly snobbish, but since the letter was actually written by Beatrice Whistler (presumably at his dictation), the comment may reflect her feelings toward a former rival. On the other hand, it reflects economic reality. Maud's name would not help sales, and no picture was exhibited with

her name. It was later cataloguers who added descriptive titles, like *Study: Maud Seated* (C. 5) or *Maud Standing* (K. 114; see figs. 129–30).

The [London] *Times* described Whistler's portraits in 1878 as "vaporous full-lengths, . . . it pleases him to call 'arrangements' . . . as if the colour of the dress imported more than the face; and as if young ladies had no right to feel aggrieved at being converted into 'arrangements.'"[11] His titles stressed priorities: color above costume, costume above the individual. "An obscure nobody" got no mention at all. Thus, although *Arrangement in Black: La Dame au brodequin jaune* had the subtitle *Portrait of Lady Archibald Campbell* (YMSM 242, see fig. 175), other portraits were given dress-related titles. This practice applied not only to oils, like *Arrangement in Black and Brown: The Fur Jacket*, but to etchings like *The Velvet Dress* (see fig. 93) and *The Muff* (fig. 125), where velvet

125 *The Muff*, 1873, drypoint, 4⅞ × 2⅞ (12.5 × 7.4), National Gallery of Art, Washington, D.C., Rosenwald Collection, 1943.3.8469 (K. 113)

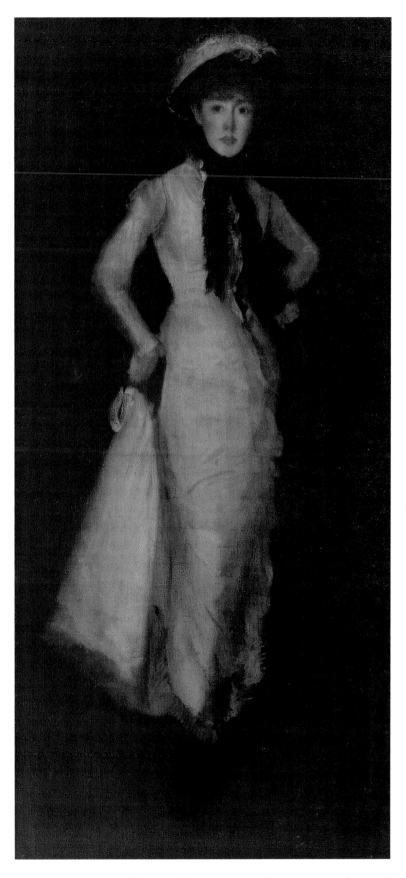

126 *Arrangement in White and Black*, c. 1876, oil on canvas, 75⅜ × 35¾ (191.4 × 90.9), Freer Gallery of Art, Smithsonian Institution, Washington, D.C., Gift of Charles Lang Freer (YMSM 185)

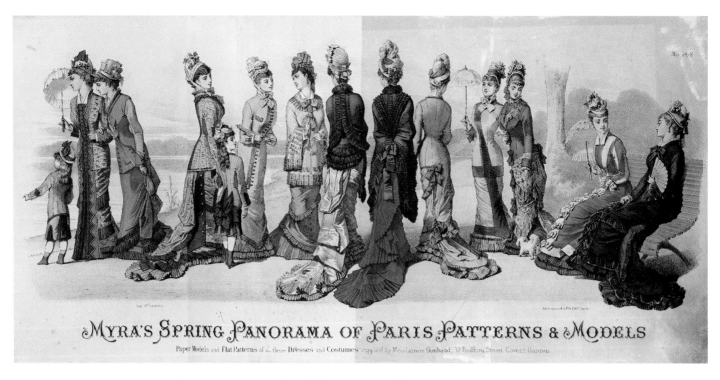

MYRA'S SPRING PANORAMA OF PARIS PATTERNS & MODELS

Paper Models and Flat Patterns of all these Dresses and Costumes supplied by Mondarnon Gouhaud, 39 Bedford Street Covent Garden

127 Myra's *Spring Panorama of Paris Patterns and Models*, May 1878, hand-colored engraving, Department of Prints and Drawings, Victoria and Albert Museum, London, 96.F.7 (E4226-1968)

and furs are more important than the sitters (Mrs. Leyland and Mrs. Herbert). Likewise in lithographs, such as *The Toilet* (see fig. 131) and *The Winged Hat* (see fig. 189), dress is the primary subject.

Lithographic crayon was eminently suited to showing the design and texture of costume and became a popular alternative to engraving for fashion plates. *Myra's Spring Panorama of Paris Patterns and Models* for May 1878 is a delightful example: a triple-page pullout showing no less than fourteen dresses with narrow hobble skirts and magnificent trains (fig. 127). The similarity in mood and detail to the silky trailing dresses of the pleasure seekers and prostitutes in Whistler's *Cremorne Gardens* is striking (fig. 128). Whistler lived within sight of Cremorne in Chelsea and sat there on summer evenings, like the dandy in top hat and frock coat who is a cool observer of the scene. The dresses invite comparison with Whistler's portraits of Maud, Louise Jopling, and Frances Leyland. The scene conjures up memories of Watteau and, above all, Gainsborough, whose delicate rendering of *The Mall in St. James's Park* hung in the Royal Academy in 1876[12]—and who was, Whistler and Henri Fantin-Latour agreed, one of "our old loves."[13]

In *Cremorne Gardens*, Whistler stroked and scraped pale colors—flesh pink and blues—over the canvas to suggest silky draperies. To achieve similar effects in silvery gray, he exploited the textural possibilities of lithography, using crayons of varying hardness and degree of point, as precise as pencil or soft as charcoal. Reinforcing the lines with ink washes in lithotint, as in *The Toilet* (fig. 131), produced rich contrasts of light and dark. Scraping with a knife created bright sparks and flashes of light: the waves of ruffles on Maud's train in *The Toilet* evolved through a combination of line and wash, of adding and taking away.

A morning dress dating from about 1876/79 (fig. 132) shows interesting similarities to this dress, both in its overall shape, with long fitted bodice and multiple-layered train, and the delicate interaction of embroidered cotton and lace over the basic structure of white linen.[14] In Whistler's lithograph, the multiple outlines of the figure suggest both the shimmering of light through the fine material and the slight quiver of movement in the turning figure. The pose was chosen to accentuate the most prominent features of the dress: the swirling train, the tiny waist, and the wrapped sleeves reminiscent of those in his portrait of Frances Leyland.

128 *Cremorne Gardens, No. 2*, 1872/77, oil on canvas, 27 × 53⅜ (68.5 × 135.5), The Metropolitan Museum of Art, New York, John Stewart Kennedy Fund, 1912, 12.32 (YMSM 164)

The Toilet is rare in having been drawn directly onto the heavy lithographic limestone, which has a fine, regular grain: usually Whistler worked on transfer paper. He either drew on artificially grained paper or laid the paper on different surfaces to achieve variety of texture. This method was the equivalent of carrying a sketchbook and was ideal for conveying momentary effects, like the buttoning of a glove or fastening of a wristband in *The Toilet*. Whistler demanded complex effects from the medium and, when all else failed, drew on the print itself; in fact nearly every impression of *The Toilet* is worked on in white crayon to soften the outline of the skirt.

Whistler also worked extensively in wash on various impressions of the etching *Maud, Standing* (figs. 129, 130). In early states, which appear to date from as early as 1873/74, Maud wore a slim-fitting, long-waisted dress with neat epaulettes. By 1878 the skirt had been lengthened with a narrow train, and she wore a warm fur tippet around her shoulders. Whistler pared down the waistline until it looked unnaturally small. Fresh drypoint lines, printed with a soft burr, define the fur tippet that set off her sharp profile under a beribboned bonnet. Angular patches of shading on the skirt suggest a stiff lightweight material—possibly taffeta—with several rows of narrow frills around the hem.

In detail it is subtle and delicate, but the figure gives a remarkable impression of strength and vigor.

THE MODEL'S WARDROBE

The dress seen in *Maud, Standing*, was teamed for winter with a broad fur tippet. Maud's wardrobe for the late 1870s also included two skirts, brown and gray; a long velvet jacket trimmed with brown fur and matching velvet hat; a golden brown shawl with a brocade pattern; and black gloves. She had "an indigo riding habit or . . . the gaberdine . . . of a blue coat boy" that figured in *Arrangement in Blue and Green* (YMSM 193)[15] and resembled a coachman's greatcoat—a borrowing from male dress that was fashionable and inspired numerous *Punch* cartoons.[16]

Maud wore a white satin walking dress, plus a black tippet and black hat with white feather. She had two muslin dresses, one with a deep flounce on the skirt and a black bow on the corsage; the other with a narrow skirt, three-quarter-length sleeves, and short-waisted top. This dress had a broad double frill around the low V-shaped neckline and appeared in two paintings that have since disappeared, one of them a *Harmony in Pink and Red* (YMSM 94,

129 *Maud, Standing*, 1873–78, etching and drypoint, 8⅞ × 5⅞ (22.5 × 14.9), National Gallery of Art, Washington, D.C., Rosenwald Collection, 1943.8470 (K. 114, v)

130 *Maud, Standing*, 1873–78, etching and drypoint with white chalk, $8\frac{7}{8} \times 5\frac{7}{8}$ (22.5 × 14.9), National Gallery of Art, Washington, D.C., Rosenwald Collection, 1943.8471 (K. 114, IX)

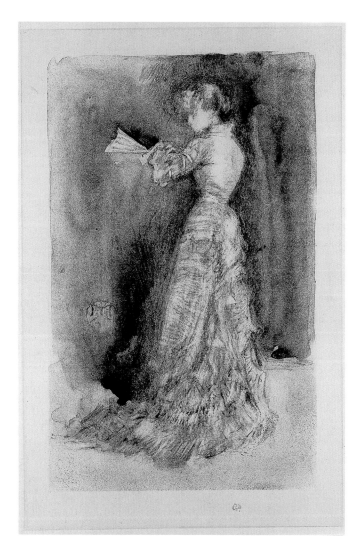

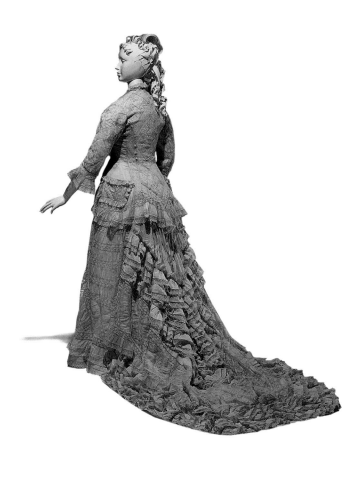

131 *The Toilet*, 1878, lithograph, image: 10³⁄₁₆ × 6⅜ (26 × 16.4), The Art Institute of Chicago, Bryan Lathrop Collection, 43.519 (C. 10, III)

132 Morning Dress, 1876–79, linen and cotton, Cincinnati Art Museum, Gift of Mrs. Eloise B. Tigar and Mrs. Colley B. Van Meter, 1964.319

YMSM 192). An afternoon dress with a sweeping train is seen in *The Toilet*, and she also had a walking dress of a darker material, with narrow sleeves trimmed with braid, which appears in *Study* (fig. 133). Whistler chose a three-quarter back view to reveal the overskirt drawn back into complex folds and flounces that would necessarily have been held underneath by a series of tapes and buttons, in the elaborate fashions of 1878.

This attire, with the accompanying corsets, under-clothes, and accessories, certainly constituted a well-stocked wardrobe. Maud's clothes were not elaborate, highly trimmed confections. They reflect aesthetic good taste, achieved on Whistler's modest and erratic income. At that time, Whistler asked two guineas for an etching and

two hundred guineas, famously, for a *Nocturne*, which he failed to sell. Maud as a model would have earned perhaps six to ten shillings a day (Beatrice Godwin paid a model 1s. 1d. an hour in 1879),[17] but as his mistress, Maud was dependent on Whistler. Whether her clothes reflect her own or Whistler's taste, they were simple and well cut, showing off her slim figure and delicate coloring to advantage.

* * *

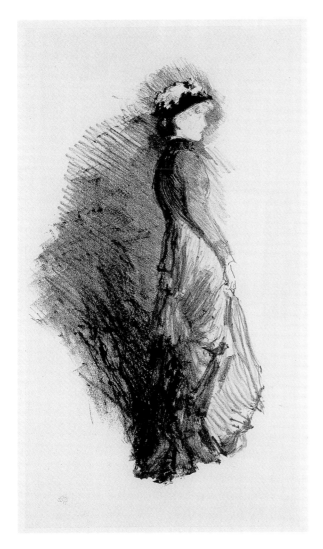

133 *Study*, 1878, lithograph, image: 10½ × 5⅞ (26.7 × 14.9), The Art Institute of Chicago, Bryan Lathrop Collection, 34.545 (C.3, II)

POVERTY AND PROSPERITY

Whistler's bankruptcy and exile in Venice brought compensations for Maud: the less restrictive society of American artists and the sheer beauty of the city. "Oh isnt this a lovely place and such a lovely day too," wrote Maud on October 23, 1879.[18] John White Alexander, who met her in Italy, described her as "not pretty, with prominent teeth, a real British type."[19] When the Venice pastel show opened in London on January 29, 1881, Maud reported to the young American etcher Otto Bacher:

As to the Pastels, well—they are the <u>fashion</u>.... All the London World was at the Private View—Princesses Painters Beauties Actors—everybody—in fact at one moment of the day it was impossible to move....

The best of it is all the pastels are selling...over a thousand pounds worth are sold—the prices range from 20 to 60 guineas—and nobody grumbles at paying that for them—Whistler bought me a dress like this scrap I have pinned above—to wear at the Private View—but the day was too dreadfull—or it would have been very lovely in that room.[20]

In this letter, Maud signed herself "Maud Whistler," but there is no record of any marriage, although many people, including Whistler, referred to her as "Madame." In another letter, she added:

I am sure you would like my dress. I've just been enjoying myself, I can tell you, and have managed to spend a hundred pounds on myself,—what do you think of that after the impecuniosity of Venice?...I have lots of things to tell you, but cannot stay now, as I am just off to a swell luncheon.[21]

This £100—presumably from the sale of two or three pastels—would have restocked Maud's wardrobe with half a dozen dresses and accessories to match.

Whistler's small drawings and watercolors of Maud in the 1880s show him delighting in her moods and grace, with warmth and humor. They were painted with bright colors and expressive brushwork. *The Yellow Room* (1883/84, watercolor, private collection, M. 881) shows her in a pale blue striped dress with diagonal bands of frills in the sitting room with its Oriental fans and parasols. In *Portrait of Miss Maud Franklin* (fig. 134) the lines are bold, the pen almost dry as it scratches over skirt and bustle. The nib splays out into double lines at the bottom of the skirt. Her hair has been blotted so that it looks lighter. The ink is a warm brown, tinged with purple, and the paper dark cream, adding color and warmth. Maud's vivacity and sense of style contributed to the elegance of the drawing. In a tiny pen sketch (fig. 135) the model—possibly Maud— is assessing Whistler coolly, while, in a nervous shorthand of dots, zigzags, and wiry broken lines, he draws the twist of her body stretching back to adjust her skirt.

Whistler painted her even when she was ill or in bed among novels and breakfast cups, suggesting an intimacy that titillated his audience. *Pink note—The Novelette* (fig. 136) was described as "a grisette reading a French novel" and "a delightful devourer of penny sentimentals... reading upon a bed."[22] The cramped room with its crum-

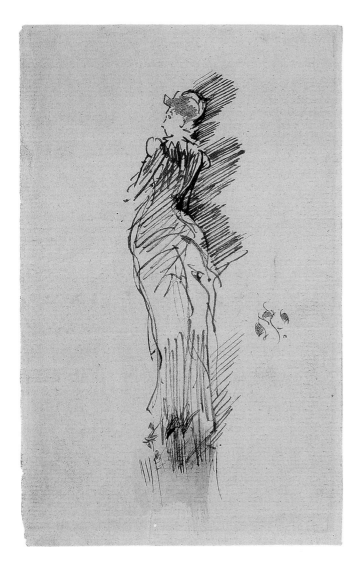

134 *Portrait of Miss Maud Franklin*, 1883/88, pen and dark brown ink on cream laid paper, 7 × 4⅜ (17.8 × 11.3), The Art Institute of Chicago, 33.298, Gift of Mr. Walter S. Brewster (M. 896)

pled bed—fans and a picture on the wall—suggest an artistic, bohemian milieu. It is the room itself rather than the girl that suggests the life of a *grisette*.

Sometimes Maud posed with another model, Millie Finch, and when she was ill, Millie took her place in the studio. Much of Maud's time and energy went into posing, both for Whistler and colleagues,[23] but she also studied painting beside Beatrice Godwin, Menpes, and Sickert and exhibited her portraits and flower paintings at the Society of British Artists, perhaps in an attempt to establish herself as more than a mistress and model.[24] In October 1886 she wrote to Lucas: "I am printing Etchings—would you like

135 *Sketch of a woman*, c. 1883, pen and pale brown ink on the back of a printed calling card for Mrs. Henry B. Callander, 72 Cadogan Place, 3¹¹⁄₁₆ × 2⅜ (9.3 × 6), National Gallery of Art, Washington, D.C., 1943.3.8821 (M. 895)

a few. . . . Mrs Godwin is now a widow. He died two weeks ago."[25] In 1888 Whistler went to Paris, the widow on one arm and Maud on the other, visiting galleries and calling on Lucas. They almost certainly bought clothes either for or during the trip. A photograph shows Maud in a new costume, wearing a hat decorated to an astounding height with ribbons (fig. 137).[26] Although she wore her towering hat with confidence, her position was insecure. Within months, Whistler left Maud abruptly and became engaged to Beatrice. Lucas sympathized with Maud, and, when she took refuge in Paris, he comforted and advised her, possibly helping her find work (it has been said that she posed to Cassatt).[27] Later, she married a New Yorker, John A. Little, had a son, and lived an affluent life, enjoying the Paris season, "like the gay and giddy thing I am,"[28] but shunning artistic circles and refusing ever to talk about Whistler.[29]

* * *

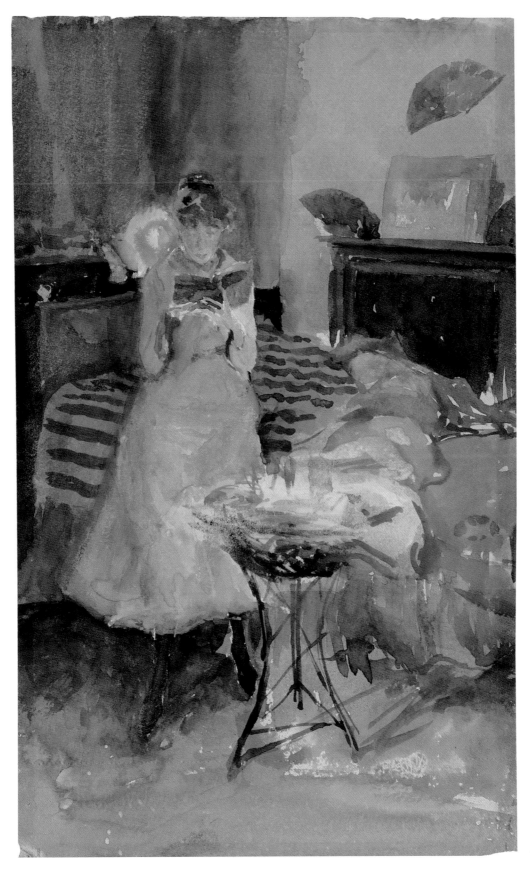

136 *Pink note—The Novelette*, 1883/84, watercolor on white wove paper, $9^{15}/_{16} \times 6^{1}/_{16}$ (25.2 × 15.4), Freer Gallery of Art, Smithsonian Institution, Washington, D.C., Gift of Charles Lang Freer (M. 900)

137 Unknown photographer, Maud, 1887/88, E. R. and J. Pennell Collection, Library of Congress, Washington, D.C.

ARTISTS AND ACTRESSES

In Whistler's last painting of Maud, *Harmony in Black, No. 10*, and of her successful rival in *Harmony in Red: Lamplight* (see fig. 179), he reused the assertive pose of *Arrangement in White and Black*.[30] Again, they were criticized for vulgarity. Beatrice was described as having "the hand on the hip, in an attitude that Mr. Whistler loves—an attitude that before the days when women were muscular and their movements free, used, at all events among very proper people, to be thought not quite a fit thing for a lady."[31]

Such pictures failed to meet accepted norms for the presentation of women, and they remained unsold. Whistler had grown up in several different environments, each with its own social rules, and to a certain extent his nationality and profession freed him from the stratification of the English class system. English society was a minefield for

the unwary, and Whistler confronted and exploited its ambiguities, with varying success. Actresses, like artists, faced certain prejudices, being both admired and suspected of decadence and immorality. Yet both their fame and their ability to project character made them ideal models.

Perhaps because of this, Whistler's subjects included more actresses than aristocrats. Kate Munro was "a most fascinating and clever actress" and reputedly a royal mistress, who first appeared at the Gaiety Theatre in 1874 (fig. 138).[32] She was a popular singer and comic actress, whose costumes range from modest simplicity to elaborate confections of striking vulgarity.[33] Whistler's portrait *Red and Black* (fig. 139) shows her swathed in a black cloak flecked with touches of red, a "scarlet woman" ready to disrobe.

138 Alexander Bassano (1829–1913), *Portrait of Kate Munro*, c. 1884, Theatre Museum, London, from The Guy Little Collection, vol. XVI, section V, p. 3, picture 1

139 *Red and Black*, 1883/84, watercolor on brown paper, 9³/₁₆ × 5¹/₈ (23.3 × 13), Fogg Art Museum, Harvard University, Cambridge, Massachusetts (M. 934)

Her reputation, as well as her vibrant personality (apparent even in Whistler's small picture), could well have added a certain frisson to his exhibition at Messrs. Dowdeswell's in 1884.

Black and red (fig. 140) is another exquisite portrait of a young woman. The sitter has not been identified but may have been an actress or model, student or career woman, since it would seem the picture was not a commission.[34]

The watercolor was exhibited in 1884 to almost universal acclaim. First, the pose transgressed no boundaries. Wedmore commented on the "dignity in the attitude, in the pose of the head."[35] She is seen in profile, sitting upright and gazing ahead, neither submissive nor confrontational: "a girl, dressed in dull violet and Indian Red . . . the head is exquisitely modelled and the hair simply but wonderfully told, sits gracefully on the lady-like figure—a few bold, vigorous touches give us her black felt hat and feather, and the folds of her dress."[36]

Whistler's studio had a huge window, and cool north light fell evenly on her face, while the flounces of the skirt merge into shadows. Gouache (a mixture of white and transparent pigment) was used for the grayish violet of the skirt. Layers of paint, applied with fine pointed brushes, build up the dress, with its narrow skirt and long fitted bodice. The costume of shot silk is so simplified as to be nonspecific, reduced to essentials of shape and color. It appears somber and restrained, except for a certain translucent richness in the color and the low-crowned, flat-brimmed hat with its parrot flash of red and gray feathers. Whistler not only added paint but also washed it off selectively, in, for instance, her hair, creating a more luminous effect and variety of texture.

Models shared with actresses the ability to project character. Whistler's models, particularly Maud Franklin and Milly Finch, appear in various guises and are not always recognizable. His enigmatic titles aroused speculation about the sitters, with rather varied results. *Note in pink and purple* (fig. 141) has been variously identified as "Milly," "Polly," "Nelly," and "Fanny," the most likely candidate being Milly Finch. This is a vivid watercolor, painted with expressive, wedge-shaped brush strokes. She stands with one hand on her hip, the other hoisting up her flounced skirt provocatively to show bright red stockings, tilting her head with an inviting smile. The bright stockings were a popular choice for "artistic" and "progressive" women, clearly anticipating the "art-student" dress seen in portraits by Augustus John.[37]

Milly Finch posed to Whistler for several paintings, none of which is dated, although the costumes suggest dates between 1881 and 1885. In *Harmony in Coral and Blue: Miss Finch* (fig. 142), she is wearing a chiffon scarf round her head and neck over a pale blue tunic dress and a narrow black belt. The skirt—ankle length—broadens at the knee into deep narrowly pleated or gathered flounces. She stands with one leg forward, holding a large Oriental fan. The picture is unfinished, as are the other portraits of her in similar dress. The style of dress and demure expression

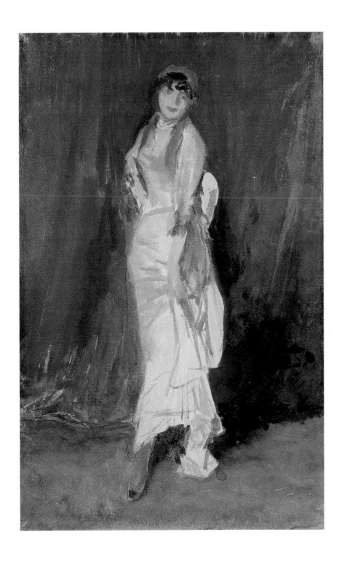

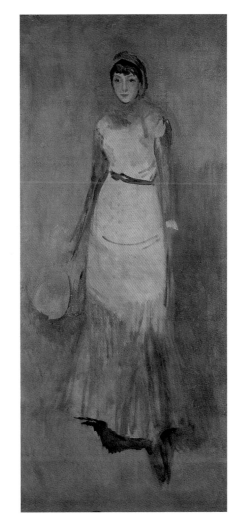

141 (*above left*) *Note in pink and purple*, 1883/84, watercolor on white laid paper, 9¾ × 6¼ (24.8 × 15.8), Cincinnati Art Museum, 56.103 (M. 935)

142 (*above right*) *Harmony in Coral and Blue: Miss Finch*, 1882/85, oil on canvas, 75¼ × 35¼ (191.1 1 × 89.5), Hunterian Art Gallery, University of Glasgow, Birnie Philip Bequest (YMSM 237)

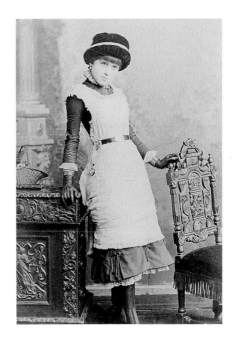

143 (*right*) The London Stereoscopic Company, *Portrait of the Child Dancer Connie Gilchrist (1865–1946)*, c. 1880, Theatre Museum, London, The Guy Little Collection, vol. III, section IV, p. 16, picture 2

140 (*facing page*) *Black and red*, 1883/84, watercolor on white laid paper, 9 × 6¼ (22.8 × 15.9), National Gallery of Art, Washington, D.C., 91.7.5 (M. 936)

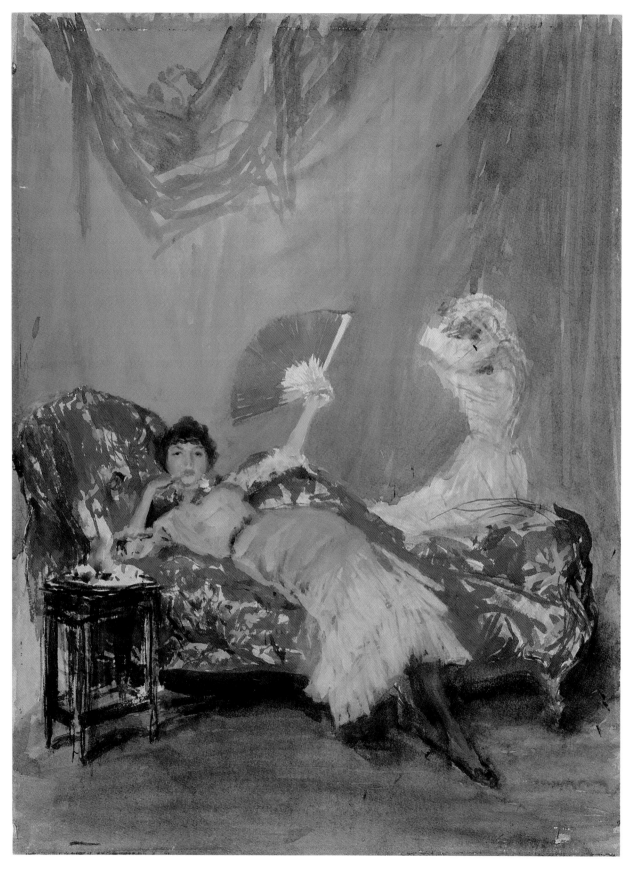

144 *Milly Finch*, 1883/84, watercolor on cream wove paper, 11^{11}/$_{16}$ × 8¾ (29.7 × 22.3), Freer Gallery of Art, Smithsonian Institution, Washington, D.C., Gift of Charles Lang Freer (M. 907)

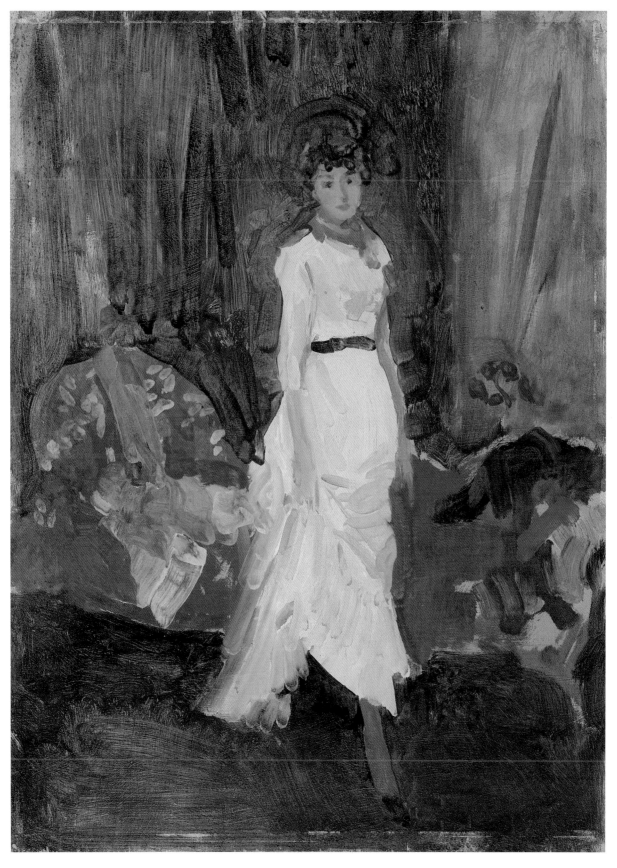

145 *Arrangement in Pink, Red and Purple*, 1885, oil on wood, 12 × 9 (30.5 × 22.8), Cincinnati Art Museum, John J. Emery Fund, 20.38 (YMSM 324)

suggest that she is a young working-class model.[38] Milly Finch's costume resembles those in photographs of such actresses as Kate Munro and Connie Gilchrist (fig. 143), who wished to accentuate their youth by the style of dress and hairstyle.

In a striking watercolor, *Milly Finch* (fig. 144), she is reclining on a red sofa, and behind her is a ghostly chaperone or maid; the scene appears like a redefinition of Manet's *Olympia*,[39] but with the courtesan fully clothed. Milly wears a lilac dress with a double row of flounces and a ribbon with flower buds around her neck. She leans on her right arm, one finger touching her lips with sensual emphasis, holding an open red fan invitingly in her left hand. The youthful face and dress contrast with the suggestive nature of her pose and surroundings.

The same red sofa appears in the background in an oil, *Note in Red: The Siesta* (YMSM 254), which is thought to represent Maud Franklin. Both works were painted in London. A third painting, *Arrangement in Pink, Red and Purple* (fig. 145), showing a young woman in a similar style of dress to that in *Milly Finch*, also includes the red sofa, thus situating it in Whistler's London studio.

There is a tantalizing reference by the artist Jacques-Émile Blanche to a portrait he painted in Dieppe in 1885 of the young Olga Alberta, daughter of the Duchess of Caracciolo. According to Blanche, this portrait "inspired" Whistler's *Arrangement in Pink, Red and Purple*, "a few spots of colour which I bought from the painter . . . because the pose he used was the same as that in my portrait."[40] The Duchess was a mistress of the Prince of Wales, and Olga, the Prince's goddaughter, became the glamorous Baroness de Meyer. Henry James said "that enchanting Olga learned more at Dieppe than my Maisie knew."[41] Blanche did not actually state that Whistler's oil showed Olga, and although it is tempting to identify the sitter with Olga, it is unlikely that they are one and the same.

The model was certainly very young, with a wistful innocence somewhat at variance with the vigorous technique. The oil was painted quickly on a small wooden panel prepared with a dove-gray undercoat. Small round brushes stab down the folds of the dress and pleats of the skirt. The cast-down clothes and sofa were painted with liquid half-mixed blobs of pink and gray. Fingers and brush ends and palette knife scraped and scuffed at the surface to create a vibrant environment. In this somewhat ambivalent portrait the model, with her provocatively raised skirt and red

146 Detail of fig. 145 (larger than acual size)

stockings, appears on the brink of a career, though whether as a demimondaine, actress, artist, or artist's model is not entirely clear.

THE "CHARMING LITTLE SWAGGERERS"

Since several of Whistler's models have a family resemblance, his *Lady in Grey* (fig. 148) might show Milly Finch or Kate Munro. It was bought by Charles K. Miller of Chicago and exhibited there in 1889. The American press accepted the status implied by the enigmatic title and found the sitter a "haughty lady":

> Whistler's haughty lady in grey is posing . . . but she does it with absolute frankness. She is there to be impertinent and no one can be as delightfully impertinent as Whistler. . . . The little picture has been snapped up of course, and thus our supercilious English girl is destined to frown upon Chicago during the rest of her immortal youth.[42]

The *Lady in Grey* wears a silver locket over a high-necked gray dress, with several silver bangles over her gloves. The sleeves are fitted, the dress has a long cuirass bodice, and the skirt is fairly narrow, encircled by a broad band of drapery (possibly tied behind into a bow) over the deep flounce of the ankle-length skirt. Narrow black boots emerge pointedly below the skirt, so she appears frozen in mid-stride, in imminent motion. A "picture" hat with broad brim curling up slightly at the edge and the flash of a silvery white feather complete the ensemble. Her hair is close-cropped, her fringe low over the eyes, her color high (the pink gouache stands out strongly against the dark background), and her features painted with fine precision, her eyes piercing and eyelids drooping with the "supercilious" look that the journalist noted.

All these models—Kate Munro, Milly Finch, and others —found their way to Whistler's new studio at 13 Tite Street, a stone's throw from Lindsey Row, where Whistler had painted the Hiffernan, Leyland, Corder, and Franklin portraits. Wilde and Frank Miles lived a few doors away. Several American artists visited Whistler there, including the sculptor Waldo Story. Whistler and Story became very close, finding themselves in rare accord both as friends and colleagues.

Years later, the Honorable Frederick Lawless mentioned to Elizabeth R. Pennell that he had a photograph showing

147 The Honourable Frederick Lawless, a Group in Whistler's Studio, Tite Street, 1881. Whistler is third from the right, with Julian and Waldo Story, Frank Miles, and Lawless, from Pennell 1908, II, facing p. 10, by permission of Glasgow University Library, Department of Special Collections

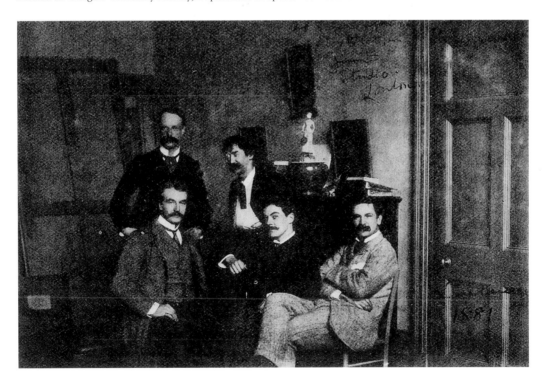

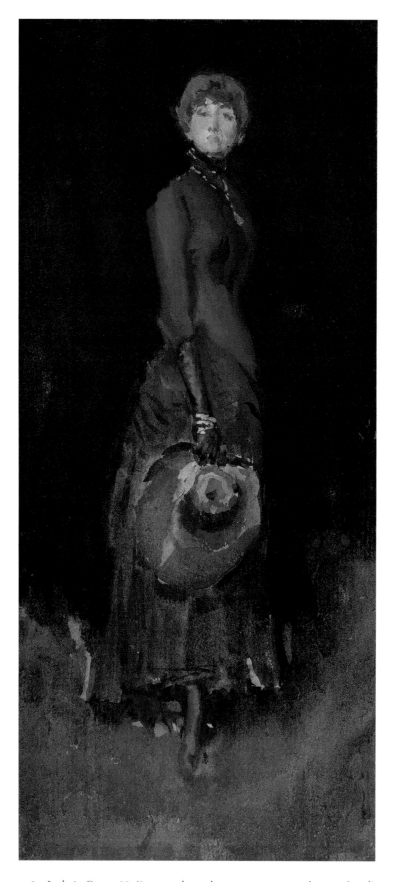

148 *Lady in Grey*, 1883/84, gouache on brown paper mounted on card, 11¹/₈ × 5 (28.3 × 12.7), The Metropolitan Museum of Art, New York, Rogers Fund, 1906, 06.312 (M. 933)

Whistler, Story, Miles, himself, and a statuette.[43] Lawless wrote, "When Whistler lived in his London studio, he often modelled statuettes, and one day he put one up on a vase, asking me to photograph it" (fig. 147).[44] The photograph shows Whistler in the Tite Street studio in 1881, and the statuette, standing on a vase, appears on the cabinet beside him. The photograph is small and the statuette appears tiny. Nevertheless, the statuette seems to be about eight inches tall. It is probably plaster, possibly fired but not glazed. It represents a woman in a slim-fitting dress, holding a wide-brimmed hat. Both the hat and a ribbon around her neck are dark and appear to have been painted. The hem of her skirt swings out, giving the feeling of movement. An affectionate letter from Whistler to Waldo Story ("Waldino") helps to fill out the story of the statuette. It was written from Holland, where Whistler had gone with Frank Miles and Matthew W. Elden ("Eldino") after Story had returned to his studio in Italy.[45]

> Yes dear old Waldino you are awfully missed— . . . the charming little swaggerers looking prettier than ever, were carefully put in their boxes and packed most perfectly in the large case by the attentive Wheatley (watched over tenderly by the faithful Carr) and despatched by him through his namesake to Rome— where, by this time, you ought to have received them, as you will see by the enclosed paper—Bon!—We all prayed for their safe arrival—and then I think we were all more depressed than ever when these last tokens of our work in the studio together had gone!—I was anyhow—! . . . Harper and Forbes careered round for about a week— we showed them everything and sent them back in a state

of whirl—the little figures they were charmed with— Waldo they are delightful—do write me a line—I know I don't deserve it—and tell me of their safe arrival.[46]

This letter makes it clear that Story and Whistler collaborated on some work on "little figures," the "charming little swaggerers," in London, almost certainly in the autumn or early winter of 1882.[47] Unfortunately, no statuettes have so far been located, and perhaps none survived, for those Whistler sent to Story in Rome met with disaster. As he wrote later, "It was awful about the lovely figurines being broken! we were all dreadfully disappointed."[48]

The pose and costume of the statuette are close to that in several of Whistler's watercolors of the early 1880s and in particular the *Lady in Grey* (fig. 148). It is possible that the statuettes were modeled by Story and painted by Whistler, but more likely that Story taught Whistler the basic principles of modeling, and he made some himself. Whistler does not seem to have pursued the experiment either on his own or when Story visited him later in both London and Paris.

Perhaps he had felt the need to extend from two-dimensional work, particularly in depicting the "swaggerers" and wanted to convey movement and substance in three dimensions. He and Story explored the technique with considerable verve and effectiveness, as far as can be judged from the sole surviving evidence, Lawless's photograph. But Whistler did not like to repeat himself, and the sad fate of the statuette may have been enough to deter him from pursuing this direction in his work. Instead, within a few years both he and Story were married, and their life and studio work took on new directions.

Lady Henry Bruce Meux and Lady Archibald Campbell

Susan Grace Galassi with Helen M. Burnham

WHISTLER PAINTED TWO PORTRAITS OF Mrs. Henry Bruce Meux, later Lady Meux, between 1881 and 1882. In the first the subject is depicted against a dark ground, magnificently garbed in a sleeveless black velvet evening gown and long fur-trimmed cloak; in the second she appears in formal afternoon dress in pink and silver gray and a straw hat against a light curtain. A third full-length portrait, in which Lady Meux posed in a sable mantle, hat, and muff, was also commissioned in 1881 and was still under way as late as 1886; Whistler abandoned it after a dispute with the sitter and probably destroyed it.[1] All three are featured in a cartoon published in *The Graphic* depicting Whistler at work on the Meux "triplex" (fig. 149).[2]

The portraits appear to have been conceived as a series, like Lely's sets of English "beauties" of the seventeenth century, though here they feature just one woman. The Whistler portraits are similar in composition: she stands against a plain background or a curtain and looks outward at the viewer. The changing element in each of them—Mrs. Meux's attire—evokes different seasons and personae. The titles of the works (*Arrangement in Black: Lady Meux; Harmony in Flesh-Colour and Pink,* renamed *Harmony in Pink and Grey: Portrait of Lady Meux;* and *Harmony in Crimson and Brown*) derive from the color of her garments. The two extant portraits are powerful statements of Mrs. Meux's intentions of refashioning her image as a grande dame and seductress and of the effectiveness of clothing in denoting status.

Accounts of Lady Meux's rise from humble origins to being one of the wealthiest women in England, and of the excesses of her married life and widowhood, are recorded in letters, Meux family documents, memoirs of guests and servants, and in a recent biographical sketch.[3] Yet certain basic facts about Lady Meux's background have remained obscure, owing in great part to her determined effort to shed her past after her marriage to a future baronet and heir to a vast brewery fortune. She was baptized Susan Langdon on June 4, 1852, in Drewsteignton, in the parish of Dartmoor, Devonshire.[4] Her parents, William Langdon and Lydia Jane Ellis, married in 1850, three years after the birth of their first child.[5] A census of 1861 lists William Langdon, butcher and victualer, as living in Drewsteignton with his wife and six children ranging in age from fourteen years to three months. By the end of the year, however, the father and youngest child had died, precipitating the

breakup of the family.[6] Susan's fate at this point remains unclear, although included in Lady Meux's will was a bequest of £20,000 "to be equally divided between the children of my late foster-mother," who remained unnamed.[7]

Susan followed her brothers to London, where one of them had become a butcher. She had little education or means, but she was a dazzling beauty with blue violet eyes, dark golden hair, and a striking figure. *The Illustrated London News* reported in her obituary that "she once appeared for a season in a Surrey pantomime."[8] Perhaps it was during her brief period on the stage (i.e. theatrical circles, cabarets, or dancehalls) that she added the name Valerie. By the time of her marriage, she was known as Val Reece; as the mistress of Corporal Reece of the Life Guards, she had taken his name.

Henry Bruce Meux, known as Harry, was born in 1856 into an immensely rich brewery family. However, soon after his birth, his father, Henry Meux (pronounced "muse"),[9] the second baronet, developed a mental illness, and his wife, Louisa Brudenell-Bruce, abandoned him and their son to live out her life in France. On reaching his majority in 1877, he was granted an enormous allowance of £28,000 a year.[10] (At the time a man with £5,000 a year was considered wealthy, while a professional man might earn £500 a year.)[11]

It is thought that the twenty-two-year-old heir met his future wife in the Horseshoe Tavern, adjacent to the Meux brewery in Holborn, or at the nearby ill-reputed dancehall, the Casino de Venise, where Val was "an *habituée* or perhaps a hostess."[12] They were married by special license on October 27, 1878, at All Souls Church, Langham Place, Marylebone, evidently to avoid interference from the Meux family or any of the "pleasure-seeking 'men about town'" who had known the new Mrs. Meux as Val Reece.[13]

Mrs. Meux's concealment of her past and fashioning of a new image began on the day of the marriage; on the certificate her father is listed as "William Langdon, deceased, a gentleman."[14] The gossip column of *Truth* reported on November 14: "Mr. H. B. Meux, having been married by Miss Reece, has abandoned all idea of Parliamentary career. . . . By marrying Mr. Meux, Miss Reece has landed the biggest fish which has floated in the matrimonial waters for some time."[15] Another article in *Truth* commented on this "extraordinary marriage" between the bride who "is not *dans la première jeunesse,*" and the bridegroom, "a youth fresh from college, the master of an enormous allowance from trustees . . . and before this strange step, was supposed

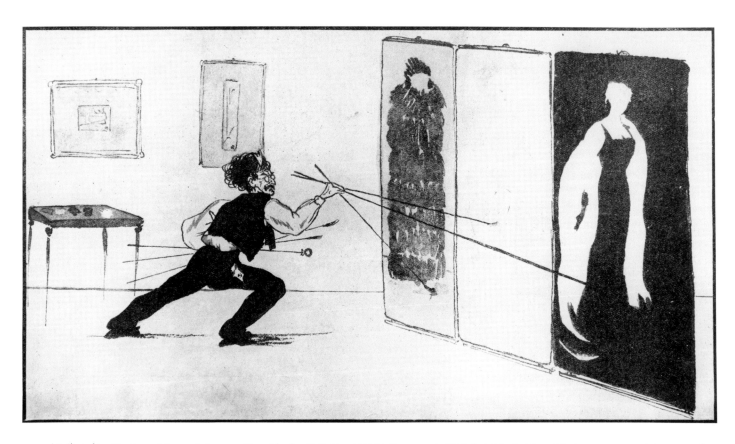

149 Attributed to Mortimer Menpes (1855–1938) or Charles H. E. Brookfield (1857–1913), *Whistler's "Lady Meux,"* before 1911, pen, ink, watercolor, and pencil, 5 × 7½ (12.7 × 19), Rosenbach Museum & Library, Philadelphia, D 2/12

to be a lad quiet, refined, and with High Church proclivities."[16] Harry's estranged mother, on receiving the news that her son had married "the kept mistress of a Captain [or Corporal] Reece," wrote to her brother: "I believed him to be quiet and a perfect gentleman, and therefore never for an instant thought it possible he should be mad enough to <u>marry</u> any lady of that class. . . . I hear she is well known and has been knocking about London for ten years. She is five years older than him. . . ."[17]

Marriage to one of the most eligible men in town was but the first of a series of bold, self-transforming steps taken by Valerie Meux. Both she and her husband seem to have believed that marriage would convert her into a lady. Shortly after the wedding, Harry showered her with diamonds valued at £10,000. The family was outraged and consequently took action to limit his power in the firm—"owing to his marriage and inordinately extravagant purchase of jewellery"—and to prevent any interference from his wife.[18]

Three years later the couple was established in grand style in both country and city residences. A Wiltshire census of 1881 lists the former Susan Langdon as Valerie Bruce Meux (birthplace Exeter), wife of Henry Bruce Meux, living at Dauntsey Manor House, a country estate on 50,000 acres of parkland and prime hunting ground, with nine servants.[19] (The couple also resided in a house in London's fashionable West End at 41 Park Lane.) Henry's age is listed as twenty-four, as is Valerie's, although according to the previous census and her date of baptism, she would have been twenty-nine. Five years have dropped out of her life along with the name Susan. However, with her dramatic change of fortune, Valerie Meux also remained loyal to her original family—in her fashion. According to Langdon family tradition, her secretary was her younger sister, whom she took in under a pseudonym; as for her brothers, she paid their passage to New Zealand and gave them sufficient funds to establish themselves on a new continent.[20]

In 1883 Henry succeeded to the baronetcy and came into an enormous fortune, consisting of one-half of the profits of the brewery. As Sir Henry and Lady Meux, they established themselves at the family seat, Theobalds Park

(Hertfordshire), in an eighteenth-century house on a historic site. Over time they enlarged it for entertaining on a large scale. Now settled in grand houses, her beauty enhanced with dazzling jewels and clothing, Lady Meux embraced the role of grande dame. A photograph of the period attests to her legendary sensuality (fig. 150). Although she was intelligent and adventurous, she was snubbed by the maternal side of her husband's family as well as the local gentry. Ten years later, Lady Meux candidly described her situation when interviewing the young Margaret McMillan, later an important figure in the Labour movement, for the position of secretary. "I am a woman not received. . . . Men come here, distinguished men, but not their women. I am outside. . . . It is only right to tell you, that it isn't a good thing for you to come here. You might not get another post."[21]

THE COMMISSION

Nothing is more revealing of Mrs. Meux's desire to remake her image and assert her rightful position in society than the portraits commissioned from Whistler in 1881.[22] The period following the artist's bankruptcy in 1879 were his "années de combat," Duret noted; "it was an act of courage to have oneself painted by Whistler . . . one was seen as an ignorant person, devoid of artistic comprehension, and above all, a dupe. . . . Nevertheless, Lady Meux, without troubling herself with the opinion of others, commissioned a first portrait of him."[23]

Introduced to her at a social club by the artist Charles Brookfield,[24] Whistler must have relished the challenge of colluding with the brash and vivacious Mrs. Meux in constructing an image that would confirm through art a status that was denied her in real life. Furthermore, the commission for three portraits at 500 guineas was the first he received for full-scale portraits after his bankruptcy. Buoyed with optimism, Whistler rented a studio at 13 Tite Street, not far from the famous White House, which he had lost to his creditors. Alan Cole reported that Whistler told him "he is going to paint all the fashionables—views of crowds competing for sittings—carriages along the streets."[25]

The expatriate Whistler seems a surprising choice for Valerie Meux, who was anxious to confirm her place in the English establishment. Was it to attract their attention or a question of *épater le bourgeoisie*? Or did she, like other outsiders of enormous wealth, such as F. R. Leyland, see an alternative avenue into society through the less hierar-

150 Unknown photographer, Valerie Meux, 1880s. Courtesy of Theobalds Park

chical world of art, where eccentrics were tolerated? In this domain, she could establish respectability as a patron and collector. On her honeymoon in Egypt, Mrs. Meux had already begun to buy antiquities and over time would build up her "museum of Egyptology" at Theobalds, some of which she left to the British Museum.[26] Nevertheless, the leap from antiquities to Whistler was a bold one and characteristic of her flair for self-transformation.

ARRANGEMENT IN BLACK: LADY MEUX, 1881

In what was described by Whistler's friend Thomas R. Way as her "state portrait,"[27] the painter created a carefully coded message that asserts her power and status as a woman of society. Mrs. Meux at age twenty-nine is

depicted full length in a dark, atmospheric space (fig. 152). Her body is turned slightly to the right, her right arm hanging down at her side, and her head facing front with eyes looking outward and down with an expression that is both aloof and somewhat wistful. We look up at her "painted" face: cheeks and lips reddened with *papier poudre* and *rouge à levres*, and eyes outlined in black. She is dressed in black for an occasion of the most elegant type—a ball, the opera, or a formal reception. Whistler continued in the vein of his Spanish-inspired black-on-black paintings begun in the early seventies with his por-

151 Francisco de Goya y Lucientes (1746–1828), *Queen María Luisa in a Mantilla*, 1799, oil on canvas, 82³/₁₆ × 49³/₁₆ (209 × 125), Museo del Prado, Madrid

trait of Leyland. The connection to the Spanish tradition here, however, is closer to the delicate painterly style of Goya than to Velázquez, as seen, for example, in Goya's portrait of *Queen María Luisa in a Mantilla* in which the queen wears *maja* costume (fig. 151).

In the *Arrangement in Black: Lady Meux*, Whistler made use of conventions of state portraiture that convey a sense of grandeur and authority: the frontal figure is depicted from slightly below and is shown still, erect, and luxuriously attired.[28] In her portrait, as in real life, Val was playing to an audience. Each part of her attire signifies her status in a code that would have been recognized by her contemporaries. Mrs. Meux's carefully chosen toilette and diamond jewelry bespeak wealth and power. Indeed, the portrait is almost a textbook illustration of the nineteenth-century American economist Thorstein Veblen's notion of apparel as the primary means of expressing one's "pecuniary standing to all observers at first glance."[29] Mrs. Meux unabashedly "wears" her new-found wealth.

The most spectacular part of her toilette is the famous diamond parure (or matched set) that had instigated a family furor.[30] Diamonds were then, as now, the most expensive and coveted precious stones, which proclaim "to the most distant of the surrounding crowd, the person of the monarch, the noble, or the beauty."[31] The crowning glory of the parure was the tiara. In the generally prosperous late Victorian era, diamond tiaras and diadems were in widespread use for state occasions, balls, and private dinners, owing in part to the increased availability of the gems through the discovery of mines in South Africa in the 1860s.[32] So prevalent had they become in the last decades of the century that in 1898 *The Illustrated London News* commented: "Hereditary gems are even outshone by tiaras of no ancestry whatsoever and the young married woman who does not glitter and scintillate at points is the exception rather than the rule."[33] Thus bejeweled, Mrs. Meux displayed herself as both enormously wealthy and in fashion, yet the influence of the diamond tiara was waning, and considered even vulgar when worn as new by the nouveaux riches. Whistler, who rarely portrayed his subjects in jewels, captured the radiance of the diamonds in short, energetic, sparkling strokes of paint that frame Mrs. Meux's face and ornament her arm. He makes use of the tiara to set off her head from the dark surrounding ground (fig. 153).

Valerie Meux wears a simple but luxurious sleeveless black velvet gown, perhaps chosen to set off her jewels.[34] It is quite likely a dress of her own, possibly bought specifically for her portrait, or selected with Whistler from her

152　*Arrangement in Black: Lady Meux*, 1881, oil on canvas, 76½ × 51¼ (194.2 × 130.2), Honolulu Academy of Arts, Purchase, 1967, 3490.1 (YMSM 228)

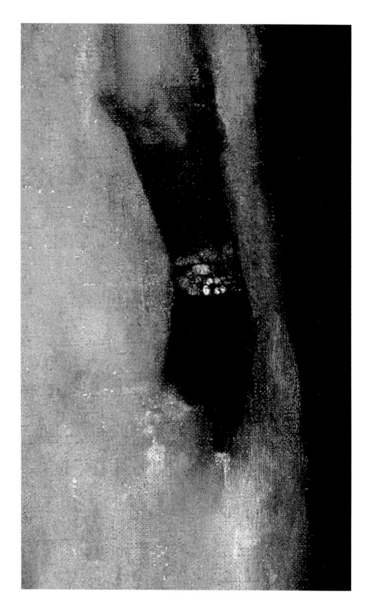

153 Detail of fig. 152

154 Detail of fig. 152

wardrobe. Resting on her left shoulder is a full-length white fur-trimmed cloak that sets off the black gown from the dark surrounding space. Black gloves, edged in net or lace, the same trimming that appears on the bodice, and a large diamond bracelet complete Mrs. Meux's toilette (fig. 154). Two vigorous pen-and-ink drawings for the painting focus on the costume and pose, largely ignoring the face; they provide another view of Valerie's attire, in which the figure as a whole is slightly more slender and dynamic than in the painting (figs. 155, 156).[35]

Whistler painted the portrait in broad strokes on coarse canvas, gliding over details and deliberately blurring the boundaries between the outer garment and the dress. Mrs. Julian Hawthorne, an American writer (and daughter-in-law of Nathaniel), who saw the painting in progress, described his technique: she recalled that the artist, standing some twenty feet from his sitter, "held in his left hand a sheath of brushes, with monstrous long handles; in his right the brush he was at the moment using. His movements were those of a duelist fencing actively and cautiously with the small sword."[36]

It is not known which couture houses Mrs. Meux patronized, nor did Whistler intend for the dress, or skirt with a separate low-cut bodice, to be clearly read in the painting:

it became in the process of painting an element in Whistler's artistic arrangement. For a formal portrait by a well-known artist, status-conscious Mrs. Meux, like other society women of the period, may well have turned to one of the leading French couturiers. The close-fitting gown is theatrical in its elegant line and dramatic sweep of drapery and flatters her voluptuous figure. In its simple shape, it does not conform fully to the fashion dictates of the period. As Ribeiro has noted, black was used at this time for sophisticated evening apparel, as seen in the sleeveless black beaded bodice and skirt made by Hoschedé-Rebours (fig. 157).[37] Nevertheless, the color evidently led to confusion when the portrait was first exhibited in 1882. One reviewer referred to the subject as a lady "dressed in deep mourning" and later to "the young widow's costume," noting that

155 *Study for "Arrangement in Black: Lady Meux,"* 1881, pen and brown ink on off-white wove paper, laid down on card, 5³⁄₁₆ × 3¾ (13.1 × 9.5), The Art Institute of Chicago, Gift of Walter S. Brewster, 33.296 (M. 850)

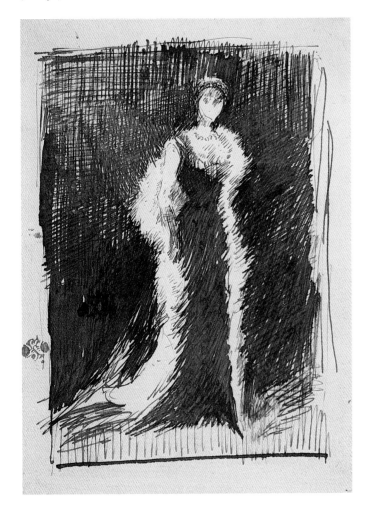

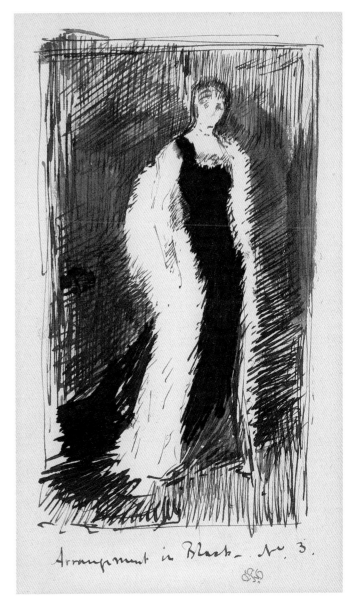

156 *Arrangement in Black—No. 3,* 1881, pencil, pen, and brown ink on off-white laid paper, 6¹⁵⁄₁₆ × 4⅜ (17.7 × 11.2), National Gallery of Art, Washington, D.C., Rosenwald Collection, 43.3.8817 (M. 851)

"the effect is startling, beyond description."[38] The stark contrast of the black velvet against the subject's pale skin may indeed startle, but Mrs. Meux's carriage exudes pride and confidence. The black gown, which she wears in a self-assured, even assertive manner, much like John Singer Sargent's *Madame X (Mme Pierre Gautreau)* of 1883–84, serves to underline her sophistication and penchant for dramatic display (fig. 158).[39]

Unconventional for the time is the spare, unembellished, fluid style of the dress, which differs from the contempo-

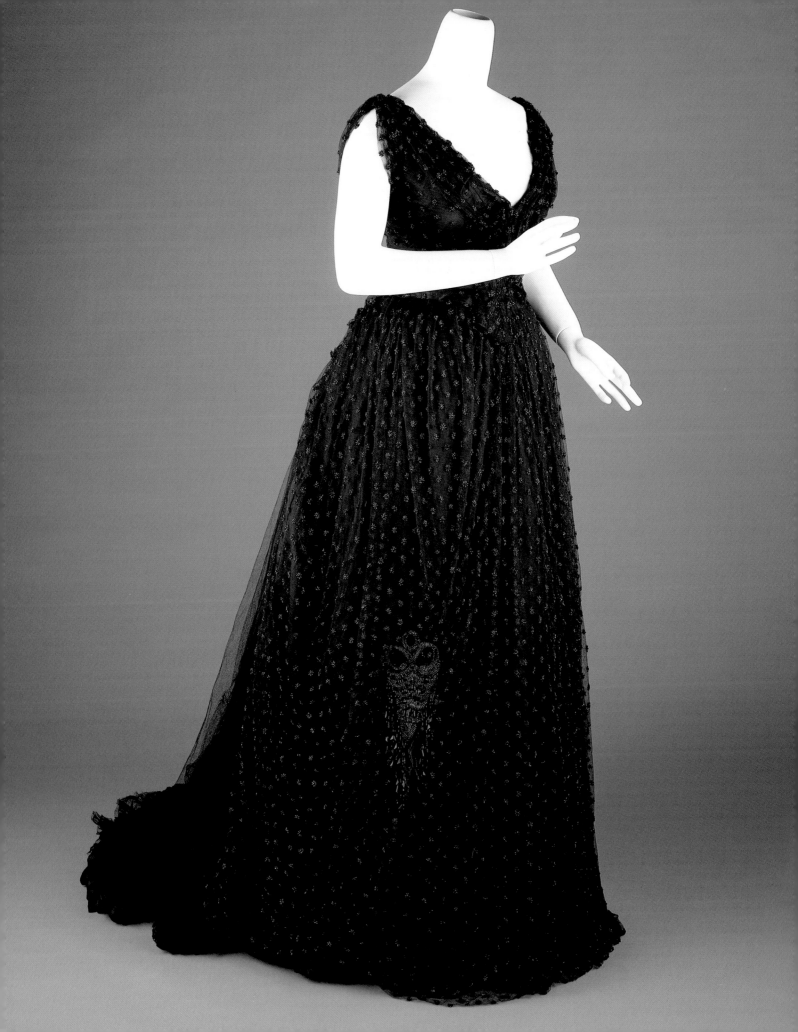

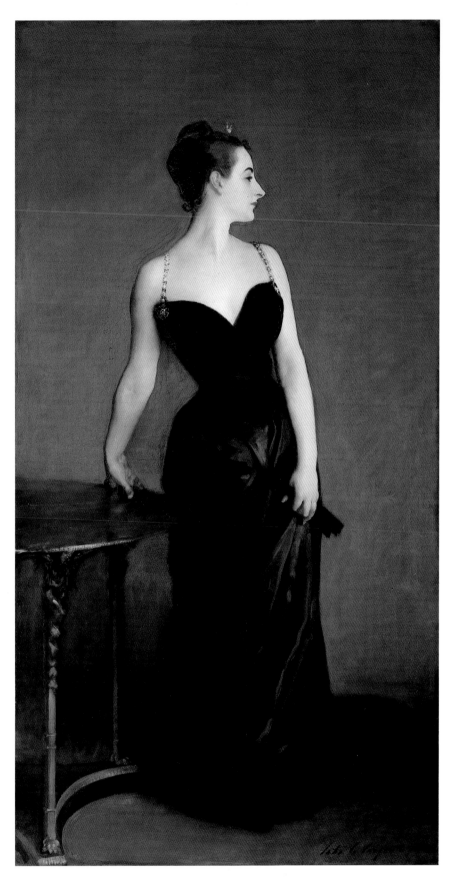

157 (*facing page*)
Evening Dress,
c. 1880, Maker:
Hoschede-Rebours, black
silk tulle (net), silk satin,
and black jet embroidery,
Brooklyn Museum of
Art, Gift of Mrs. Fredrick
S. Prince, Jr., 67.110.89

158 (*left*) John Singer
Sargent (1856–1925),
*Madame X (Madame
Pierre Gautreau)*,
1883–84, oil on canvas,
82⅛ × 43¼
(208.6 × 109.9), The
Metropolitan Museum of
Art, New York, Arthur
Hoppock Hearn Fund,
1916, 16.53

159 Léon-Joseph Florentin Bonnat (1833–1922), *Jane Lathrop Stanford*, 1881, oil on canvas, 91$^5/_{16}$ × 63$^{13}/_{16}$ (232 × 162), Iris. and B. Gerald Cantor Center for Visual Arts at Stanford University, Stanford Family Collections, CCVA, 12020

purest kind. . . . How Mr. Whistler contrives to give an effect of softness and harmony to a subject which in any other hands would appear hard and crude is a mystery known only to himself. . . . You feel that the reality in all its details is there, though, as it were, behind a veil."[41] In a review of Whistler's exhibition at the Goupil Gallery in London in 1892, the painter Walter Richard Sickert commented: "Look at the revel of the brush on the coarse threads of the portrait of Lady Meux. Is it not beautiful and exhilarating in itself, and is it not a marvel how the living, breathing woman in that dainty gown is built up by passages of brushwork, which in no way copy the dress, but express it in a language of inspiration?"[42]

The element of ambiguity as to how to read the garment—to the frustration of the costume and art histo-

160 James Tissot (1836–1902), *The Woman of Fashion (La Mondaine)*, 1883–85, oil on canvas, 57 × 39 (148.3 × 103), private collection

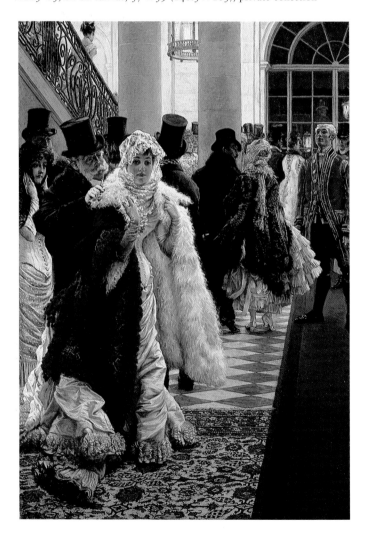

raneous ornate *grandes toilettes*, as seen, for example, in the Worth gown worn by Mrs. Leland Stanford in her portrait of 1881 by Léon-Joseph Florentin Bonnat (fig. 159).[40] Mrs. Meux's gown, with its fitted waist, defined, low-cut neck, and streamlined appearance points to the future, anticipating the sleek modern style of the early twentieth century. Whistler emphasized the strikingly simple lines of the dress, leaving details to the viewer's imagination.

Just as Whistler glided over details of the dress, so he did with the enormous fur wrap, eschewing literal description for the expressive power of the abstract qualities of form and color. The costume is transformed, in the words of Mrs. Hawthorne, into "a study of black and white of the

rian—suggests a symbolic function in the painting. Does the train belong to the cloak, which would have been made of black velvet and lined or liberally trimmed with white fur? Or is it worn over a black velvet gown with a long train? And what kind of fur is it, or is it fur at all?[43] Contemporaries described the garment in various ways. Mrs. Hawthorne noted: "She is dressed in a flowing black robe, broadly-trimmed with soft white fur or swan's down," and, in a later article, she described the costume as a "splendid fur-trimmed cloak falling off her white shoulders."[44] According to Way, Mrs. Meux was "dressed in evening robes of black velvet...a white fur cloak which hangs from her shoulders."[45]

The type of fur is also left to the viewer's imagination. Duret, who also saw the painting in progress, referred to it as "mouton du Thibet."[46] We see such an evening cloak lined with sheep's wool in James Tissot's *The Woman of Fashion (La Mondaine)* (fig. 160).[47] The fur in the Meux portrait, however, appears softer and lighter than wool. Later accounts of the painting refer to the fur as ermine, white sable, and white fox.[48] Even if we are not able to identify Mrs. Meux's outer garment as a specific type, or to name the fur, it expresses opulence through its sheer size; fur, like diamonds, was long associated with nobility, wealth, and power.[49] In Victorian England, it was used extensively in clothing by the aristocracy and the nouveaux riches alike to denote status and wealth.[50] Whistler himself owned a fur-lined coat and depicted many of his sitters wearing or holding fur garments, a notable example being the Comte de Montesquiou with his chinchilla stole (fig. 161).[51] In the portrait of Meux, however, Whistler translated the voluptuous garment, whether of white fox, Tibetan wool, or swan's down, into pictorial values of lightness and softness, and invested it with multivalent meaning; it caresses the figure and seems to radiate from her. She seems to emerge from her animal skin like a mythological creature, lending a fantastic element to the work, a testament to her animal magnetism. Duret referred to the work as "mystérieux" and "fantastique,"[52] while the Symbolist J.-K. Huysmans described it as "ghost-like, and above all bizarre."[53]

Through ambiguity, Whistler struck at a more aggressive side of this newly coined society matron in the so-called state portrait by drawing as well on conventions associated with the representation of the femme fatale. Viewers would have picked up on such allusions to the predatory figure whose spellbinding erotic power leads men to ruin or death, for the femme fatale was a ubiquitous figure in late nineteenth-century art and literature. She was celebrated in

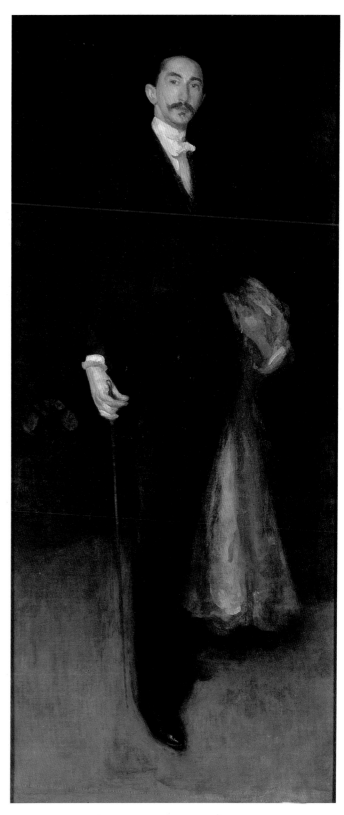

161 *Arrangement in Black and Gold: Comte Robert de Montesquiou-Fezensac*, 1891–92, oil on canvas, 82⅛ × 36⅛ (208.6 × 91.8), The Frick Collection, New York, 14.1.131 (YMSM 398)

the stories of Gautier and Flaubert and the poems of Baudelaire (*Les Fleurs du mal*) and represented in paintings of the Pre-Raphaelites, Manet, and others.[54] The femme fatale is often depicted surrounded by wild animals, or adorned in fur or feathers, or as transmogrified into part-woman part-beast.[55] A caricature of 1882 in the *Journal Amusant* entitled "Madame Harry-Men," bearing the inscription *seule inventeur de la pommade Albinos, pour faire blanchir instantanément les cheveux*, depicts the

162 "Madame Harry-Men" (*sic*), *Journal Amusant* (May 20, 1882), by permission of Glasgow University Library, Department of Special Collections

subject with flowing white hair falling from her head to her feet (fig. 162).[56] The conversion of fur into long tresses—another common attribute of the femme fatale—points to the seductress beneath the veneer of the grande dame.

Mrs. Meux's direct stare further connects her with representations of the *cocotte*, the most famous example of which is Manet's *Olympia*. Her "painted" face also situates her somewhat ambiguously between the demimonde and the more avant-garde segment of *le monde*. Up until the late 1870s rouge, eye makeup, and lipstick were common signifiers of the prostitute or actress; no respectable woman would use them, but the tide of taste was turning. In 1878 Eliza Haweis argued that the discreet use of cosmetics need not be condemned, when so many other artifices, such as tight corsets and padding, were accepted.[57] Cosmetics were beginning to be sold on open counters in department stores.[58] Mrs. Meux's opulent attire, abundance of fur, conspicuous use of makeup, and aggressive stare situate her at the edge of respectability and the forefront of fashion and attest to her independent spirit and will to provoke. Whistler's "beautiful Black Lady," as he affectionately referred to his portrait, extends the boundaries of society portraiture by investing it with a darker Baudelairean view of woman, whose task it is to devote herself to "appearing magical and supernatural; she has to astonish and charm us; as an idol, she is obliged to adorn herself in order to be adored."[59]

While in Bonnat's portrait of Mrs. Stanford, her gown, fur cloak, and parure can be clearly identified.[60] Whistler downplays the material nature and specificity of costume and jewels, in keeping with his emphasis on abstract aesthetic qualities. A review of 1883 mentioned the forward-looking aspects of the work:

> Last year Mr. Whistler had a portrait of a woman with a fur in black and white; she looked like a vision and she does not seem to have been understood in her utter simplicity. Yet one must become accustomed to these concerns when one wishes to appreciate all individual revelations in the form in which they are produced.[61]

Degas summed it up when he saw the work at the Salon and described it as "an astonishing Whistler, excessively refined, but of such quality"[62]

In his first portrait of Mrs. Meux, Whistler portrayed her as a grande dame in a manner that gently satirized as well as reinforced her status. The subject is depicted in all her finery, as if challenging the viewer to question her authenticity as a real lady. Yet in her portraitist's subtle manipulation of codes, she is represented also as a "painted lady."

* * *

HARMONY IN PINK AND GREY: PORTRAIT OF LADY MEUX, 1881–1882

Also commissioned in 1881, Whistler's portrait of Mrs. Meux in The Frick Collection was completed and exhibited in 1882 at the Grosvenor Gallery in London, the same year the "state portrait" was displayed across the Channel at the Paris Salon. If she was wrapped in mystery and ambiguity in the first portrait, Mrs. Meux here emerges from the shadows and boldly takes the stage in full three-dimensional form. A synergy of art, high fashion, and sexuality characterizes the Frick portrait (fig. 165).

Here Mrs. Meux stands in profile facing right, head turned to the front, displaying her voluptuous form to best advantage, as well as the magnificent long train of her dress. Her upright posture and the taut vertical line of her right arm express defiance and set off the curves of her body and costume, while the tilt of her head, partially concealed under a large round hat, and bold outward gaze convey her confidence in her seductive powers. She stands in front of a pale curtain in a shallow, stagelike space on a reddish brown ground. The formality of the Spanish-inspired black portrait is replaced by a palette in warm pastel shades and an even more vigorous painterly technique that evokes the style of Gainsborough.

Mrs. Meux wears an afternoon dress in pink satin and a fine silver gray fabric, probably chiffon, and a large, beribboned round straw hat with an upturned brim. The bodice is made of semitransparent chiffon with a ruffle at the neck and tight sleeves banded in satin at the wrist, ending in a ruffle. Over the chiffon bodice is a form-fitting pink satin waistcoat embellished with a row of tiny pink satin-covered buttons that provocatively outline her breast, suggestive of the act of buttoning and unbuttoning. The sleek appearance of the bodice, with a dramatically cinched-in waist and uplifted bust, could only have been achieved with the invention in the 1870s of the steam-molded corset.[63]

The skirt, made of the same silver gray, possibly diaphanous, fabric as the bodice, cascades to the ground in rhythmic folds, terminating in a train trimmed in pink satin and pink chiffon ruffle, painted in free bold brush strokes. The shiny, opaque satin fabric, represented in strokes of thin glossy paint, contrasts with the matte finish and translucency of chiffon, providing Whistler with an opportunity for a display of virtuoso brush technique and a subtle range of pink and silver tones that compete in its sensuality with that of the dress and the sitter herself. The delicacy and color of the fabric of her dress reinforce the image of a woman of leisure and wealth—woman as ornament.

Mrs. Meux is probably dressed in French haute couture. Like the silk dress of 1880 discussed previously by Ribeiro (fig. 164), Valerie Meux's dress exemplifies the virtuoso dressmaking of the period.[64] While it is not possible to connect the dress, perhaps transformed in the process of painting, to a specific couturier, it is close in spirit to the ultrafeminine gowns of Jacques Doucet, known for their soft, pastel colors and elaborate workmanship, which were inspired by the fashions of eighteenth-century France,

163 Unknown photographer, *Harry and Val in the Highlands*, c. 1880. Photograph courtesy of Peter Rooke

although it could equally be by Worth. While the titled ladies of Europe and American heiresses flocked to the House of Worth for its prestige, the seductive style of Doucet appealed to women of more dramatic temperament, and the grand courtesans.[65] As a client, Mrs. Meux fit both categories. While Whistler may have simplified the style of the dress to fit the requirements of his art, he certainly modified the shape of his client (whose figure the Pennells kindly described as "luxuriant"), as a comparison with a contemporaneous photograph of Mrs. Meux, in which she stands in almost the exact same position as in this portrait, makes clear (fig. 163).[66] In its marriage of the artifice and luxury of haute couture with sexual display, Whistler's *Harmony in Pink and Grey* seems to allude to the more basic function of fashion—to ensnare.

As in the previous portrait, Whistler draws on aspects of the representation of the femme fatale in the figure's assertive stance and outward stare. Among the most

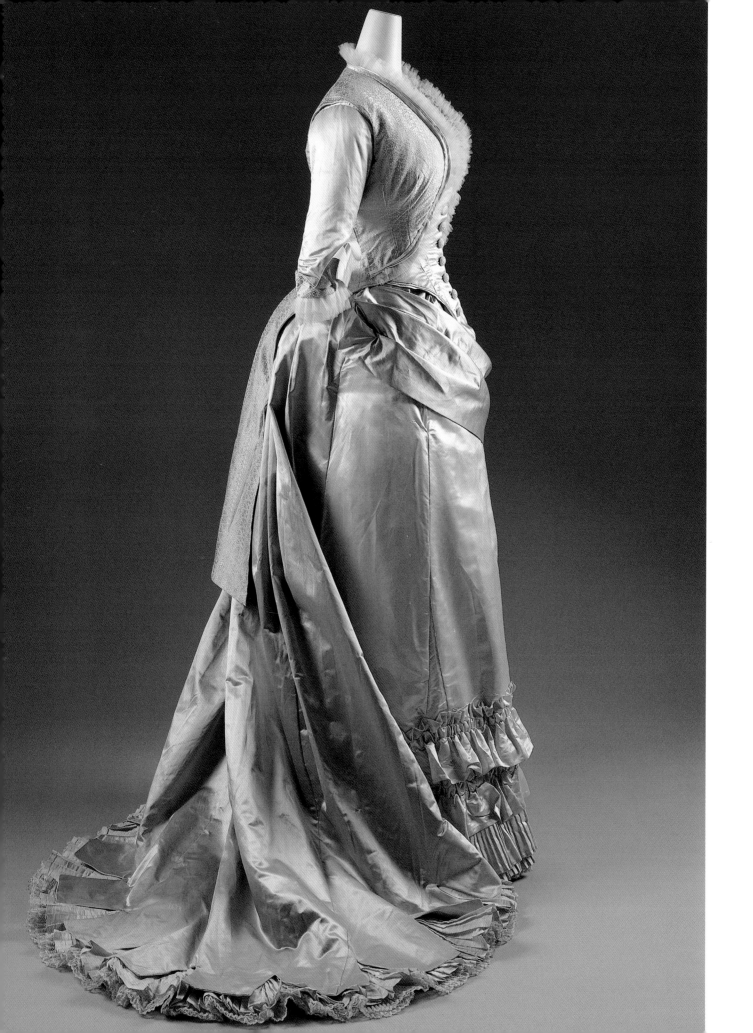

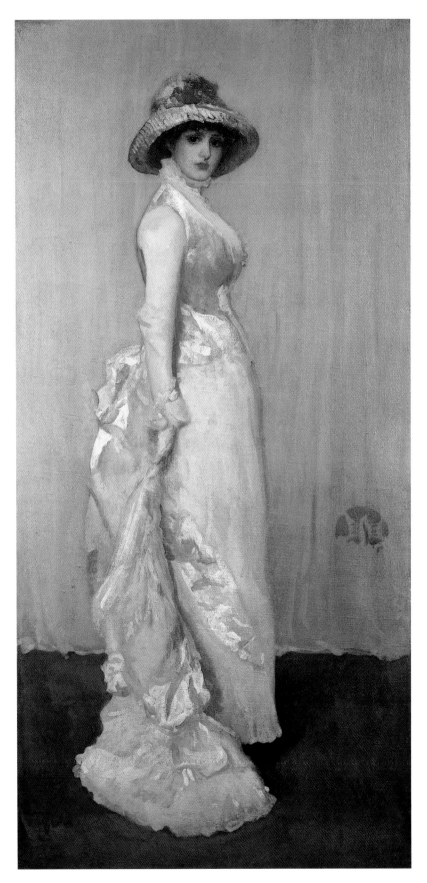

164 (*facing page*) Dinner Dress, two piece, c. 1877–83, American or French, brocade and satin, The Metropolitan Museum of Art, New York, Gift of Elizabeth Kellogg Ammidon, 1979, 1979.34.2a–d

165 (*left*) *Harmony in Pink and Grey: Portrait of Lady Meux*, 1881–82, oil on canvas, 76¼ × 36⅝ (193.7 × 93), The Frick Collection, New York, 18.1.132 (YMSM 229)

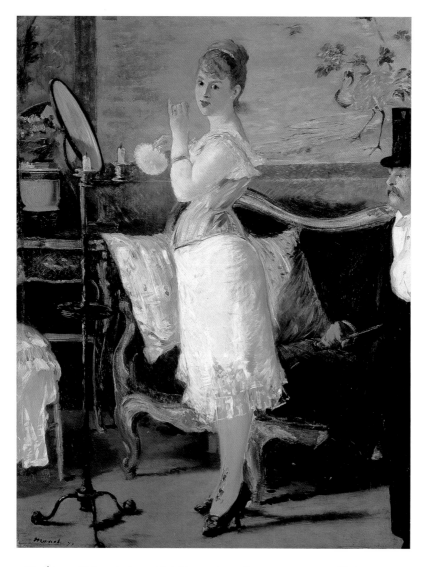

166 Édouard Manet (1832–1883), *Nana*, 1877, oil on canvas, 59 × 45¹¹⁄₁₆ (150 × 116),
Kunsthalle, Hamburg

famous representations of a *cocotte* of the time was Manet's scandalous *Nana* (1877), which depicted a scantily clad young courtesan in corset and petticoat pausing, while powdering her face, to look out at the spectator (fig. 166).⁶⁷ Whistler would have known the painting and possibly even seen it in Manet's studio; his portrait of Mrs. Meux exudes a similar spirit of defiance and overt sexuality. In fact, Valerie's pose, though facing the opposite direction, and her confrontational stare are also similar to those of Manet's model. Although she appears in form-fitting attire, not *deshabillée*, Mrs. Meux's shiny pink vest reads, as Ribeiro has noted, almost as a corset worn on the outside. Both paintings are light in tone, pastel in color, and

painted in free, energetic brush strokes, which echo the sensuality of the sitter and her clothes. The similarities may allude to the shared background of the subjects of the two works: one a former "actress," the other a fictional courtesan created by Zola, whose likeness was based on a well-known actress of the period, Henriette Hauser.

The curious round straw hat with the deep pink ribbon does not appear appropriate to the type of dress the subject is wearing. When the painting was exhibited to generally favorable reviews at the Grosvenor Gallery in 1882 and ten years later at the Salon in Paris, the hat was singled out for derisive comment. It has been described as a "queer basket-shaped hat"⁶⁸ and "a hat of peculiar hideousness, more like

an extinguisher than an article of headgear,"[69] while Henry James commented, "the hat does not fit."[70] The straw hat, boldly painted in slashing brush strokes, appears to have been added for primarily formal reasons to balance the curves of bust and train and add another texture to the painting, as well as to contribute a note of coy sexuality that underlines her obvious sophistication. In a drawing entitled *Harmony in Flesh Colour and Pink*, which appears to date between 1882 and 1884 and thus follows the oil, Whistler drew the figure in a more curvilinear form, relaxed the tension of the arm, and increased the width of the brim of the hat—alterations that he may have made in response to criticisms of the painting (fig. 167).[71]

On the walls of the Grosvenor Gallery—the hotbed of aestheticism— Valerie Meux through her representation by Whistler took a place among the titled ladies, nouveaux riches, and intellectual elite. A review in *The Art Journal* proclaimed their joint triumph: "Mr. Whistler has never painted anything more delicate in colour than this, nor even, perhaps, anything quite equal to it in the rhythm of line to be obtained from the sweep of female drapery."[72] The freedom of his brushwork inspired a cartoon of the painting in *Punch*, with a caption reading: "To be completed in a few more Sittings" (fig. 168). When Whistler exhibited the work at the Salon in Paris a decade later, the response was equally favorable. The *Gazette des Beaux-Arts* reference to the subject as a "noble lady in elegant toilette" and the artist as "one who understood the intimate union between a woman and her attire" would have been deeply gratifying to both.[73]

In both portraits of Mrs. Meux, Whistler pushed his image of the subject to the limits of decorum and respectability, endowing her with a vitality that did not preclude overt display of her wealth and sexuality, verging on the vulgar. Whistler ennobled his subject, while showing her as daring and unconventional. In playing the norms of the representation of the grande dame against those of the less respectable social counterpart, Whistler subtly satirizes his subject, while also critiquing the rigid stratification of society that excluded her. His portraits acknowledged what her husband's family and society refused to recognize: that she was legitimately one of them, with even more wealth and beauty, though her conspicuous display of both suggested she was not.

167 *Harmony in Flesh Colour and Pink*, 1882–84, pen and brown ink on cream laid paper, 6⅞ × 4⅜ (17.6 × 11.1), Davison Art Center, Wesleyan University, Middletown, Connecticut, 37.D1-94 (M. 852)

168 "To be completed in a few more Sittings," *Punch*, vol. 82 (May 27, 1882), p. 241, by permission of Glasgow University Library, Department of Special Collections

169 *Harmony in Crimson and Brown*, 1881, pen and brown ink on cream laid paper, 6⁹/₁₆ × 3¹³/₁₆ (16.7 × 9.7), Collection of Janet Freeman (M. 853)

PORTRAIT OF LADY MEUX IN FURS

The third full-length portrait by Whistler of Lady Meux, which was smaller in scale than the first two and probably destroyed, is known today through a description by a contemporary writer, two drawings, and a photograph of the painting in an unfinished state.[74] When Mrs. Hawthorne visited Whistler in 1881, she reported: "The other portrait, apparently of the same subject, was treated in a subdued tone of brown and brownish-red. The pose is somewhat as

before, but the figure is enveloped in a long brown fur cloak reaching nearly to the feet." Like the *Arrangement in Black*, she described it as a work "defiantly unelaborate in detail and broad in treatment."[75]

An exquisite, vigorously drawn pen-and-ink study of 1881 entitled *Harmony in Crimson and Brown* shows Mrs. Meux standing in a frontal position in full-length fur, her hands in a fur muff at her waist, and wearing a fur hat or toque (fig. 169). Her brightly lit face is the only part of her body that is exposed. She has almost completely merged with her fur attire, taking on a quasi-feline persona. Dressed in a coat or jacket whose fur is worn on the outside—a Victorian innovation—Mrs. Meux demonstrates here, as she does in her other portraits, her fashion currency, flaunting her "pecuniary worth."[76]

The canvas in unfinished form may be seen in a photograph in Glasgow University Library (fig. 170). (A second pen-and-ink sketch of 1884, which has since disappeared, shows the painting in its frame, the texture of the fur conveyed with puddles of ink giving a "rich and lustrous effect.") In the *Harmony in Crimson and Brown*, as in the *Arrangement in Black*, Whistler made use of the formula for the "state portrait"; here, however, the figure is yet more frontal, static, symmetrical, and iconic, and the clothing even more luxurious. She is dressed from head to toe in winter sable, the most highly esteemed and costly fur of all.[77] The painting, in fact, echoes Holbein's regal portrait, *Christina of Denmark, Duchess of Milan* (c. 1538), in which the subject is represented in a similarly frontal position, hands at her waist, wearing a full-length sable-lined gown and a hat pulled down on her head, against a plain ground (fig. 171). Whistler, who admired Holbein, owned a photograph of this work.

Posing for Whistler through interminable sessions and endless scraping down was an ordeal for most of his sitters. The additional physical burden of standing in heavy furs (which had to be stored in summer) led to the painting's demise. The portrait was still in progress in 1886, to the growing displeasure of both artist and model. Lady Meux was anxious to have the furs altered, presumably to update them. When she telegrammed Whistler on July 29, 1886, asking if her maid could stand in her place, he replied: "cannot struggle with melting maids in altered furs ridiculous prefer to pay back money though as always charming will paint you quite a new portrait new arrangement if you promise to stand for it yourself."[78] Lady Meux, however, dealt the last blow to the faltering relationship in an incident witnessed by the artist Harper Pennington and reported by the Pennells. Whistler, feeling exasperated,

170 Photograph of *Portrait of Lady Meux in Furs* (*Harmony in Crimson and Brown*), 1881–86, by permission of Glasgow University Library, Department of Special Collections (YMSM 230)

171 Hans Holbein the Younger (1497/98–1543), *Christina of Denmark, Duchess of Milan*, c. 1538, oil on oak, 70½ × 32½ (179.1 × 82.6), National Gallery, London

made a comment that offended Lady Meux. She replied softly: " 'See here Jimmy Whistler! You keep a civil tongue in that head of yours or I will have in some one to *finish* those portraits you have made of me!'—with the faintest emphasis on 'finish.' Jimmy fairly danced with rage. . . . Lady Meux did not sit again. . . ."[79]

"YOU OUGHT TO PAINT ME IN <u>WHITE</u>"

No evidence of those fashionable clothes that featured so prominently in Whistler's representations of Lady Meux, or the famous parure in *Arrangement in Black*, remain; however, the two extant portraits and sketch for the third reveal both the artist and his patron's attitude toward fashion. Lady Meux appears to have been a true believer in the ability of fashion, like theatrical costume, to transform one's image. The following vignette from the biography of the young socialist Margaret McMillan provides insight. Socialism, Lady Meux opined, "was a creed for the down and out," telling Margaret, "You will abandon it at once."[80] Meux encouraged Margaret to pursue an acting career and made efforts to change the young woman's image. "At once, she replaced most of Margaret's clothes. She bought her dresses, coats, hats, cloaks, gloves, laces and other things in profusion including a diamond and sapphire broach and other jewelry." She also provided Margaret with "tuition for a stage career."[81] The former actress Val Reece had experience in these matters; she had followed a similar process of self-transformation in taking up the role of the fashionable Lady Valerie Bruce Meux.

Lady Meux was gradually accepted by society, and in later years she devoted herself to philanthropic causes and horse racing.[82] Despite their rift, Lady Meux and Whistler kept in touch, often in connection with his requests to borrow one of the portraits for an exhibition, which she usually granted. She reminisced in a letter of January 13, 1892, "you & I always get on well together [.] I suppose we are both a little <u>eccentric</u> and <u>not</u> loved by <u>all</u> the world, personally I am glad of it as I should prefer a little hate."[83] There were passing references in her letters to other possible portraits that he might undertake. True to her priorities, Lady Meux described them in terms of what she would wear: "If you <u>ever</u> paint me again, I should like you to paint me in something <u>dreamy</u> I look best in soft colours."[84] "You ought to paint me in <u>white</u> with a large garden hat on."[85] Or, presumably in response to a suggestion of his: "I . . . regret that I am not in the mood to be painted as a Spanish female of the <u>15th</u> century."[86] Finally,

once Whistler had taken up residence in France, she concluded that the prospect of another portrait was unrealistic: "I fear you will never have the pleasure of painting me again now you are not in England as when in Paris, I spend all of my time at the dressmakers."[87]

SGG

LADY ARCHIBALD CAMPBELL

She was a tall woman of great distinction, svelte, blond, and also intelligent and independent in spirit. She was an ideal model for a painter.

– Duret, 1904

Lady Archibald Campbell had little in common with Lady Meux, other than being another of Whistler's major female patrons during the early 1880s. Lady Archie, as she was known, moved comfortably among the elite of English society; she was born Janey Sevilla Callendar and became the ward of the Duke of Argyll, whose second son she married in 1869. Her friend and sister-in-law Princess Louise was the daughter of Queen Victoria. Lady Archie was a strong advocate of aestheticism, becoming known in her time as "la grand dame esthétique de Londres."[88] Her role in the movement exceeded what would have been expected of a wealthy socialite; in addition to lending her financial support to artists, she initiated and acted in a series of plays, contributed articles to journals, and published a treatise on the relationship of music to color.[89] Entitled *Rainbow-Music*, the work displays her familiarity with the avant-garde principle of correspondence between the arts; examples drawn from Edgar Allan Poe, Velázquez, and Whistler form the basis of her "philosophy" of interior design.[90] Intelligent and assertive, Lady Archie at times elicited criticism from her well-connected peers and family for such bold choices as selecting the then controversial Whistler to be her portraitist.[91]

Between 1882 and 1884 Whistler painted three portraits of Lady Archie. The last and only surviving is *Arrangement in Black: La Dame au brodequin jaune—Portrait of Lady Archibald Campbell*, 1882–84 (fig. 175). The first painting by Whistler bought for an American public collection, the celebrated work portrays Lady Campbell in an unorthodox pose and modern costume.[92] The portrait strikingly contrasts with those of Lady Meux, whose luxurious dress and grand-manner poses emphasize her figure and wealth.

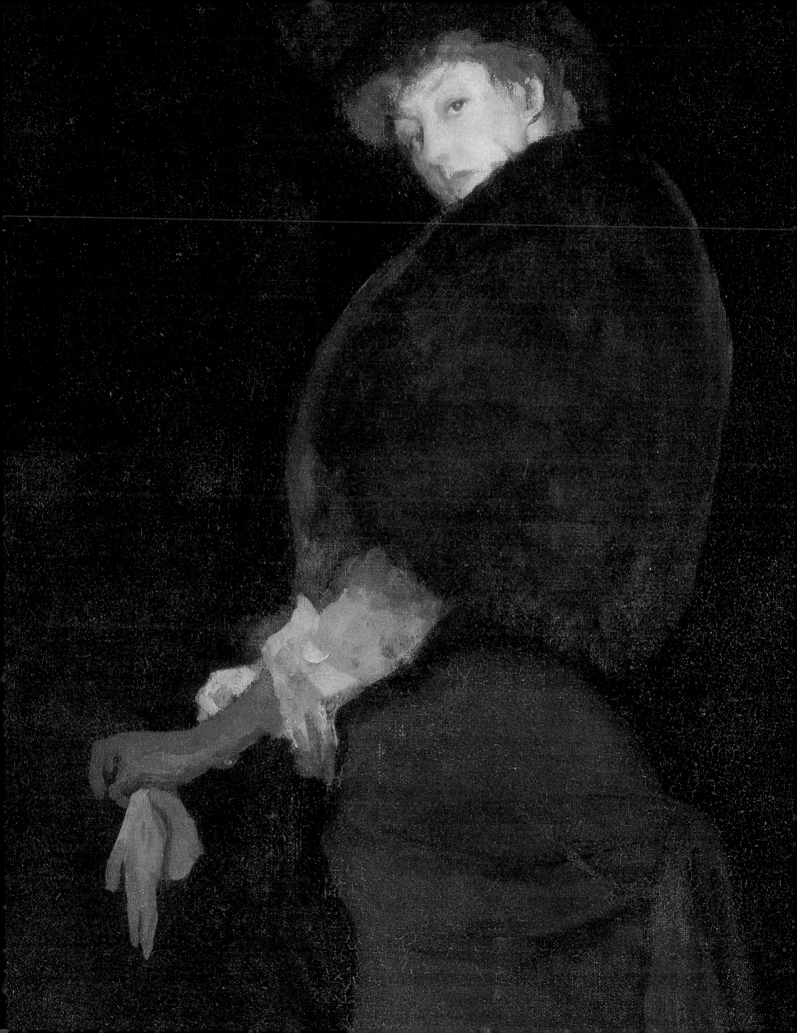

173 *Note in Green and Brown: Orlando at Coombe*, c. 1884, oil on panel, 5⅞ × 3½ (14.8 × 9), Hunterian Art Gallery, University of Glasgow, Birnie Philip Bequest (YMSM 317)

174 "Scene in Underground Railway Station," *Punch* (May 24, 1884), vol. 86, p. 244, by permission of Glasgow University Library, Department of Special Collections

Instead, Lady Archie turns away from the viewer. She is rendered in a state of motion, at a transitional moment satirized in *Punch* in 1884 as being conducive to catching a train in the Underground Railway Station (fig. 174). Her stance is one of "a great many studies in different costumes and poses" that Whistler attempted until Lady Archie threatened to discontinue the process, apparently staying because Duret convinced her that the work was a potential masterpiece.[93] Lady Archie's clothing complements the twisting pose. Her costume forms a series of oppositional

curves—from the blue gray skirt swinging out from the atmospheric background, to the fur cap pointing away from the viewer—while revealing only the broadest outlines of her reportedly svelte figure.[94]

Lady Archie later remembered the ensemble as being based on "the dress in which I called upon him."[95] Her costume is representative of a new mode—both fashionable and functional—offering increased mobility to women in the 1880s as they began to pursue careers and play sports. The skirt's weighty wool, loosely pleated style, short

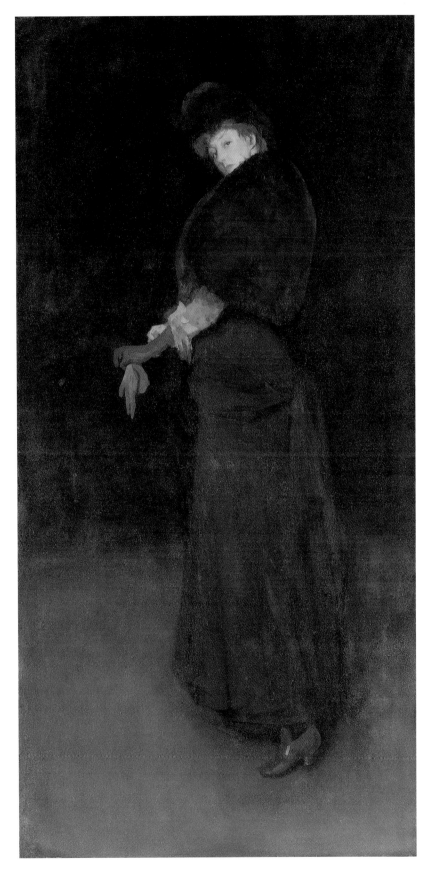

175 *Arrangement in Black: La Dame au brodequin jaune—Portrait of Lady Archibald Campbell*, 1882–84, oil on canvas, 98¹/₈ × 55⁵/₈ (218.4 × 110.5), Philadelphia Museum of Art, Purchased with the W. P. Wilstach Fund, 1895, W1895-1-11 (YMSM 242)

176 *Design for Lady Archibald Campbell's parasol*, 1881/82, pencil and watercolor on off-white wove paper, 11⁹⁄₁₆ × 9⅛ (29.3 × 23.2), Hunterian Art Gallery, University of Glasgow, Birnie Philip Bequest (M. 849)

177 *Harmony in White and Ivory: Portrait of Lady Colin Campbell*, after Whistler, 1866, wood engraving, by permission of Glasgow University Library, Department of Special Collections (YMSM 354)

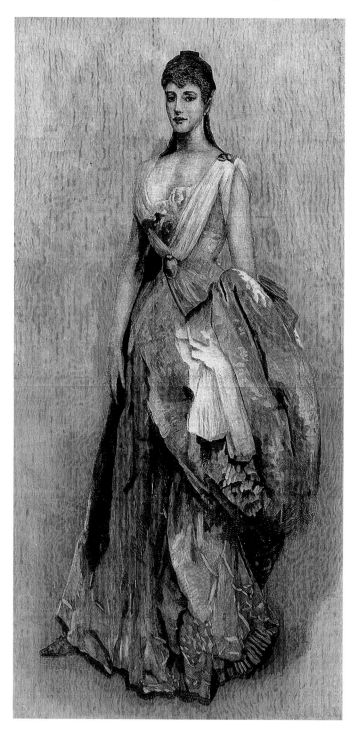

hemline, and tie-back over the hips are features of the "tailor-made." This type of clothing, incorporating details from men's apparel, had its origins in the riding habits created for wealthy ladies by men's tailors from the seventeenth century on and would have been worn primarily by upper- and upper-middle-class women in the 1880s.[96] The fur cape and toque, which appear to be of beaver or sable, were also adapted from men's coachwear as jaunty overgarments for everyday use.[97] The tailor-made enables the mobility suggested by her kinetic pose, while the accessories—particularly the historicizing "brodequin jaune" with its Louis XV heel and archaic name—link Lady Archie to the vanguard of fashion. The ensemble represents a "new conception of women's dress...a tacit recognition of women's advance towards equality with men."[98]

Lady Archie became directly involved with historic costume revival and dress reform through her friendship

with E. W. Godwin, whom she met through Whistler. In 1884, the year Lady Archie and Godwin began to collaborate on a series of plays, he published *Dress and Its Relation to Health and Climate*. As an indication of her affiliation with the Rational Dress reform movement, Lady Archie was reported to have worn at an exhibition, probably the International Health Exhibition, a "divided skirt dress."[99] The uniform of dress reformers, the "divided-skirt" was a more extreme and controversial costume than the "tailor-made" but shared with it the integration of masculine and feminine dress in an attempt to create a more salubrious, unfettered alternative costume for women. That year, Lady Archie and Godwin introduced theatrical productions innovatively set outdoors, featuring apparel inspired by the medieval and classical eras. It may have been at this time that Whistler designed a parasol in the shape of a flower for Lady Archie, seen in a watercolor depicting it from two angles (fig. 176). He also sketched her playing Orlando in *As You Like It*, the first play; wearing tights and a tunic, she is seen in a vigorous manly stance (fig. 173). Despite the masculine pose and costume, Lady Archie's red lips, curly hair, and tilted head add a sense of femininity to the image, a combined effect which perhaps accounts for Oscar Wilde's ironic praise of her Orlando as being "more charming than Rosalind."[100]

Whistler's *Arrangement in Black: La Dame au brodequin jaune—Portrait of Lady Archibald Campbell* similarly allows inconsistent or mixed readings, as the differing reactions of viewers attest. Theodore Duret, believing Lady Archie to be "une des femmes les plus belles de l'Angleterre," thought that Whistler had captured a look of disdain and pity on her face perfectly suited "à qui est aussi belle que cela."[101] The Campbell family, on the other hand, is reported to have judged Lady Archie's backward glance to be scandalously suggestive of a prostitute beckoning clients.[102] The lightest areas of the composition focus attention on Lady Archie's flushed face with its rosy lips (possibly a sign of still somewhat immodest makeup), her hands in the process of putting on gloves, and her shoe revealed by the relatively short skirt. The exposure of the foot and ankle might have been read as an inviting gesture, with the shoe's yellow brown leather, as a daring color, adding a racy sexual overtone.[103] On the other hand, her attire could be seen as less indicative of sexual promiscuity than reflective of the keen style of an enlightened woman. In 1892 an observer succinctly captured the provocative spirit of the painting, noting "it is almost necessary to use the dreadful word *chic* in homage to the slangy elegance and defiant

allure attributed to this figure in the huge fur shoulder cape."[104]

Just as Whistler finished and exhibited Lady Archie's portrait in 1884, another sister-in-law, Lady Colin Campbell, also renowned for her intelligence and beauty, became associated in the public forum with sexual misconduct. From 1884 to 1886 Lady Colin legally separated from and attempted to divorce her husband, the youngest son of the Duke of Argyll. Even as her husband accused her of multiple counts of adultery, she sat for a portrait by Whistler.[105] The painting no longer exists, but a wood engraving of *Harmony in White and Ivory: Portrait of Lady Colin Campbell* shows the sitter wearing a white gown, possibly by Worth—the color chosen, perhaps, to signify virtue in the face of threats to her reputation (fig. 177).[106] In 1897, after Lady Colin had launched a successful career as a writer, survived her ex-husband, and to an extent overcome the scandal of their divorce, she was painted by the society artist Giovanni Boldini (see fig. 36). The work gives a sense of the "grace and charm" that enraptured observers of the day: the fantastically elongated and curved figure and ethereal evening dress combine with a keen gaze that simultaneously encourages and dismisses the viewer.[107] Boldini's portrait and Whistler's lost painting of Lady Colin adhere to the traditions of society portraiture; she is represented in a less controversial mode than Lady Archie, who allowed Whistler to experiment more freely with her image.

Whistler's painting of Lady Archie portrays a confident woman in an elegant everyday costume and active manner suited to her role as a social and artistic leader. As noted, key aspects of the painting—the makeup, gloves, and shoe—enhance the sitter's allure and therefore have been seen as contributing to the controversy surrounding the painting. In this regard, however, Lady Archie's "tailor-made" dress may have been equally responsible for the mixed reactions of viewers. The suit-inspired apparel of the New Woman could be seen as fashionable, but it could also signal a new level of female assertiveness linked to competition with men. Perhaps, then, the appealingly modish accessories might be understood to balance the socially progressive implications of the dress, as in the sketch of Orlando, where similar details insist on Lady Archie's femininity despite her appearance in men's costume. The avant-garde critic Duret appreciated the portrait along these lines—praising its combination of beauty, self-assuredness, and mobility—a distinctly modern interpretation of fashion for women, alive in Whistler's "oeuvre de grand art."[108]

HMB

Love and Fashion: The Birnie Philips

Margaret F. MacDonald

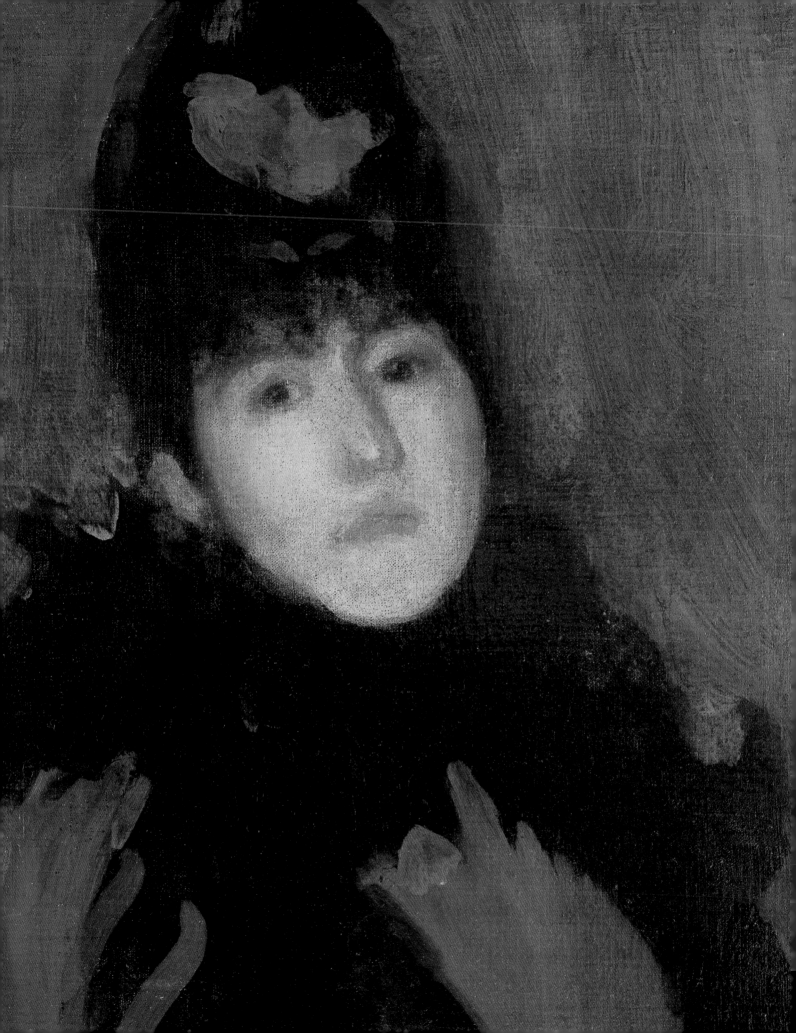

"I THINK I'VE LOVED YOU ALWAYS, even from the Peacock Room days," wrote Beatrice Whistler to James in 1895.[1] They had met, twenty years earlier, when she was married to the architect E. W. Godwin, a leading figure in the Aesthetic movement. The second of ten children of Frances Black and the sculptor John Birnie Philip, she studied in her father's Chelsea studio and with Godwin. When her father died in 1875, Beatrice, then eighteen years old, married Godwin. In 1876 they had a child, "Teddie" (Godwin's children in and out of wedlock were named Edward, Edith, and Edward, suggesting some self-centeredness in their father). She was ill for months while her sisters looked after Teddie, and mother and son were never very close.

The Godwins collaborated on furniture and house projects and sold her designs to manufacturers like Minton's china works in Stoke-on-Trent and William Watt and Co.[2] They were both interested in dress. Godwin designed theatrical costumes (for Ellen Terry as Portia, for instance, and Lady Archie as Orlando) and advised Liberty & Co. on textiles for "Historic and Artistic Studios."[3] Beatrice made textile and interior designs, wore Liberty dresses, and carried out research on costume in the British Museum for the history painter R. C. Woodville.[4]

She also joined Whistler's pupils, who exhibited together in the Society of British Artists while he was president.[5] Her paintings—small, intimate studies of women, with soft, somber color harmonies[6]—were shown under the name Rix Birnie to avoid classification as a woman's work. She made her own contacts, including Sandys, Phil May, and Oscar Wilde (she drew a witty caricature of Wilde). Although Godwin had encouraged her career, he was irritated by her growing independence. His death in 1886 left his widow destitute, and Whistler supported petitions to provide a pension and subsidize retraining as an artist and designer.[7]

She stayed briefly with the Woodvilles, who lived in the flat above Whistler in Tite Street, "a great nuisance he was, too, as he was trotting all day long across the floor of the

178 Beatrice Whistler (1857–1896), *Head of "Rix Birnie" (Beatrice Whistler)*, 1888/92, etching, 3⅞ × 2⅝ (9.9 × 6.7), Hunterian Art Gallery, University of Glasgow, Birnie Philip Bequest

studio putting a few touches on his canvas and trotting back to see the effect."[8] In the mid-1880s Beatrice had started to pose for her portrait, *Harmony in Red: Lamplight* (fig. 179). Malcolm Salaman, a critic, saw it in the studio: "[it] will rank among Mr Whistler's *chefs-d'oeuvre*. The lady stands in an ample red cloak over a black dress, against red draperies, and in her bonnet is a red plume."[9] Seen by gaslight, the cloak, with its long vertical armholes, appeared a tawny rust red. Her face, modeled with flickering soft brush strokes, looked at Whistler with amused tolerance. The dramatic cloak made the sitter's face and small, feathered bonnet seem delicate in proportion. The portrait was finally exhibited at the Society of British Artists in 1886 and was never sold, perhaps because it was too personal: the record of their developing relationship.

Whistler called her "Trixie" or "Chinkie" (because she had slanting eyes), or "Wam." An early photograph shows her wearing an elaborately tied fichu over a dark lustrous dress with a frill at the neck (figs. 180–81). Frizzily tangled curls cluster close to her head. At Godwin's funeral, Woodville mentioned her "gipsy-like hair flying round her uncovered head" in a white fur-lined cloak.[10] Friends thought she and Whistler well suited in their careless bohemianism. Two years later, in 1888, they were married (fig. 182).

Press reports of the wedding varied in accuracy but generally agreed that the bride, "a widow with an attractive face," was wearing blue[11] and was "a remarkably clever artist and decorativedraughtswoman."[12] The editor of *Truth*, Henry Labouchère, remembered her as "a remarkably pretty woman and very agreeable," who for trousseau bought "a new toothbrush and a sponge."[13] The press apparently found Whistler's attire more interesting than the bride's:

enter Mr Whistler, charmingly attired in an admirably made blue frock coat, fitting like a glove, a shining new hat with a broad brim, the same canary-coloured gloves,

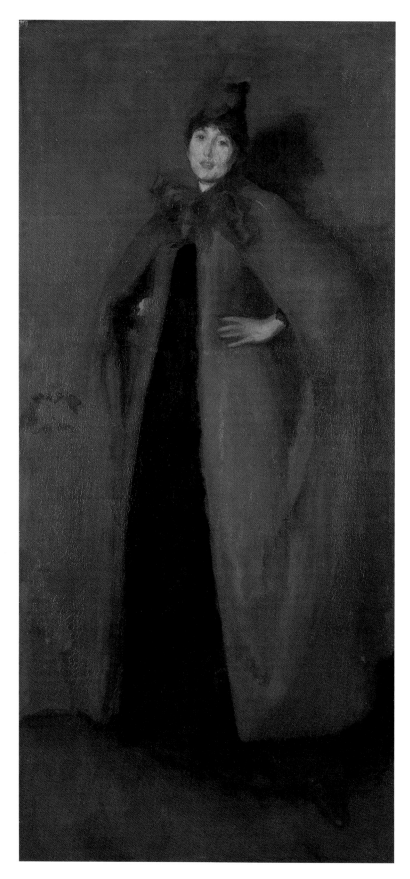

179 *Harmony in Red: Lamplight*, 1886, oil on canvas, 75 × 35¼ (190.5 × 89.7),
Hunterian Art Gallery, University of Glasgow, Birnie Philip Gift (YMSM 253)

180 Unknown photographer, Beatrice Whistler, 1886/88, by permission of Glasgow University Library, Department of Special Collections

181 "The Bartlet Fichu," *The Queen* (February 11, 1888), p. 176, courtesy of The Mitchell Library, Cultural and Leisure Services, Glasgow City Council

spotless, of course, the square-toed boots, and the long thin, yellow wand of the Master. . . . Mrs Godwin was dressed in a gown of some blue stuff, and wore a shapely hat of the same colour, with a spray of red in it.[14]

They went to France on honeymoon: "The fascinating ex Widdie! and I are both looking amazing!! . . . here we are—'in the Garden of France'—pottering about this old town in straw hats and white shoes!"[15] Whistler taught Beatrice to etch, and a small but striking self-portrait shows her wearing a round toque low over her forehead, the folds of sculptured velvet surmounted by a tuft of fur or feather (fig. 178). Back in Chelsea, they moved into the Tower House, where for the first time Beatrice had a studio to herself.

A parlor maid described life in Tite Street:

On the top floor was Mr and Mrs Whistler's bed-sitting room, [and] Mrs Whistler's studio (she painted beautifully). . . . Mr Whistler was a good deal older than his wife. I think he had married her out of real sympathy for her sorrow. . . . I used to think him a pretty old gentleman with a very pleasant voice though I seem to fancy he did not care for women, I liked to hear him calling in a loving way to Mrs Whistler, "Trixie. I want you" or "Bunnie" to his sister-in-law.[16]

Marriage transformed Whistler and his life. Beatrice helped print, sell, and promote Whistler's etchings and ran the domestic and business side of life. They enjoyed collecting silver, china, and jewelry. In July 1888, just before their wedding, Whistler bought from Pyke Brothers a

Mrs. W. E. Godwin, who was a daughter of the late Mr. Phillip, the sculptor, is a remarkably clever artist and decorative draughtswoman. Since she has been under the influence of the great James M'Neil it can be readily imagined that her undoubted artistic talents have been considerably matured. Mrs. Godwin's sister, the widow of the late Mr. Lawson, the artist, is also an accomplished wielder of the brush.

THE FATE OF AN "IMPRESSIONIST."

182 "The Fate of an 'Impressionist,'" *Pall Mall Gazette* (August 1, 1888), by permission of Glasgow University Library, Department of Special Collections

"Curious Pink Topaz & Enamel Brooch," a "Pink Topaz & Enamelled Necklace," an "Enamelled Garnet & Aqua Marine Bracelet," and "Antique Diamond Hoop Ring" at prices ranging from £5 to £13.[17] In 1890 a bill from James Unitt Parkes in Vigo Street included purchases, repairs, and possibly materials for making jewelry.[18] They were immensely proud of her full set of garnets (fig. 185). "She wore the most marvellous antique jewellery, usually composed of garnets, pearls, or rubies and diamonds, and were nearly all figures or animals," wrote Rose Pettigrew, a young model much beloved of the Whistlers.[19] These were costume pieces, probably including Beatrice's designs of swirling mermaids, fish, and birds (figs. 183, 184).[20]

Whistler's portraits rarely show jewelry. A gold ring and pearl earrings for Hiffernan denote modesty and respectability, and pearls as accessory and symbol appear in two pastels of the Pettigrews, *Mother and Child—The Pearl* and *The Shell*.[21] A full house of diamonds blaze in *Arrangement in Black: Lady Meux*, affirming her beauty and status (see fig. 153). Jewelry provided opportunities for virtuoso brushwork as well as reflecting the sitters' wealth and status. But, if clients wanted their glamorous clothes and jewelry displayed, Whistler was not the artist to come to. He concealed jewels in shadow, brushed into the silky curls of hair and drapery.

Montesquiou, who was sitting to Whistler for the superb portrait that is now in The Frick Collection, gave Beatrice a gold butterfly brooch with quivering antennae (fig. 186).

183 Beatrice Whistler (1857–1896), *Designs for jewellery* (detail), pen on white paper, 6¼ × 4 (15.8 × 10), Hunterian Art Gallery, University of Glasgow, Birnie Philip Bequest

184 (*below*) Beatrice Whistler (1857–1896), Lovebird ring, 1892/94, gold and enamel with chip diamonds set in silver, ¾ (17 mm) diameter, Hunterian Art Gallery, University of Glasgow, Birnie Philip Bequest

Painting Montesquiou's portrait brought the Whistlers into aristocratic circles. Whistler described, with immense enjoyment, his entrée into society:

On Friday then, le grand monde! . . . Enfin! We cross the street to the Vaudeville—carriages and "good people" without end—and at last we are seated—I am placed

185 Beatrice Whistler's garnet necklace, Hunterian Art Gallery, University of Glasgow,
Birnie Philip Bequest

186 Butterfly brooch, gold and glass, 2 × 1¼ × ⅝ (5 × 3.2 × 1.5), given by Robert de Montesquiou to Beatrice Whistler, Hunterian Art Gallery, University of Glasgow, Birnie Philip Bequest

look up any of the old Nicolls 'frocks'? or must I say that we are only here incognito!"[24] Beatrice responded with understandable alarm, for the Comtesse Greffulhe wore breathtaking dresses.[25] Whistler wrote back, reassuringly:

I am to tell "ces dames" that still they must go to the Opéra . . . that it need be no occasion for grandes toilettes—for the box is a most retired one—a baignoire—you know—one of those very low boxes just down by the Orchestra—and that any little evening dress of black would do—only, of course, no bonnet—[26]

One wonders if this was much help, however grand the "little black dress" from Nicols, "Tailor to the Royal Family."[27] Possibly the dress was a mistake, for Aubrey Beardsley drew two startlingly cruel caricatures of a woman resembling Beatrice, one, in black décolleté, at the theater, and a second, *The Fat Woman* or *A study in Major Lines*, in a café (fig. 187). This was, he said, "one of my best efforts and extremely witty," and threatened to kill himself if the publisher John Lane omitted it from *The Yellow Book*.[28] Lane probably thought that Whistler would do the job for him and refused point blank to publish it.

behind the "ra-vi-sante" Grefhule—who is queen of the group—with Madame de Montebello on the one side and a Russian Princesse, who speaks to me in English, on the other!—The Prince de Polignac in front turns round and says most amiable things. . . . The Comtesse asks if I stay long in Paris and I tell her that I am waiting for my own beautiful Wam—and I look well at them all and I know, as I always did know, that among them, there would be no one more "belle" as Drouet says, and no one more attractive from their own point of view than his own gypsie Trix!—and I am quite settled and superior in this matter and only wish she could have a peep at him in this "hoight of fine company—"[22]

Not surprisingly, Beatrice became a little jealous of Whistler's forays into society. He chided her for not writing, in her "beautiful smooth round sunny southern way," but added, "We are much to be envied though I know—for I look round and I see no others so happy as we two are in each other."[23] Whistler transmitted messages from Montesquiou: "his intentions seems to involve all sorts of difficulties of toilette—for he had engaged a box for our arrival at the Opera!! . . . What do you think—can you

DRESS AND DRESSMAKERS

Beatrice and Ethel joined Whistler in Paris, where Montesquiou longed to entertain them, but, said Whistler, they always had "rendez-vous avec leurs dressmakers."[29] Through the count, Beatrice had obtained a "little special word" to a dressmaker from the fashionable Madame de Montebello that "makes everything perfect."[30] Mallarmé also advised them—"were the addresses useful to the ladies?" he asked—and Whistler apologized for missing Mallarmé's Tuesday Salon because the dresses were not ready: "They are now taking shape!"[31] Mallarmé sympathized: "When the ladies are beautiful in their rags, we will see them at tea time."[32] The results of these forays into fashion become apparent in the next few years in the portraits of the Philip sisters.

Whistler probably paid for his wife's clothes, as later he paid for those of her youngest sister, Rosalind, but it is difficult to tell whether he influenced their choice or chose what they should wear when posing. Little is known about these collaborations, least of all in his portraits of Ethel Birnie Philip. Whistler called Ethel "Bunnie" and occasionally "the blind Bunnie" (presumably she was shortsighted). Ruthlessly using his sisters-in-law to run errands, he found Ethel inefficient: "The elegant blind Bunnie! You

187 Aubrey Beardsley (1872–1898), *The Fat Woman* or *A study in Major Lines*, 1894, pen, ink and wash on paper, 7 × 6³/₈ (17.8 × 16.2), Tate Britain, London, presented by Colonel James Lister Melvill at the request of his brother, Harry Edward Melvill, 1931

should see the things she has packed together in the trunk!"[33]

The portraits of Ethel were probably started soon after the marriage in 1888. Two lithographs, *The Winged Hat* (fig. 189) and *Gants de Suède* (fig. 190), date from 1890, when Ethel was twenty-nine. *The Winged Hat* was published on October 25, 1890, in *The Whirlwind*, a witty, short-lived journal.[34] Ethel's costume was drawn with fine, sharp lines that outline the basic details of the suit and pose: the blouse with its summery striped sleeves, the slim suit crumpling in folds, the low brimmed hat with the bird's wing standing up sharply. She is sitting on a wooden chair, one arm hanging by her side, but alert and poised in attitude, turning slightly as if at a sudden noise. Her expression is rather aloof. She is the epitome of the independent young middle-class woman.

188 (*right*) "Albert," "Novel and Becoming Hats," *Lady's Pictorial* (October 6, 1894), p. 473, by courtesy of The Mitchell Library, Cultural & Leisure Services, Glasgow City Council

Ethel Philip appears in these and later lithographs in a range of plumed hats, which looked well on her strong oval face with its clean-cut profile. Flocks of birds migrated regularly from distant lands to the milliners' shops of the fashionable world. "Fancy plumes are made of heads, wings and bodies," announced *The Woman's World* calmly, unmoved by this wholesale slaughter: "Vulture plumes, curled and twisted curiously, are introduced into many aigrettes."[35] Women could buy the constituents of "untrimmed shapes and millinery materials," including anything from feathers to whole birds, or buy them made up on brims of every shape and size, in colors natural or dyed, and in forms realistic, fantastical, or just plain daft (fig. 188).[36]

Whistler also started to paint Ethel in full-length portraits from about 1889. These include *Rose et Argent: La Jolie Mutine*,[37] *Harmony in Brown: The Felt Hat*,[38] and *Red and Black: The Fan*. Some of these pictures were still in progress eight years later: there are references to "the red Bunnie!" or "the red lady" (presumably *Red and Black: The Fan*) between June 1891 and 1897. These were followed by, and painted alongside, *Harmony in Black: Portrait of Miss Ethel Philip*, *Rose et or: La Tulipe*, and finally *Mother of Pearl and Silver: The Andalusian*.[39] In addition,

189 *The Winged Hat*, 1890, lithograph, image: 7 × 6⅞ (17.9 × 17.4), The Art Institute of Chicago, Mansfield-Whittemore-Crown Collection on deposit, 57.1984 (C. 34, II)

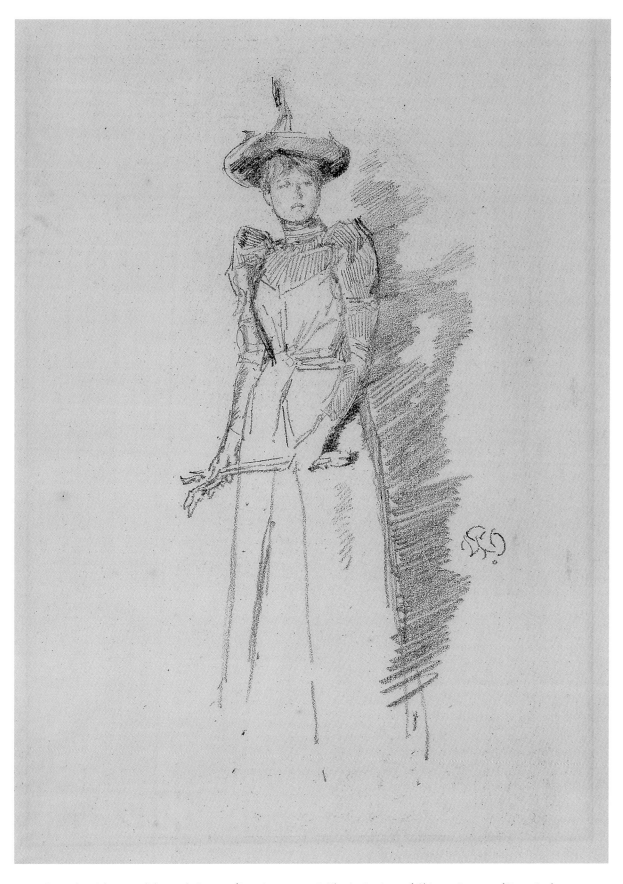

190 *Gants de suède*, 1890, lithograph, image: 8½ × 4 (21.6 × 10.2), The Art Institute of Chicago, Bequest of Bryan Lathrop, 17.559
(C. 35)

there are small head and half-length oil studies. The paintings are undated, and although visitors saw them in the studio, their memories are imprecise. Costume therefore provides vital clues to dating them.

RED AND BLACK

Red and Black: The Fan is a beautiful portrait (fig. 192), with color, brushwork and composition in perfect harmony. It shows Ethel in a simple red costume—a red tending toward russet and brown tones. The sleeves are narrow, the dress close fitting with the hint of a black bow or bustle. The hem is trimmed with a broad band of fur or brown velvet. The structure of the costume is unclear and it could be interpreted as a dress, or dress under a matching coat. The most striking features of the outfit are the black accessories: a shiny fan, gloves, a tall bonnet with a red cockade dyed to match the dress, and a long, feathery boa. A diagonal motif across her breast may be a ribbon holding the boa or a deep collar, and indeed, it is possible to interpret the boa itself as trimming down a coat.

The Queen on November 2, 1889 (fig. 191), shows similar costumes from the Maison Mentel: on the left, a wool coat ("redingote") "trimmed with black bear's fur . . . carried boa fashion round the throat and down the fronts" and a "Turban hat in poppy-red velvet." On the right, a cloak with a Princess front fastens diagonally "with a deep collar of dark fur extending as a single band down to the waist." A year later coats by Worth embodied all "the fairy riches of the Orient," embroidered with silver and gold and encrusted with precious stones.[40] Compared to these couturier costumes, the Philips' outfits with their rich colors and simple outlines suggest a restrained elegance of taste. This restraint is indeed seen throughout Whistler's portraits of women and fashion.

The fan, held partly open in her right hand, in a rather stiff, angular gesture, cuts diagonally across the red skirt between the dramatic undulating verticals of the boa. This gesture must have been very hard to hold for long, and it gives the impression of a transitory or transitional effect (although in fact it was repeated innumerable times over the years). To achieve unity, Whistler tried to cover the whole canvas at one time, so if he was not satisfied he had to rub it down and start again. He was painting extremely thinly, and painting wet on wet: that is, the paint had not dried before he put on the next color. Thus the edges of the fan and hat, of the dress itself, and particularly of the boa are slightly blurred and feathery. Her dress merges with the brown background, and shadows fall to the right. A foot, advanced to the very edge of the canvas, is unclear, suggesting the blurred, repetitive effect of movement recorded by time exposure photography. This lack of definition gives an impression of enveloping atmosphere, of a mysterious and shadowy space. Her face, however, is facing the light and lit flatly, so that the pure oval shape is unblemished, providing points of focus and definition.

Ethel's hat, lost in shadows, is difficult to distinguish. In *Woman's World*, "November Fashions" for 1887 (fig. 193) a similar hat is constructed from piled up velvet "supported by wings, which give it great height. This is a style which is generally worn, and it is not difficult to carry out, for the wings are a trimming in themselves, and the material falls in natural pleats and folds."[41] The red bow on the front of the hat, dyed to match the dress, is so much like a butterfly that it may well have stood for Whistler's butterfly monogram. The hat reflects a fashion that recurred, with

191 Fashion Plate, *The Queen*, vol. 86 (November 2, 1889), facing p. 604, by courtesy of The Mitchell Library, Cultural & Leisure Services, Glasgow City Council

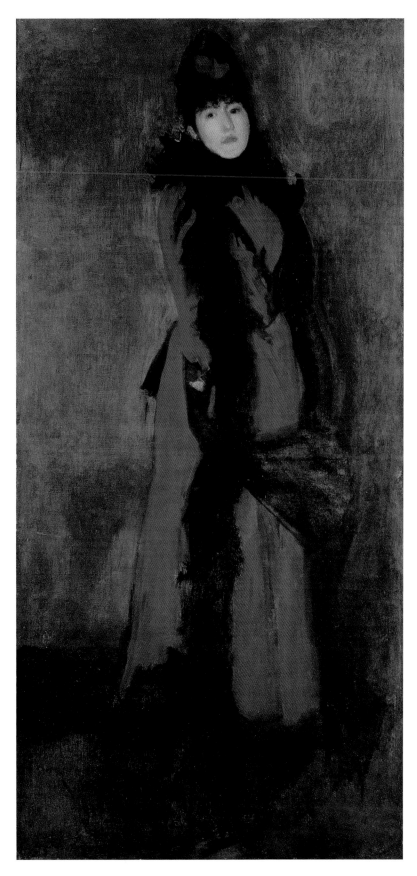

192 *Red and Black: The Fan*, 1891/94, oil on canvas, 73¾ × 35⅜ (187.4 × 89.8), Hunterian Art Gallery, University of Glasgow, Birnie Philip Bequest (YMSM 388)

AT THE ALHAMBRA.

" Waiter, bring me a brandy and soda."
" Beg pardon, Miss, but we're not allowed to serve ladies."
" I'm *not* a lady."

195 (*above*) Phil May (1864–1903), "At the Alhambra," pen drawing published in the *Graphic* (1894), Witt Library, Courtauld Institute, London

193 (*left top*) "Winter Mantles and Mantlets" (detail of engraving), *The Woman's World* (November 1887), p. 45, by courtesy of The Mitchell Library, Cultural & Leisure Services, Glasgow City Council

194 (*left bottom*) Linley Sambourne (1845–1910), Woman in a boa, 1892, Chelsea Public Library, London, Linley Sambourne Collection

1940

196 *A Lady Seated*, 1893, lithograph, image: $7\frac{9}{16} \times 6\frac{13}{16}$ (19.3 × 17.2), The Art Institute of Chicago, Bequest of Bryan Lathrop, 17.677 (C. 79, II)

variations, throughout the 1890s. Given that *Red and Black: The Fan* was painted over a long time, what was fashionable in 1887 could well have looked dated by 1897. It does not appear that either the artist or model made more than minor adjustments to compensate for this.

Although the title is *Red and Black: The Fan*, it is the boa that dominates the composition—the boa that fascinated Montesquiou, who prostrated himself "at the feet of the silky black feather boa!"[42] The mere name of "boa" underlined its association with seduction. Thus, Du

Maurier suggested entwining the ends round the necks of admirers![43] It was the accessory of the femme fatale, sweeping men off their feet and destroying them, and it is the main feature of another portrait of Ethel, *A Lady Seated* (fig. 196), drawn with a muscular wriggly scrawl that creates a truly snakelike boa. Sinuous brush strokes perfectly describe the boa in a superb watercolor of Ethel (fig. 197).

The boa grew in popularity during the late 1880s as a fashion accessory. *The Queen* announced:

197 *Rose and Silver: Portrait of Mrs Whibley*, 1894/95, watercolor on brown paper, laid down on card, 10^{13}/$_{16}$ × 7^{3}/$_{16}$ (27.4 × 18.2), Freer Gallery of Art, Smithsonian Institution, Washington, D.C., Gift of Charles Lang Freer (M. 1415)

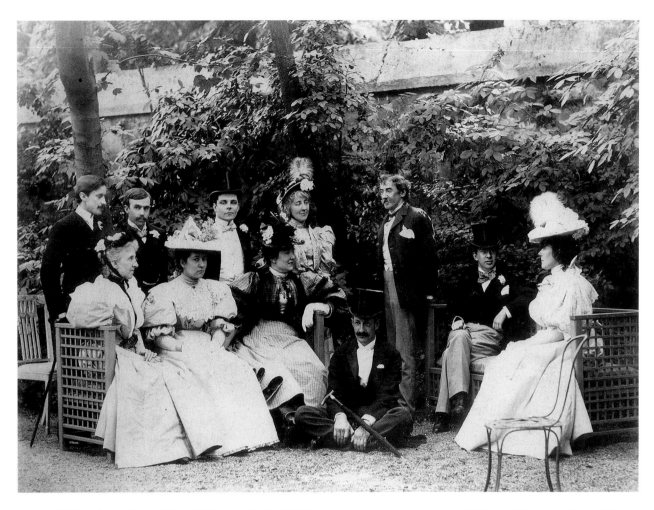

198 E. Vallois, the wedding of Ethel Philip and Charles Whibley, July 11, 1895, by permission of Glasgow University Library, Department of Special Collections

Boas are much worn in the evening, either made of sable or the fur of a Siberian cat . . . others are of swansdown or ostrich feathers of all shades. These boas are taken off, put on, rolled and twisted, and turned about, at the caprice of the wearer, and the effect is most pretty.[44]

By 1894 boas were available in all sizes, to suit all pockets. A photograph by Sambourne shows a model in a cheap feather boa with the price tag still attached (fig. 194)! Prices ranged from 14s. 6d. for a full-length, 2½-yard ostrich feather boa to 27s. 6d. for "real skunk" and more than 49s. for black fox executive models.[45] Thus a working girl could upgrade a cheap outfit with a flashy hat and boa. A cartoon by Phil May suggests that wearing such accessories blurred class boundaries (fig. 195). However, most women could estimate the price of a boa to the nearest sixpence and distinguish the class and circumstances of a woman by her dress and accessories and her manner of wearing them.

Ethel is portrayed in *Red and Black: The Fan* as a distinguished, fashionable woman and, given that she was Whistler's sister-in-law, that is hardly surprising. However, he subverts this respectable image by loading the portrait with significant details. The serpentlike boa is associated with Eve, the temptress, and the dramatic juxtaposition of black and red—black continually cutting into, breaking up, and overriding red—creates a deliberately sensual effect. In *Red and Black: The Fan*, as in his portraits of Lady Meux, Whistler used color and technique to convert a fashionable image into a femme fatale.

* * *

199 Beatrice Whistler (1857–1896), *Woman Wearing a Hat with Flowers and a Veil*, c. 1892–93, black ink on white wove paper, 4³/₄ × 3 (12.3 × 7.5) Hunterian Art Gallery, University of Glasgow, Birnie Philip Bequest

200 Dress design by Mme Pelletier Vidal, hand-colored engraving, *La Mode Pratique* (1894), from the Whistler Collection, by permission of Glasgow University Library, Department of Special Collections

THE WEDDING PARTY

Ethel Philip married the journalist and writer Charles Whibley in Paris in July 1894. A photograph shows the wedding party in the garden of the pretty house the Whistlers had taken at 110 rue du Bac (fig. 198). In the center is a blond whom Whistler is ogling unashamedly. On the left is the widowed Mrs. Philip; next, one of the sisters (Rosalind or Philippa Maud or Frances), then Beatrice. The Whibleys are on the right, looking suitably serious. Ethel— a handsome woman, with a strong face and good profile— wears a spectacular broad-brimmed hat trimmed with huge plumes. She sits very upright, wearing a deep lace collar over big puff sleeves, a tight waist, and wide-spreading skirts. The dress itself was not of unusual design—wedding dresses tended to adopt a slightly exaggerated form of current visiting dress. Just such a dress was drawn and possibly designed by Beatrice Whistler (fig. 199). The

Philips made preparations for the wedding, choosing materials and collecting fashion plates—*La Mode Pratique*, for instance—as models (fig. 200). A friend, Mlle d'Anethan, offered to take Beatrice to her dressmaker, Mme Morin at 16 rue de Seine, and the Belgian artist Alfred Stevens recommended another, Mme Fanet, in the rue Thérèse near the Opéra.[46] Their dresses were the height of fashion. The Philips were quite large, so that their waists required severe corseting, but they flaunted the lace collars, short boleros, bright materials, and flower-trimmed broad-brimmed hats confidently.

A fashion plate from *The Queen* shows a selection of dresses (fig. 201). An elegant two-piece costume in striped pink has lace trimming around the neck and shoulders, epaulettes split to show the flounced layers of leg-o'-mutton sleeve below, a fitted jacket with frilled skirt, and a long fringed sash. It is a strikingly graceful ensemble. In detail, though not in total effect, this costume is very like an elabo-

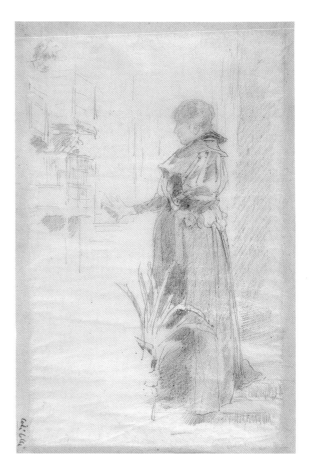

201 "Latest Paris Fashions," *The Queen*, vol. 95 (April 7, 1894), by courtesy of The Mitchell Library, Cultural & Leisure Services, Glasgow City Council

202 *Beatrice Whistler looking at her birds*, 1893/95, pencil or lithographic crayon on dark cream lithographic transfer paper, 9⅛ × 6¹/₁₆ (23.1 × 15.4), Hunterian Art Gallery, University of Glasgow, Birnie Philip Bequest (M. 1398)

rate outfit worn by Beatrice (fig. 202). Standing in the garden of 110 rue du Bac, she looks softer, more rounded, more relaxed—and less smart. The drawing was done in lithographic crayon on transfer paper and was never printed, perhaps because in some way it was felt to be unsatisfactory as a portrait or dress study, or perhaps it was merely forgotten or mislaid.

LA BELLE DAME

Fashion plates provide a startling contrast to dress as represented in Whistler's monochrome drawings and prints. *The Sisters*, for instance, shows Ethel and Beatrice in the drawing room of 110 rue du Bac (fig. 203). Their voluminous sleeves are drawn with overlapping undulating outlines, the dress sketched with two or three wiry lines, and the bulk of the rich material suggested by patches of diag-

onal shading. Irregular areas of contrasting line and shading suggest the luster of satin falling in heavy folds, or stretched tightly over an arm. What the drawing loses in color it gains in mood, light, and shadow.

Beatrice's pose recalls earlier studies of reclining women, like the etching *Weary*. However, there is a barely definable undercurrent of emotion. Beatrice's face is composed, but her body is slumped wearily, and Ethel looks at her with thoughtful solicitude. The mood is echoed in other lithographs of Beatrice: *La Belle Dame Paresseuse*, drawn in August, and *La Robe Rouge* and *La Belle Dame Endormie*, drawn on September 22, 1894.[47] In fact, the "Belle Dame" was showing signs of the malignant cancer that was to kill her within two years.

Whistler's last lithographs of Beatrice, *By the Balcony* and *The Siesta* show her lying in a room at the Savoy Hotel in London (fig. 204). They had left France to seek the advice of doctors in London and the support of her sisters.

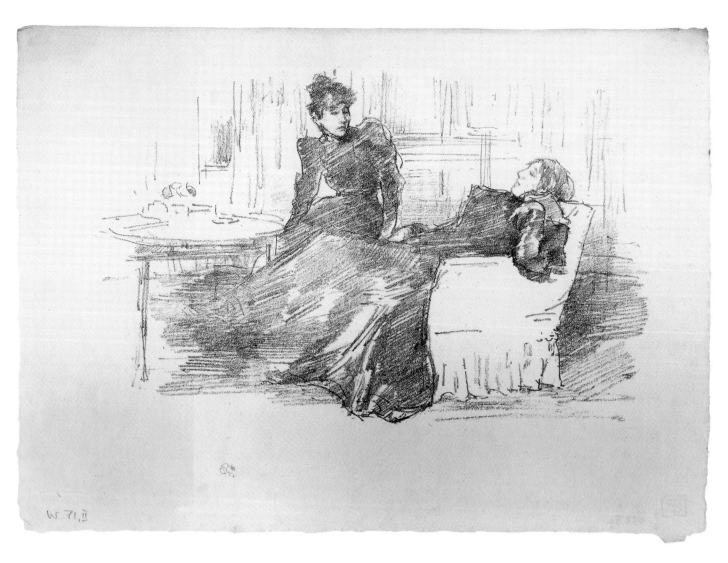

W.71,II

203 *The Sisters*, 1894/95, lithograph, image: 6 × 9¼ (15 × 23.6), The Metropolitan Museum of Art, New York, Gift of Paul F. Walter, 1984, 84.1119.16
(C. 109, II)

There were periods of remission when she wrote passionately to Whistler of her love: "I do suffer[.]—I never thought it would be like this—but you know—I was too happy, so I am given some aches to remind me that this world is not quite paradise."[48] There were, increasingly, times when she lay back in bed, too exhausted to dress, to sit up, or to read. In *The Siesta* the book has fallen from her hand. Her face, slimmed by the wasting disease, looks across wearily at her husband as he draws her with lean, broken lines. These lithographs are the most achingly poignant of his portraits. Whistler was overwhelmed with concern for her and in real financial straits with the expenses of the illness. By March 1896 he was desperately worried, "Fitful—and terror stricken," he told Kennedy, "The Lady of my life still suffers!"[49] In July she died.

ETHEL AND ROSALIND: LATE PORTRAITS

After the first awful months when he destroyed and ruined work and friendships in his despair, Whistler turned more and more to the Birnie Philips for comfort. Continuing the portraits of Ethel provided a sense of continuity. The portraits were in Paris—"I have sent for The Pink Girl, and the Black and grey one—and you shall hear," he told Kennedy, who was eager to buy them.[50] The "pink one" was *Rose et or: La Tulipe* (fig. 205) and the second, *Mother of Pearl and Silver: The Andalusian* (fig. 206). The costume in *La Tulipe* suggests a date of 1892/94, but before sleeves reached their full capacity. The title suggests a Whistlerian combination of fashion and symbolism, equating a woman with a flower, in a dress of silky sheen with curling petal-

204 *The Siesta*, 1896, lithograph, image: 5½ × 8⁷⁄₁₆ (13.9 × 21.4), The Art Institute of Chicago, Mansfield-Whittemore-Crown Collection, 130.1984 (C. 159)

like sleeves. Fashion plates collected by the Whistlers and/or the Philips make an interesting comparison. The dress itself may have been fresh from the dressmaker, and called *La Tulipe*, just as *The Andalusian* almost certainly reflects the dressmaker's name for a new creation.[51]

There is a tantalizing reference in a New Year's greeting from Charles Drouet, on December 31, 1892, in which he mentions lending Whistler "le costume Espagnol" and requests its return if no longer needed.[52] But was this the splendid evening dress in which Ethel posed as *The Andalusian* or a real or fancy dress costume such as was popular at the time,[53] and could it have inspired the dress she actually wore in any way? Certainly the painting reflects the passion for everything Spanish in the 1890s, seen in music, dance and song, fancy and fashionable dress, and, for

instance, in a flamenco-style dress in the *Lady's Pictorial* on November 4, 1893 (fig. 207).

In *The Andalusian*, Ethel appears reflective, abstracted, caught in mid-movement. She is seen from three-quarters back, turning to show her fine profile (with her dark hair twisted into a topknot) and the principal features of the dress. The sleeves are layers of black gauze, an ivory satin bow girdles a small waist, and the lustrous, evanescent gray skirt flows into a short train. It is a typical color scheme: the grays and blacks and flesh tones recalling Velázquez portraits and those of Whistler of the 1870s. Furthermore, the fluid brush strokes that describe flesh seen through gauze are reminiscent of Goya (see fig. 151). In technique, *The Andalusian* is wonderfully fluent; a broad brush covers the dress with long, unstructured strokes of thin paint, with

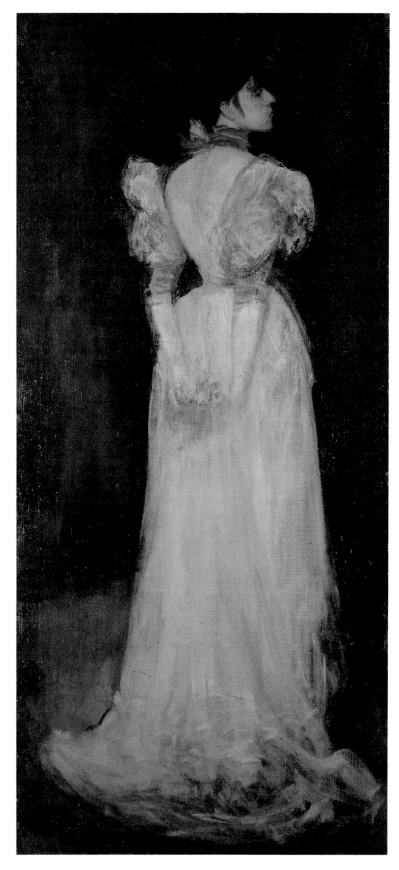

205　*Rose et or: La Tulipe*, 1893, oil on canvas, 75 × 35 (190.5 × 89), Hunterian
Art Gallery, University of Glasgow, Birnie Philip Gift (YMSM 418)

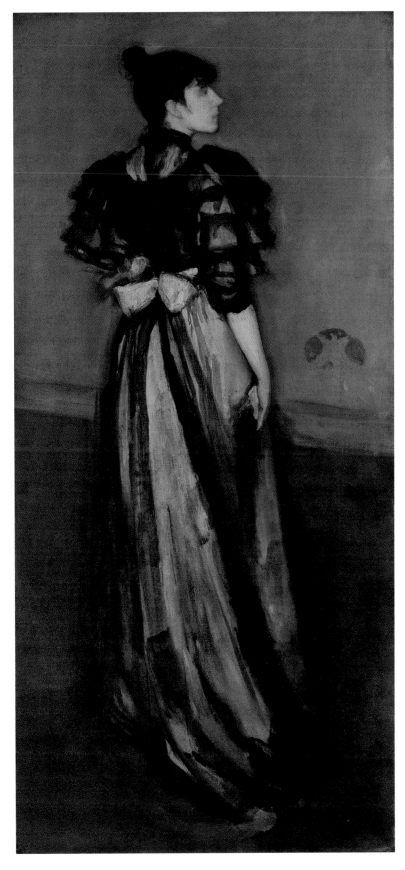

206 *Mother of Pearl and Silver: The Andalusian*, 1888–1900, oil on canvas, 75³⁄₈ × 35³⁄₈ (191.5 × 89.8), National Gallery of Art, Washington, D.C., Harris Whittemore Collection (YMSM 378)

207 Spanish-inspired dress, *Lady's Pictorial* (November 4, 1893), by courtesy of The Mitchell Library, Cultural & Leisure Services, Glasgow City Council

angular stops and starts and sweeping strokes. Smaller brushes depict details with creamy paint. The brushwork is sensuous but neither flashy nor cursory. The effect is intensely dramatic and glamorous.

By the mid-1890s Ethel was joined in the studio by her youngest sister, Rosalind (fig. 208). Whistler made her his ward and executrix, and she guarded both the artist and his work with determination. She was to give the Hunterian Art Gallery at the University of Glasgow the finest collection of the work both of Beatrice and James McNeill Whistler. Their relationship was not merely one of dutiful responsibility. The artist, somewhat mellowed in old age, was affectionate and indulgent, the girl, bright, caring, and mostly obedient. He discussed clothes with her, sent money for hats she coveted, approved the new black trim on a yellow dress, and reverently admired a white jacket "with the 'black heart.'"[54] He questioned her affectionately about her appearance: "Was it the black dress I like? . . . The pearl necklace Major? around the straight throat—

most stately!—to say nothing of the small smooth head, to which I have never done justice!"[55]

His late portraits include *The Jade Necklace*, where the jewelry is as much the subject as Rosalind herself, and *The Black Hat—Miss Rosalind Birnie Philip*, which was, a visitor commented, "more suggestive of Velasquez than any other portrait I have ever seen."[56] A small panel portrait of her in black (fig. 209) respectfully echoes Holbein's portrait of *Christina of Denmark*,[57] which may also have inspired his long-lost portrait of Lady Meux in furs (see fig. 170). His late portraits reference both contemporary fashion and Old Master portraiture. They are intimate studies, dark and atmospheric, where the figure is lost in the shadows of the studio. Washes of paint, thin as "the breath on the surface of a plate of glass," create hints of glowing color.[58] These last portraits, painted in a dark studio, with the figure barely visible, are so reduced that concepts of fashion become inappropriate. The emphasis has shifted, from fashion to mood, from modernism to minimalism, and from definition to suggestion.

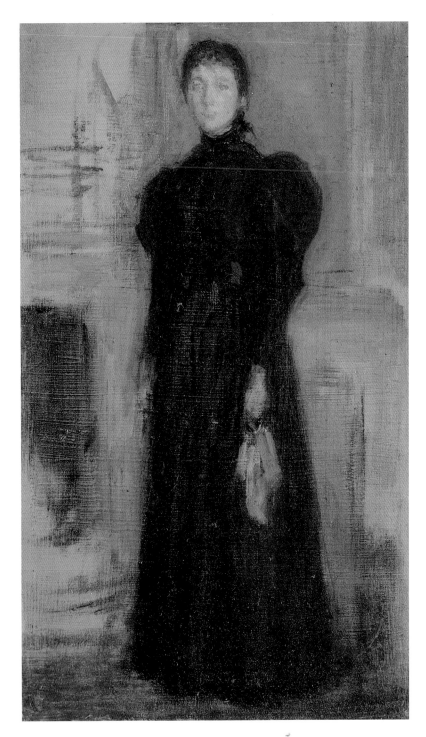

209 *Miss Rosalind Birnie Philip Standing*, c. 1897, oil on wood, 9¼ × 5⅜ (23.4 × 13.7), Hunterian Art Gallery, University of Glasgow, Birnie Philip Bequest (YMSM 479)

208 (*facing page bottom*) Photographer unknown, Rosalind Birnie Philip with jade necklace, c. 1898, by permission of Glasgow University Library, Department of Special Collections

Afterword

"Beautiful Women"

Margaret F. MacDonald

Every fashion is charming, relatively speaking, each one being a new and more or less happy effort in the direction of Beauty. . . . But if one wants to appreciate them properly, fashions should never be considered as dead things; you might as well admire the tattered old rags hung up, as slack and lifeless as the skin of St Bartholomew, in an old clothes dealer's cupboard. Rather they should be thought of as vitalized and animated by the beautiful women who wore them. Only in this way can their sense and meaning be understood.

– Baudelaire, 1863

210 *Chelsea Rags*, 1888, lithograph, image: 7⅛ × 6¼ (18 × 15.9); sheet: 12¾ × 8¹/₁₆ (32.4 × 20.5), The Metropolitan Museum of Art, New York, Gift of Paul F. Walters, 1985, 85.1161.1 (C. 26)

211 *Note in pink and brown*, 1880, chalk and pastel on brown paper, 11¾ × 7¼ (29.8 × 18.4), The Metropolitan Museum of Art, New York, Harris Brisbane Dick Fund, 1917.17.97.5 (M. 787)

WHISTLER WENT FAR BEYOND THE REPRESENTATION of beautiful women in the studio, recording dress and fashion wherever he went. Obsessively, he noted the life of the streets—beggars, women shopping, mothers with babies, and pretty girls. The dress of the poor—of *La Mère Gérard* (fig. 212), who sold flowers outside the *bal Bullier*, for instance—was depicted in as great, or even greater detail than that of *Finette*, in her gorgeous domino (see fig. 52). His sketchbooks filled with drawings of women, from the casinos of Baden-Baden to London slums, and from the beach at Dieppe to Ajaccio and the Mediterranean.[1]

In Venice he always carried a pocketful of etching plates and boxes of pastels and brown paper, ready to sit down and sketch when he found a suitable subject. He etched a dark and brooding study of *The Beggars*, a woman as gaunt and ragged as a Magdalen by Donatello.[2] In a courtyard near the Riva degli Schiavoni he spent hours etching *Bead-Stringers*, developing contrasts of age and appearance, to produce a low-key study of four ages of women (fig. 213). A jewel-like pastel, *Note in pink and brown*, shows a young family in front of their canalside home, with washing hanging on the balcony (fig. 211). Short strokes and blocks of color between sharp black outlines interact with the brown paper to create a vibrant effect. He wrote to his mother, "The people with their gay gowns and handkerchiefs—and the many tinted buildings for them to lounge against or pose before, seem to exist especially for one's pictures—and to have no other reason for being!"[3] His figures are drawn summarily, almost certainly from life, for Whistler worked outdoors from dawn to dusk, changing from one scene to another as the light and figures changed. They have distinctive shapes, giving an impression of individuality without actually being recognizable.

This is also true of Whistler's later work. He painted watercolours of day-trippers on *Southend Pier* (Freer Gallery of Art, Washington, D.C.), or tourists at Dieppe

213 (*right*) *Bead-Stringers*, 1880, etching, 9¹³/₁₆ × 6 (23.4 × 15.3), The Baltimore Museum of Art, George A. Lucas Collection, BMA 96.48.12297 (K. 198, v)

212 *La Mère Gérard*, 1858, etching, 4⅞ × 3½ (12.4 × 8.9), S. P. Avery Collection, Miriam and Ira D. Wallach Division of Art, Prints and Photographs, The New York Public Library, Astor, Lenox and Tilden Foundations (K. 11, I)

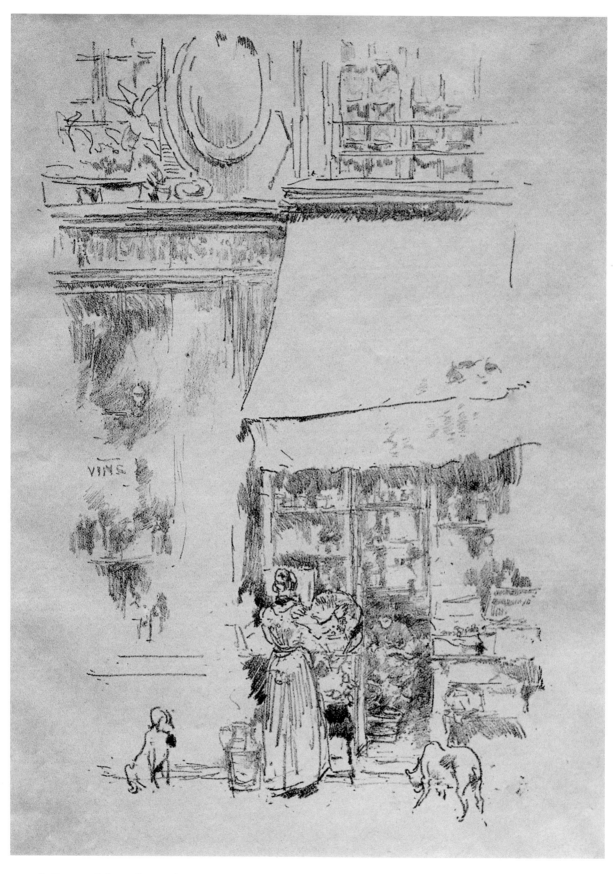

214 *La Fruitière de la rue de Grenelle*, 1894, lithograph, image: 9 × 6⅛ (22.9 × 15.6), The Metropolitan Museum of Art, New York, Harris Brisbane Dick Fund, 1917, 17.3.214 (C. 106)

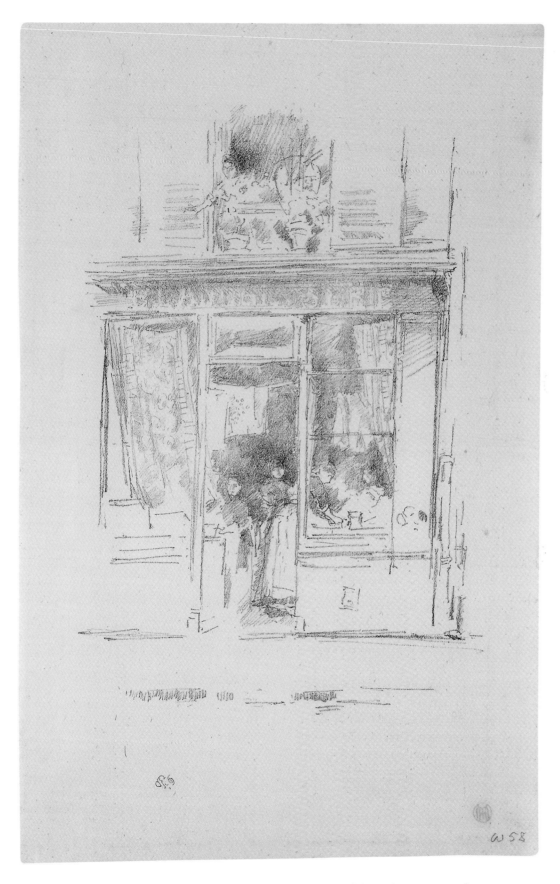

215 *The Laundress: "La Blanchisseuse de la Place Dauphine,"* 1894, lithograph, image: 9 × 6³/₁₆ (22.9 × 15.7),
The Art Institute of Chicago, Mansfield-Whittemore-Crown Collection on deposit, 90.1984 (C. 93)

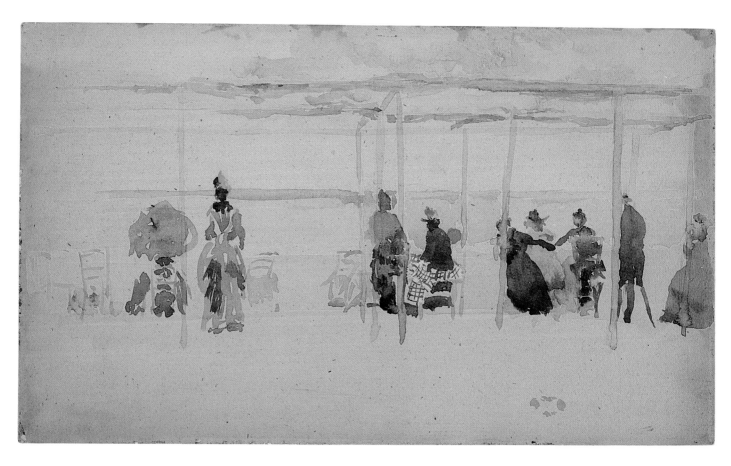

216 *Au bord de la mer*, probably 1885, watercolor on beige paper, 4⁵/₁₆ × 8⁷/₁₆ (12.6 × 21.5), Hunterian Art Gallery, University of Glasgow, Birnie Philip Gift (M. 1027)

(fig. 216). Fine brush strokes, as economical and expressive as those on a Chinese scroll, distinguish each figure. Striped and checkered materials mix with the somber blacks of older women; flounces and bustles on ankle-length seaside costumes and bonnets bedecked with flowers are painted with the finest of pointed sable brushes in bright clear colors. The women form a bright frieze suspended in the sparkling light.

A single graceful woman is the focus of *La Fruitière de la rue de Grenelle* (fig. 214), one of many drawings of Parisian life, drawn within a short stroll of his house in the rue du Bac. The essence of movement and costume—the silky small-waisted dress and puffed sleeves of 1894—is caught with extremely simple and economical lines. Duret had defined *parisianisme* as "the jewels of Lalique and the robes of the great couturiers,"[4] but perhaps for Whistler the street life of Paris—dress, costume, and fashion on the street—rather than designer jewels and clothes, was the essence of *parisianisme*.

THE CLOTHING TRADE

Certain themes and subjects recurred frequently in Whistler's work. The whole infrastructure of making, embroidering, mending, and laundering fascinated the artist. *La Blanchisseuse de la Place Dauphine* (fig. 215) combines two dominant themes: women at work in dress-associated trades and the severely geometrical frame of a shop front. The Place Dauphine is between the Palais de Justice and the Pont Neuf in Paris, and Whistler drew the lithograph there on August 6, 1894. He was delighted with "what I fancy is perhaps the best drawing I have done."[5] It shows five women at work, wearing huge aprons. One is ironing by the window, with a jar of water beside her to sprinkle on the clothes. The women emerge slightly out of focus from shadows drawn with patches of irregular shading that gradually merge into soft steamy darkness. Two seem to be glancing out, as if aware of the artist across the way.

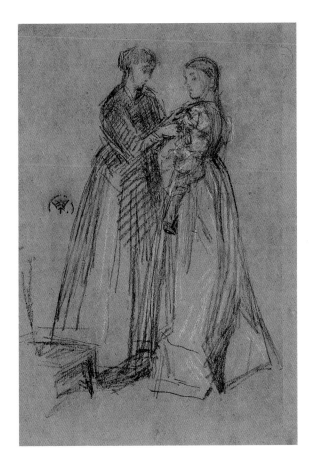

217 *The Dressmaker*, c. 1873, chalk on brown paper, 11 × 7⅛ (27.9 × 18.1), Hunterian Art Gallery, University of Glasgow, Birnie Philip Gift (M. 531r)

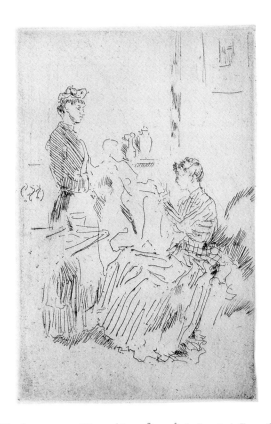

218 *The Seamstress*, 1887, etching, 3⅞ × 2⅝ (9.8 × 6.7), Freer Gallery of Art, Smithsonian Institution, Washington, D.C., Gift of Charles Lang Freer, F1903.248 (K. 252)

Laundries were an essential part of city life, when facilities for heating water and hanging out washing were not universally available. Whistler's Chinese laundryman was among his creditors in 1879,[6] which shows that despite his fluctuating fortunes, he did indeed value the cleaned and ironed shirts that preserved his sartorial image before the world. "I just wish M'ame you could see my linen as I appear now at the table!" he told the Birnie Philips:

Madame Lefèvre has given the washing to one of these wonderful Blanchiseuses here—and my shirts are gotten up like the Prince Poniatowski's!!!—and look like lawn!—"Tout à fait comme celles de Monsieur le Prince!" says Madame Lefèvre with affection!—and certainly such laundry work M'ame, is unknown in the Island![7]

Cotton shirts, fragile lawn and silk, muslin dresses, linen suits—all had to be washed by hand, boiled and thumped if necessary, dried and bleached and steamed and ironed and repaired. Laundry and linen were extremely important

components in middle-class life. In this alone the bourgeois and the beau monde could achieve similar standards of perfection.

Whistler's obsession with dress extended to all aspects of the clothing trade. In the 1870s, for instance, he not only etched Mrs. Leyland in *The Velvet Dress* (K. 105) but drew the dressmaker at work on the children's clothes (fig. 217).[8] He drew the shops that sold dresses and accessories in side streets and the high-street stores. He etched *The Bonnet-shop* (K. 253) and *The Seamstress* (fig. 218), the latter a tiny, rather oppressive etching, which suggests the cramped conditions of her work, and her skinny, underfed body (seamstresses got 1s. for making a dozen shirts, which worked out at a near-starvation wage of 6d. a day).[9] The mood in *The Seamstress* is comparatively dark, perhaps reflecting these economic realities. It is in strong contrast to a wonderfully soft and delicate watercolor, *The dressmaker's shop*, which shows pink dresses like headless dancers in a rather surreal shop-window display (fig. 219).

* * *

219 *The dressmaker's shop*, 1897/98, pencil and watercolor on white wove paper, 8½ × 5 (21.6 × 12.8), Yale Center for British Art, New Haven, Paul Mellon Collection, B1993.30.123 (M. 1512)

After a year or two, these high-fashion clothes would become the attractive, slightly out-of-fashion clothes of maids and poor relations. Those who had not the time, expertise, or money to make or buy new clothes, and could not rely on the hand-me-downs of their employers, had no choice but to resort to secondhand clothes shops. There was a huge old-clothing industry. *Clothes-Exchange, Nos. 1* and *2* (K. 287–88) show the famous East End market, where the poor bought and exchanged clothing in search of cheap respectability.

Whistler chronicled and brought to life the social history of women and dress. He recorded a descending scale of poverty in the rag- and pawnshops of Milman's Row (K. 272). *Chelsea Rags* (figs. 210, 220), with its close-up, square composition and understated realism, is comparable to J. Thomson's documentary photographs of the East End

of London (fig. 221). Even in the last stages of decay, the remnants of bygone fashions had a pervading presence, an aura of past histories and of the men and women who had worn them. Clothes were worn to destruction and, when they were no longer fit for wear, were sold for rags and recycled. The same dress thus passed from the couturier to the rag trade, and perhaps reappeared as a poster for the autumn sale at Liberty's, or a brown paper panel for a Whistler pastel.

Great gulfs divided individual lives and naturally influenced people's perception of themselves in society. Whistler himself epitomizes these deep rifts in society, etching *Mère Gérard* in her mismatched castoffs, the rag shops and Clothes-Exchange, yet firing a servant for "stealing" a skirt.[10] He was constrained by his own background and preconceptions. In 1897 Whistler drew his housekeeper, Mrs. Willis ("my honest native—bringing in the tea"), a drink to which she herself was not addicted (preferring

220 Detail of fig. 210

221 John Thomson (1837–1921), *Old Clothes Shop at Seven Dials*, 1876, from *Street Life in London* (1877–78), Museum of London, IN 633-5

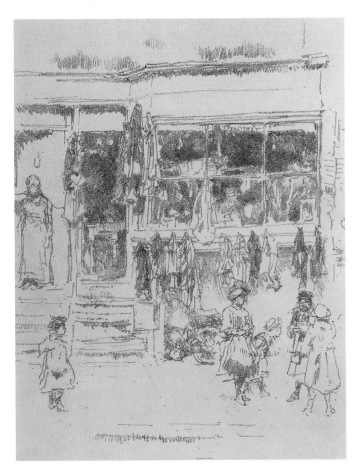

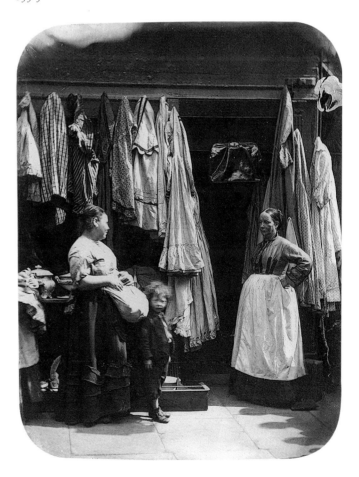

gin) (fig. 222). The sketch was satirical, but with a bitter edge: "I loathe . . . the people among whom I live," he told Rosalind.[11]

Whistler's dislike was in part affectation but arose from years of neglect; he received honors throughout Europe and America, but not in England. Yet, in his last years, although he was depressed by the death of his wife and in failing health himself, his reputation was secure. The portrait of his mother had entered the Musée du Luxembourg. John G. Johnson had bought *Purple and Rose: The Lange Leizen of the Six Marks* and the portrait of Lady Archibald Campbell. Collectors like C. L. Freer were buying all the Whistlers they could get—he bought the Six Projects from Whistler in July 1903, just before the artist's death and, soon after, the dazzling portrait of Maud Franklin, *Arrangement in White and Black*. After Whistler's death the *White Girls* were soon on their way to the National Galleries of London and Washington. Finally, Henry Clay Frick, with unerring taste, snapped up the magnificent portraits of Frances Leyland, Rosa Corder, and Valerie Meux, and the ultimate dandy, Montesquiou.[12]

During his lifetime Whistler was greatly admired in some circles and equally disliked in others. He was extremely influential among a wide international group of artists. His reputation and fortunes rose and fell dramatically during his lifetime and have fluctuated since. The image promoted by Whistler himself, and his reputation as a dandy, aesthete, and wit, although they made him widely known, have created something of a barrier between the public and his work. Many misunderstand the nature

of his dandyism, which came close to what Baudelaire defined:

Whether these men are nicknamed exquisites, *incroyables*, . . . or dandies . . . they all partake of the same characteristic display of opposition and revolt; they are all representatives of what is finest in human pride, of that compelling need . . . of combating and destroying triviality. It is from this that the dandies obtain that haughty exclusiveness, provocative in its coldness. Dandyism appears above all in moments of transition, when democracy is not yet all-powerful, and aristocracy is just beginning to totter and fall.[13]

Whistler's dandyism and his obsession with dress and fashion, which expressed itself distinctively in his portraits of women, were the product of a moment of transition, reflecting transitions in fashion and in the fortunes of his sitters. In his work he reaches across the barriers of class and time. His involvement with women is complex, both on a personal level and in his depiction of them. Whether they are nude, in costume, daily dress, or high fashion, he draws out significant aspects of their character, their position, and their place in society. Interactions between artist and models are reflected in the controlled eloquence of his brush, in subtle harmonies of color, and in understated complexities of composition. His works reflect conflicts and changes in individual relationships, in society, and in the position of women. These conflicts and these resolutions produced works of great beauty and power, fascinating then and now.

222 *Mrs Willis bringing in the tea*, January 16, 1897,
pen and black ink on white laid paper (detail of sheet),
4⁵/₁₆ × 8⁷/₁₆ (126 × 215), by permission of Glasgow University Library,
Department of Special Collections (M. 1502)

EPIGRAPHS

Chapter 2　Blanc 1877, 149; Huysmans 1883, 31.

Chapter 3　Whistler 1890, 159.

Chapter 4　Gustave Courbet to Whistler, Feb. 14, 1877, GUL C196; GUW 00695.

Chapter 5　Mayne 1964, 31

Chapter 7　Whistler to George A. Lucas, Apr. 16, 1879, Baltimore Museum of Art, GUW 09201.

Afterword　Mayne 1964, 33.

1　WHISTLER: PAINTING THE MAN

1　Anna M. Whistler to Catherine J. MacNeill, Nov. 22, 1829, GUL W344; GUW 06347; see Toutziari 2002.

2　See *St Petersburg sketchbook* (M. 7, 28–29).

3　Whistler to Anna M. Whistler, Mar. 17–20, 1849, GUL W386; GUW 06390.

4　Anna M. Whistler to Whistler, Sept. 30 and Oct. 12, 1848, GUL W364; GUW 06368.

5　See, for example, *West Point cadets* (M. 106) and *Song of the Graduates* (M. 108); dandies (M. 105, 110, 159–61).

6　List of demerits, United States Military Academy archives, West Point, New York; see Fleming 1978, 84–85.

7　Anna M. Whistler to Whistler, Sept. 16, [1851], GUL W396; GUW 06400.

8　Anna M. Whistler to Whistler, [Sept. 13, 1853], GUL W410; see also, Sept. 29, [1853], GUL W424; GUW 06415, 06429.

9　The Metropolitan Museum of Art, New York, M. 152.

10　Anna M. Whistler to Whistler, Apr. 24, [1855], GUL W454; GUW 06459.

11　Anna M. Whistler to Whistler, Apr. 30 and May 4, [1857], GUL W467; GUW 06472.

12　Anna M. Whistler to Whistler, Nov. 18, 1858, GUL W496; GUW 06501.

13　Henry Murger, *Scènes de la vie de Bohème*, published serially in 1848 and, in book form, 1851; it inspired Puccini's opera *La Bohème*, 1896.

14　See *An artist in his studio* (M. 211) and *Scene from Bohemian life* (M. 213).

15　*Après le Débardeur le fin du monde!*, published in *Le Diable à Paris: Paris et les Parisiens*, engraved by L. H. Brevière (Paris, 1845–46), 164–65; see Whistler's *Woman Drinking* (M. 132) and "*Vive les Débardeurs!!*" (M. 133); and drawing of *Débardeur*, Rhode Island School of Design, Providence.

16　Anna M. Whistler to Whistler, Apr. 30 and May 4, [1857], GUL W467; GUW 06472.

17　Armstrong 1912, 191–92.

18　*Whistler Smoking* (YMSM 9), oil, private collection. See also Denker 1995 on portraits of Whistler.

19　George Du Maurier to his mother, [May 1860], Du Maurier 1951, 4.

20　George Du Maurier to his mother, [June 1860], Du Maurier 1951, 6–7.

21　Ibid., 9.

22　"Legros est d'abord d'un beau à ne plus le reconnaitre! sa grande préoccupation e[s]t la nuance des gants qu'il porte.—Je vais le faire photographier pour que tu puisse le voir dans la fine fleur de sa splendeur! du reste il est le cheri du beau monde içi . . . ses tableaux on les lui prend sur le chevalet meme, et tous ses loisirs il passe enfermé avec son tailleur, une des renomées de Londres!" Whistler to Henri Fantin-Latour, [July 6/10, 1863], LC PWC 1/33/23; GUW 08043.

23　Anna M. Whistler to Catherine J. Palmer, May 21–June 3, [1872], Princeton University Library; GUW 09938.

24　Fogg Art Museum, Harvard University, Cambridge, Massachusetts, YMSM 113.

25　Merrill 1992, 144.

26　*Mayfair* (Dec. 3, 1878); GUL pc2/25.

27　Whistler to A. Lasenby Liberty, [Nov. 26/31, 1878], GUL L147; see also Liberty to Whistler, Sept. 14, 1878, LC PWC 4/17; Liberty's accounts, Nov. and Dec. 25, 1878; Bankruptcy Papers, LC PWC; GUW 02613, 08740, 08946, 08962, 11926.

28　Halling, Pearce & Stone to Whistler; Linley & Linley to Thomas Allingham, forwarded to James A. Rose, Jan. 15, 1879; Bankruptcy Papers, LC PWC; GUW 08854, 12085, 11926.

29　A. and H. Hamper to Thomas Allingham, [Oct. 15, 1878], and lists of creditors, LC PWC; GUW 11888, 11926.

30　Feb. 16, 1879, LC PWC; Bankruptcy Papers and lists of creditors, LC PWC; GUW 08954, 11711, 11888, and 11926.

31　For example, he pawned a gold medal in 1879; see Somes to Whistler, Nov. 12, 1881, GUL S130; GUW 05485.

32　Whistler to Deborah Haden, [Jan. 1, 1880], GUL H20; GUW 11563.

33　Alan S. Cole, Diary [1875–1883], in Pennell 1908, 1: 300.

34　*Weekly Register* (Feb. 24, 1883); GUL pc6/49.

35　Whistler to Waldo Story, Feb. 5, 1883, Pierpont Morgan Library, New York, Heinemann MSS. 244; GUW 09430. See MacDonald 2001, 111–13.

36　Alan S. Cole, Diary [June 11, 1882], in Pennell 1908, 1: 300; copies in LC PWC 281/557–87 and GUL LB6/226–44; GUW 13132, 03432.

37　See Stephenson 2000 for a discussion of Whistler's masculinity and national identity.

38　"Il faut avoir vu l'impeccable artiste, avec un dandysme supreme, le monocle à l'oeil, plus correct dans sa tenue que Lord Brummel, occupé, dans la partie de son atelier réservée aux préparations culinaires, . . . à griller un tranche de saumon." *L'Art Moderne* (Aug. 1885); GUL pc6/30.

39 Hunterian Art Gallery, University of Glasgow, YMSM 191; see fig. 16.

40 Whistler to John E. C. Bodley, [May 1883(?)], GUL B276; GUW 00493.

41 *The Queen*, vol. 77 (Feb. 1885); GUL pc5/45.

42 *Truth*, vol. 17 (Feb. 26, 1885), 319; GUL pc5/39.

43 *Birmingham Weekly Post*, [Feb. 1885]; GUL pc5.

44 Alan S. Cole to Whistler, Feb. 21, 1885, GUL C143; GUW 00642; see Whistler 1892, 154.

45 Whistler 1890, 154.

46 Wilde 1885.

47 Whistler 1890, 243; Isaac Nathan & Son were theatrical and fancy dress costumiers, 18 Castle Street, Leicester Square, London. Whistler possibly confused the Polish patriot Thaddeus Kosciusko with the Hungarian statesman Lajos Kossuth.

48 "A May Meeting," *Punch*, vol. 92 (May 21, 1887), 249.

49 Whistler to G. P. Jacomb Hood, [Dec. 1/9, 1886(?)], GUL H357; GUW 12783.

50 Whistler to Charles J. W. Hanson, [June 12/13, 1888], LC PWC 1/44/8; GUW 08018.

51 Whistler to Charles J. W. Hanson, [June 1888(?)], William Andrews Clark Memorial Library, University of California at Los Angeles, Wilde W576L U58; GUW 09133.

52 *World* (June 20, 1888); GUL pc9/121.

53 Whistler to Beatrice Whistler, [Feb. 1892], GUL W597; GUW 06604.

54 Whistler to Rosalind B. Philip, [Nov. 1899], GUL P400; GUW 04760. William Boxall's portrait of Whistler as curly-haired child is in the Hunterian Art Gallery, University of Glasgow.

55 Pennell 1908, II: 193.

56 "The Red Rag," in *World* (May 22, 1878), and Whistler 1890, 126–28.

2 FASHION AND WHISTLER

1 Cherry 2000, 186, 1.

2 Jopling 1925, 115.

3 Haweis 1878, 12.

4 De Marly 1980, 209. Haweis notes apropos Worth that although his dresses were pretty, they were not "picturesque" (that is, "formed on art principles"), and "therefore I do not think he is an artist" (Haweis 1878, 221).

5 Oliphant 1878, 4.

6 Jopling 1925, 139.

7 Ibid., 144.

8 See Ribeiro 1999, 9 et seq.

9 Brilliant 1991, 14.

10 Steele 1988, 202.

11 Blanc 1877, 53.

12 Huysmans 1883, 32.

13 Eddy 1903, 246.

14 Sweeney 1989, 136.

15 Huysmans 1883, 35.

16 See Roskill 1970.

17 Merrifield 1854, 105.

18 Haweis 1879, 14.

19 Haweis 1878, 209; see also 224, 297.

20 Haweis 1879, 54.

21 Patterns for embroidery and accessories appeared in fashion magazines in the early years of the nineteenth century, but complete dress patterns only from midcentury. See Emery 1997.

22 Breward 1995, 158.

23 Garfield 2001, 8.

24 Matthews 1999, 176.

25 Ibid., 177. See also Haweis 1879, 116.

26 *The Queen* (May 17, 1862), 202.

27 See Perrot 1994, 103.

28 Breward 1995, 161–62.

29 Cherry 2000, 2.

30 Campbell 1893, 82.

31 Wharton 1974, 166.

32 From an essay on "Americans Abroad" by Henry James in *The Nation* (Oct. 30, 1878). Quoted in Aziz 1984, 519.

33 See Noels 1999.

34 Steele 1988, 113.

35 Levitt 1991, 14.

36 In 1847 Paris had 233 ready-to-wear manufacturers employing more than 7,000 workers: Perrot 1994, 54.

37 Oliphant 1878, 66.

38 *The Golden Bowl*, 1904. See James 2000, 83.

39 Worth remarked in 1871 that while a respectable woman in Paris could dress on £60 a year, his clients were in quite a different league, for the "simplest day costume at Worth's cost 1600 francs—over £60, more than the most luxurious ballgown elsewhere" (quoted in De Marly 1980, 100).

40 Ellington 1869, 24, 28.

41 Coleman 1989, 88.

42 Worth 1928, 49–50.

43 Arthur 1992, 137.

44 *The Queen* (Dec. 5, 1863), 375.

45 See, for example, a collection, in the Victoria and Albert Museum's Prints and Drawings Department, of his costume designs from the late 1860s (lithographed figures with the dresses painted on below) with similar gowns and delicate motifs such as spots, garlands, curving lines, and stripes at the hem.

46 *The Queen* (Nov. 14, 1863), 322.

47 See Worth 1928, 55.

48 Blanc 1877, 274. See also Ellington 1869, 88.

49 In about 1873 Worth introduced the *corset-cuirasse*, a body-molding, armor-inspired corset, long over the hips to give a tight, smooth line; it created a "womanly" figure.

50 Haweis 1878, 118.

51 For example, Trollope [1875] 1994, 200. The vogue for false hair (see Ellington 1869, 46) was deplored by aesthetic women such as

Haweis. The evidence of his paintings demonstrates that Whistler preferred simple hairstyles.

52 Blanc 1877, 44.

53 Ellington 1869, 579.

54 Worth 1928, 145.

55 De Marly 1980, 144.

56 Laver [1930] 1951, 235.

57 Ibid., 127, 139.

58 Pennell 1908, I: 218, 301. In the Edwardian period when the Pennells were writing, such styles seemed ugly because they were both out-of-date and yet not "historical" enough to be thought romantic.

59 Blanc 1877, 180; Haweis 1878, 38.

60 James 1986, 106.

61 *The Woman's World* (June 1888), 378.

62 Pritchard 1902, 5.

63 The flexibility of jersey ("so warm and elastic," said *The Graphic* [Sept. 13, 1884]) made it a popular fabric for sportswear.

64 Sherwood 1884, 119.

65 Blanc 1877, 189. In the way gloves were worn, he added, women should consult "the great masters of portrait painting," such as Velázquez, van Dyck, Lawrence, and Ingres.

66 Campbell 1893, 79.

67 Trollope 1994, 200.

68 Blanc 1877, 69.

69 Haweis 1878, 85. The author of *Manners and Social Usages* expressed the truism that all women look good in black and are especially admired by men when they wear "fresh ruffles at neck and wrists"; indeed, a black velvet dress positively "demands for its trimmings expensive and real lace. . . ." (Sherwood 1884, 161, 113).

70 See Holt 1879 et seq.

71 See also the woman wearing a fur-trimmed red sheathlike coat-dress in William Logsdail's painting *St. Martin-in-the-Fields*, 1888 (Tate Britain, London).

72 Wharton 1974, 90. Olenska in this dress reminds Archer of a portrait by Carolus Duran.

73 Newton 1974, 2.

74 Pritchard 1902, 16.

75 See, for example, George Du Maurier, "Candid Criticism," *Punch*, vol. 103 (Nov. 19, 1892), 231.

76 Grenville 1892, 130.

77 Ibid., 136.

78 The first women's colleges were Vassar in the United States, founded in 1865, and Girton at Cambridge University, England, founded in 1869.

79 For example, *Punch* in 1886 described the "Girton Girl" as "affecting" in her dress "the limpest materials and the strangest hues," and—distrusting "a slim ankle and a pointed toe"—adopting mannish black boots. See Boehn 1927, II: 72.

80 "The Rational Dress Show," *Punch*, vol. 84 (June 2, 1883), 254; Adburgham 1961, 137.

81 *Patience* was subtitled "An Aesthetic Opera"; Bunthorne, although "fleshly" like

Wilde, had Whistler's black curls, white lock of hair, a monocle, and the artist's characteristic exclamation, an abrupt "ha ha!"; see Bendix 1995, 21. Gilbert was concerned about getting the aesthetic costumes right and designed many himself, using Liberty silks, a feature advertised in the theater programs; see Adburgham 1975, 31.

82 Menpes 1904, 7.

83 See Jopling 1925, 50, 60.

84 Eddy 1903, 42.

85 Laver 1951, 181.

86 James 1997, 93.

87 Blanche to his mother, quoted in Weintraub 1974, 271.

88 Pennell 1921, 301. The harmony of dress and room décor was strongly advocated by those in the Aesthetic movement. Haweis, for example, states firmly that "no colours suit a room that are not pleasing in dress" (Haweis 1889, 365).

89 James 1997, 285.

90 Berger 1992, 36.

91 Brilliant 1991, 149.

92 The [London] Times (May 2, 1978).

93 Blanc 1877, 184.

94 Hughes 2000, 10.

95 Ibid., 9.

96 Sweeney 1989, 209. James's comment is dated 1882.

97 Eddy 1903, 193.

98 "brodées . . . la même couleur reparaître continuellement ça et là . . . le tout formant de cette façon un patron harmonieux—" Whistler to Fantin-Latour, Sept. 30–Nov. 22, 1868, LC PWC 1/33/28; cited in Thorp 1994, 33.

99 Quoted in Lehmann 2000, 18.

100 Laver 1951, 235.

101 Quoted in Eddy 1903, 214.

102 Cited in Lehmann 2000, 98.

103 "Le bouffant d'une manche"; "J'oubliais! Mallarmé aime le chic!"; quoted in Barbier 1964, 263.

104 Blanc 1877, 148–49.

105 The portrait is in the Hunterian Art Gallery, University of Glasgow. YMSM 408.

106 Whistler 1899, 23.

107 Pennell 1908, I: 303.

108 Burger 1863; Bénédite 1905, 510.

109 Athenaeum, no. 1809, June 28, 859; cited in Weintraub 1974, 76.

110 From La Dernière Mode, 1874; cited in Lehmann 2000, 77.

111 Quoted in Byrde 1992, 118.

112 James 1997, 341.

113 Grenville 1892, 138.

114 The Woman's World (July 1888), 415.

115 See Holt 1887, 9, 23. See also Stevenson and Bennett 1978.

116 Ormond 1968, 34, 38.

117 In an essay "The Relation of Dress to Art," Pall Mall Gazette (Feb. 28, 1885); see Ellman 1974, 4. Wilde admired classical dress and perhaps envisaged a kind of flowing drapery, in agreement with Haweis's diktat that "no

costume is good which has no folds" (Haweis 1889, 190).

118 Haweis 1878, 18 et seq.

119 Ibid., 36.

120 Ibid.

121 The Graphic (Oct. 11, 1884), 374.

122 Quoted in Newton 1974, 97.

123 See the Liberty Archive at the City of Westminster Archives Centre, London. See also Soros 1999, 59.

124 Quoted in Adburgham 1975, 14.

125 See Berger 1992, 7.

126 Adburgham 1975, 23.

127 Museum of Fine Arts, Boston.

128 Jopling 1925, 68.

129 Aglaia, vol. 3 (1894), 29, 27.

130 The Woman's World (Nov. 1888), 6.

131 Cherry 2000, 198.

132 Frith 1887, II: 256.

133 See, for instance, "The Cimabue Browns," Punch (1880) in Ormond 1969, 288.

134 My thanks to Valerie Cumming for this information. Cumming 1987 reproduces an "engraving after J. M. Whistler" (no source given) of Terry as Iolanthe, 1881; the actress's costume is an aesthetic version of late fourteenth-century court dress.

135 Soros 1999, 29, figs. 1–11.

136 Quoted in Wilson 1996, 28.

137 Haweis 1878, 89.

138 Jopling 1925, 184–85.

139 Maynard 1989, 331.

140 James 1976, 361.

141 Menpes 1904, 81.

142 Arrangement in Grey: Portrait of the Painter (YMSM 122), 1872, Detroit Institute of Arts.

143 C. 1780, Royal Academy of Arts, London.

144 1721, Staatliche Museen, Schloss Charlottenburg, Berlin.

3 EAST AND WEST

1 Murger's Scènes de la vie de Bohème describes Rodolphe's relationship with Mimi, a grisette; Alfred de Musset's song (1845) starts "Mimi Pinson est une blonde, / Une blonde que l'on connaît. / Elle n'a qu'une robe au monde. . . ." Allem 1962, 429.

2 Pennell 1921, 91.

3 For example, Jupiter and Antiope, H. 302; Lochnan 1984, 107. See also Fumette (M. 289), Fumette Standing (K. 56), and Fumette's Bent Head (K. 57).

4 Whistler to Beatrice Whistler, [Jan. 24, 1892(?)], GUL W599; GUW 06606.

5 Many thanks to Aileen Ribeiro for identifying the domino. See women in masks and dominos in Manet's Masked Ball at the Opera, 1873–74, National Gallery of Art, Washington, D.C.; see Metropolitan Museum 1983, cat. 138.

6 Getscher 1977–78, 27, cat. 5.

7 Wedmore 1886, 37, cat. 54; Mansfield 1910, cat. 58.

8 Listed by Beatrice Whistler, [1890/1892], GUL NB2/31–77; GUW 12715. "Finette" is the diminutive of "Fin" and implies prankishness or cunning. Watteau's painting Finette, a seated woman playing a diabolo, could have been known to Whistler. It was mentioned by P. Mantz in "L'École française sous la Régence, Antoine Watteau," Revue Française, 16 (Feb.–Apr. 1859): 263–72, 345–53. It was bequeathed to the Louvre in 1867 (Grasselli and Rosenberg 1884, cat. 58).

9 Duret 1904, 12, and Duret 1917, 19; Goncourt Journal, May 31, 1896, in Ricatte 1989, 1290, quotes Duret deploring Whistler's marriage to a widow "qui n'avait aucune fortune."

10 Pennell 1921, 91.

11 See speculations in Anderson and Koval 1995, 74.

12 Whistler later wrote "Lady in Blue Dress" on an impression of Finette owned by S. P. Avery, now in the New York Public Library; Fine 1984–85, 51, cat. 14.

13 P.1951; see Parry 1980, 43.

14 For example, photographs Whistler owned, PH1/6–8; see also Kozloff 1979, 85–87; Pearl 1955.

15 "C'est rempli de superbes porcelaines tirés de ma collection, et comme arrangement et couleur est bien—Cela représente une marchande de porcelaine, une Chinoise en train de peindre un pot"; Jan. 4–Feb. 3, 1864, LC PWC; GUW 08036. See MacDonald 2002b, 61–68.

16 Anna M. Whistler to James H. Gamble, Feb. 10–11, 1864, GUL W516; GUW 06522.

17 See Merrill 1998, 53–56.

18 See Wilson 1998, 61, repr. 63.

19 Athenaeum (May 14, 1864), 682; GUL pc1/11.

20 Whistler to Beatrice Whistler, [Mar. 15, 1892], GUL W607; GUW 06613.

21 Freer Gallery of Art, Washington, D.C., YMSM 60.

22 Musée d'Orsay, Paris, YMSM 101; see Ono 2002 and MacDonald 2003, 38.

23 Japanese: [London] Daily Courier, Mar. 3, 1877; Chinese: [London] Observer, Jan. 28, 1877; see also [London] Standard, Feb. 27, 1877; GUL pc1/21, pc2/6–8.

24 "princesse du pays des chimères, autant que du pays chinois, un apparition vague, impalpable, qui s'évanouirait sous le battement d'ailes d'un Papillion; finalement, une chinoiserie de grandeur naturelle, aussi fantasque et aussi fine que les petites figures des porcelains du bons temps; . . . Je souhaite que la mode vienne de sa costume"; L'Indépendance belge, June 13, 1865; GUL pc1/29.

25 Rossetti to Mrs. Gabriel Rossetti, Doughty and Wahl 1965, 527, no. 563.

26 Tate Britain, London; Surtees 1971, 42, cat. 178, 182; Parris 1984, cat. 132–33.

27 1869, Cincinnati Art Museum; Wentworth 1984, 68–72, pl. 55, 56, 59.

28 Whistler to Henri Fantin-Latour, [Sept. 1865], LC PWC 1/33/17; GUW 08037.

29 Freer Gallery of Art, Washington, D.C., YMSM 56.

30 See a fragment of a kimono, in figured silk with paste-resist (*yuzen*), stenciled (*katazome*) decoration, and embroidery, late nineteenth century, Victoria and Albert Museum, London, 79–1884, in Jackson 1999, pl. 93.

31 Clifford Addams to Elizabeth R. Pennell, Jan. 26, 1912, LC PWC; YMSM 56.

32 Prints from the Beatrix Whistler Collection, in Oriental Department, The British Museum, London, and Hunterian Art Gallery, University of Glasgow.

33 Whistler to Alexander Reid, [June 26, 1892], GUL LB 4/47/2–48/1; GUW 03206.

34 The Art Institute of Chicago, YMSM 63.

35 Copy of Diary, July 20, 1868, Maryland Historical Society Library, Baltimore; GUW 12493. The "Chinese girls" were probably *The White Symphony: Three Girls* or *The Three Girls* (YMSM 87 or 88), the latter was destroyed unfinished at Whistler's bankruptcy. Milly Jones (wife of the minstrel singer Stuart Robson) was presumably nude (hence Mrs. Whistler's concerns) or wearing transparent draperies.

36 See Sir Henry Cole to Whistler, Mar. 20, 1872, GUL S163; GUW 05518; see also M. 458, M. 460.

37 Private collection, M. 1226.

38 Dalby 2001, 115–20.

39 The earliest kimonos, Victoria and Albert Museum, London, 110/1767 and 110/1551; purchases recorded on Jan. 11, 1871, Art ref., 957; Reg. 228-'71; from Liberty's, 874–1891; records in Far Eastern Department. They also received a white silk crepe kimono embroidered with colored silks said to have been brought from Japan in 1868 (98/o/R3) T56-1923.

40 Dalby 2001, 188.

41 For example, Mrs. Asher's hair bows, advertisement, *Lady's Pictorial*, vol. 25 (Feb. 18, 1893).

42 "Ten O'Clock" lecture, in Whistler 1890, 158.

43 Whistler to Thomas Winans, [Sept./Nov. 1869], The Metropolitan Museum of Art, New York, Autograph Letters, Box II; GUW 10632. *Venus*, Freer Gallery of Art, Washington, D.C., M. 357.

44 Comme il nous aurait sainement conduit —le dessin! pardieu! la couleur—c'est vrai c'est le vice!" Whistler to Henri Fantin-Latour, [Sept. 1867], LC PWC 1/33/25; GUW 08045.

45 Fogg Art Museum, Harvard University, Cambridge, Massachusetts, M. 448.

46 *Nude standing*, private collection, M. 439.

47 Anon., "Society of French Artists," *The Architect* (Nov. 27, 1875), 299; see M. 566.

48 Smith 1996, 216–37; see also Wedmore 1884, 374; GUL pc6/13, 56.

49 *Kensington News* (May 29, 1884); see also *Fun* (June 4, 1884); GUL pc6/13, 6/56.

50 Whistler to *Pall Mall Gazette*, published Dec. 10, 1885, reprinted in Whistler 1892, 195.

51 Unidentified press cutting, [Apr. 1889]; GUL pc10/101.

52 London *Daily Telegraph* (Apr. 19, 1889); GUL pc10/101.

53 Hunterian Art Gallery, University of Glasgow, M. 1419; see also M. 356, 1213, 1420.

54 *Venus*, Hunterian Art Gallery, University of Glasgow, M. 1523; see also M. 352, 357, 461, 1232. *Venus*, oil on canvas, Freer Gallery of Art, Washington, D.C., YMSM 82.

55 M. 19; Rouart and Wildenstein 1975, I, no. 21; see De Montfort 1997, 222.

56 *Catalogue of the Art Treasures of the United Kingdom Collected at Manchester* (London, 1857), 8. See also De Montfort 1997, 223.

57 *The* [London] *Times* (May 17, 1860).

58 Pennell 1921, 225; in 1902 at the Royal Academy, Whistler saw a copy, attributed to Velázquez, of *Las Meninas*, owned by W. J. Burkes of Kingston Lacy.

59 Nine photographs, GUL PH3. He based his portrait of Henry Irving as Philip II on his photograph of *Pablo de Valladolid*, and his last self-portrait echoes the same pose; see Merrill 1992, 38.

60 "Tu dois attendre avec impatience mon voyage en Espagne . . . je serais le premier qui puisse regarder les Velasquez pour toi. . . . Aussi s'il y a des photographies a avoir, j'en rapporterai—pour des esquisses je n'ose presque pas en hasarder! . . . Tu sais! ca doit être de cette glorieuse peinture qui ne laisse pas copier. . . . Ah mon cher comme il a du travailler!" Whistler to Henri Fantin-Latour, [Oct. 14/21, 1862(?)], LC PWC; GUW 08028.

61 Whistler to Henri Fantin-Latour, [Nov. 10, 1862]; GUW 01076. See also Eddy 1904, 71.

62 *The Corregidor of Madrid*, whereabouts unknown; see Merrill 1998, 123.

63 Anna M. Whistler and Whistler to F. R. Leyland, Aug. 23, [1871], LC PWC 6B; GUW 11867.

64 In 1859 Whistler urged Fantin-Latour to see the *British Exhibition of Old Masters* at the British Institution; Whistler to Henri Fantin-Latour, [June 29, 1859], LC PWC 1/33/31; GUW 08050.

65 Anna M. Whistler to R. A. Alexander, Aug. 26, [1872], Department of Prints and Drawings, The British Museum, 1958-2-8-34; GUW 07571. Messrs Farmer and Roger's Great Cloak and Shawl Emporium at 119 Great Regent Street; Lasenby Liberty was Oriental Manager before establishing his own famous store.

66 "Ten O'Clock" lecture, 1885, in Whistler 1890, 137.

67 *Daily Graphic* (Mar. 19, 1892); GUL pc13/15.

68 Pennell 1908, I: 171.

69 Ibid., 173–74.

70 De Montfort 1997, 224, n. 24.

71 "Ten O'Clock" lecture, 1885, in Whistler 1890, 158.

72 Pennell 1908, I: 172.

73 For example, John Singer Sargent's *Daughters of Edward Darley Boit* could have been inspired by *Las Meninas*, which Sargent had copied in 1879, or from Whistler's painting, exhibited two years later. Kilmurray and Ormond 1998, 98–99, cat. 24; copy after Velázquez, private collection, repr. fig. 65.

74 Williamson 1919, 45.

75 *Suffolk Chronicle* (July 26, 1884), *Nottingham Mercury* (Nov. 15, 1884); *Household Words* (Oct. 25, 1884); in GUL pc3/35, pc3/122, pc6/12: reprinted in Ford 1890, 250. See Getscher and Marks 1986, 258–59, K. 9–10.

76 Pennell 1908, II: 125.

4 WHITE MUSLIN

1 In the 1881 London Census, Hiffernan's age is recorded as thirty-eight.

2 Pennell 1921, 161 and ff. Captain Costigan was an ebullient, slightly disreputable character in William Makepeace Thackeray's story of journalistic and literary life in London, *The History of Pendennis* (1848–50). Chirography was the art or business of handwriting. A chirographer may have been a copying (often a legal) clerk.

3 Du Maurier 1951, 118. How long the family was at Newman Street is unclear. The 1861 Census records 69 Newman Street as a lodging house, but the Hiffernans were absent at this point.

4 Du Maurier 1951, 185.

5 Pennell 1921, 161. No trace of him has yet been found. Whistler talked of his son Charles James Whistler Hanson, born 1870, the product of a liaison with Louisa Hanson, a parlor-maid, as an "infidelity to Jo" long after his apparent separation from Hiffernan in about 1866/67. Pennell 1921, 163.

6 Ibid., 163.

7 Pennell 1908, I: 95.

8 Elizabeth Pennell, unpublished journal, May 10, 1907, in LC PWC.

9 "parmi les femmes il y aura Jo toute claire et rose, aupres d'elle une vielle toute en noir." Whistler to Henri Fantin-Latour, [Oct. 5, 1862], LC PWC; GUW 07951.

10 There are four versions of the picture: Nationalmuseum, Stockholm; The Metropolitan Museum of Art, New York; Nelson-Atkins Museum of Art, Kansas City; and private collection, although it is unclear whether they all date from the same period.

11 J. A. Rose, power of attorney, Jan. 31, 1866, LC PWC; GUW 11480.

12 Works including *Variations in Flesh*

Colour and Green (YMSM 56) were in Whistler's studio.

13 Le Sommeil, 1866, Musée du Petit Palais, Paris.

14 Hiffernan was an occasional visitor to Whistler's studio in Great Russell Street from 1868 to 1869. Unpublished Pennell Journal, Oct. 18, 1906, LC PWC.

15 Copy of diary of Alan S. Cole, LC PWC; GUW 13132. In fact, Hiffernan would have been about thirty-four in 1877.

16 May 2, 1880, GUL H55; GUW 01954.

17 Unpublished Pennell Journal, Sept. 13, 1907, LC PWC; Whistler's first exhibition with Dowdeswells' took place in May 1884. The Dowdeswells were possibly confusing Hiffernan with her successor, Maud Franklin. However, it is feasible that they were still in contact in 1884, not least through Hanson.

18 Millais's drawing technique is closest to that of Whistler at this time, as in his vigorous treatment of seated female figures in his first illustration for the novel Mistress and Maid, in Good Words (1862), 289.

19 "Il y a trois personnes—un vieux en chemise blanche celui du milieu qui regarde par la fenêtre—puis à droite dans le coin, un matelot en casquette et en chemise bleu à grand col rabattu d'un bleu plus clair, qui cause avec une fille bigrement difficile a peindre! . . . C'est des cheveux les plus beaux que tu n'aie jamais vu! d'un rouge non pas doré mais cuivré—comme tout ce qu'on a revé de Venitienne!—une peau blanche jaune ou dorée si tu veux—et avec cette fameuse expression dont je te parle—un air de dire à son matelot 'Tout ça est bon mon vieux! J'en ai vu d'autres!' tu sais elle cligne de l'oeil et elle se moque de lui! . . . La gorge est exposée—la chemise se voit presque en entier qui est bien peinte mon cher—et puis une jacquette vois tu c'est ça! en etoffe fond blanc à grand arabesques et fleurs de toutes couleurs!" Whistler to Henri Fantin-Latour, [Jan./July 1861], LC PWC; GUW 08042.

20 For a detailed analysis of Wapping, see Spencer 1982, 131–42.

21 Surtees 1980, 35.

22 Ibid., 45.

23 Wallace and Gillespie 1949, 1149. My thanks to Norman MacDonald for this reference.

24 Du Maurier 1951, 227.

25 Ibid., 105.

26 Ibid., 139.

27 Ribeiro 1986, 127–29.

28 Mayne 1964, 30.

29 Mayhew 1865, 86.

30 Linton, "The Modern Revolt" (1870), in Hamilton 1995, 180.

31 Linton, "The Girl of the Period" (1868) in ibid., 172.

32 Diary of Lady Frederick Cavendish, 1865, quoted in Gere 1996, 12.

33 It is important to bear in mind that its twenty-year popularity did not decline significantly until 1865–66. Adburgham 1964, 133.

34 Documented in Dante Gabriel Rossetti's photographic studies of Morris, which closely relate to his painted works (see Ovenden 1972).

35 Howitt 1889, II: 143.

36 Never completed; National Gallery of Art, Washington, D.C.; YMSM 44.

37 Quoted in Adburgham 1964, 175.

38 Collins 1920, 352, 367.

39 1862; Hamburger Kunsthalle.

40 Hiffernan to George A. Lucas, Apr. 9, 1862, Baltimore Museum of Art, W-Lucas file; GUW 09186.

41 Whistler to George A. Lucas, June 26, [1862], Wadsworth Atheneum, Hartford; GUW 11977.

42 Whistler, July 1, 1862, published in Athenaeum (July 5, 1862), 23; GUW 13149.

43 Athenaeum (July 19, 1862), 86; GUW 12979.

44 William Powell Frith's The Railway Station (1862, Royal Holloway College, London) was a substantial popular success during its exhibition.

45 See Ellis 1951, 29–30.

46 See Spencer 1998, 309.

47 1866, Tate Britain, London.

48 Leonée Ormond first drew attention to this point, Ormond 1974, 26–29.

49 Whistler's concern for costume details is documented in his correspondence while planning Harmony in Grey and Green: Miss Cicely Alexander (YMSM 129). See Anna M. Whistler and Whistler to R. A. Alexander, Aug. 26, [1872], Department of Prints, British Museum; GUW 07571.

50 Gere 1996, 15.

51 Ormond 1974, 27.

52 Whistler's passport, [1862/1864], GUL NB 10; GUW 12745.

53 Surtees 1971, cat. 124a.

54 See, for example, in Ovenden 1972.

55 "The Royal Academy Exhibition (Third Notice)," Saturday Review (June 3, 1865), 665.

56 As described by Du Maurier, "a beautiful white cambric dress, standing against a window which filters the light through a transparent white muslin curtain"; Du Maurier 1951, 105.

57 "The Royal Academy Exhibition (Third Notice)," Saturday Review (June 3, 1865), 665.

58 There is a comparable example dated 1860–64 in the Museum of London (66.134/1a and b).

59 With thanks to Joyce Townsend, Conservation Department, Tate Britain, London, for her assistance.

60 "J'ai laissé deux boucles d'oreille immitation de perle pour être reparé chez un bijoutier . . . il me les faut pour un tableau." Whistler to Henri Fantin-Latour, [July 6/10, 1863], LC PWC; GUW 08043.

61 "De toile très blanc, la même robe que la fille blanche d'autrefois . . . cette figure est tout ce que j'ai fait de plus pur—tête charmante. Le corps, les jambes, etc., se voient parfaitement à travers la robe." Whistler to Henri Fantin-Latour, Aug. 16, [1865(?)], LC PWC; GUW 11477. Initially, Whistler seems to have used a similar title, "The Two Little White Girls" (see Rossetti 1903, 228, diary entry, Mar. 31, 1867).

62 A Musician, Yale Center for British Art, New Haven.

5 WHISTLER AND AESTHETIC DRESS

1 Pennell 1921, 101.

2 Casteras 1982, 47.

3 See, for instance, Tibbles's account of life at Speke Hall, 1994, 37.

4 Haweis 1878, 14.

5 See Bissonnette 1998.

6 Ormond 1970, 49.

7 For an extensive biography of Leyland, see Merrill 1998, chapter 3, pp. 109–46.

8 Ibid., 117. See also The [London] Times (Jan. 13, 1910).

9 Orchard 1884, 95.

10 Dorment and MacDonald 1994, 155.

11 MacPhee 1993, 45. On Leyland as a collector, see Prinsep 1892, Robinson 1892, and Duval 1986.

12 Prinsep 1892, 130.

13 See Fennell 1978; Merrill 1998, 78.

14 Merrill 1998, 88. Whistler and Leyland may have met earlier.

15 Tibbles 1994, 34–37.

16 See Merrill 1998, 109–46; Orchard 1884, 93–98; Stripe c. 1893. See also Chapter 3.

17 Arrangement in Black: Portrait of F. R. Leyland, Freer Gallery of Art, Washington, D.C. (YMSM 97); YMSM 82–88; Curry 1984, 107–10; Merrill 1998, 88–89, 98–106.

18 Merrill 1998, 88; YMSM 61.

19 YMSM 88; Anna M. Whistler to J. H. Gamble, [Aug. 27, 1867], LC PWC 1/33/25; GUW 06535: "Now he [Whistler] is steadily at work in his studio, for he has received orders for two pictures at 300 guineas each."

20 See Swinburne 1875; Girl with Cherry Blossom, YMSM 90.

21 YMSM 87.

22 See Curry 1984, 107–10.

23 Merrill 1998, 87; Correspondances, from Baudelaire's Fleurs du Mal, introduces the notion of synaesthesia or the correspondence and conflation of the senses. In this poem, "Les parfums, les couleurs et les sons se répondent." Whistler himself wrote in his essay "The Red Rag," "As music is the poetry of sound, so is painting the poetry of sight. . . ." (Whistler 1890, 127).

24 Anna M. Whistler to Frederick R. Leyland, Mar. 11, [1869], LC PWC 34/1/1; GUW 08182.

25 Whistler to Frances Leyland, [Aug. 27/31, 1871], LC PWC 2/16/2; GUW 08051.

26 Pennell 1921, 101.

27 Ibid., 97; Whistler to Frances Leyland, [Jan. 1, 1874(?)], LC PWC 13/1171-2/1; GUW 10867.

28 See Merrill 1998, 122.

29 See ibid., 123, 127.

30 Musée d'Orsay, Paris; YMSM 101.

31 Lochnan 1984, 158–59. The etching was carried out between 1870 and 1879, during which time Whistler transformed the original composition considerably, substituting a different figure in a different costume for Frances Leyland.

32 Tibbles 1994, 35: "Fanny [sic] is shown here against an imaginary Speke Hall, concocted of parts of the north and south fronts of the building."

33 Anna M. Whistler to Kate Palmer, Nov. 3–4, 1871, LC PWC 34/75-76; GUW 10071.

34 Pennell 1921, 101.

35 Letter from Anna M. Whistler to J. H. Gamble, Mar. 13, 1872, GUL W542; GUW 06548.

36 Pennell 1921, 101–102.

37 Pennell 1908, I: 177.

38 Pennell 1921, 102.

39 See also K. 106 and Lochnan 1984, 161–62.

40 See, for example, M. 432.

41 Pennell 1921, 301.

42 Ibid., 101–102.

43 Ibid., 102.

44 Whistler to Frances Leyland, [Jan. 1, 1874(?)], LC PWC 13/1171-2/1; GUW 10867.

45 See Marsh 1987.

46 Nakanishi 1992, 162.

47 See Surtees 1971, no. 198, pl. 289. See also Fennell 1978, 4–5, letter 6.

48 Merrill 1998, 88. In a letter to F. R. Leyland of June 18, 1867, Rossetti writes: "I have now given the figure a flowing white and gold drapery, which I think comes remarkably well and suits the head perfectly." He also cites verse by Poliziano in reference to the painting; see Fennell 1978, 4–5.

49 Bissonnette 1998, 6; Fisher 1998, 5.

50 See Bissonnette 1998, 58, n. 9, for a list of English fashion periodicals of the early 1870s that show examples of robes d'intérieur with Watteau backs.

51 Bissonnette 1998, 7.

52 Cunnington 1966, 497.

53 Cited in Cachin and Moffett 1983, 254.

54 On Manet and Watteau, see Fried 1969, 1996. On Whister and Watteau, see Curry 1984, 35–51. On the possibility of Whistler seeing Watteau drawings, see M. 430 and MacDonald 2001, 36–37.

55 See Cunnington 1990, in which only a few examples of the Watteau mode prior to 1870 are cited; see 214 for mention of a "Watteau" day dress of 1862.

56 Curry 1984, 46, notes that from 1865 to

1900 Watteau's ladies were imitated in popular fashion, citing such journals as the Revue de la Mode and L'Art et la Mode. MacDonald notes that examples of the Watteau mode appear later and that Whistler anticipated the fashion (see M. 430). In my opinion, Whistler was at the cutting edge of the Watteau fashion in England, which was already under way in France, acting as a transmitter.

57 Merrill 1992, 131.

58 See M. 428–39, 454v, 468; Curry 1984, cats. 229–34; Nakanishi 1992.

59 With thanks to Elizabeth Ann Coleman, Curator of Textile and Fashion Arts at the Museum of Fine Arts, Boston, for sharing her ideas about the progression of the drawings in a letter of Dec. 10, 2001, and for her analysis of the costumes. The discussion of the drawings also benefited from the guidance of Aileen Ribeiro and Margaret MacDonald.

60 Coleman letter to the author, Dec. 10, 2001.

61 An article in the Revue de la mode of Jan. 29, 1879, in Garnier 1977, 171, notes: "le style grec et le style Watteau se disputent l'empire de la mode."

62 See Prinsep 1892 and Robinson 1892.

63 On Whistler's pastel technique, see Way and Dennis 1903, 90.

64 Curry 1984, 251. On Watteau's technique, see Wintermute 1999, 8–49.

65 M. 434, 435. According to MacDonald, notes written in French appearing on M. 435 indicate that the top rosettes were intended for the waist, the central one for the bodice, and the lower for a hair ornament.

66 See M. 428, although this drawing is less clearly connected with the portrait of Mrs. Leyland.

67 Nakanishi 1992, 160.

68 Pennell 1921, 102.

69 The Art Institute of Chicago, M. 454v.

70 Nakanishi 1992. See also M. 454v for a summary of views on this work.

71 MacDonald notes: "Nakanishi considered it, like No. 429, as dating from early in Whistler's acquaintance with Mrs Leyland, before he decided on the standing pose for her portrait. However, there is nothing in the dress to relate it to other studies for the portrait, while the confident style suggests a later date" (M. 549). See also Nakanishi 1992, 159.

72 With thanks to Phyllis Magidson, Curator of Costume at the Museum of the City of New York, for this observation. The back of the neck is also considered an erogenous zone in Western dress.

73 See M. 493r,v and 494r,v.

74 Bendix 1995, 92.

75 "Proposition, No. 2" in Whistler 1890, 115.

76 Mayne 1964, 13.

6 THE ARTIST AS MODEL

1 Ellen Terry to W. Graham Robertson, Apr. 16, 1904; cited in Robertson 1931, 191.

2 The deteriorating condition of the painting, which darkened even in Whistler's lifetime, has contributed to the problem.

3 Siècle (May 14, 1891); GUL pc11/43: "presque noyée des ténèbres."

4 Rothenstein 1937, 111.

5 "C'est une des plus nobles figures féminines qu'on puisse rencontrer . . . le modèle, sérieux, jusqu'à la gravité, se manifeste avec une autorité calme, une sérénité pleine de douceur." Echo de la Semaine (May 24, 1891); GUL pc11/47.

6 Robertson 1931, 191.

7 Ibid.

8 For the most recent biographical information, see Cockerill, in Galassi 2001, 36: see also F. Corder Clayton 1914, 20.

9 Cockerill in Galassi 2001, 36.

10 E. C. Clayton 1876, I: 44.

11 Cockerill in Galassi 2001, 36.

12 See Cline 1978.

13 Williamson 1919, 118.

14 Rossetti 1895, I: 350–51; Angeli 1954, 241–46.

15 Williamson 1919, 133.

16 Doughty and Wahl 1947, vol. 3, 1308, letter no. 1518.

17 Angeli 1954, 233.

18 Ibid, 236.

19 Robertson 1931, 190.

20 Whistler to Corder, University of Texas, Austin, cited in YMSM 203; GUW 10040.

21 Whistler to Howell, GUL LB 11/69; GUW 02790. Pennell 1908, vol. 1, 228.

22 Robertson 1931, 190.

23 Pennell 1921, 301.

24 YMSM 203; Dorment and MacDonald 1994, 208.

25 Tate Britain, YMSM 127.

26 Dorment and MacDonald 1994, cat. 128.

27 Cited in Janet Arnold, "Dashing Amazons: The Development of Women's Riding Dress, c. 1500–1900," in de la Haye and Wilson 1999, 20.

28 Ibid., 18.

29 Cited in Dorment and MacDonald 1994, 208.

30 See Lou Taylor, "Wool cloth and gender: the use of woolen cloth in women's dress in Britain, 1865–85," in de la Haye and Wilson 1999, 30–47.

31 Cunnington 1990, 283.

32 Ibid., 256.

33 Quoted in ibid., 279.

34 In a letter [Sept./Oct. 1874(?)] to Rachel Agnes Alexander, Whistler also mentions that the Leyland children had hats from this shop. BM 1958-2-8-4, 35-6; GUW 07583.

35 See MacPhee 1993, 49–54. The portraits of Mr. and Mrs. Naylor were commissioned by Naylor's tenants as a wedding present, 52.

36 Whistler to Alexander Reid, [Aug. 2, 1892], GUL LB4/40; GUW 03201. YMSM 203.

37 The painting recalls an earlier depiction of an artist's companion, Claude Monet's portrait of his future wife, Camille, in *Camille* or *The Woman with a Green Dress*, 1866, Kunsthalle, Bremen.

38 Jopling 1925, 71.

39 YMSM 191.

40 Detroit Institute of Arts, YMSM 170.

41 This letter was generously provided by the late J. A. Allen.

42 Doughty and Wahl 1947, vol. 4, 1580, letter no. 1942. There is no record of its having been published.

43 Rossetti 1895, 1: 350–51. See also Angeli 1954, 241–46.

44 See Jones 1990, 221–22.

45 Montesquiou 1892, 279: "Miss Corder, au chapeau que contourne la plume, / Son profil de frondeuse aux airs ligueurs bénins."

46 *The Globe* (May 1, 1879).

47 *The World* (May 7, 1879).

48 See Galassi 2001 on Rosa Corder's career as an artist.

49 This letter was generously provided by the late J. A. Allen.

50 Matthew Robinson Elden to Whistler, [Feb. 1880], GUL E37; GUW 01049.

51 Beatrice Ellen Howell (1887–1943) married Charles Allen in 1907. Information courtesy of Timothy Cockerill and a great-granddaughter of Rosa Corder, Yvonne Gray. Thanks are due also to Avis Berman.

52 Cockerill in Galassi 2001, 36.

53 Williamson 1919, 132.

7 MAUD FRANKLIN

1 Maud Little, née Franklin, to W. Tyler, Dec. 27, [1901], GUL F570; GUW 12876.

2 Alan S. Cole, Mar. 12, 1876, in Pennell 1908, 1: 189; Mar. 6, 1878, ms. partial copy of diary, LC PWC 281/557–87; GUW 13132 and in GUL LB6/226–44; GUW 03432.

3 See Holt 1887; see also Macdonald 1987.

4 Maud Little, née Franklin, to Ione and/or Warwick Tyler, [1900/1901], GUL F569; GUW 12871.

5 Maud Little to Ione Franklin, [Mar. 1902], GUL F572; GUW 12873.

6 Wilde 1877.

7 London *Daily News* (Nov. 26, 1878).

8 See YMSM 181; Merrill 1992, 146–47.

9 "The Grosvenor Gallery: First Notice," *Magazine of Art*, vol. 1 (1878), 51.

10 Whistler to Alexander Reid, Aug. 2, 1892, GUL LB 4/40; GUW 03201.

11 *The* [London] *Times*, May 2, 1878.

12 The Frick Collection, New York; see Dorment and MacDonald 1995, cat. 57; see also Ribeiro 1997, 67–68.

13 "Nos anciens amours," Whistler to Henri Fantin-Latour, June 29, 1859, LC PWC 1/33/31; GUW 08050; forty-two Gainsboroughs were in *British Exhibition of Old Masters*, British Institution, 1859.

14 Thieme 1993, pl. 18.

15 Unidentified press clipping, GUL pc1/93; see also "The Grosvenor Gallery: First Notice," *Magazine of Art*, vol. 1 (1878), 51.

16 Linley Sambourne, "Imitation the Sincerest Flattery," *Punch*, vol. 74 (Jan. 5, 1878), 309; George Du Maurier, *Punch*, vol. 74 (June 29, 1878), 299.

17 Diary of Edward W. Godwin, Mar. 21, 1879; see MacDonald 1987, 24–25.

18 Maud Franklin to George A. Lucas, Oct. 23, 1879, Baltimore Museum of Art; GUW 09202.

19 Quoted in Pennell 1921, 164–65; see MacDonald 1987, 16.

20 Maud Franklin to Otto Bacher, [Mar. 21, 1881], Freer Gallery of Art, Washington, D.C.; GUW 11621; MacDonald 2001, 93.

21 Maud Franklin to Otto Bacher, [Apr. 12/30, 1880]; GUW 10057; Bacher 1906, 138–63.

22 London *Standard*, May 19, 1884; GUL pc6/9.

23 See, for example, Mortimer Menpes, *Dolce Far Niente*, Hunterian Art Gallery, University of Glasgow; William Stott of Oldham, *Venus Born of the Sea Foam*, Oldham Art Gallery.

24 Pseudonym "Clifton Lin," at Society of British Artists (SBA), 1884/85 to 1887/88 (Royal Society of British Artists); see MacDonald 1987, 26, n. 40, and 24, pl. 19.

25 Maud Franklin to George A. Lucas, [Oct. 23, 1886], Baltimore Museum of Art; GUW 09209.

26 See "November Fashions," *The Woman's World* (Nov. 1887), 45, showing similar outfits.

27 George A. Lucas to Maud Franklin, Oct. 27, 1886; Diary, Jan. 1888, and June 13, 1892, quoted in Randall 1979, 1: 27.

28 Maud Little, née Franklin, to Ione Tyler, Mar. 13, [1903 or after], GUL F57; GUW 12902; see also Maud Little to Ione Tyler, Apr. 29, [1902], GUL F574; GUW 12879. After Little's death she married another New Yorker, R. H. S. Abbott, and lived in Cannes until her death about 1941.

29 Maud Franklin to George A. Lucas, Jan. 1, 1902, quoted in Randall 1979, 1: 27–28.

30 YMSM 357, 253.

31 London *Standard*, Nov. 30, 1886; GUL pc7/57.

32 Kate Munro (Mrs. Miles) (1848–1887); see Pascoe 1880, 267; and Guy Little Collection, Theatre Museum, London, Archives, XVI. V. 3.

33 Guy Little Collection, Theatre Museum, London, Archives, XVI. V. 4 and 6.

34 When *Black and red* was exhibited in 1884, a note by Whistler identified the sitter as "Madge" (short for Margaret); "*Notes*"— "*Harmonies*"—"*Nocturnes*," catalogue annotated by Whistler, 1884, Rosenwald Collection, LC. In 1905 (that is, after Whistler's death) it was called "Noir et or. Madge O'Donoghue" (Paris 1905, cat. 87). There are no other clues to the identity of the sitter.

35 Wedmore 1884, 374.

36 *Artist*, vol. 5 (June 1884), 164, in GUL pc6/9.

37 See for instance George Du Maurier, "A Group of 'Arries," *Punch*, vol. 77 (Sept. 20, 1879), 130, showing working-class dress.

38 See costumes in *Weldon's Ladies Journal of Dress, Fashion and Needlework* (July 1, 1881), 10–11, 18–19, and (June 1, 1882), 260; *The World of Fashion* (Feb. 1882), pl. 1, no. 348, and children's dresses in Sept. 1883, pl. 3, in album of fashion plates, Victoria and Albert Museum, London, Prints and Drawings 96.F7, E4290–1968 and E4316–1969.

39 1863, Musée d'Orsay; see Clark 1999, 78 et seq.

40 Blanche 1937, 1: 56.

41 Ibid., 53; James's novel *What Maisie Knew* was published in 1897.

42 *Chicago Tribune* (June 9, 1889).

43 Frederick Lawless to Elizabeth R. Pennell, Oct. 23, [1907(?)], LC PWC; Anderson 1985, 45.

44 Pennell 1908, 11: 10, repr. facing p. 10.

45 See Heijbroek and MacDonald 1987, 137.

46 Whistler (in Amsterdam) to Waldo Story (in Rome), [Dec. 1882], Institut Néerlandais, Paris, Fondation Custodia, Frits Lugt Collection, Doc. J1692; GUW 09434.

47 Although Whistler does not use the term "swaggerer" in the sense of grand portraiture (see Wilton 1992, 11–19), the physical "swagger" of his models was equated with confidence and sexual allure.

48 Whistler to Waldo Story, Feb. 5, 1883, Pierpont Morgan Library, New York, PM 22–27; GUW 09430.

8 LADY HENRY BRUCE MEUX AND LADY ARCHIBALD CAMPBELL

1 YMSM 230; Dorment and MacDonald 1994, cat. 126.

2 A fourth, in which she was to pose in riding clothes, was apparently discussed but never begun; Way 1912, 65.

3 See Rooke 1980; Phillips 1986; Lambton 1925; Bradburn 1989; Surtees 1997.

4 Richard Langdon of Ashburton, New Zealand, a descendent of Lady Meux's brother William, has traced the Langdon family back to 1703 in Devonshire and has generously shared his information with The Frick Collection. See email dated Dec. 29, 2001, in the curatorial file of The Frick Collection.

5 A marriage certificate documents their

union, which took place in the Parish Church of Drewsteignton on Jan. 22, 1850.

6 Langdon, email dated June 16, 2001.

7 Phillips 1986, 26. According to Langdon family history, however, the so-called foster mother was, in fact, her real mother. See Langdon email of June 16, 2001.

8 *The Illustrated London News* (Dec. 31, 1910). Phillips 1986, 31, specifies the Old Surrey Music Hall, London.

9 Surtees 1997, 106, notes that the Brewery sounded the final x.

10 Ibid., 114–15.

11 De Marly 1980, 100.

12 Surtees 1997, 116; Phillips 1986, 26.

13 Phillips 1986, 24.

14 Langdon, email dated Aug. 22, 2001. (Information provided to Langdon by Rhys Griffith, Senior Archivist, Corporation of London.)

15 *Truth*, vol. 4, no. 98 (Nov. 14, 1878), 545.

16 Ibid., vol. 4, no. 99 (Nov. 21, 1878), 577.

17 Phillips 1986, 27.

18 Surtees 1997, 121; Phillips 1986, 26.

19 Langdon, email dated Sept. 9, 2001, forwarding information from 1881 Wiltshire Census (Source FHL Film 1341488 Pro Ref RG11).

20 Langdon, email dated Mar. 3, 2002.

21 Bradburn 1989, 29.

22 On the notion of constructing an identity through portraiture, to which this section is indebted, see Brilliant 1991, 45–141.

23 Duret 1904, 93–94: "ce fut un acte de courage que se faire peindre par Whistler.... on passait pour un ignorant, dénué de comprehension artistique et surtout pour une dupe.... Cependant Mme Meux, sans s'inquiéter de l'opinion des autres, lui demandait un premier portrait."

24 Sutton 1974, 38.

25 Pennell 1908, I: 300.

26 See Budge 1896.

27 Way 1912, 64; YMSM 228; Sutton 1974, 36–43; Dorment and MacDonald 1994, 201–3.

28 Wilton 1992, 19; see 11–62 for an excellent discussion of state and society portraiture.

29 Veblen 2001, 123.

30 Whether Mrs. Meux's jewels were bought by her husband at the Meux family jewelers, C. F. Hancock & Company in London, is not known. Thanks are due to Karin Bejerano for looking into this. For a history of Hancock's, see Gere in Snowman 1990, 46–60. Way described Mrs. Meux's jewels as "a tiara and necklet of diamonds of great size" (Way 1912, 64).

31 Mawe 1823, xiii–xv.

32 Scarisbrick 2000, 20.

33 Cited in ibid., 24.

34 Whistler to Valerie Meux, [Jan. 1/8, 1884], LC PWC 2/26/1; GUW 07928. Whistler refers to "the one in black velvet."

35 M. 850, 851; Dorment and MacDonald 1994, cat. 125.

36 Hawthorne 1899, 295.

37 See Chapter 2.

38 *The Continental Gazette* (May 6, 1882); GUL pc3/83.

39 See Harvey 1995, 225.

40 Coleman 1989, 191.

41 Hawthorne 1881.

42 "Whistler To-day," *The Fortnightly Review* (Apr. 1892), cited in Spencer 1989, 278.

43 In an email of Mar. 4, 2002, Jennifer Saville, Curator of the Honolulu Academy of Arts, notes that "it is rather inconclusive as to whether it was a full robe, a stole, mantle, a boa...."

44 Hawthorne 1881, 1899.

45 Way and Dennis 1903, 47.

46 Duret 1904, 94.

47 See Lochnan 199.

48 Dorment and MacDonald 1994, 201; Surtees 1997, 165, n. 109, citing fur expert J. G. Links, notes that "the cloak could only have been white arctic fox at that time." See also Ribeiro 1979, 231.

49 See Ribeiro 1979, 226–31.

50 See Ewing 1981, 98. The Hudson Bay Company's exhibit at the Great Exhibition of 1851 displayed the wider range of fur, including raccoon, beaver, chinchilla, bear, fox, mink, and so on that were in common use.

51 See Munhall 1995, 75–76.

52 Duret 1904, 94.

53 Huysmans 1908, 66: "un portrait noir, fantômatique, surtout bizarre."

54 Bade 1979, 6.

55 Ibid., 8.

56 "Sole inventor of the Albino pommade, for instantly bleaching hair." Press clipping in GUL pc4, cited in YMSM 229.

57 Cited in McLaughlin 1972, 128–29.

58 Ibid., 130.

59 Mayne 1964, 33. See also Whistler to Samuel Wreford Paddon, referring to the "beautiful black lady," [Mar. 22, 1882], in Whistler 1882, 3–4, letter v; GUW 09523.

60 Coleman 1989, 190, identifies dress by Worth and mantle by Pingat.

61 *Le Jour* (May 5, 1883), in Spencer 1989, 201.

62 "Un Whistler étonnant, raffiné à l'excès, mais d'une trempe," Degas to Rouart, May 2, 1882, translated in YMSM 229.

63 Levitt 1986, 31; see also 26–40. On tight lacing, see Ribeiro 1986, 135.

64 A label inside the dress reads, "Maison Lord & Taylor, Brevêté."

65 See Coleman 1989, 137–67.

66 Pennell 1908, I: 301; Surtees 1997, 127.

67 The painting was rejected by the Salon for reasons of indecency and set off a storm of protest when exhibited in the window of the paint shop Giroux in Paris. See Friedrich 1992, 159; 156–90.

68 *Stock Exchange* (Jan. 23, 1892); GUL pc13/3.

69 *Yorkshire Daily Post* (Mar. 21, 1892); GUL pc13/20.

70 Cited in Sweeney 1956, 209–10.

71 Wiehl 1983.

72 *The Art Journal* (1882), 189.

73 Pottier 1892, 455: "Voilà sans doute un homme qui ne dédaigne pas les effets de costume et qui ne craint pas de faire poser devant lui une noble dame en élègante toilette. Mais comme il a bien compris l'intime union de la femme et de son ajustement."

74 YMSM 230.

75 Hawthorne 1881.

76 Ewing 1981, 97.

77 Davey 1895, 72.

78 Valerie Meux to Whistler, GUL M338; GUW 04067; Whistler to Valerie Meux, [July 30, 1886], GUL M338a; GUW 04068.

79 Pennell 1908, I: 302.

80 Quoted in Bradburn 1989, 30.

81 Ibid., 30–31.

82 *The Illustrated London News* (Dec. 31, 1910).

83 Valerie Meux to Whistler, Jan. 13, 1892, GUL M341; GUW 04071.

84 Ibid.

85 Ibid., May 16, 1892, GUL M344; GUW 04074.

86 Ibid., Sept. 22, 1891, GUL M339; GUW 04069.

87 Ibid., Dec. 2, 1892, GUL M345; GUW 04075.

88 Bruscambille 1888, 1.

89 Campbell 1885, 1031–1042; Campbell 1888, 1–7; 1886.

90 Campbell 1886, 16.

91 Duret 1904, 96.

92 YMSM 242: The painting won a gold medal at the 1889 International Exhibition in Paris, was exhibited at the 1893 Columbia Exhibition, and received another gold in Philadelphia that year.

93 Pennell 1911, 213–14. See Duret 1904, 98.

94 Duret 1904, 95.

95 Pennell 1911, 213.

96 Lou Taylor, "Wool cloth and gender: the use of woolen cloth in women's dress in Britain, 1865–85," in de la Haye and Wilson 1999, 31.

97 With thanks to Aileen Ribeiro for her guidance on the costume analysis.

98 Cunnington 1990, 309.

99 Godwin in Cunnington 1970, 527.

100 Cited in YMSM 317.

101 Duret 1884, 535.

102 Robertson, Feb. 9, 1937, cited in Preston 1953, 367.

103 Dorment and MacDonald 1994, 212.

104 *Tablet*, Feb. 4, 1892; GUL pc13/44.

105 See YMSM 354; Ribeiro 2000, 195–96.

106 YMSM 354.

107 *Lady's Pictorial* (Dec. 9, 1893), 923.

108 Duret 1884, 536: "One senses the model living, walking, becoming restless. If my notions about the art of painting aren't entirely erroneous, it seems to me that here are realized all the conditions for work of great art." See Hollander

1994, who argues that the more formally integrated and dynamic suit is sexier than the dress.

9 LOVE AND FASHION

1 Beatrice Whistler to Whistler, Nov. 20, 1895, GUL W639; GUW 06645.

2 See sale of panels to Watts recorded in Edward W. Godwin's diary, May 1879, Victoria and Albert Museum, London. Panels in Hunterian Art Gallery, University of Glasgow. MacDonald 1997, 30, repr. 31, cat. 74.

3 Designs in Print Room, Theatre Archive, and AAD, Victoria and Albert Museum, London. See Soros 1999, 263–79, 313–51.

4 Godwin's diary, Nov. 21, 1877, re buying Beatrice a Liberty dress for £3; Victoria and Albert Museum, London; see MacDonald 1997, 23–24, 26–29.

5 London, Society of British Artists, 1885–86, to Royal Society of British Artists, 1887/88.

6 For example, *The Muslin Gown* (private collection), exh. Royal Society of British Artists, 1887–88, cat. 360.

7 MacDonald 1987, 11, 33; caricature, Hunterian Art Gallery, University of Glasgow.

8 Woodville 1914, 137, 138–40. Many thanks to Martin Hopkinson for this reference.

9 "In Whistler's Studio," *Court and Society Review*, vol. 3 (July 1, 1886), 488–90. GUL pc3/65.

10 Woodville 1914, 137, 138–40.

11 Manchester *Sunday Chronicle*, Aug. 12, 1888; GUL pc10/24.

12 Anon., "The Fate of an 'Impressionist,'" *Illustrated Bits* (July 21, 1888).

13 Henry Labouchère, *Truth*, vol. 54 (July 23, 1903), 206–7.

14 *Pall Mall Gazette* (Aug. 11, 1888); GUL pc10/25.

15 Whistler to Helen Whistler, [Sept. 22, 1888]; GUL W707; GUW 06713.

16 Letter signed "E. B.," *The* [London] *Times* (July 17, 1934).

17 Pyke Brothers to Whistler, [Dec. 25, 1889], GUL D47; GUW 00841.

18 James Unitt Parkes to Whistler, [Dec. 25, 1890], GUL P165; GUW 04525.

19 Cited in Laughton 1971, 117.

20 See pencil drawings, National Gallery of Art, Washington, D.C., Rosenwald Collection B-10,875 and 10,876, formerly attributed to Whistler. Enameled flowers and animals were popular for daytime jewelry; see *The Queen*, vol. 83 (Jan. 14, 1888), 41.

21 Freer Gallery of Art, Washington, D.C., M. 1290–91.

22 Whistler to Beatrice Whistler, [Jan. 24, 1892], GUL W599; GUW 06606.

23 Ibid.

24 Whistler to Beatrice Whistler, [Jan. 19, 1892], GUL W600; GUW 06607.

25 See photograph by Nadar, repr. in Munhall 1995, 44, pl. 39.

26 Whistler to Beatrice Whistler, [Feb. 1892], GUL W598; GUW 06605.

27 Advertisement, *Lady's Pictorial*, vol. 27 (Jan. 20, 1894), n.p.

28 Correspondence between Beardsley and Lane quoted in Mix 1960, 76. *The Fat Woman* was in fact published, in "A New Master of Art. Aubrey Beardsley," *To-Day* (May 12, 1894), 28, and *Le Courrier Français* (Nov. 11, 1894), 5. I am grateful to Linda Zatlin for this information. See also Beardsley's drawing *The Wagnerites* for *The Yellow Book*, vol. 3 (Oct. 1894); line-block, V&A E.15-1900. Beardsley also drew Whistler as an effeminate dandy; Rosenwald Collection, National Gallery of Art, Washington, D.C.; see Calloway 1998, 79.

29 Whistler to Robert de Montesquiou, [1892], copy, GUL LB 4/103/2; Newton 1990, 203, no. 109; GUW 03002.

30 "Le petit mot spéciale de Madame de Montebello à la couturière rend tout parfait"; Beatrice Whistler to Robert de Montesquiou, [Apr. 1892], Bibliothèque Nationale Nouv. Acq. Fr. 15335, f. 67, in Newton 1990, 202, no. 108; GUW 03255. See Munhall 1995, 34, pl. 29.

31 "Les addresses, très sérieuses, vous savez, ont elles pu servir à ces Dames?" Stéphane Mallarmé to Whistler, [Feb. 12, 1892]; "Les chiffons prennent maintenant des proportions!" Whistler to Stéphane Mallarmé, [Feb. 11, 1892]; GUL M173, M172; Barbier 1964, 152–54; GUW 03839, 03838.

32 "Quand ces dames seront belles à leur gré, nous les attendons, même sans vous, vers l'heure du thé, une après-midi." Stéphane Mallarmé to Whistler, [Feb. 12, 1892], GUL M173; GUW 03839.

33 Whistler to Beatrice Whistler, [Jan. 19, 1892], GUL W600; GUW 06607: see also Ethel B. Philip to W. Morley-Pegge, [Feb./Apr. 1892(?)], GUL P188; GUW 04548.

34 *The Winged Hat* was published on Oct. 25, 1890; *Gants de Suède* was published in *The Studio* on Apr. 16, 1894 (see C. 34–35).

35 "November Fashions," *The Woman's World* (Nov. 1887), 45.

36 See also Messrs Hyam & Co., "Novel and Becoming Hats," *Lady's Pictorial*, vol. 28 (Oct. 6, 1894), 469.

37 YMSM 389; Beatrice drew Ethel in *La Jolie Mutine*, Hunterian Art Gallery, University of Glasgow.

38 YMSM 395; a similar suit with front pleat skirt and felt hat appeared in *The Queen*, vol. 86 (July 6, 1889), f. 19.

39 YMSM 389, 395, 388, 419, 418, 378.

40 "Description of coloured Fashion Plate," *The Queen*, vol. 86 (Nov. 2, 1889), 618.

"Richesse féeriques de l'Orient"; see *The Queen*, vol. 88 (Nov. 1, 1890), 650, repr. facing 640; an engraving of the same illustration signed "AS" appeared in Anon. (La Masque de Velours), "La Vie Mondaine. Dernières Modes/Nouvelles Etrennes," *Revue Illustré*, vol. 10 (Dec. 1890), 408, repr. 409.

41 "November Fashions," *The Woman's World*, vol. 84 (Nov. 1887), 45.

42 "Aux pieds du soyeux boa de plumes noires." Robert de Montesquiou to Whistler, May 6, 1891, GUL M405; GUW 04135.

43 George Du Maurier, "Happy thought," *Punch*, vol. 92 (March 5, 1887), 111.

44 "Paris Fashions," *The Queen*, vol. 83 (Jan. 14, 1888), 41.

45 *Lady's Pictorial*, vol. 27 (March 17, 1894), 374; advertisement, vol. 28 (July 14, 1894), n.p. Sambourne's photograph formed the basis for a cartoon "A Bird of Prey," *Punch*, vol. 102 (May 14, 1892), 231. I am grateful to Pamela Robertson for this reference.

46 Alfred Stevens to Beatrice Whistler, [1894/1895], GUL S234; GUW 05588.

47 C. 98, 107, 108.

48 Beatrice Whistler to Whistler, Nov. 20, 1895, GUL W639; GUW 06645.

49 Whistler to Edward G. Kennedy, Mar. 14, 1896, New York Public Library, Kennedy I/175; GUW 09738.

50 Ibid.

51 See a comparable dress, but elaborately embroidered, with green bows, in *The Queen*, vol. 97 (Jan. 5, 1895), color supplement, n.p. See also Charles Kerr, *The Rose Coloured Gown*, Guildhall Art Gallery, 1896, 58–1907, no. 1078, with lace over a pink dress, the figure viewed from three-quarter back.

52 GUL D164; GUW 00958.

53 See *The Queen*, vol. 77 (Jan. 4, 1890), 128–29, costumes including a domino, a kimono, and a Spanish dress.

54 Whistler to Rosalind Birnie Philip, [July 5, 1897], [Nov. 30, 1900], GUL P348, 421; GUW 04708, 04781.

55 Feb. 18, 1901, GUL P430; GUW 04790.

56 Andrews 1904, 325, quoted in YMSM 535; Hunterian Art Gallery, University of Glasgow, YMSM 478, 535.

57 National Gallery, London; Whistler's photograph of the painting is in GUL PH 8/2.

58 Whistler, quoted in Bacher 1908, 31; see also Dorment and MacDonald 1994–95, cat. 25.

AFTERWORD

1 Sketchbooks: M. 340, 1001, 1144–45, 1333, 1363, 1475, 1580, 1634, 1643, 1666, 1693, 1711; all in Hunterian Art Gallery.

2 K. 194; MacDonald 2001, 20, 22, 38.

3 Whistler to Anna M. Whistler, [March/May 1880], GUL LB4/19-22; GUW 03125.

4 "Les bijoux de Lalique et les robes des grandes couturières." Théodore Duret to Whistler, June 14, 1900, GUL D199; GUW 00993.

5 Whistler to Thomas R. Way, Aug. 7, 1894, Freer Gallery of Art, Washington, D.C.; GUW 03385.

6 Richard Wright to Whistler, Mar. 26, 1879, in J. Anderson Rose Papers, LC PWC; GUW 08964.

7 Whistler to Rosalind Birnie Philip, Oct. 24, 1899, GUL, P393; GUW 04753.

8 Hunterian Art Gallery, University of Glasgow, M. 531.

9 "Something about Needlewomen," The Woman's World (1888), 300–304.

10 Whistler to Rosalind Birnie Philip, Jan. 16, 1897, GUL P339; GUW 04699.

11 Ibid., Jan. 22, 1897, GUL P340; GUW 04700.

12 Freer bought YMSM 87 from T. R. Way in 1902 and the rest of the Six Projects (YMSM 82–86) from Whistler. He bought the portrait of Maud through Duret in June 1904 (YMSM 185). Frick bought the portraits of Rosa Corder and Montesquiou in 1914 and of Mrs. Leyland and Lady Meux in 1916.

13 Charles Baudelaire, "The Dandy," from The Painter of Modern Life, trans. Mayne 1964, 28.

Bibliography of Works Cited

ABBREVIATIONS

B — Bartsch, Adam. *Le Peintre-graveur.* 21 vols. 1803–21. Reprinted Joh. Ambr. Barth, ed. Leipzig, 1876.

BM — The British Museum, Department of Prints and Drawings, London.

C — Spink, Nesta R., et al. *The Lithographs of James McNeill Whistler.* Eds. Harriet K. Stratis and Martha Tedeschi. 2 vols. Chicago, 1998.

FGA — Archives, Freer Gallery of Art, Washington, D.C.

GUL — Whistler Collection, Special Collections, Glasgow University Library, University of Glasgow.

GUW — *The Correspondence of James McNeill Whistler, 1855–1903.* Eds. Margaret MacDonald, Patricia de Montfort, and Nigel Thorp. On-line Centenary Edition, Centre for Whistler Studies, University of Glasgow, 2003: www.whistler.arts.gla.ac.uk/correspondence.

H — Hind, H. A. *A Catalogue of Rembrandt's Etchings: Chronologically Arranged and Completely Illustrated.* 2d ed. London, 1923.

K — Kennedy, Edward G. *The Etched Work of Whistler.* The Grolier Club, New York, 1910. Reprinted San Francisco, 1978.

LC — Library of Congress, Washington, D.C.

LC PWC — E. R. & J. Pennell Collection, Library of Congress, Washington, D.C.

M — MacDonald, Margaret F. *James McNeill Whistler: Drawings, Pastels, and Watercolours. A Catalogue Raisonné.* New Haven and London, 1995.

P — Parthey, Gustave. *G. Wenzel Hollar, Beschreibendes Verzeichniss seiner Kupferstiche.* Berlin, 1853.

YMSM — Young, Andrew McLaren, Margaret MacDonald, Robin Spencer, and Hamish Miles. *The Paintings of James McNeill Whistler.* New Haven and London, 1980.

Adburgham 1961: Adburgham, Alison. *A Punch History of Manners and Modes.* London, 1961.

Adburgham 1964: ———. *Shops and Shopping 1800–1914.* London, 1964.

Adburgham 1975: ———. *Liberty's: A Biography of a Shop.* London, 1975.

Allem 1962: Allem, Maurice, ed. *Alfred de Musset, Poésies complètes.* Paris, 1962.

Anderson 1986: Anderson, Ronald. "Whistler—An Irish Rebel and Ireland—Implications of an Undocumented Friendship." *Apollo,* vol. 123 (April 1986): 254–58.

Anderson and Koval 1995: Anderson, Ronald, and Anne Koval. *Beyond the Myth.* London, 1995.

Andrews 1904: Andrews, Annulet. "Cousin Butterfly, Being Some Memories of Whistler." *Lippincott's Magazine,* vol. 73 (March 1904): 318–27.

Angeli 1954: Angeli, Helen Rossetti. *Pre-Raphaelite Twilight: The Story of Charles Augustus Howell.* London, 1954.

Armstrong 1912: Armstrong, Thomas. *Thomas Armstrong, C. B., A Memoir: 1832–1911*. Ed. L. M. Lamont. London, 1912.

Arthur 1992: Arthur, Liz. "Fashionable Dress and Boudin." In *Boudin at Trouville*, exh. cat., Burrell Collection, Glasgow, 1992.

Aslin 1986: Aslin, Elizabeth. *E. W. Godwin*, London, 1986.

Aziz 1984: Aziz, Maqbool, ed. *The Tales of Henry James*. Vol. 3. Oxford, [1875–1879] 1984.

Bacher 1906: Bacher, Otto H. *With Whistler in Venice*. New York, 1906 (edition suppressed).

Bacher 1908: ———. *With Whistler in Venice*. New York, 1908.

Bade 1979: Bade, Patrick. *Femme Fatale: Images of Evil and Fascinating Women*. New York, 1979.

Barbier 1964: Barbier, Carl, ed. *Correspondance Mallarmé— Whistler*. Paris, 1964.

Bendix 1995: Bendix, Deanna Marohn. *Diabolical Designs: Paintings, Interiors and Exhibitions of James McNeill Whistler*. Washington, D.C., and London, 1995.

Bénédite 1905: Bénédite, Leonce. "Artistes Contemporains: Whistler." *Gazette des Beaux-Arts*, vol. 33 (1905): 403–10, 491–511; vol. 34 (1905): 142–58, 231–46.

Berger 1992: Berger, Klaus. *Japonisme in Western Painting from Whistler to Matisse*. Cambridge, 1992.

Bissonnette 1998: Bissonnette, Ann. "At Home at Tea Time: The Distinctive Tea Gown of the Victorian Era." *Ladies Gallery, Repository of Victorian Fashion and Pleasure to 20th Century Elegance*, vol. 4, issue 5 (Jan.–Mar. 1998): 6–14, 58.

Blanc 1877: Blanc, Charles. *Art in Ornament and Dress*. London, 1877.

Blanche 1937: Blanche, Jacques-Émile. *Portraits of a Lifetime*. Ed. W. Clement. London, 1937.

Boehn 1927: Boehn, Max von. *Modes and Manners of the Nineteenth Century*. 2 vols. Trans. Michael Edwardes. London, 1927.

Bradburn 1989: Bradburn, Elizabeth. *Margaret McMillan: Portrait of a Pioneer*. London and New York, 1989.

Breward 1995: Breward, Christopher. *The Culture of Fashion*. Manchester and London, 1995.

Brilliant 1991: Brilliant, Richard. *Portraiture*. London, 1991.

Bruscambille 1888: Bruscambille. "Chez John Bull." *Chronique de Paris* (Aug. 18, 1888).

Brydon and Niessen 1998: Brydon, Anne, and Sandra Niessen. *Consuming Fashion: Adorning the Transnational Body*. Oxford and New York, 1998.

Budge 1896: Budge, E. A. Wallis. *Egyptian Antiquities in the Possession of Lady Meux at Theobalds Park*. Privately printed, n.p., 1896.

Bürger 1863: Bürger, Willem (pseud. Théophile Thoré) in *L'Indépendance Belge*, June 11, 1863, repr. in *Salons de W. Bürger, 1861 à 1868*, Paris, 1870.

Burty 1865: Burty, Philippe. "Exposition de la Royal Academy." *Gazette des Beaux-Arts*, vol. 18 (June 1865): 553–65.

Byrde 1992: Byrde, Penelope. *Nineteenth Century Fashion*. London, 1992.

Cachin and Moffett 1983: Cachin, Françoise, and Charles S. Moffett. *Manet, 1832–1883*, exh. cat., The Metropolitan Museum of Art, New York, 1983.

Calloway 1998: Calloway, Stephen. *Aubrey Beardsley*. London, 1998.

Campbell 1885: Campbell, Janey Sevilla [Lady Archibald]. "The Faithful Shepherdess." *The Nineteenth Century: A Monthly Review* (June 1885): 1031–42.

Campbell 1886: Campbell, Lady Archibald. *Rainbow-Music; or, The Philosophy of Harmony in Colour-Grouping*. London, 1886.

Campbell 1888: Campbell, J. S. [Lady Archibald]. "The Woodland Gods." *The Woman's World* (Nov. 1888): 1–7.

Campbell 1893: Campbell, Lady Colin. *The Etiquette of Good Society*. London, 1893.

Casteras 1982: Casteras, Susan P. *The Substance or the Shadow: Images of Victorian Womanhood*. New Haven, 1982.

Cherry 2000: Cherry, Deborah. *Beyond the Frame: Feminism and Visual Culture in Britain 1850–1900*. London, 2000.

Clark 1999: Clark, T. J. *The Painting of Modern Life: Paris in the Art of Manet and His Followers*. London, 1999.

E. C. Clayton 1876: Clayton, Ellen C. *English Female Artists*. Vol. 1. London, 1876.

F. Clayton 1914: Clayton, F. Corder. *A Few Memoranda Concerning Micah Corder (1680–1766) of Feering Bury, in the County of Essex, and His Descendants*. Privately printed, n.p., 1885 with additions in 1914.

Cline 1978: Cline, Clarence Lee, ed. *The Owl and the Rossettis: Letters of Charles A. Howell and Dante Gabriel, Christina, and William Michael Rossetti*. University Park, Pennsylvania, 1978.

Coleman 1989: Coleman, Elizabeth Ann. *The Opulent Era: Fashions of Worth, Doucet, and Pingat*, exh. cat., The Brooklyn Museum, 1989.

Collins 1920: Collins, William Wilkie. *Armadale*. London, [1864–66] 1920.

Cumming 1987: Cumming, Valerie. "Ellen Terry: An Aesthetic Actress and her Costumes." *Costume*, vol. 21 (1987): 67–74.

Cunnington 1966: Cunnington, Cecil Willett and Phillis. *Handbook of English Costume in the Nineteenth Century*. London, 1966.

Cunnington 1970: ———. *Handbook of English Costume in the Nineteenth Century*. Brookfield, Wisconsin, 1970.

Cunnington 1990: Cunnington, Cecil Willett. *English Women's Clothing in the Nineteenth Century*. New York, 1990.

Curry 1984: Curry, David Park. *James McNeill Whistler at the Freer Gallery of Art*. New York and London, 1984.

Dalby 2001: Dalby, Liza. *Kimono. Fashioning Culture*. Seattle, 2001.

Davey 1895: Davey, Richard. *Furs and Fur Garments*. London, 1895.

Davidson 1968: Davidson, Bernice. *The Frick Collection: An Illustrated Catalogue*. Vol. 1. New York, 1968.

Davis 1991: Davis, Tracy C. *Actresses as Working Women*. London and New York, 1991.

De la Haye and Wilson 1999: de la Haye, Amy, and Elizabeth Wilson, eds. *Defining Dress: Dress as Object, Meaning, and Identity*. Manchester and New York, 1999.

De Marly 1980: de Marly, Diana. *Worth: Father of Haute Couture*. London, 1980.

De Montfort 1997: de Montfort, Patricia. "The Master from Madrid: Whistler, Velasquez and Spanish Art." In *Whistler*, exh. cat., La Caixa, Madrid, 1997.

De Montfort 2002: ———. "Joanna Hiffernan." In *Dictionary of Artist's Models*. London, 2002.

Denker 1995: Denker, Eric. *In Pursuit of the Butterfly*. Seattle, 1995.

Dorment and MacDonald 1994: Dorment, Richard, and Margaret F. MacDonald. *James McNeill Whistler*, exh. cat., Tate Gallery, London, 1994; Musée d'Orsay, Paris, 1995; National Gallery of Art, Washington, D.C., 1995.

Doughty and Wahl 1947: Doughty, Oswald, and John Robert Wahl, eds. *Dante Gabriel Rossetti: Collected Letters*. Vols. 3 and 4. Oxford, 1947.

Doughty and Wahl 1965: ———. *Letters of Dante Gabriel Rossetti*. Oxford, 1965.

Druick 1982: Druick, Douglas, and Michel Hoog. *Fantin-Latour*, exh. cat., Galeries nationales du Grand Palais, Paris, 1982; National Gallery of Canada, Ottawa, 1983.

Du Maurier 1951: du Maurier, Daphne, ed. *The Young George Du Maurier*. London, 1951.

Duret 1884: Duret, Théodore. "Expositions de la Royal Academy et de la Grosvenor Gallery." *Gazette des Beaux-Arts*, vol. 29 (June 1884): 531–36.

Duret 1904: ———. *Histoire de J. McN. Whistler et de son oeuvre*. Paris, 1904.

Duret 1917: ———. *Whistler*. Trans. Frank Rutter. London and Philadelphia, 1917.

Duval 1986: Duval, M. Susan. "F. R. Leyland: A Maecenas from Liverpool." *Apollo*, vol. 124 (August 1986): 110–15.

Eddy 1903: Eddy, Arthur Jerome. *Recollections and Impressions of James A. McNeill Whistler*. Philadelphia, 1903.

Ellington 1869: Ellington, George. *The Women of New York*. New York, 1869.

Ellis 1951: Ellis, S. M. *Wilkie Collins, Le Fanu, and Others*. London, 1951.

Ellman 1974: Ellman, Richard, ed. *The Artist as Critic: Critical Writings of Oscar Wilde*. London, 1974.

Emery 1997: Emery, Joy Spanabel. "Development of the American Commercial Pattern Industry: The First Generation, 1850–1880." *Costume*, vol. 31 (1997): 78–91.

Ewing 1981: Ewing, Elizabeth. *Fur in Dress*. London, 1981.

Fennell 1978: Fennell Jr., Francis L., ed. *The Rossetti-Leyland Letters: The Correspondence of an Artist and His Patron*. Athens, Ohio, 1978.

Fine 1984–85: Fine, Ruth E. *Drawing Near: Whistler Etchings from the Zelman Collection*, exh. cat., Los Angeles County Museum of Art, 1984–85.

Fisher 1998: Fisher, Ellen. "Reading Tea Gowns: A Category of Apparel That Symbolizes the Belle Epoque." Ph.D. diss., New York University, 1998.

Fleming 1978: Fleming, Gordon. *The Young Whistler*. London, 1978.

Ford 1890: Ford, Sheridan, ed. *Gentle Art of Making Enemies*. New York, 1890.

Fried 1969: Fried, Michael. "Manet's Sources: Aspects of His Art, 1859–1865." *Artforum*, vol. 7 (March 1969): 28–82.

Fried 1996: ———. *Manet's Modernism, or, The Face of Painting in the 1860s*. Chicago and London, 1996.

Friedrich 1992: Friedrich, Otto. *Olympia: Paris in the Age of Manet*. New York, 1992.

Frith 1887: Frith, William Powell. *My Autobiography and Reminiscences*. 3 vols. London, 1887.

Funnell and Warner 1999: Funnell, Peter, Malcolm Warner, et al. *Millais: Portraits*, exh. cat., National Portrait Gallery, London, 1999.

Galassi 2001: Galassi, Susan Grace. "Rearranging Rosa Corder." *Apollo*, vol. 154, no. 476 (Oct. 2001): 24–36.

Garfield 2001: Garfield, Simon. *Mauve*. London, 2001.

Garnier 1977: Garnier, Christine. "La Mode Watteau: *rubans, myosotis et collerettes*." In *Pèlerinage à Watteau*. Paris, 1977.

Gere 1996: Gere, Charlotte. "The Art of Dress: Victorian Artists and the Aesthetic Style." In Wilson 1996.

Gernsheim 1963: Gernsheim, Alison. *Fashion and Reality 1840–1914*. London, 1963.

Getscher 1977–78: Getscher, Robert H. *The Stamp of Whistler*, exh. cat., Allan Memorial Art Museum, Oberlin, Ohio, 1977–78.

Getscher 1991: ———. *James McNeill Whistler: Pastels*. London, 1991.

Getscher and Marks 1986: Getscher, Robert H., and Paul Marks. *James McNeill Whistler and John Singer Sargent: Two Annotated Bibliographies*. New York and London, 1986.

Ginsburg 1983: Ginsburg, Madeleine. *Victorian Dress in Photographs*. New York, 1983.

Gleadle 2001: Gleadle, Kathryn. *British Women in the Nineteenth Century*. New York, 2001.

Grasselli and Rosenberg 1985: Grasselli, Margaret M., and Pierre Rosenberg, *Watteau 1684–1721*, exh. cat., National Gallery, London, 1984.

Grenville 1892: Lady Grenville. *The Gentlewoman in Society*. London, 1892.

Hamilton 1995: Hamilton, Susan, ed. *Criminals, Idiots, Women, and Minors: Victorian Writing by Women on Women*. Peterborough, Ontario, 1995.

Hanson 1979: Hanson, Anne Coffin. *Manet and the Modern Tradition*. 2d ed. New Haven and London, 1979.

Hartley 1958: Hartley, Anthony, ed. *The Penguin Book of French Verse, 3, The Nineteenth Century*. London, 1958.

Harvey 1995: Harvey, John. *Men in Black*. Chicago, 1995.

Haweis 1878: Haweis, Eliza Ann. *The Art of Beauty*. London, 1878.

Haweis 1879: ———. *The Art of Dress*. London, 1879.

Haweis 1889: ———. *The Art of Decoration*. London, 1889.

Hawthorne 1881: Hawthorne, Mrs. Julian. "Mr Whistler's New Portraits." *Harper's Bazar* (Oct. 15, 1881): 658–59.

Hawthorne 1899: ———. "A Champion of Art." *Independent*, vol. 52 (Nov. 2, 1899): 2954–60.

Heijbroek and MacDonald 1997: Heijbroek, J. F., and Margaret F. MacDonald. *Whistler and Holland*. Amsterdam, 1997.

Hollander 1994: Hollander, Anne. *Sex and Suits*. New York, 1994.

Holt 1879: Holt, Ardern. *Fancy Dresses Described; or, What to Wear at Fancy Balls*. London, 1879.

Holt 1887: ———. *Fancy Dresses Described*. 5th ed. London, 1887.

Howitt 1889: Howitt, Mary. *An Autobiography*. Ed. Margaret Howitt. 2 vols. London, 1889.

Hughes 2000: Hughes, Claire. *Henry James and the Art of Dress*. Basingstoke, 2000.

Huysmans 1883: Huysmans, Joris-Karl. *L'Art Moderne*. Paris, 1883.

Huysmans 1908: ———. *Certains*. Paris, 1908.

Jackson 1999: Jackson, Anna. *Japanese Textiles*. Victoria and Albert Museum, London, 1999.

James 1976: James, Henry. *The Ambassadors*. London, [1903] 1976.

James 1986: ———. *The Wings of a Dove*. Ed. and intr. John Bayley. London, [1902] 1986.

James 1997: ———. *The Portrait of a Lady*. London, [1881] 1997.

James 2000: ———. *The Golden Bowl*. Ware, Herts, [1904] 2000.

Jones 1990: Jones, Mark, ed. *Fake? The Art of Deception*. London, 1990.

Jopling 1925: Jopling, Louise. *Twenty Years of My Life: 1867 to 1887*. London, 1925.

Kilmurray and Ormond 1998: Kilmurray, Elaine, and Richard Ormond. *John Singer Sargent*, exh. cat., Tate Britain, London, 1998.

Kleinert 1980: Kleinert, Anne Marie. "'La Dernière Mode': une tentative de Mallarmé dans la presse féminine." In *Lendemain*. Paris, 1980.

Kozloff 1979: Kozloff, Max. *Photography and Fascination*. Danbury, New Hampshire, 1979.

Lambert 1991: Lambert, Miles. *Fashion in Photographs 1860–1880*. London, 1991.

Lambton 1925: Lambton, Arthur. *My Story*. London, 1925.

Laughton 1971: Laughton, Bruce. *Phillip Wilson Steer, 1860–1942*. Oxford, 1971.

Laver [1930] 1951: Laver, James. *Whistler*. London, 1951.

Lecercle 1989: Lecercle, J. P. *Mallarmé et la Mode*. Paris, 1989.

Lehmann 2000: Lehmann, Ulrich. *Tigersprung: Fashion in Modernity*. Cambridge, Massachusetts, 2000.

Levitt 1986: Levitt, Sarah. *Victorians Unbuttoned*. London and Boston, 1986.

Levitt 1991: ———. *Fashion in Photographs 1880–1900*. London, 1991.

Lochnan 1984: Lochnan, Katharine. *The Etchings of James McNeill Whistler*. New Haven and London, 1984.

Lochnan 1999: ———, ed. *Seductive Surfaces: The Art of Tissot*. Studies in British Art, vol. 6. London, 1999.

Ludovici 1926: Ludovici, Albert. *An Artist's Life in London and Paris, 1870–1925*. London, 1926.

MacDonald 1987: MacDonald, Margaret F. "Maud Franklin." In *James McNeill Whistler: A Reexamination*. Ed. Ruth E. Fine. Washington, D.C., 1987.

MacDonald 1997: ———. *Beatrice Whistler, Artist and Designer*, exh. cat., Hunterian Art Gallery, University of Glasgow, 1997.

MacDonald 2001: ———. *Palaces in the Night: Whistler in Venice*. London and Berkeley, 2001.

MacDonald 2002: ———. "Maud Franklin." In *Dictionary of Artists' Models*. London, 2002.

MacDonald 2003: ———, ed. *Whistler's Mother: An American Icon*. London, 2003.

MacPhee 1993: MacPhee, Anne. "Two Patrons of Victorian Art." *Riches into Art*. Ed. Pat Starkey. Liverpool, 1993.

McLaughlin 1972: McLaughlin, Terence. *The Gilded Lily*. London, 1972.

Mansfield 1909: Mansfield, Howard. *A Descriptive Catalogue of the Etchings and Drypoints of J. M. Whistler*. Chicago, 1909.

Marsh 1987: Marsh, Jan. *Pre-Raphaelite Women: Images of Femininity*. New York, 1987.

Matthews 1999: Matthews, Alison M. "Aestheticism's True Colors. The Politics of Pigment in Victorian Art, Criticism and Fashion." In *Women and British Aestheticism*. Eds. Talia Schaffer and Kathy A. Psomides. Charlottesville, N.C., and London, 1999.

Mawe 1823: Mawe, John. *A Treatise on Diamonds and Precious Stones*. London, 1823.

May 1936: May, John Lewis. *John Lane in the Nineties*. London, 1936.

Maynard 1989: Maynard, Margaret. "'A Dream of Fair Women': Revival Dress and the Formation of Late Victorian Images of Femininity." *Art History*, vol. 12, no. 3 (Sept. 1989): 322–41.

Mayne 1964: Mayne, Jonathan, trans. Charles Baudelaire. *The Painter of Modern Life*. London, 1964.

Menpes 1904: Menpes, Mortimer. *Whistler as I Knew Him*. London, 1904.

Merrifield 1854: Merrifield, Mrs. Mary. *Dress as a Fine Art*. London, 1854.

Merrill 1992: Merrill, Linda. *A Pot of Paint: Aesthetics on Trial in "Whistler v. Ruskin."* Washington, D.C., and London, 1992.

Merrill 1998: ———. *The Peacock Room: A Cultural Biography*. New Haven and London, 1998.

Mix 1960: Mix, Katherine Lyon. *A Study in Yellow: The Yellow Book and Its Contributors*. London, 1960.

Montesquiou 1892: Montesquiou-Fezensac, Robert, comte de. *Les Chauve-Souris*. Paris, 1892.

Munhall 1995: Munhall, Edgar. *Whistler and Montesquiou*. New York and Paris, 1995.

Murger 1848: Murger, Henry. *Scènes de la vie de Bohème*. Published serially in 1848, and in book form, 1851.

Nakanishi 1992: Nakanishi, Branka. "A Symphony Reexamined: An Unpublished Study for Whistler's Portrait of Mrs. Frances Leyland." *The Art Institute of Chicago Museum Studies*, vol. 18, no. 2 (1992): 157–67, 188–91.

Newton 1974: Newton, Stella. *Health, Art and Reason. Dress Reformers of the Nineteenth Century*. London, 1974.

Newton 1990: Newton, Joy. *La Chauve-Souris et le Papillon. Correspondance Montesquiou-Whistler*. Glasgow, 1990.

Nicholson 1998: Nicholson, Shirley. *A Victorian Household*. 2d ed. Stroud, 1998.

Noels 1999: Noels, J. "The Dollar Princess: Fashion and the American Heiress in Late Nineteenth Century England." M.A. thesis, Courtauld Institute of Art, London University, 1999.

Olian 1998: Olian, Joanne, ed. *Victorian and Edwardian Fashions from La Mode Illustrée*. New York, 1998.

Oliphant 1878: Oliphant, Margaret. *Dress*. London, 1878.

Ono 2002: Ono, Ayako. "Japonisme in Britain: A Source of Inspiration: James McNeill Whistler, Mortimer Menpes, George Henry, E. A. Hornel and Nineteenth-Century Japan." Ph. D. diss., University of Glasgow, 2002.

Orchard 1884: Orchard, B. G. "Victor Fumigus." In *A Liverpool Exchange Portrait Gallery. Second Series: Being Lively Biographical Sketches of Some Gentleman Known on the Flags; Sketched from Memory, and Filled in from Fancy.* Liverpool, 1884.

Ormond 1968: Ormond, Leonée. "Female costume in the Aesthetic Movement of the 1870s and 1880s." *Costume*, vol. 2 (1968): 33–38.

Ormond 1969: ———. *George Du Maurier.* London, 1969.

Ormond 1970: ———. "Female Costume in the Aesthetic Movement of the 1870s and 1880s." *Costume*, vol. 4 (1970): 47–52.

Ormond 1974: ———. "Dress in the Painting of Dante Gabriel Rossetti." *Costume*, vol. 8 (1974): 26–29.

Ovenden 1972: Ovenden, Graham. *Pre-Raphaelite Photography.* London, 1972.

Paris 1905: *Oeuvres de James McNeill Whistler*, exh. cat., Palais de l'École des Beaux-Arts, Paris, 1905.

Parris 1984: Parris, Leslie, ed., *The Pre-Raphaelites*, exh. cat., Tate Gallery, London, 1984.

Parry 1980: Parry, Graham. *Hollar's England: A Mid-Seventeenth Century View.* Salisbury, 1980.

Pascoe 1880: Pascoe, Charles L., ed. *The Dramatic List.* London, 1880.

Pearl 1955: Pearl, Cyril. *The Girl with the Swansdown Seat.* Indianapolis, 1955.

Pennell 1908: Pennell, Elizabeth R. and Joseph. *The Life of James McNeill Whistler.* 2 vols. London and Philadelphia, 1908.

Pennell 1911: ———. *The Life of James McNeill Whistler.* 2 vols. 5th ed. London and Philadelphia, 1911.

Pennell 1921: ———. *The Whistler Journal.* Philadelphia, 1921.

Perrot 1994: Perrot, Philippe. *Fashioning the Bourgeoisie.* Princeton, 1994.

Phillips 1986: Phillips, P. "The Meux Succession: The Rise and Demise of a Dynasty." Unpublished typescript in the Wiltshire Library and Museum Service, 1986.

Philpott c. 1864: Philpott, Edward. *Crinoline in our Parks and Promenades from 1710 to 1864.* London, c. 1864.

Pottier 1892: Pottier, Edmond. "Les Salons de 1892." *Gazette des Beaux-Arts* (June 1892): 441–67.

Preston 1953: Preston, Kerison, ed. *Letters of W. Graham Robertson.* London, 1953.

Prinsep 1892: Prinsep, Val. "The Private Art Collections of London: The Late Mr. Frederick Leyland's in Prince's Gate. First paper: Rossetti and His Friend." *The Art Journal* (1892): 129–34.

Pritchard 1902: Pritchard, Mrs. E. *The Cult of Chiffon.* London, 1902.

Randall 1979: Randall, Lillian, ed. *George A. Lucas: An American Art Agent in Paris, 1857–1909.* Princeton, 1979.

Ribeiro 1979: Ribeiro, Aileen. "Furs in Fashion: The Eighteenth and Early Nineteenth Centuries." *The Connoisseur*, vol. 202, no. 814 (Dec. 1979): 226–31.

Ribeiro 1986: ———. *Dress and Morality.* London, 1986.

Ribeiro 1999: ———. *Ingres in Fashion: Representations of Dress and Appearance in Ingres's Images of Women.* New Haven and London, 1999.

Ribeiro 2000: ———. *The Gallery of Fashion.* Princeton, 2000.

Ribeiro and Cumming 1997: Ribeiro, Aileen, and Valerie Cumming. *The Visual History of Costume.* New York, 1997.

Ricatte 1989: Ricatte, Robert, ed. *Journal des Goncourt.* Paris, 1989.

Robertson 2003: Robertson, Pamela. *Beauty and the Butterfly: Whistler's Depictions of Women*, exh. cat., Hunterian Art Gallery, University of Glasgow, 2003.

Robertson 1931: Robertson, W. Graham. *Life Was Worth Living.* New York and London, 1931.

Robinson 1892: Robinson, Lionel. "The Private Art Collections of London: The Late Mr. Frederick Leyland's in Prince's Gate. Second paper: The Leyland Collection." *The Art Journal* (1892): 134–38.

Roe 1998: Roe, Gordon. "The Body of Art and the Mantle of Authority." In *Consuming Fashion: Adorning the Transnational Body.* Eds. Anne Brydon and Sandra Niessen. Oxford and New York, 1998: 91–107.

Rooke 1980: Rooke, P. E., ed. *Theobalds through the Centuries: The Changing Fortunes of a Hertfordshire House and Estate.* Waltham Cross, 1980.

Roskill 1970: Roskill, Mark. "Early Impressionism and the Fashion Print." *Burlington Magazine*, vol. 112 (June 1970): 390–93.

Rossetti 1867: Rossetti, William Michael. *Fine Art, Chiefly Contemporary.* London, 1867.

Rossetti 1895: ———. *Dante Gabriel Rossetti: His Family Letters, with a Memoir.* Vol. 1. London, 1895.

Rothenstein 1937: Rothenstein, William. *Men and Memories: A History of the Arts, 1872–1922, Being the Recollections of William Rothenstein.* New York, 1937.

Rouart and Wildenstein 1975: Rouart, Denis, and Daniel Wildenstein. *Édouard Manet: Catalogue raisonné.* 2 vols. Lausanne, 1975.

Scarisbrick 2000: Scarisbrick, Diana. *Tiara.* San Francisco, 2000.

Sherwood 1884: Sherwood, Mrs. J. *Manners and Social Usages.* New York, 1884.

Sickert 1947: Sickert, Richard. *A Free House! . . . the writings of Walter Richard Sickert.* Ed. Osbert Sitwell. London, 1947.

Smith 1996: Smith, Alison. *The Victorian Nude: Sexuality, Morality and Art.* Manchester, 1996.

Snowman 1990: Snowman, A. Kenneth, ed. *The Master Jewelers.* London, 1990.

Soros 1999: Soros, Susan, ed. *E. W. Godwin, Aesthetic Movement Architect and Designer.* New Haven and London, 1999.

Spencer 1989: Spencer, Robin. *A Retrospective.* New York, 1989.

Spencer 1998: ———. "'The White Girl': painting, poetry and meaning." *Burlington Magazine*, vol. 140, no. 1142 (May 1998): 300–11.

Steele 1988: Steele, Valerie. *Paris Fashion. A Cultural History.* Oxford, 1988.

Stephenson 2000: Stephenson, Andrew. "Refashioning Masculinity: Whistler, Aestheticism and National Identity." In *English Art 1860–1914.* Eds. David Peters Corbett and Lara Perry. Manchester, 2000.

Stevenson and Bennett 1978: Stevenson, Sara, and Helen Bennett. *Van Dyck in Check Trousers: Fancy Dress in Art and Life 1700–1900.* Edinburgh, 1978.

Stripe c. 1893: "Sketch of the Commercial Life of H. E. Stripe."

Unpublished manuscript of autobiographical notes, Merseyside Maritime Museum Archives. Liverpool, c. 1893.

Surtees 1971: Surtees, Virginia. *The Paintings and Drawings of Dante Gabriel Rossetti (1828–1882): A Catalogue Raisonné.* Oxford, 1971.

Surtees 1997: ———. *The Actress and the Brewer's Wife: Two Victorian Vignettes.* Wilby, Norwich, 1997.

Sutton 1974: Sutton, Denys. "Whistler and Lady Meux." *Journal of the Honolulu Academy of Arts* (1974): 36–43.

Sweeney 1956: Sweeney, John L., ed. *The Painter's Eye: Notes and Essays on the Pictorial Arts by Henry James.* Cambridge, Mass., 1956.

Sweeney 1989: ———. *The Painter's Eye: Notes and Essays on the Pictorial Arts by Henry James.* Madison, 1989.

Swinburne 1875: Swinburne, Algernon Charles. "Notes on Some Pictures of 1868." In *Essays and Studies.* London, 1875, 358–80.

Thieme 1993: Thieme, Otto Charles, et al. *Victorian and Edwardian Fashion in America*, exh cat., Cincinnati Art Museum, 1993.

Thomas 1874: Thomas, Ralph. *A Catalogue of the Etchings and Drypoints of James Abbott MacNeil [sic] Whistler.* London, 1874.

Thorp 1994: Thorp, Nigel, ed. *Whistler on Art, Selected Letters and Writings, 1849–1903.* Manchester, 1994.

Tibbles 1994: Tibbles, Tony. "Speke Hall and Frederick Leyland: Antiquarian Refinements." *The National Trust Historic Houses and Collections Annual* (London, 1994): 34–37.

Toutziari 2002: Toutziari, Georgia. "Anna Matilda Whistler— An Annotated Correspondence." Ph.D. diss., University of Glasgow, 2002.

Trollope 1994: Trollope, Anthony. *The Way We Live Now.* Ed. F. Kermode. London, [1875] 1994.

Veblen 2001: Veblen, Thorstein. *The Theory of the Leisure Class.* New York, [1899] 2001.

Wallace and Gillespie 1949: Wallace, Sarah Agnes, and Frances Elma Gillespie, eds. *The Journal of Benjamin Moran 1857–1865.* Vol. 1. Chicago, 1949.

Watts 1912: Watts, M. S. *George Frederick Watts.* London, 1912.

Way 1912: Way, Thomas R. *Memories of James McNeill Whistler the Artist.* London, 1912.

Way and Dennis 1903: Way, Thomas. R., and G. R. Dennis. *The Art of J. McNeill Whistler.* London, 1903.

Wedmore 1884: Wedmore, Frederick. "Mr Whistler's Arrangement in Flesh Colour and Gray." *Academy*, vol. 25 (May 24, 1884): 374.

Wedmore 1886: Wedmore, Frederick. *Whistler's Etchings: A Study and a Catalogue.* London, 1886.

Weintraub 1974: Weintraub, Stanley. *Whistler: A Biography.* London, 1974.

Wentworth 1984: Wentworth, Michael. *James Tissot.* Oxford, 1984.

Wharton 1974: Wharton, Edith. *The Age of Innocence.* London, [1920] 1974.

Whistler 1878: Whistler, James McNeill. "The Red Rag." From the interview, "Mr Whistler at Cheyne Walk." *World* (May 22, 1878).

Whistler 1882: ———. *Correspondence, Padden Papers. The Owl and the Cabinet.* London, [1882].

Whistler 1890: ———. *The Gentle Art of Making Enemies.* London, 1890.

Whistler 1892: ———. *The Gentle Art of Making Enemies.* 2d ed. London, 1892.

Whistler 1899: ———. *Eden versus Whistler. The Baronet and The Butterfly. A Valentine with a Verdict.* Paris, 1899.

Wiehl 1983: Wiehl, M. Lee, *A Cultivated Taste: Whistler and American Print Collectors*, exh. cat., Davison Art Center, Wesleyan University, Middletown, Connecticut, 1983.

Wilde 1877: Wilde, Oscar. "The Grosvenor Gallery." *Dublin University Magazine*, vol. 90 (1877): 118–26. Repr. in *Miscellanies*, ed. R. Ross, vol. 14, London 1908.

Wilde 1885: ———. "The Relation of Dress to Art." *Pall Mall Gazette* (Feb. 28, 1885). Reprinted in *The Artist as Critic: Critical Writings of Oscar Wilde.* Ed. Richard Ellman. London, 1974.

Williamson 1919: Williamson, George C. *Murray Marks and His Friends.* London and New York, 1919.

Wilson 1996: Wilson, Sophia, ed. *Simply Stunning: The Pre-Raphaelite Art of Dressing*, exh. cat., Cheltenham Art Gallery and Museum, 1996.

Wilson 1998: Wilson, Verity. *Chinese Dress*, Victoria and Albert Museum, London, 1998.

Wilton 1992: Wilton, Andrew. *The Swagger Portrait: Grand Manner Portraiture in Britain from Van Dyck to Augustus John 1630–1930.* London, 1992.

Wintermute 1999: Wintermute, Alan. *Watteau and His World: French Drawing from 1700 to 1750.* New York, 1999.

Woodville 1914: Woodville, R. Caton. *Random Recollections.* London, 1914.

Worth 1928: Worth, J. P. *A Century of Fashion.* Boston, 1928.

Index

Accessories: boa, 38, 196, 199–201; bolero, 38, 58; bonnet, 8, 85, 187, 196, 216–17; burnous, 45; cape, 35, 38, 139, 180; cloak, 146, 159, 164, 168–69, 187; domino, 55, 213; fans, 39, 44, 55, 57–58, 144, 147, 152, 196, figs. 39, 65; fichu, 114, 187, fig. 181; gloves, 35, 183, 196; hats, 30, 38, 45, 55, 71, 100, 119, 124–25, 127, 129, 130, 135, 139, 144, 147, 155, 159, 171, 174–75, 189, 193, 196, 199, 201–202; jewelry, 10, 24, 28, 35, 58, 103, 153, 161–62, 169, 178, 190–92, 196, 208, 213, 216, figs. 184–86; mask, 55, 57; muff, 159, 176, fig. 53; parasol, 11, 68–69, 183, fig. 176; scarf, 61, 114; shawl, 58, 127; shoes/boots, 26, 35, 44–45, 50, 58, 153, 182–83; stockings, 26, 45, 71, 152
Aesthetic dress: 49; Movement, 8, 19, 21, 46, 95–96
Alexander: Cicely Henrietta (1864–1932), 71–75, 127; Agnes Mary Alexander (May) (1862–1950), 122–23, 127; Rachel Agnes, Mrs. W. C., 71, 127; William Cleverly (1840–1916), 71, 124
Alexander, John White (1856–1915), 143
Alma-Tadema, Lawrence (1836–1912), 47
Alias, Mme, 44
Anethan, Alex d', 202
Armstrong, Thomas (1832–1911), 7, 79
Austria, Empress Elizabeth of (1837–1898), 34, 124

Bacher, Otto Henry (1856–1909), 143
Bassano, Alexander (1829–1913), 146; *Portrait of Kate Munro*, fig. 138
Baudelaire, Charles (1821–1867), 85, 92, 96, 97, 115, 170, 210, 220; *The Painter of Modern Life*, 85, 115, 125, 220; *Les Fleurs du Mal*, 170
Beardsley, Aubrey Vincent (1872–1898), 192–93; *Fat Woman* or *A Study in Major Lines*, fig. 187
Beatrice May Victoria, Princess (1857–1944), 34
Beerbohm, Max (1872–1956), 131; *Mr. __ and Miss __ Nervously Perpetuating the Touch of the Vanished Hand*, fig. 123
Beeton, Samuel (1831–1877), 21
Bénédite, Léonce (1859–1925), 44
Bey, Khalil, 80
Bibby, John, & Sons, 96
Black, Frances (1824–1917), Mrs. J. Birnie Philip, 187
Blanc, Charles (1813–1882), 16, 21, 26, 28, 35–36, 43, 44, 46
Blanche, Jacques Émile Blanche (1861–1942), 43
Bloomer, Amelia Jenks (1818–1894), 41
Bodley, John Edward Courtenay (1853–1925), 10
Boldini, Giovanni (1845–1931), 13, 21, 35, 37, 183; *Gertrude Elizabeth, Lady Colin Campbell*, fig. 36; *Portrait of Whistler*, fig. 13
Bonnard, Camille, *Costume Historique*, 88

Bonnat, Léon-Joseph Florentin (1833–1922), 168, 170; *Jane Lathrop Stanford*, fig. 159
Botticelli, Alessandro di Mariano Filipepi (c. 1445–1510), *Primavera*, 106
Bourely, J. et Cie, 40, fig. 41
Boyce, George Price (1826–1897), 84
Boxall, William (1800–1879), 13
British Museum, The, 161, 187
British School, *J. McN. Whistler and the Family of F. R. Leyland . . .* , 110, fig. 104
Brookfield, Charles Hallam Elton (1857–1913), 159–61; *Whistler's "Lady Meux,"* fig. 149
Brown, Ford Madox (1821–1893), 88, 120
Brummell, Lord George Bryan (1778–1840), 10
Burne-Jones, Edward Coley (1833–1898), 120

Cameron, Julia Margaret (1815–1879), 62; *Portrait of Marie Spartali*, 62, fig. 59
Campbell: Lady Archibald (c. 1846–1923), 35, 136, 178, 182–83, 187; Lady Colin (Gertrude Elizabeth) (1857–1911), 21, 35, 183; *The Etiquette of Good Society*, 21; George Douglas (1823–1900), 8th Duke of Argyll, 178
Caracciola, Maria Beatrice Olga Alberta (1871–1929), 152
Carlyle, Thomas (1795–1881), 71
Carnegie, Mrs. Andrew, 50, 103, fig. 95
Carolus-Duran, Émile-Auguste (1837–1917), 38; *La Dame au gant: Portrait of Mme. X****, 38
Cassatt, Mary Stevenson (1844–1926), 124, 144
Cassell's, Mrs., Mourning Warehouse, 30, fig. 27
Cavendish, Lady Frederick, 85
China, blue and white, 43, 58–61
Chinese art, 119; *see also* Dress, kimono.
Clayton, Ellen C., *English Female Artists*, 119
Clayton, Francis Corder, 119
Cole, Alan Summerly (1846–1934), 9–10, 80, 135; Sir Henry (1808–1882), 9, 64
Collins, (William) Wilkie (1824–1889), 86; *Armadale*, 86; *The Woman in White*, 86
Color, 8–9, 19, 21–22, 30, 35, 38–39, 42, 61, 159; dyes, 22, 26, 44, 71, 89
Comyns-Carr, Alice, 49
Corder: Charlotte, née Hill, 119, 129; Frederick, 119; Micah (1680–1766), 119; Rosa Frances (1853–1884), 117–31
Cornforth, Fanny (1824–1906), 84, 85, 88
Costume Society, 47
Courbet, Jean-Désiré-Gustave (1819–1877), 69, 76, 79, 80; *La Belle Irlandaise*, 79, 80, fig. 75; *Le Sommeil*, 80
Crane, Walter (1845–1915), 21, 41
Craig, Edith Ailsa Geraldine (1869–1947), 50, 187
Craig, Edward Gordon (1817–1905), 187
Cruikshank, George (1792–1878), 5

Dalziel brothers, 80
Dandy, 5, 13, 42, 138, 220

Photograph Credits